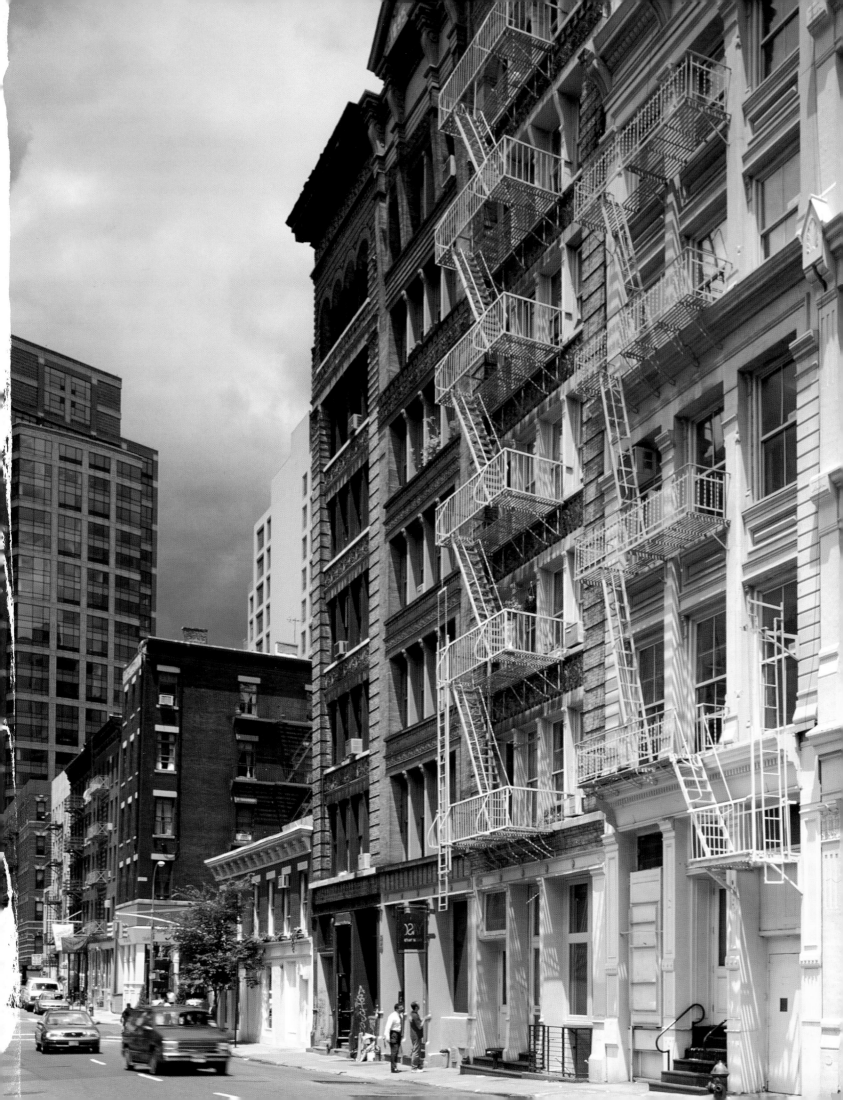

Loft Mayer Rus Photographs by Paul Warchol

THE MONACELLI PRESS

First published in the United States of America in 1998 by The Monacelli Press, Inc.
10 East 92nd Street, New York, New York 10128.

Copyright © 1998 The Monacelli Press, Inc.
Text copyright © 1998 Mayer Rus
Photographs copyright © 1998 Paul Warchol

Library of Congress Cataloging-in-Publication Data
Rus, Mayer.
Loft / Mayer Rus ; photographs by Paul Warchol.
p. cm.
ISBN 1-58093-013-1
1. Lofts—New York (State)—New York. 2. New York (N.Y.)—Buildings, structures, etc.
3. Lofts—Decoration—New York (State)—New York. I. Title.
NA7882.R87 1998
747'.88314—dc21 98-37001

Printed and bound in Hong Kong

For Sam and Bluma —M.R.

For (in order of appearance) Ulla,
Lucinda, and Leo —P.W.

Acknowledgments

I owe an enormous debt of gratitude to Stanley Abercrombie
for his inestimable support, guidance, and friendship.
David Rimanelli's incisive criticism of the manuscript forced me to clarify my thoughts
and to reevaluate certain fundamental ideas. His input elevated the caliber of the entire project.
With unfailing generosity of spirit, Judith Nasatir provided
wise counsel and encouragement throughout the process of creating this book.
The exceptionally gifted Alexa Mulvihill made important early contributions.
For specific acts of kindness, and for simply putting up with me, I must acknowledge
Jon Cooper, Julian Fleisher, Jean Godfrey-June, Jane Kaplowitz and Robert Rosenblum, Joshua Malina,
Andrea Monfried, Sarah Pettit, Andrea Schwan, Christopher Stulpin, and Henry Urbach.
Special thanks are due to the architects and designers whose talents and artistry inspired this book.
I am also indebted to the clients who graciously allowed us into their homes.
Finally, a bit of well-deserved logrolling. Paul Warchol's unerring eye and singular vision
have challenged me to look at the world with far greater clarity and depth.
His photographs achieve a kind of poetry to which my words can only aspire.
Mayer Rus

Thanks to Gianfranco Monacelli and Andrea Monfried for the opportunity,
to all the architects for the chance to record their blood and sweat,
to the residents of these remarkable spaces for permission to invade their homes,
to Mayer for his good humor and insight,
to Michael Rock and David Israel of 2x4 for knowing what to do with the photographs,
to Elizabeth Felicella for keeping things clear,
to Amy Barkow for organizing,
to all of the photo assistants who toiled with me in the service of these pictures,
to Ben and Louis Diep at Hong Color for their printing artistry,
and to Ulla for her help, love, and patience.
Paul Warchol

Introduction

The New York loft presents an intriguing twist in the evolution of personal living spaces, one that creates particular problems for architects trying to adapt erstwhile industrial spaces to quotidian human needs: sleeping, eating, entertaining, storage, and so on. Having firmly entered the vernacular of urban domestic life and design, the loft long ago ceased functioning as a neat, ready-made signifier of bohemian rebellion and otherness. Yet even as the romantic mythology traditionally associated with loft living has given way to more complex realities, the concept of loft habitation still preserves a frisson of its original strangeness and allure.

The lofts in this book represent various exemplary, ingenious, and often visually and spatially stunning solutions to basic issues of architectural transformation. All of the lofts are in New York City, which remains to this day the main center as well as the original locus of loft living, even as the demands of the Manhattan real-estate market have pushed loft colonization beyond its earliest and densest enclaves, Soho and Tribeca. And as New York is the birthplace of the loft as domestic space, so too has the loft achieved in New York its broadest practical applications as well as its finest flowers.

At the end of the twentieth century, loft living, once an apparently radical, antibourgeois gesture, has been thoroughly domesticated—domesticated, but by no means rendered bland or conventional. New demands for originality and ingenuity within the constraints of a given architectural environment continue to challenge loft dwellers and the architects and designers they engage to realize practical living and working arrangements. These demands are multiplied by the ever broadening demographics of the new generation of loft inhabitants. Once typically the preserve of artists and other "creative" types, in the 1980s the loft became no less archetypally the sanctum of newly made plutocrats—a legacy, no doubt, of the reckless, booming 1980s economy of arbitrage, leveraged buyouts, and junk bonds. In the late 1990s, four or five decades after the first wave of loft colonization in New York, no one stereotypical profile of the urban loft dweller holds sway. New Yorkers of infinitely varied personal and professional backgrounds have heeded the loft's siren call of glorious, expansive space in a hard, claustrophobic city.

Working in tandem with the economic forces that propel New York's ravenous real-estate market, the popular media has without doubt contributed to the widening appeal of loft living. Lavish spreads in glossy design magazines tantalize readers with visions of seemingly endless space encompassing such delectable appurtenances as the palatial kitchen bedizened with shiny, high-dollar professional cooking equipment. Movies, too, have provided a reservoir of popularizing images of "out there" urban living. The elaborate Soho loft renovation in *Ghost* (1990) nicely mirrored shifts in the symbolic register of loft culture by conflating two dominant stereotypes of loft dwellers: Patrick Swayze played an investment banker awash in new money; his wife, played by Demi Moore, was a sensitive ceramicist/artist. For a somewhat darker version of loft mythology, consider the abode of Mickey Rourke's sleek, perverted, Comme des Garçons–clad arbitrageur in Adrian Lyne's *9 1/2 Weeks* (1986). Rourke's achingly severe, precious loft—a perfect lair for someone who transgresses societal norms—should have received star billing. More recent films continue to traffic in received notions. *A Perfect Murder* (1998) served up an artist's loft of such capacious grandeur (and exquisitely manicured grubbiness) that it could exist only in the realm of Hollywood fantasy.

Most of the loft buildings in New York City were erected in the late nineteenth and early twentieth centuries for the purposes of manufacturing and light industry. They served as clothing factories and printing shops, as warehouses and production plants. These enterprises were frequently housed in the cast-iron buildings so prevalent in Soho, which boasts the highest concentration of cast-iron architecture in America.

Behind the eclectic ornamental facades of these buildings, loft floors were fairly standard from one building to the next: long, narrow spaces (well suited for assembly-line work) with large windows and a notable lack of extraneous, decorative architectural details. Tribeca and far western Chelsea are also rich in loft buildings, due in part to their proximity to the docks along the Hudson River.

In the 1930s and 1940s, as New York's manufacturing base shifted to larger factories outside the city, loft buildings generally fell into desuetude, neglected by landlords if not abandoned altogether. The once thriving business district of Soho devolved into a creepy, desolate no-man's-land of urban blight between the downtown financial center and Greenwich Village. It was this grim scenario that greeted the first wave of loft colonizers, artists searching for large expanses of cheap space.

As early as the late 1940s, the abstract expressionist painter Barnett Newman had settled in a loft in Soho. The material conditions of the early loft environments—raw, unfinished, industrial, defiantly unpretty and antibourgeois—provided an ideal crucible for the styles of living and modes of aesthetic expression that were sedimenting in the "underground" avant-gardist culture of the 1950s. The apparent privations of loft living—no heat or running water—readily accorded with the image of the struggling, impoverished, yet enterprising artist and bohemian. In a more practical vein, the ample spaces accommodated the often enormous canvases on which the abstract expressionists worked. They also allowed for other dramatic (and would-be dramatic) modes of expression, such as action painting.

While lofts functioned efficiently as arenas for abstract expressionist production, they achieved a new level of importance for the radical aesthetics of the next generation of avant-garde artists: Robert Rauschenberg, Jasper Johns, John Cage, and their circle. Whereas the abstract expressionists had viewed the space of the canvas as a kind of stage on which they could act out personal and cosmic dramas, the successor generation of artists quickly came to disdain such theatrics, even as it admitted *actual* performance into the creation of artworks. Lofts supplied both the acreage and the mood appropriate to burgeoning performance art, body art, the avant-garde dance of Merce Cunningham and the Judson Church, Fluxus events,

and Happenings. Lofts also suited the new era in sculpture—minimalism—both because of the typically large spaces required for the creation and display of these works and because the architecture itself reflected the mind-set of artists such as Donald Judd, Carl Andre, Dan Flavin, Robert Morris, and Sol Lewitt. These sculptors explicitly embraced modes of industrial production and disdained the mythos of the artist's hand so enthusiastically endorsed by the painters of first- and second-generation abstract expressionism.

The artists gathering in Soho were inevitably followed by their commercial representatives: galleries. In 1968 Paula Cooper opened her gallery on Wooster Street; she was soon followed by such dealers as Leo Castelli and Ivan Karp, the impresario behind the O.K. Harris Gallery. The pared-down aesthetic of the lofts in which the new art was made also had an impact on the design of the galleries in which it was shown. Quite often, the gallery appeared as simply a tidier, more organized version of the artist's loft. In the 1970s, as the gallery scene flourished in Soho, other commercial ventures (restaurants, shops, and the like) entered the picture—after all, the art world has to eat. A thriving street life began to overtake Soho, both by day and by night, in a process of commercialization whose end is still not in sight. Hence, in the late 1990s Soho is as much about shopping for the latest fashions in clothes and home design as it is about contemporary art, and perhaps even more so.

In the larger urban picture, beyond the rarefied confines of the art world, the early loft renovations in Soho functioned as a catalyst for urban renewal during a period of radical changes in urban planning theory and practice. For one thing, the historic-preservation movement that began and flourished in New York during the 1960s and 1970s encouraged and helped to validate the move toward loft living. Buildings once regarded as useless, empty shells of industries that had long since died or moved away from the city were reevaluated for their intrinsic architectural qualities. With Soho providing a model for a new kind of urban rehabilitation, the city of New York enacted ordinances in 1964 and 1971 that allowed residential occupancy of structures originally zoned as commercial in specific neighborhoods such as Soho and Tribeca. (Prior to the enactment of the new legislation, loft occupants had often been forced to take extreme measures of caution and deception to insure that they were not found out as residents as well as workers in loft buildings.) With loft occupancy officially sanctioned by the city, the clandestine, makeshift domestic improvisations of the early loft pioneers slowly, inevitably gave way to more ordered renovation efforts in an evolutionary process ultimately leading to the bravado architectural transformations so common in the 1980s and 1990s.

With the advent of a commercial culture in Soho, and with the new residency ordinances, the edge of radicalism that had been so important to the loft pioneers was blunted. While hints of domesticity began to creep into the loft early on, as the first tenants adopted cunning strategies to render the harsh environments more hospitable and comfortable, by the 1980s the very character of the artist had been thoroughly transformed: from penniless bohemian living on the margins of society to wheeler-dealer entrepreneur in the seemingly ever expansive era of neo-expressionism and neo-geo. It is in this era of a booming art market that the loft truly came into its own as a lavish showplace of architecture and design, rather than the dramatic yet often squalid cavern of days gone by.

The roots of contemporary loft design and its attendant mentality can be traced back to early modernism. The free, open spaces of lofts are a natural, perhaps even ideal, locus for the implementation of the ideas of the early modernist architects and designers: Adolf Loos, Le Corbusier, Mies van der Rohe, and even Frank Lloyd Wright can be conscripted, with varying degrees of reluctance to be sure, into the

service of loft design. Wright is not especially associated with urban architecture, but his call for a more organic approach to the free flow of space, unimpeded by the artificial demarcations established by traditional rooms, is perfectly adaptable to the structure of lofts. Consider, for example, Wright's exultant, hortatory essay "In Order to be Modern" (1930): "Free in spirit, grasp now the new order of sunlit space, beautifully screened in by glass and steel." Wright was celebrating the age of the machine and the need to embrace new kinds of living arrangements unencumbered by the suffocating weight of history; he could almost have been speaking of the cast-iron architecture of industrial loft buildings pierced by huge windows.

European Modernism harbors other precursors for the development of loft design. With his concept of the *Raumplan*, Adolf Loos instigated a rebellion against the conventions of domestic architecture—discrete rooms, arranged around connecting hallways, each with a supposedly specific use distinct from the uses of all other rooms. Instead, he proposed a more open, flexible approach to the sequence of living spaces, of which the *Raumplan* was the theoretical distillation. Loos insisted that the size and positioning of spatial volumes should be determined by an analysis of usage patterns; the overall volume would be enriched by a strategic overlap of spaces.

Mies van der Rohe also advocated an open plan emphasizing the free flow of space rather than compartmentalized rooms. The architect's vision of this *echt*-modernist idea found its perfect, eloquent realization in his Barcelona Pavilion and his iconic house designs. But it remains Le Corbusier, in his landmark *Towards a New Architecture* (1923), who provided the greatest theoretical support for an architectural sensibility that would flower in contemporary loft design. He exulted in the new forms of industrial architecture with the kind of perfervid enthusiasm usually associated with political and religious revolutionaries and reformers: "Thus we have the American grain elevators and factories, the magnificent first-fruits of the new age. The American engineers overwhelm with their calculations our expiring architecture." Le Corbusier recast the rhetoric of modern architecture in a dialectic of old and new, Europe and America, dead and living.

Other passages from *Towards a New Architecture* seem to provide an uncanny validation for the general concept and

specific conditions of loft living: "The most noble quarters of our towns are inevitably the manufacturing ones where the basis of grandeur and style—namely, geometry—results from the problem itself." In regard to particular aspects of residential design, Le Corbusier avers: "Demand one really large living room instead of a number of small ones" and "There is no shame in living in a house without a pointed roof, with walls as smooth as sheet iron, with windows like those of factories."

Lofts have gone on to enjoy enormous influence and prestige as models for urban living. Their vocabulary of openness and light has exerted a profound effect both on new residential construction and, more directly, on the renovation of existing residences: for example, apartment owners who desire the flexibility and freedom of loft life within their more traditional buildings. Needless to say, the loft style also appeals to those people who covet the glossy veneer of urban sophistication and hipness that loft living implies. As such, often otherwise conventional buildings have begun to incorporate open plans, large volumes of space, and exposed structural elements.

Perhaps the most powerful influence of loft design farther afield has not been within the domestic context but rather within that of cutting-edge office design. Many of the new high-tech, advertising, and media businesses have set up shop in renovated lofts. Such locales and designs endow these companies with a desirable spirit of progressivism, innovation, experimentation, and, yes, coolness. On the level of form rather than iconology, the nature of loft design, with its typically exposed ceilings and mechanical equipment, is well suited to the electronic needs of these high-tech companies, which demand easy access to wiring systems and the utmost flexibility.

Nevertheless, the focus of this book is, once again, the conditions of state-of-the-art domestic loft design. While the essential features of loft design and living appear more or less immutable, there have been extraordinary as well as incremental changes since the advent of this particular form of urban architectural transformation in the 1950s. The challenge for contemporary loft design that seeks to be a creative as well as an efficient medium is the maintenance of lofts' intrinsic qualities of openness and light and the simultaneous creation of provisions for privacy and the necessary subdivision of space: a purely open space, without any mediations, would be rather undesirable, indeed ineffectual and impractical. Often with relatively few restrictions in terms of surface area and square footage, lofts are thrilling opportunities for enterprising architects and designers, veritable laboratories or playgrounds for clever, off-beat, sometimes dazzling exercises in their respective arts.

The lofts featured in this book represent a broad and varied spectrum of design strategies, even as common issues of loft habitation are addressed. Certain architects celebrate and even fetishize existing architectural details while others choose to eradicate vestigial traces of past lives. Even the selection of "appropriate" building materials is happily schizophrenic. Many designers explore new uses for mundane materials recontextualized from other areas of industry: plywood, industrial metals, and all manner of commercial acrylics and glass. Others choose to specify more precious materials, investigating the tension between raw, unfinished space and highly refined surface treatments and furnishings. Clearly, no one approach or idea can be deemed more valid than another. As societal norms evolve at an ever accelerating rate, loft design remains a thoughtful pursuit that is not based on formulas or absolute rules. The most successful lofts are those that deliver an appropriate expression, both aesthetically and programatically, for the specific concerns and unique spirit of the client.

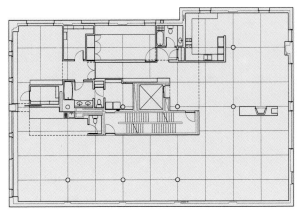

Howell Loft, Greenwich Village, 1997

Deborah Berke Architect

Having renovated two other lofts in the same Greenwich Village building, Deborah Berke was intimately familiar with the particular challenges of this site. The 1920s concrete structure—one of the few true loft buildings in the far West Village—had been used for horse stables and warehouse space, and its condition was still decidedly raw. Berke's clients—Jim Howell, a minimalist painter, and his wife, Joy—had acquired a 4,800-square-foot, floor-through space meant to serve living needs as well as to provide ample area for a painting studio, exhibition space, and office.

The plan locates the master bedroom, bath, and closets behind an existing core and leaves the remaining two-thirds of the loft essentially open. The living room, defined by an island fireplace and adjacent seating arrangement, serves as an arrival zone that permits glimpses into the exhibition area beyond. That exhibition space is bordered by a 120-foot-long uninterrupted plaster wall that terminates in Howell's painting studio. A massive floor-to-ceiling three-way door provides the mechanism for adapting the office space: fully closed, it forms a guest suite with an attached bath; partially closed, it locks the office while allowing bathroom access for visitors.

Working with project architect Maitland Jones, Berke devised a rigorous gray-and-white interior scheme deferential to the nature of Howell's paintings, which she describes as "unbelievably exacting and pure studies in gray." White plaster walls and a new concrete floor are consciously evocative of the spare, minimalist aesthetic prevalent in New York's cutting-edge contemporary art galleries. Similarly, the basic gallery-type lighting system installed here provides the constancy of illumination required for viewing the artwork. The modest materials palette—white plastic laminate, white glazed tiles, and white paint—was applied with the painstaking precision and seamlessness that characterize Berke's overall design and Howell's mesmerizing paintings.

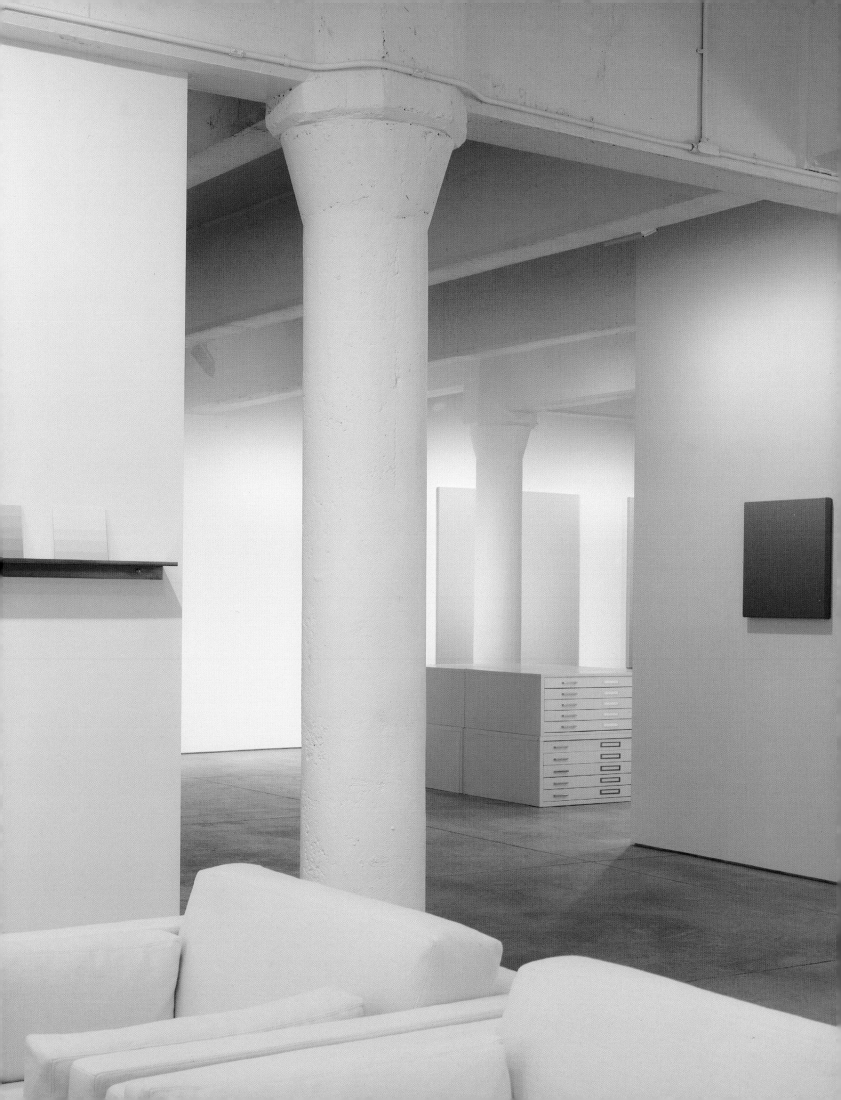

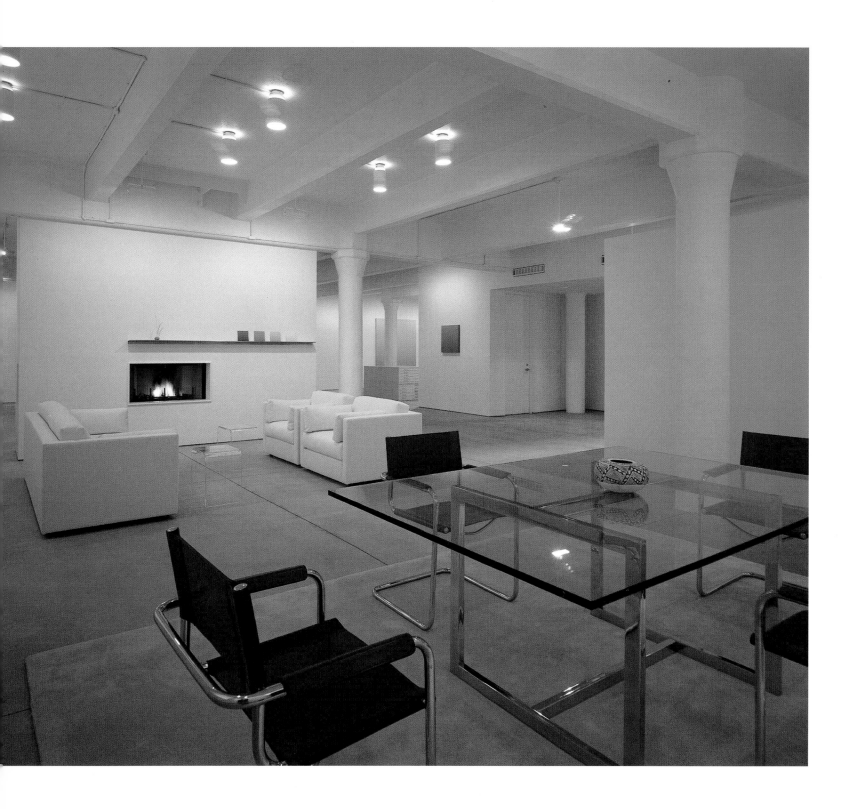

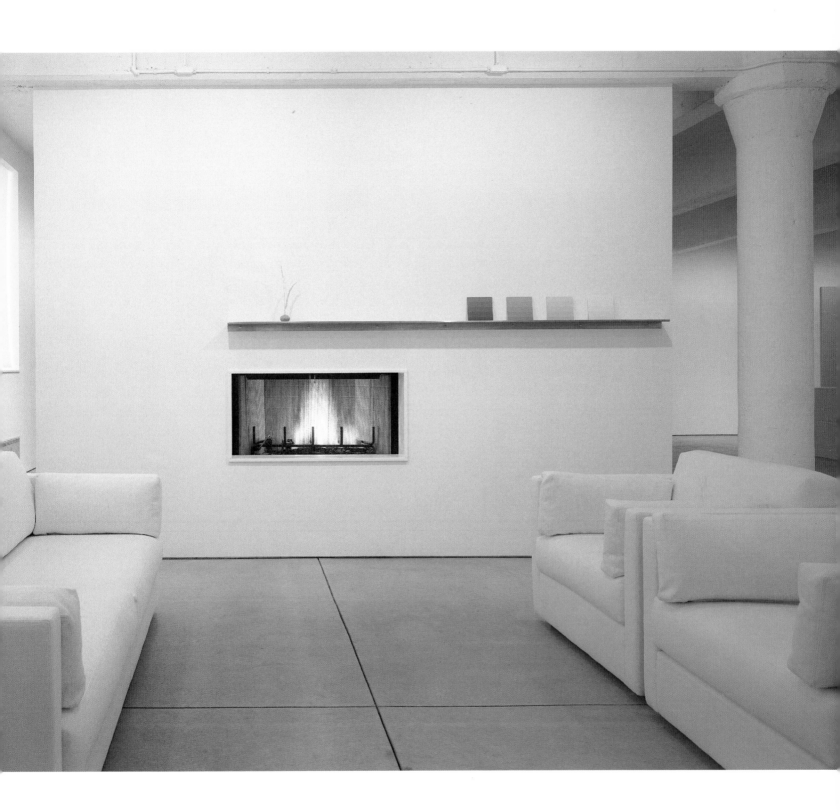

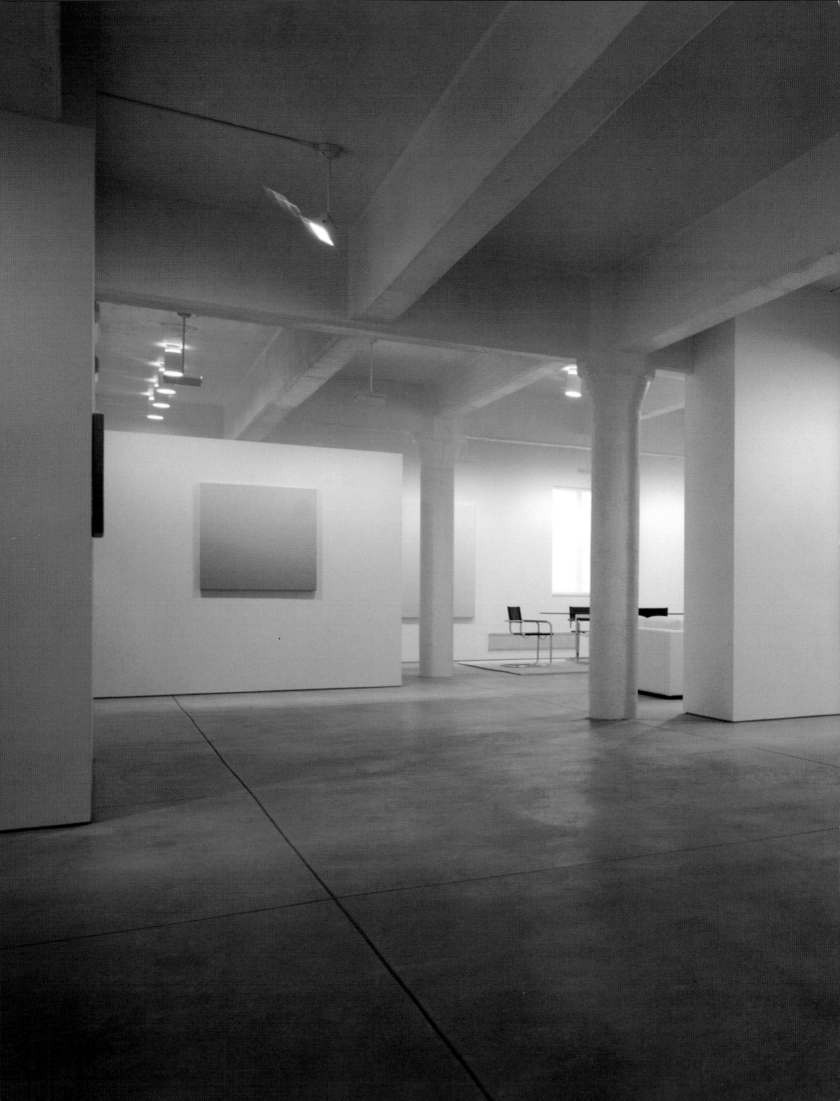

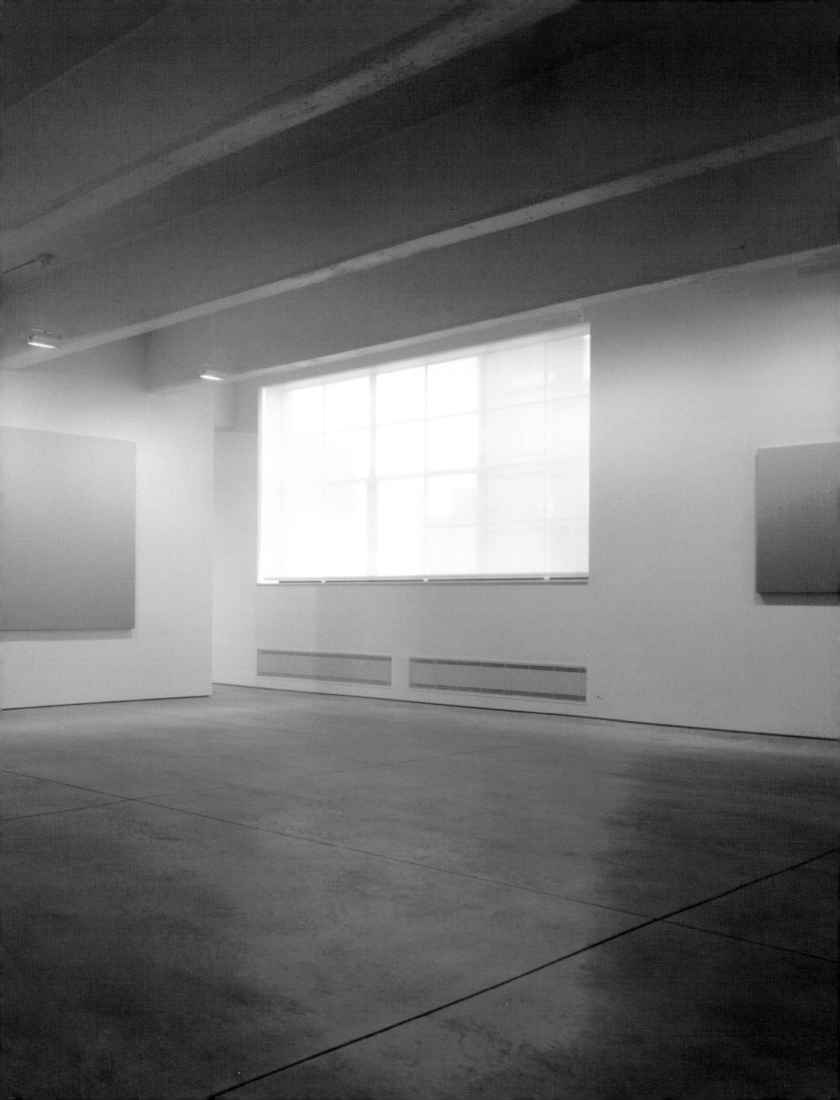

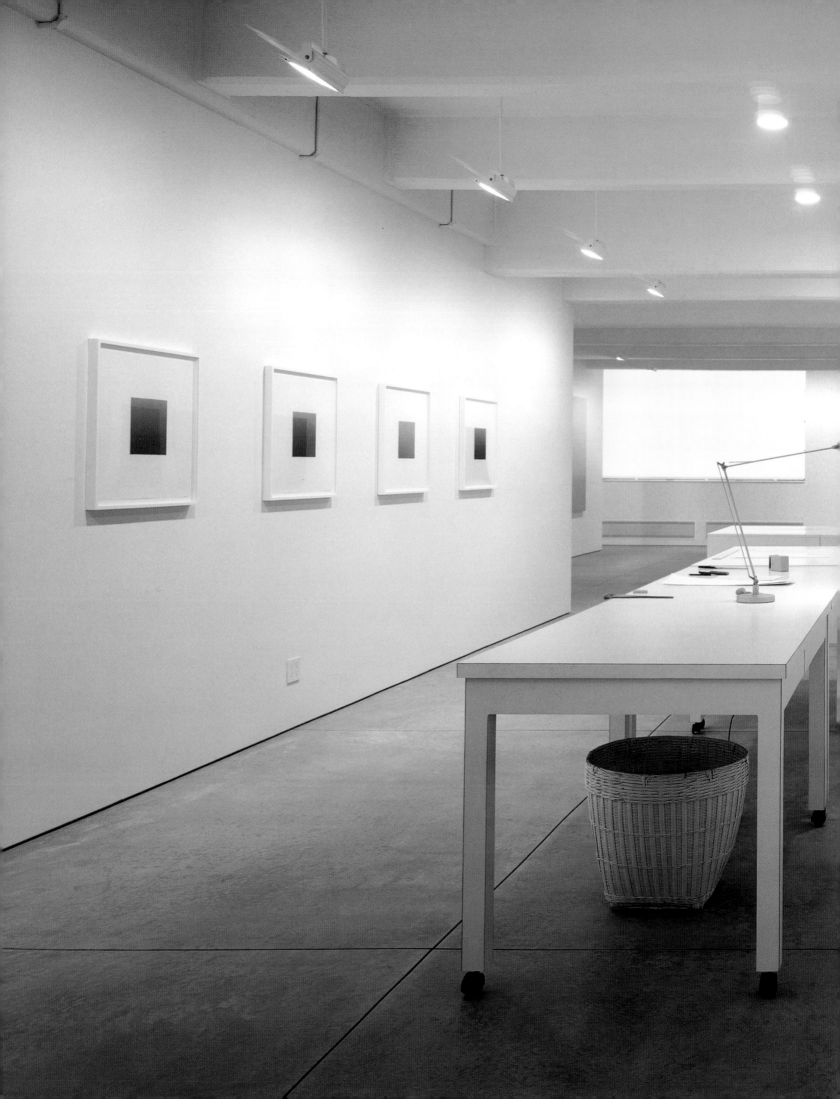

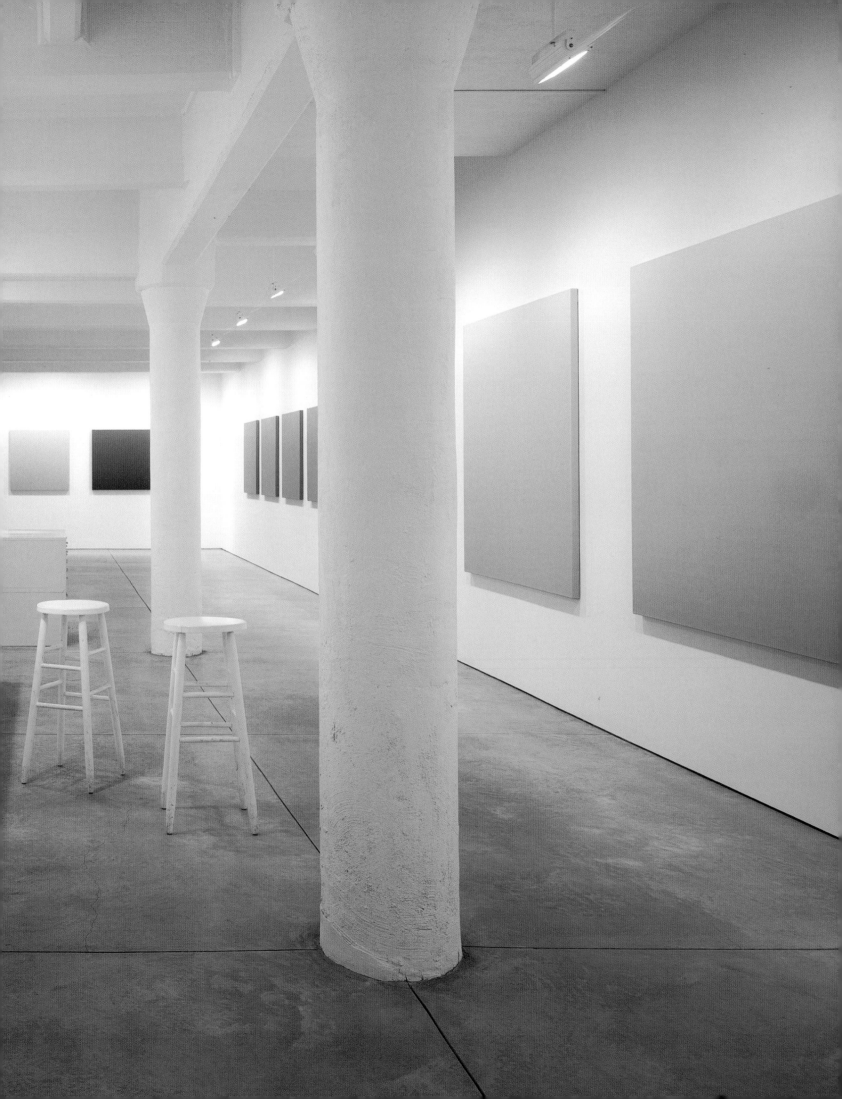

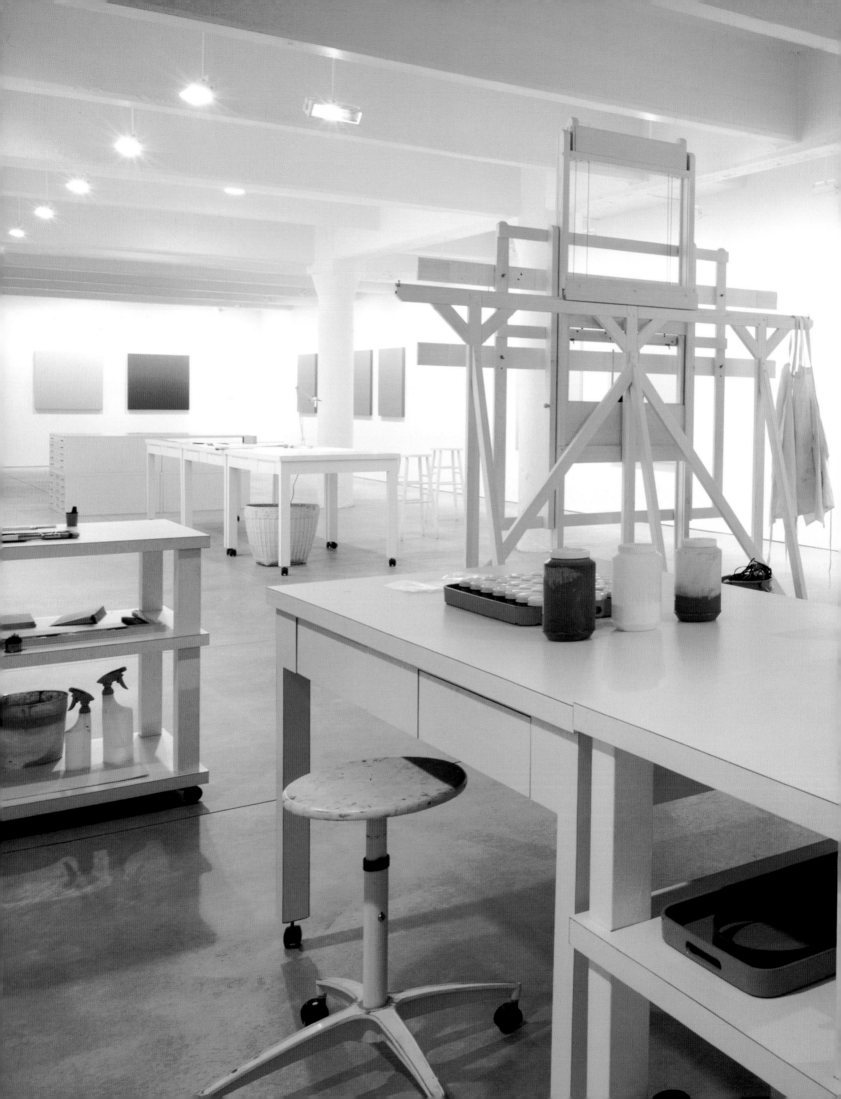

Morris / Sato Studio

What began as a straightforward renovation of limited scope turned into a complex two-year project when architects Michael Morris and Yoshiko Sato uncovered serious structural problems in the 2,200-square-foot loft of Betsy Pearce and Michael Quinn. The loft is located in a landmarked five-story cast-iron building in Tribeca originally used as an egg and butter warehouse. The initial 1825 structure encompassed just two floors. When three additional levels were added in 1865, the roof of the original building, a wood joist construction, became the hose-down floor of the third-level loft, which would eventually belong to Pearce and Quinn. Over the years, the floor was covered in successive layers of concrete, producing a dangerously heavy accretion that in certain areas measured twelve inches in thickness. The caveat issued by the architects' structural engineer summed up the situation: "Tell your clients not to jump up and down on the floor. If you don't remove the concrete and secure the joists, your building could become a cover story of the *Post*." The clients moved out immediately and the gut renovation began.

Once the urgent remedial work was completed, Morris and Sato implemented a plan predicated on the clients' mandate for an uncommon degree of openness. The bedroom and study are the only private, enclosed spaces in the loft. Walls of bookcases in those rooms reinforce the desired perception of insulation and privacy, while strategically placed slot windows of clear and colored glass pierce the volumes to offer glimpses of activity beyond. The idiosyncratic shower and dressing area remains largely exposed not only to the bedroom and study but also to the main sweep of space that flows the entire length of the loft. Its central feature consists of a freestanding circular shower constructed of cast-in-place terrazzo defined by an overhead canopy housing a recessed track for the shower curtain. The highly personal, exhibitionistic arrangement demands attention from all who visit.

The living/dining/entertaining zone that occupies the front half of the space is determinedly open with only a few minimal gestures to define function areas. A structurally attenuated eleven-foot bar counter of glass and steel brackets the unobtrusive kitchen, while an arrangement of custom furnishings anchored by a latex mat loosely controls the boundaries of the dining area. Different types of flooring—pigmented concrete in the front half, slate in the rear—subtly demarcate the loft's two arenas. A prominent window punctures the south wall of the study, visually opening the small room to views and borrowed light from the public realm.

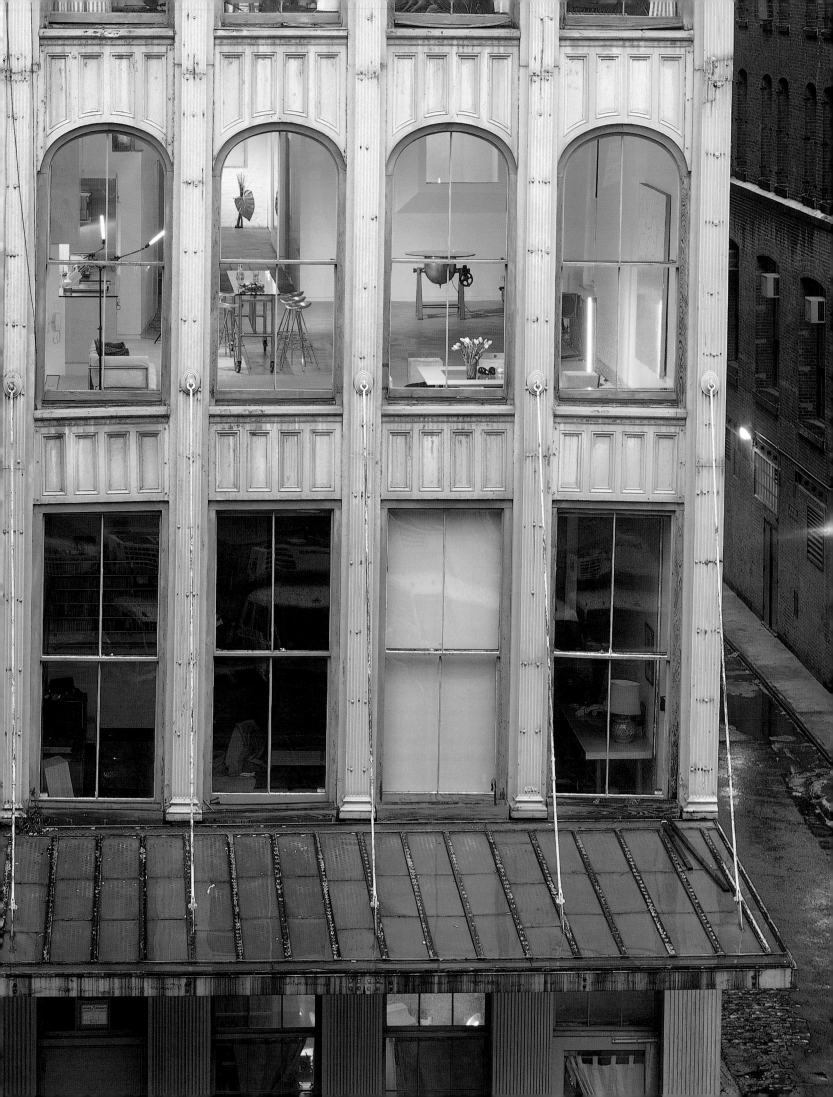

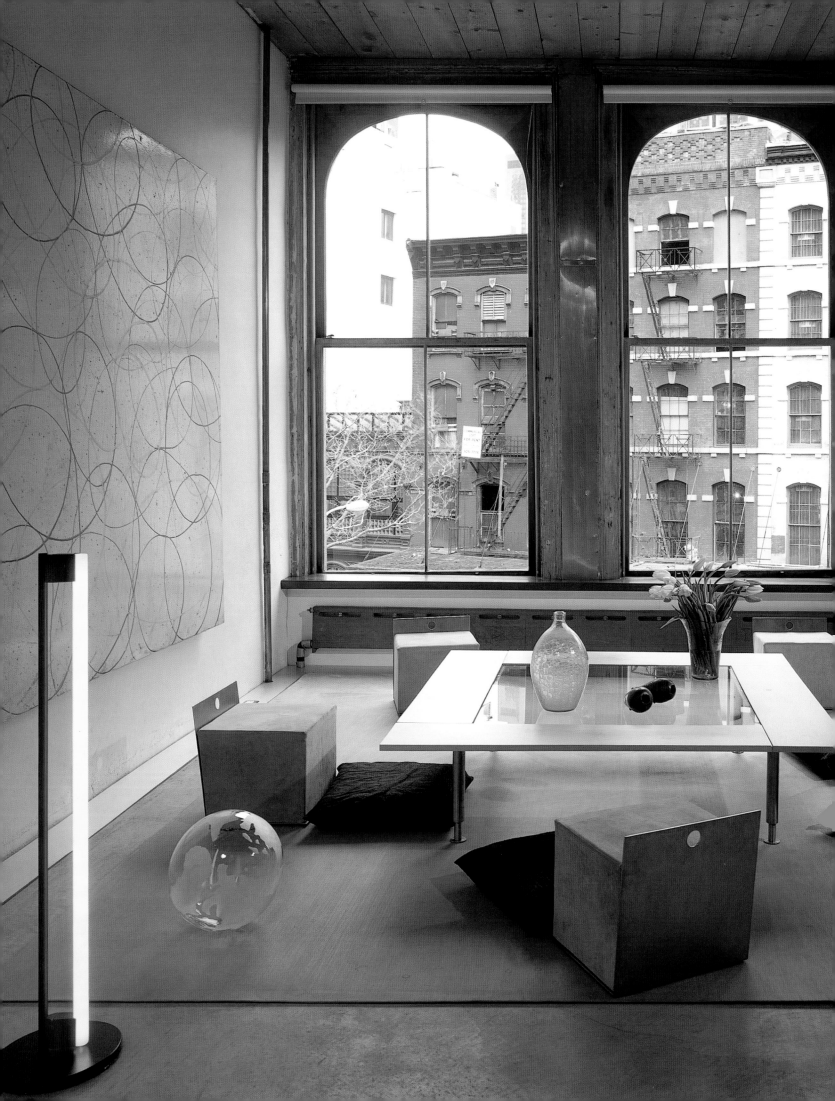

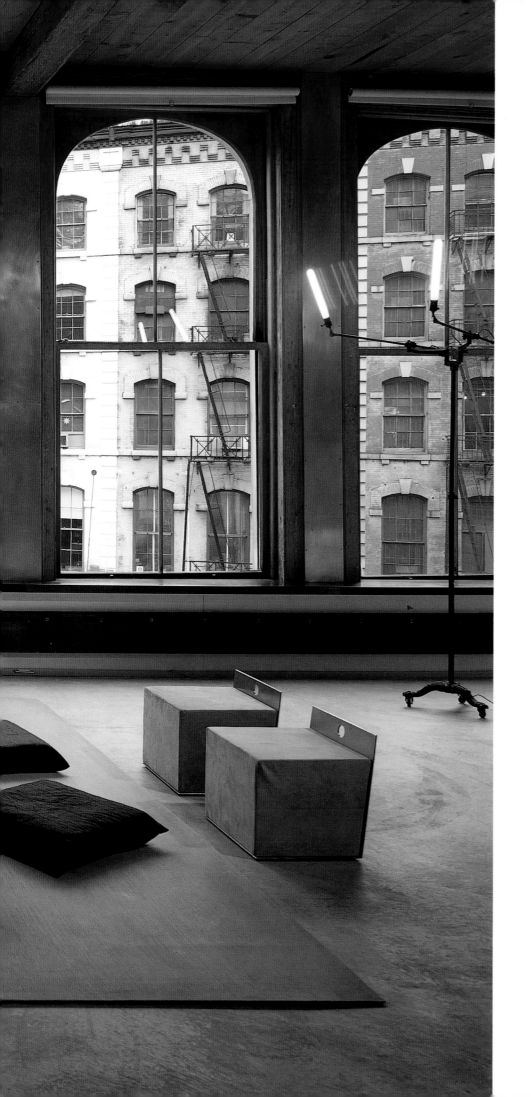

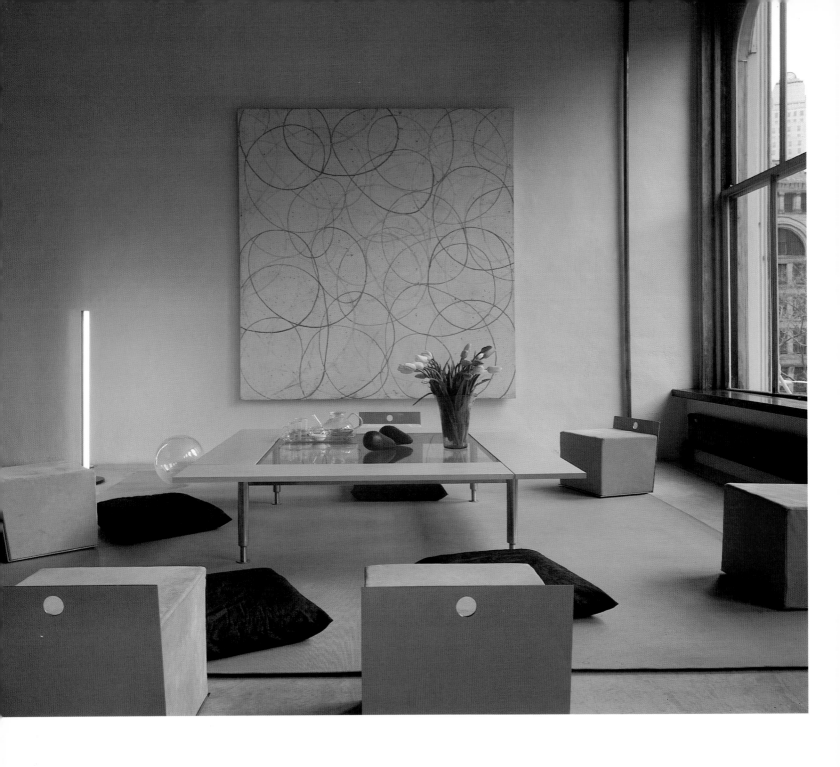

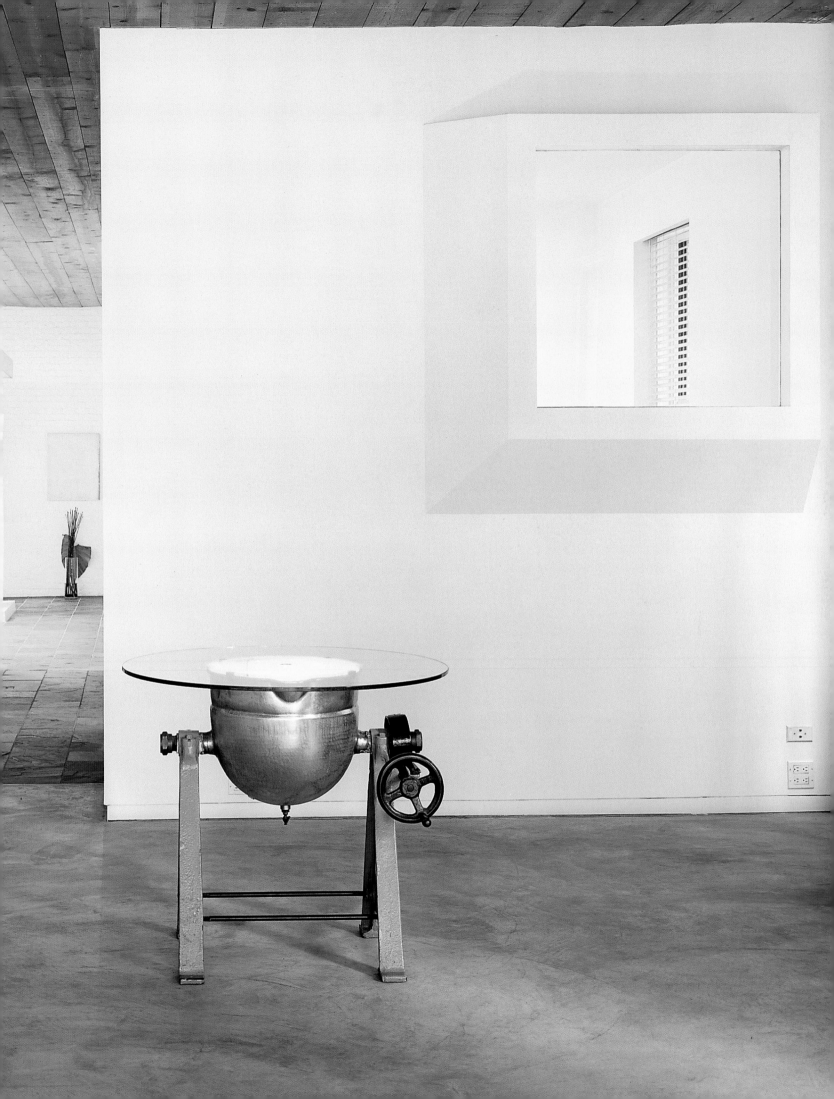

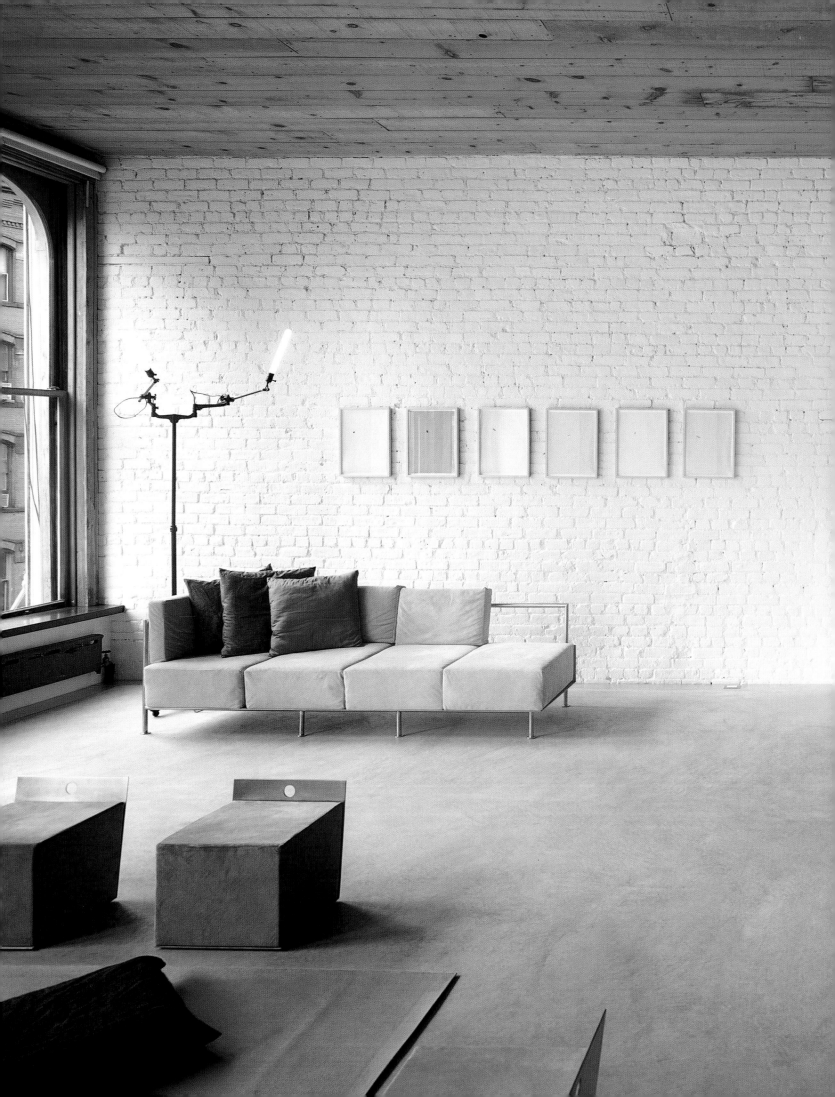

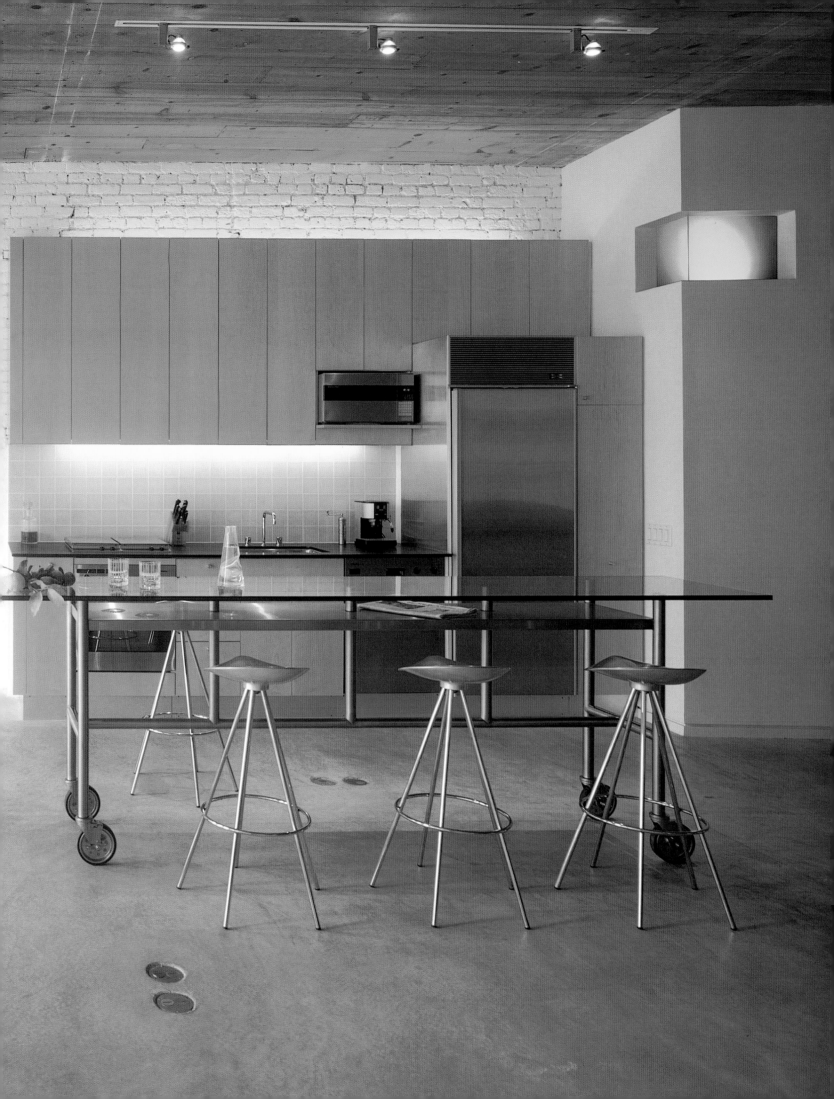

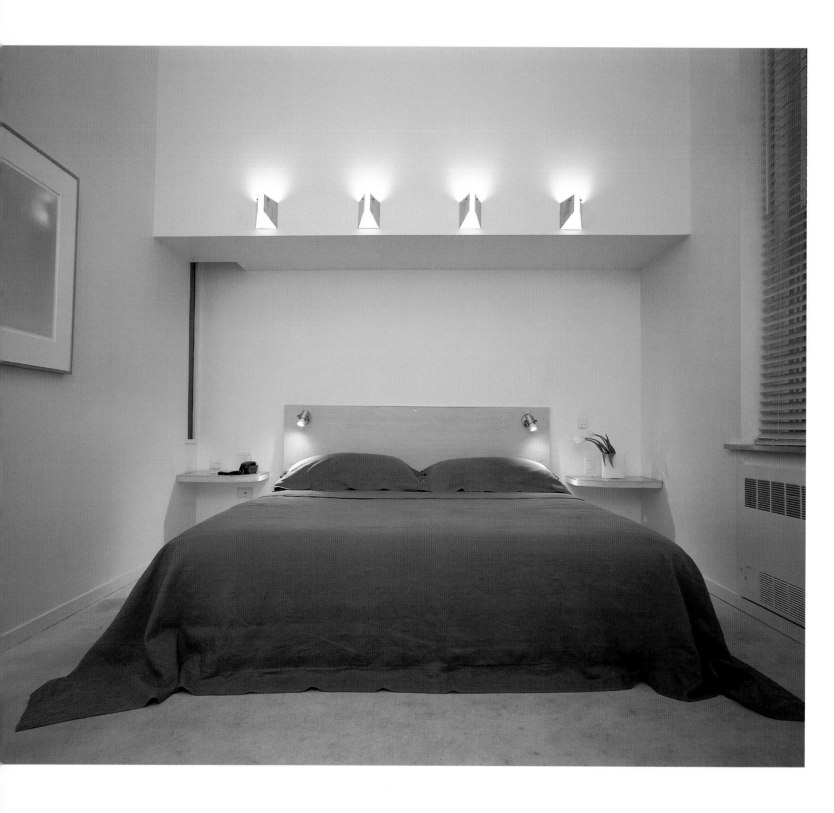

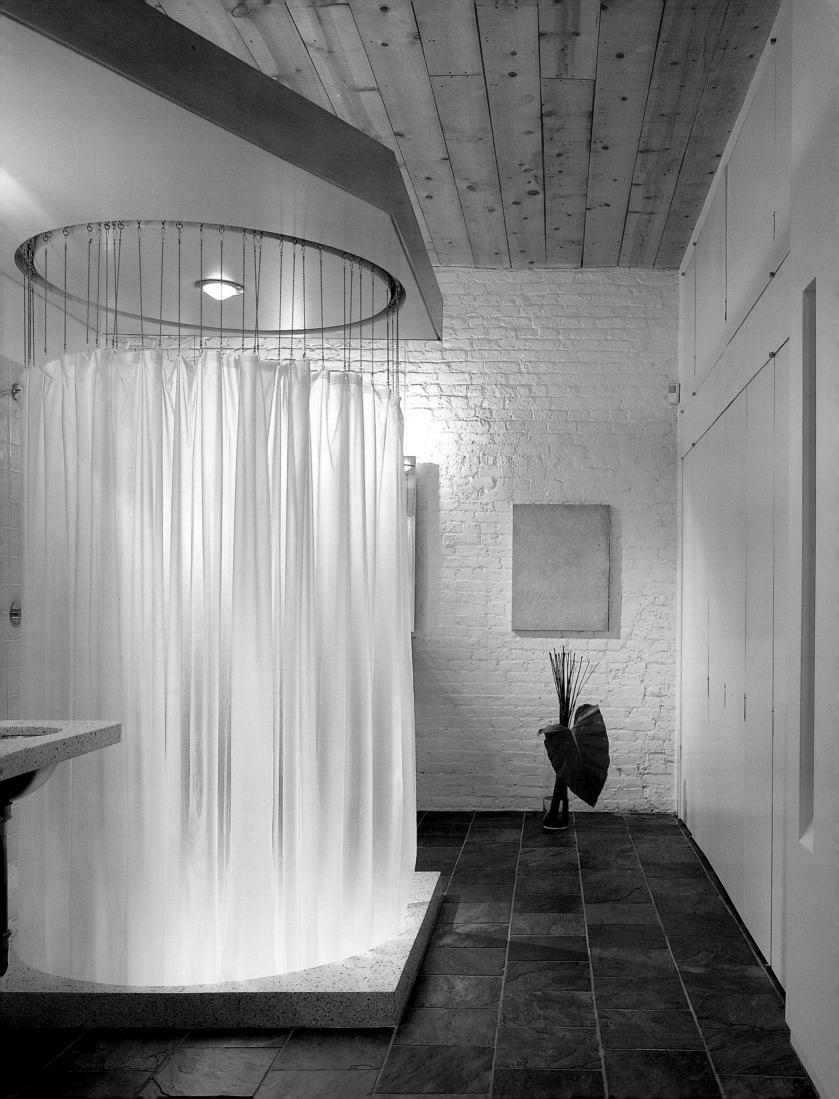

Robert Greenberg Loft, Midtown, 1997

Smith-Miller + Hawkinson Architects

In the infinitely varied world of New York lofts, every renovation presents a unique set of conditions and challenges. Certain spaces, however, are inherently more demanding than others, confronting the architect with unalterable structural elements and spatial restrictions that defy the possibility of ordered, wholesale transformation. These spaces emphatically establish the ground rules of architectural engagement.

The double-loft penthouse of Robert Greenberg, which sprawls across 10,000 square feet on multiple levels, is such a case. Architects Henry Smith-Miller and Laurie Hawkinson were asked to create specific areas within the newly added northern sec-

tor of the conjoined loft. The project evolved as a series of architectural interventions—each dedicated to specific programmatic requirements—bound together not by one formal idea or artificially holistic strategy but by expert craftsmanship and a consistent vocabulary of materials and forms.

The architects planned these strategic interventions first and foremost in response to the physical constraints of the existing spaces. The new mezzanine, which houses two diminutive guest bedrooms and a bathroom, has a floor of reinforced, poured-in-place concrete measuring only four inches in thickness. To take advantage of the spectacular views offered by the rehabilitated north-facing window wall–cum–skylight, the architects detailed the mezzanine with a glass balustrade, steel handrails, and exceptionally thin structural bar hangers. Other areas are cross-programmed for variable uses; their flexible boundaries are defined by pivoting panels, overscaled doors, and the variety of atmospheric possibilities offered by numerous skylights with mechanized shades.

Despite the ad hoc quality of the project, Smith-Miller and Hawkinson approached it with an overriding concern for creating spatial threads that connect the new constructions and also emphasize continuity with the existing renovation, by Studio Morsa and David W. Roth in collaboration with the client. The result is a delightfully multifaceted, idiosyncratic design that achieves a respectful détente between the client's needs and the forceful will of the urban site.

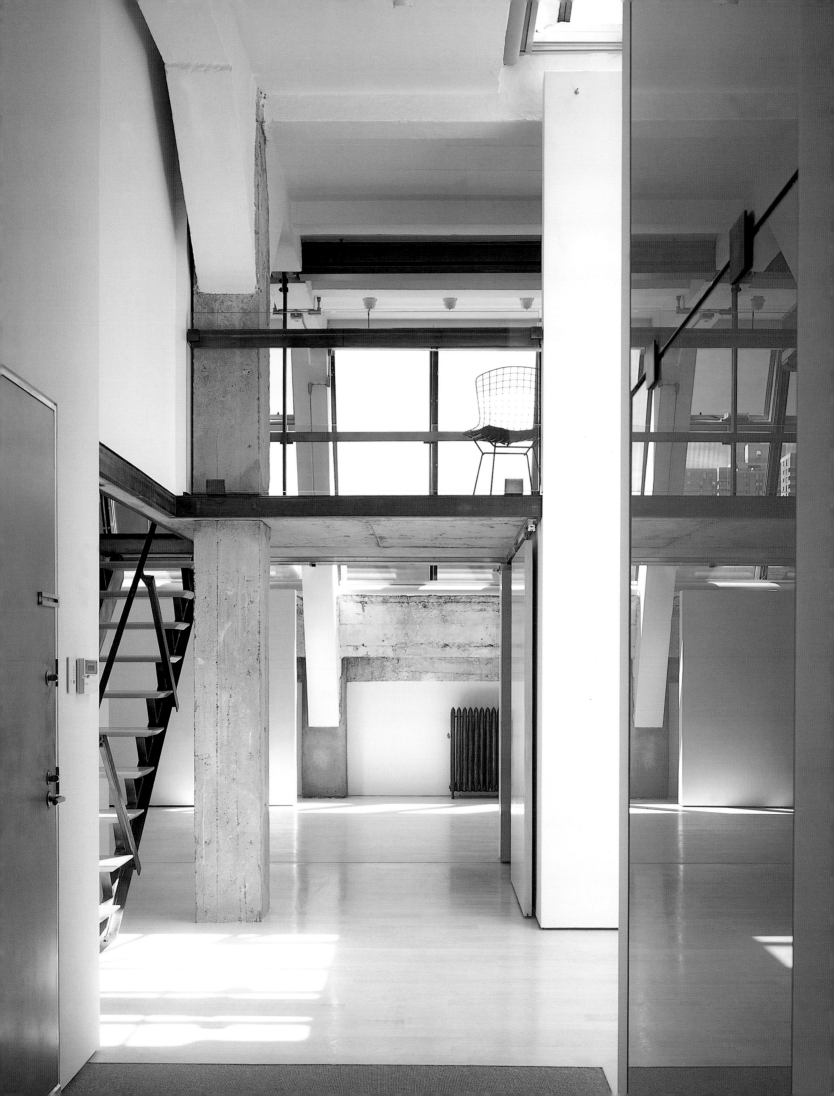

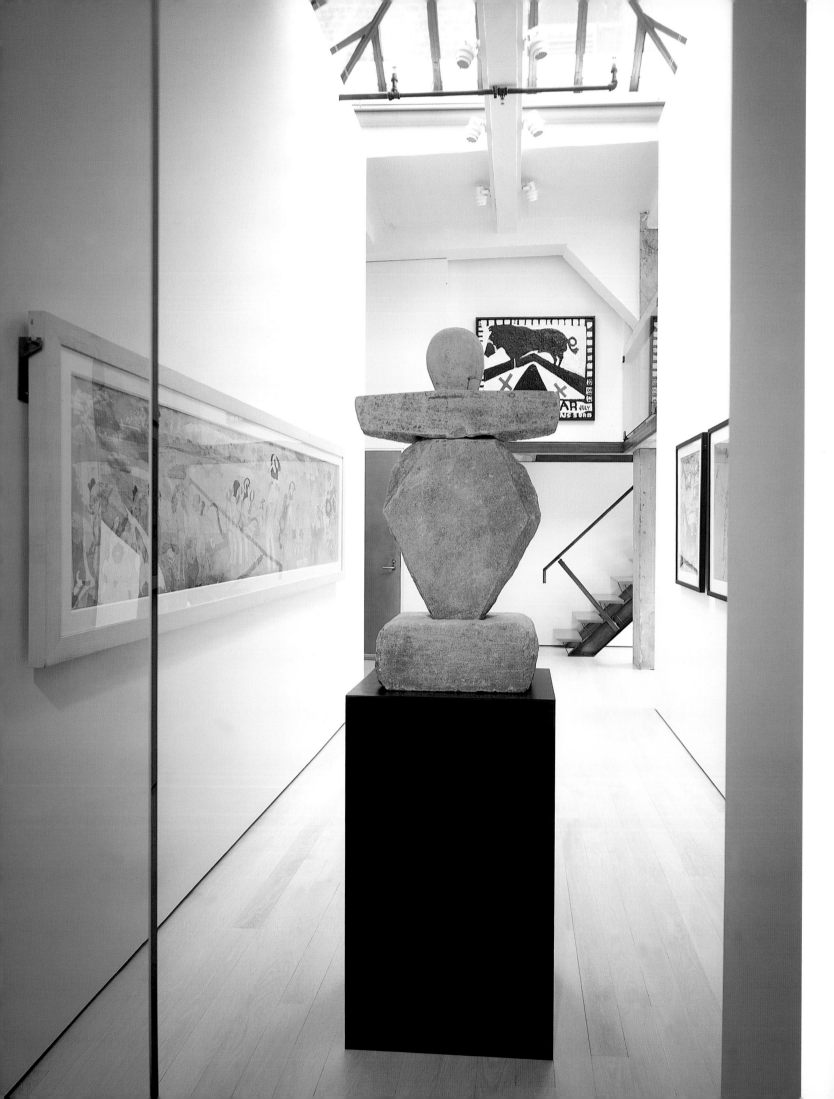

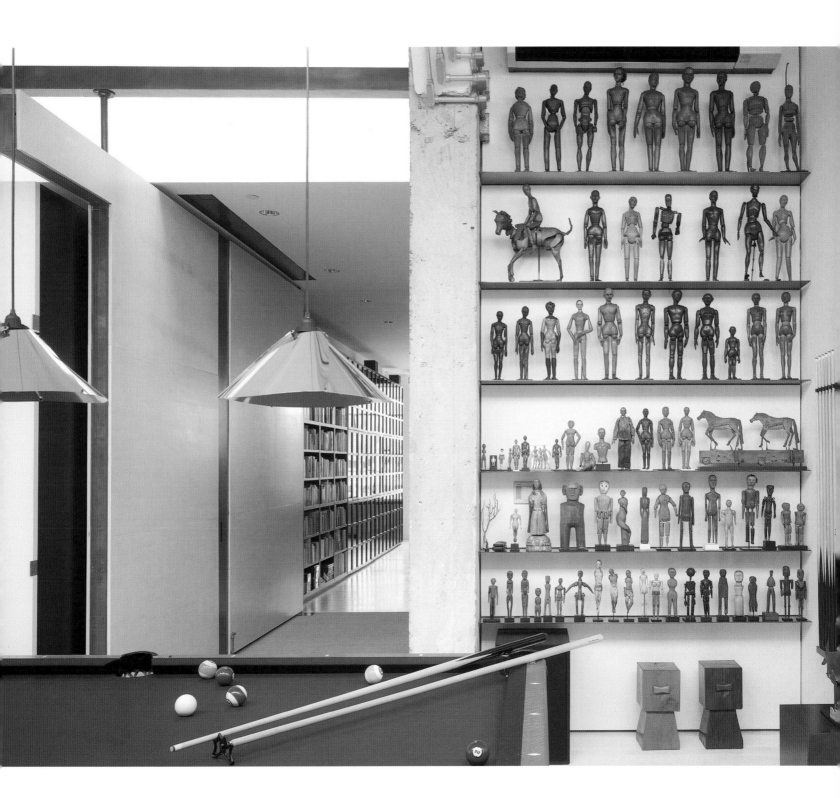

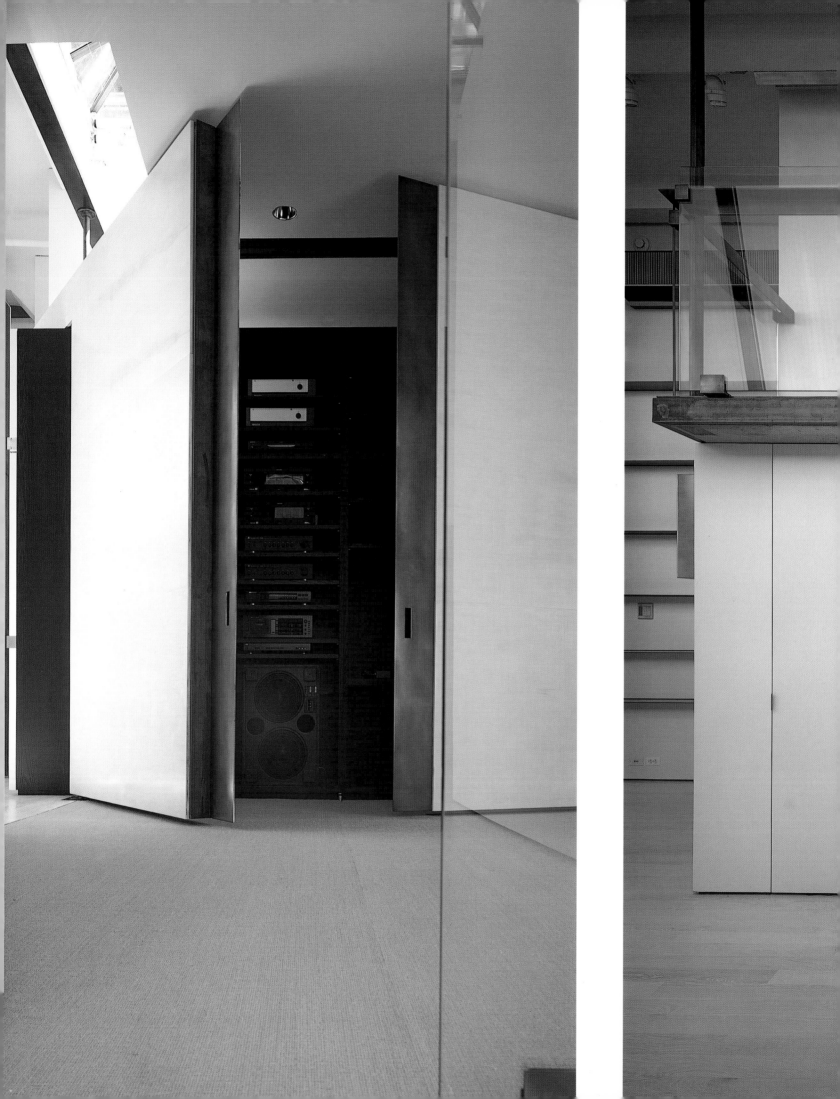

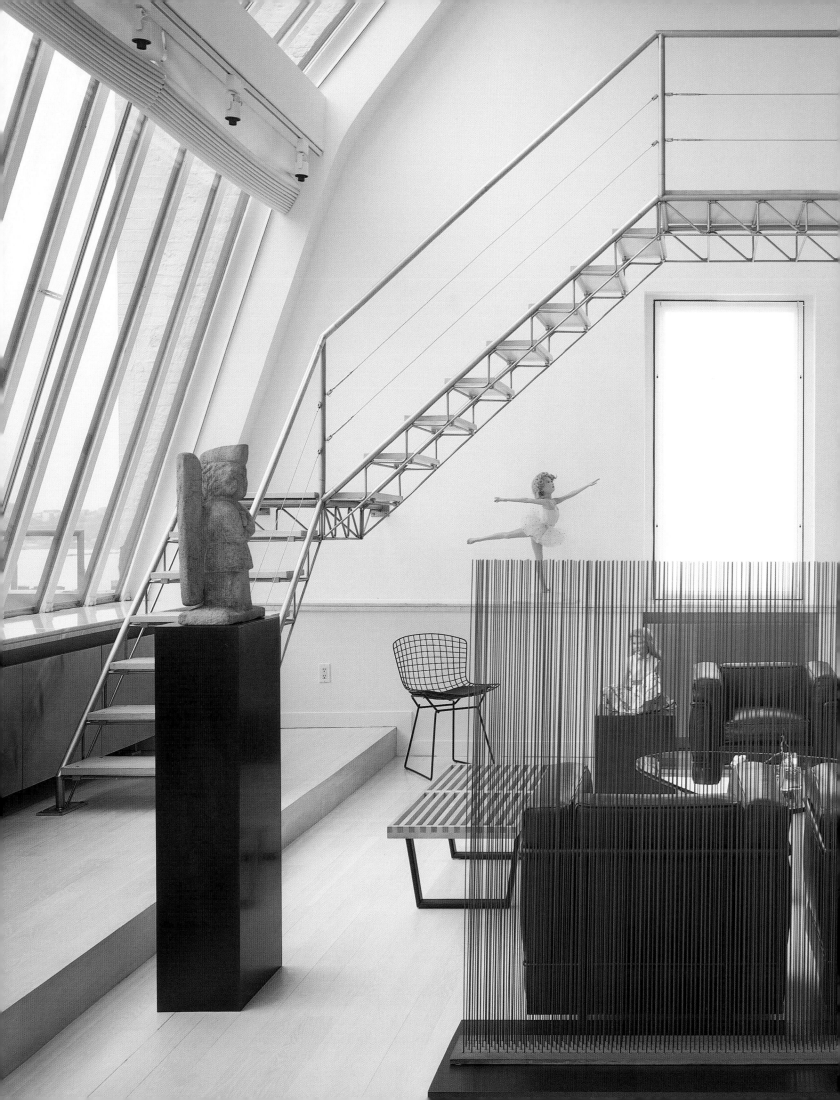

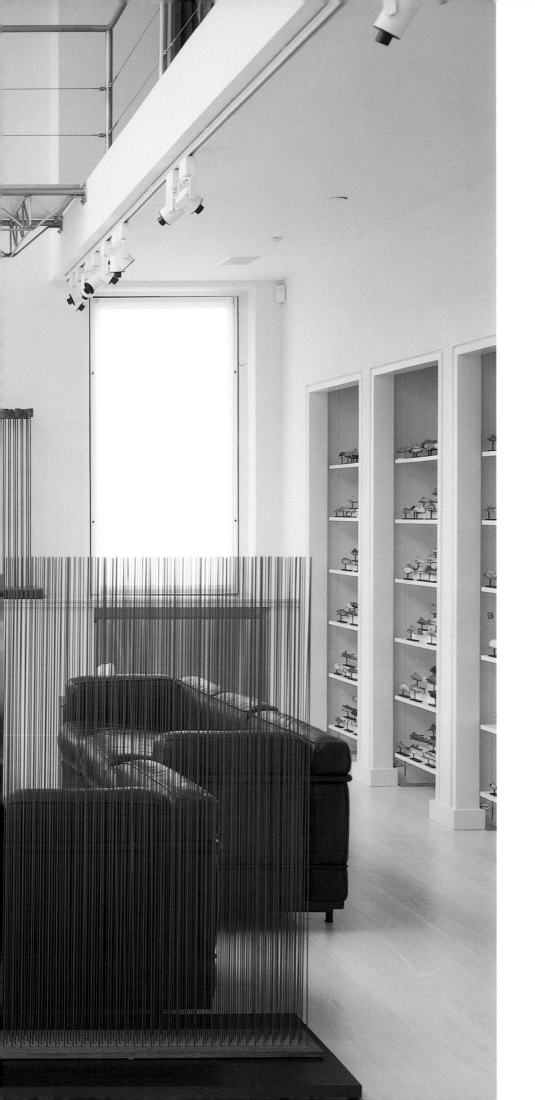

Midtown Loft, 1996

LOT/EK Architecture

Although reluctant to describe themselves as "recyclers," LOT/EK (pronounced "low-tech") principals Ada Tolla and Giuseppe Lignano find the instruments and inspiration for their work amid the chaos of the modern cityscape and the detritus of consumer society. The loft they created for two photographers and their young son represents one of the more fascinating experiments in the rehabilitation of derelict urban structures. With forceful, idiosyncratic gestures, Tolla and Lignano transformed a disused mechanical penthouse located on the roof of a commercial loft building into habitable domestic space.

An earlier renovation had essentially stripped the penthouse down to its raw structure. LOT/EK began the project by exposing interior concrete walls and cladding the exterior of the freestanding pavilion with insulation and an outer layer of corrugated steel. Their boldest design stroke was the installation of the cargo body of an old truck—located in an abandoned New Jersey truck yard—atop the existing structure to create a second-level sleep loft and terrace. The architects bisected the truck's volume with an aluminum-framed door and glazing. They then peeled away the truck's metal skin at one end to expose its steel skeleton, thereby creating a simple space frame for the new south-facing terrace off the upper bedroom. A utilitarian escape ladder joins the two levels.

Other moments of unexpected recontextualization of commercial castoffs occur on the main level. The architects replaced three existing west-facing windows with recycled doorless refrigerators that block the uninspiring views of a neighboring brick wall. The newly fashioned niches create dedicated storage and display for stereo equipment, audiovisual gadgetry, and books. Tolla and Lignano then punctured the wall in other areas to install old newspaper vending boxes that function as vitrinelike display windows for assorted objets. Glazed end walls to the north and south extend the space of the living area onto a felicitous rooftop garden. The Empire State Building looms majestically above the penthouse in the near distance.

LOT/EK's unorthodox approach might at first seem hopelessly contrived, straining for avant-garde effect. But the firm's functional and aesthetic experiments cannot be dismissed so easily. The sheer familiarity and human scale of the truck body, to cite the most obvious example, render the indoor sleeping area rather cozy and domestic. There is, however, no mistaking the architects' respect for and fascination with the loft's urban context, with the true grit and delirious life of the city.

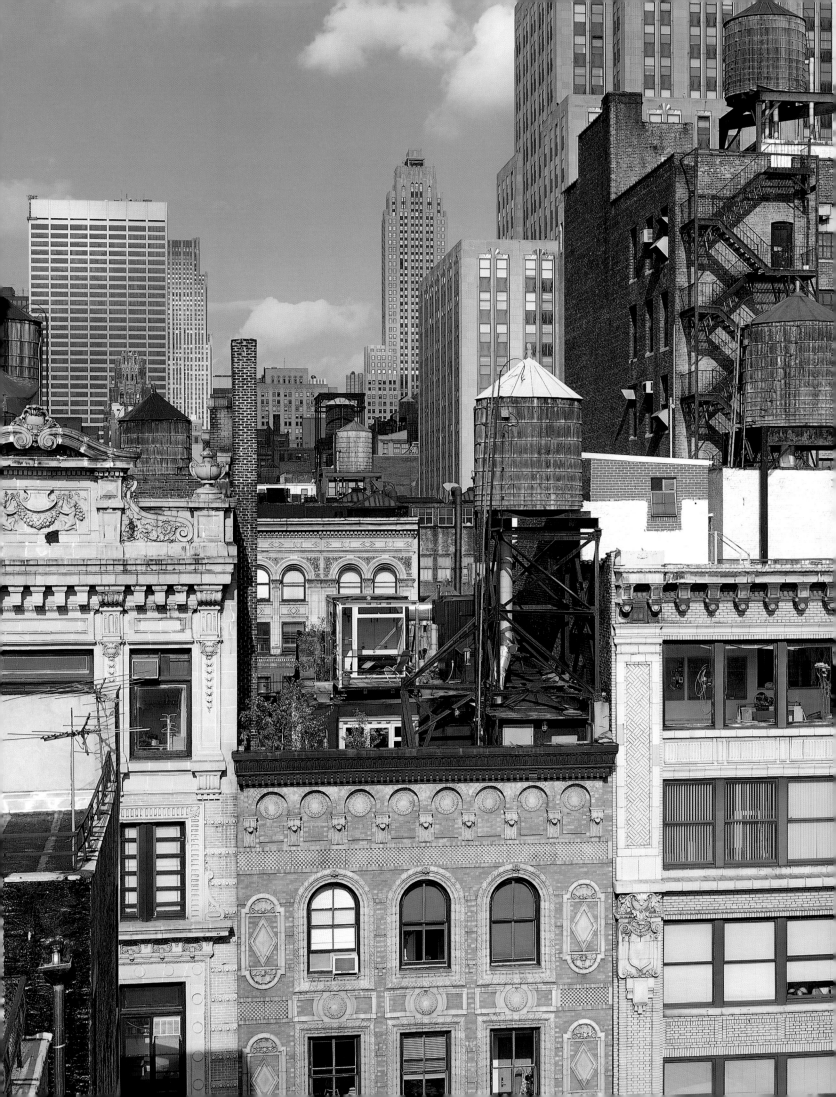

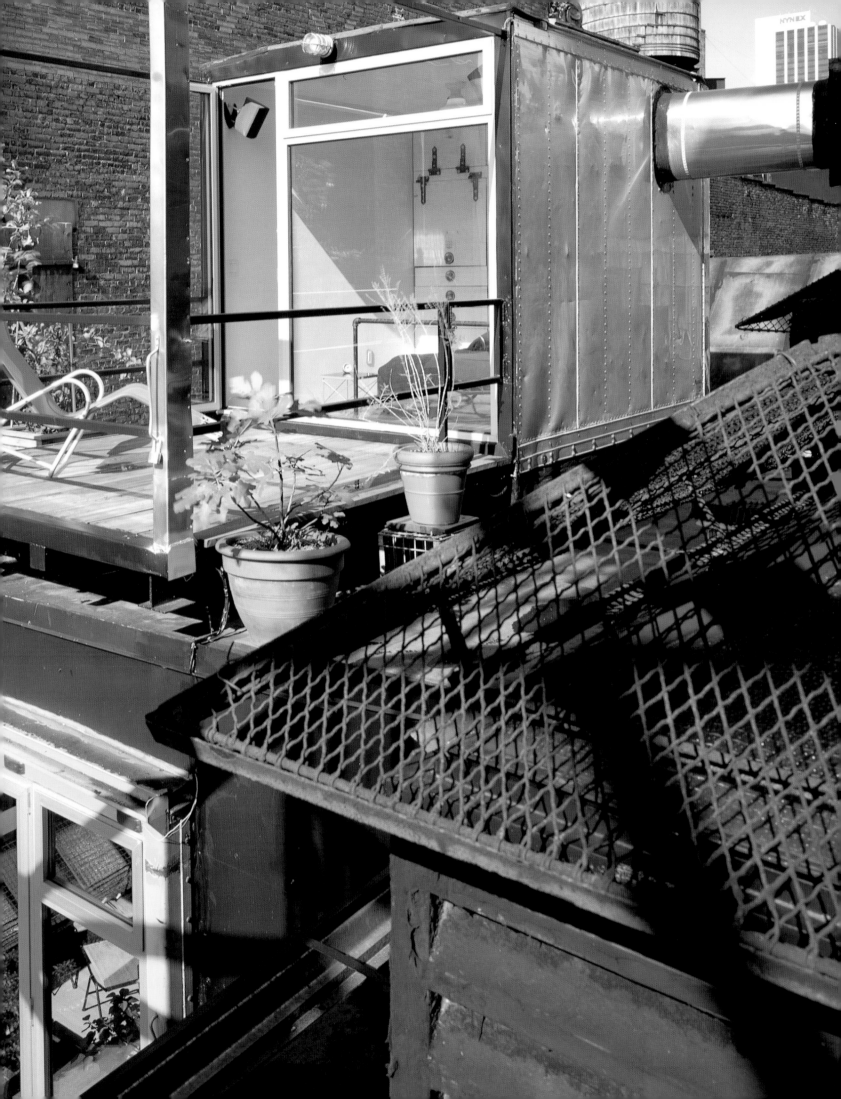

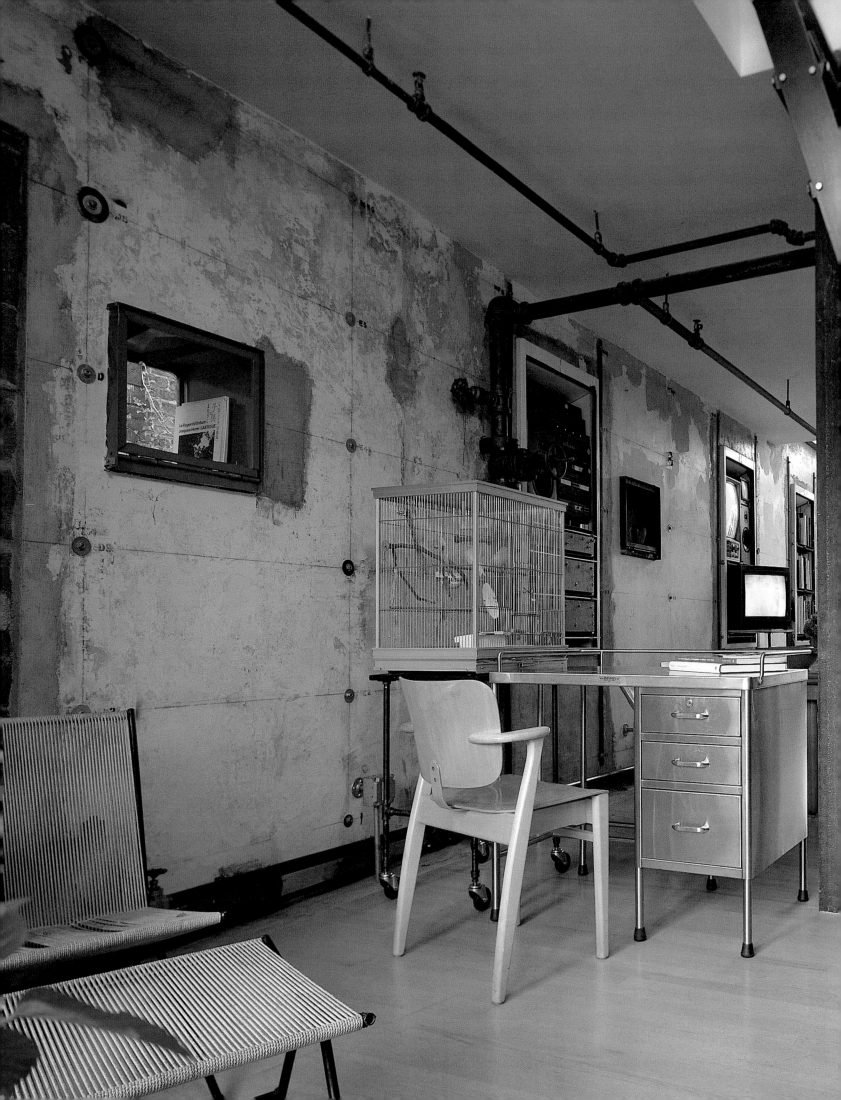

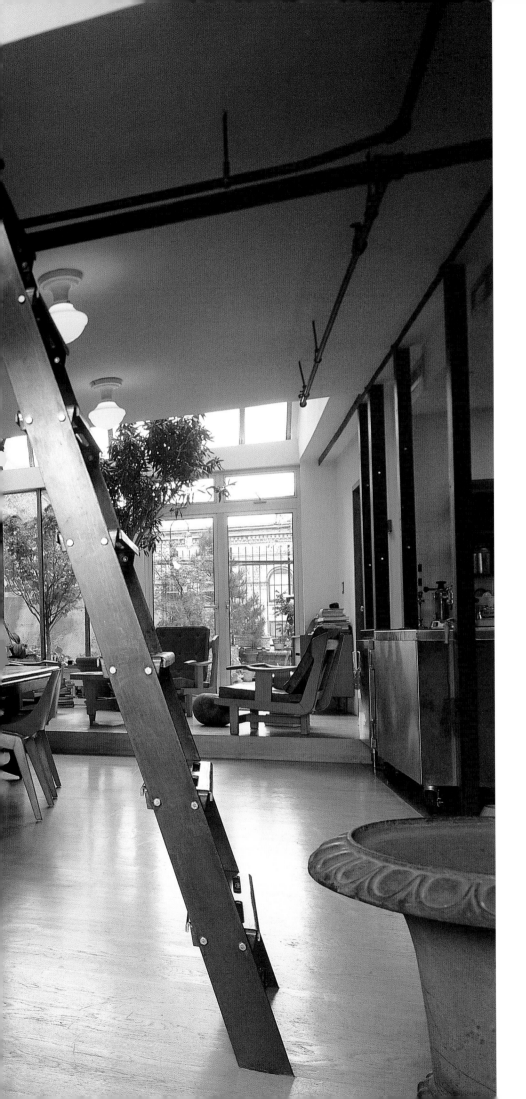

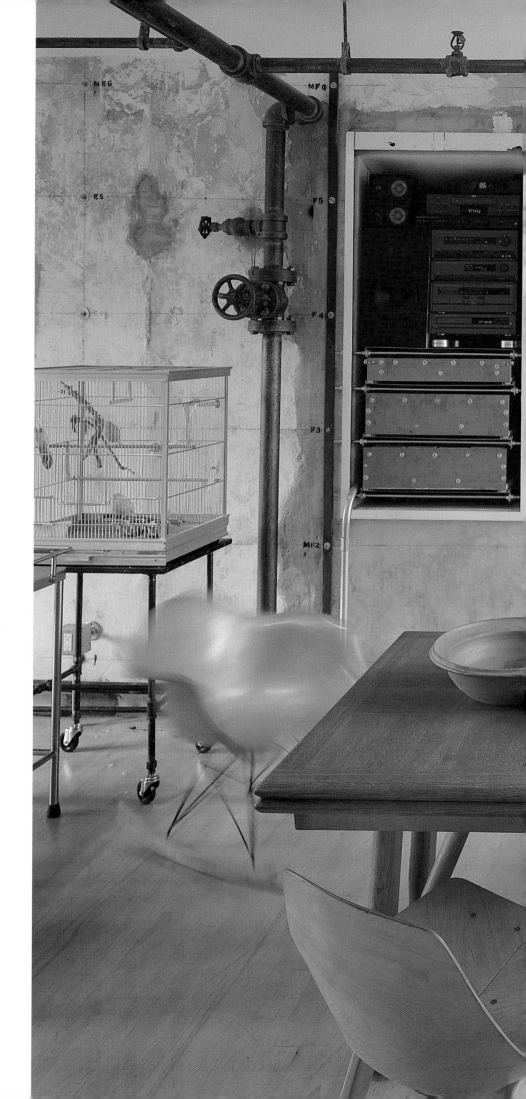

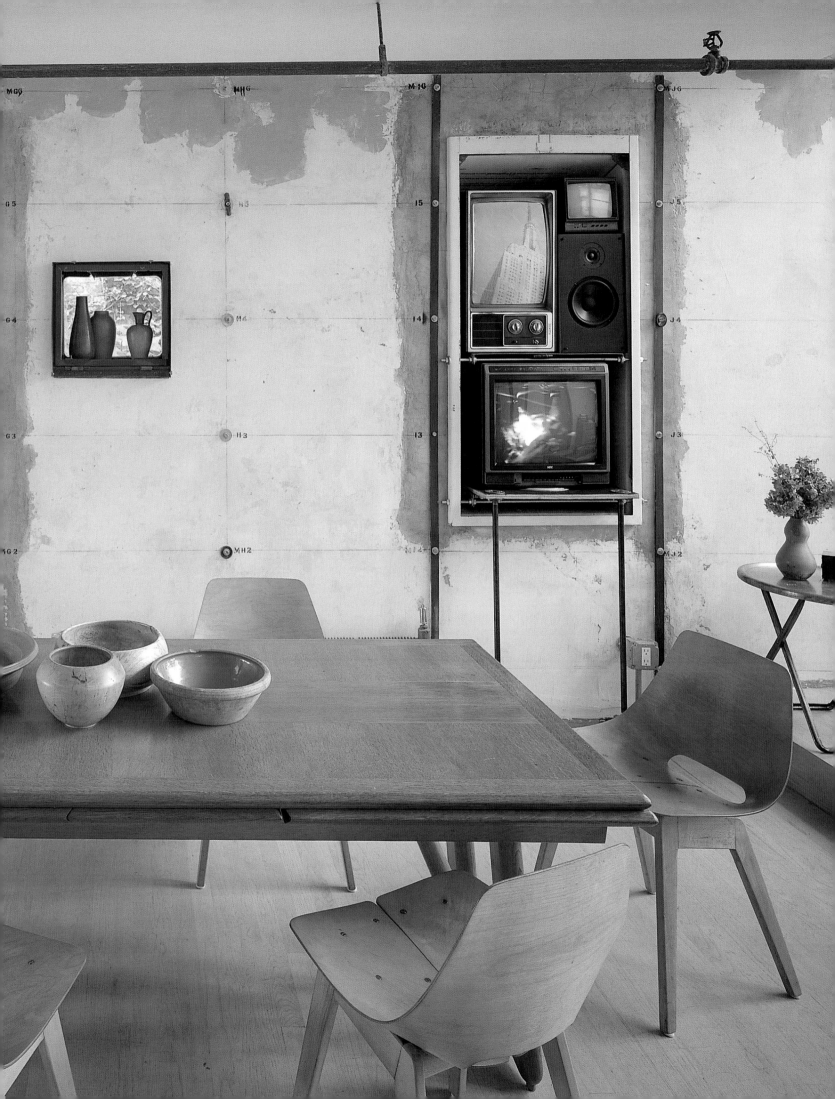

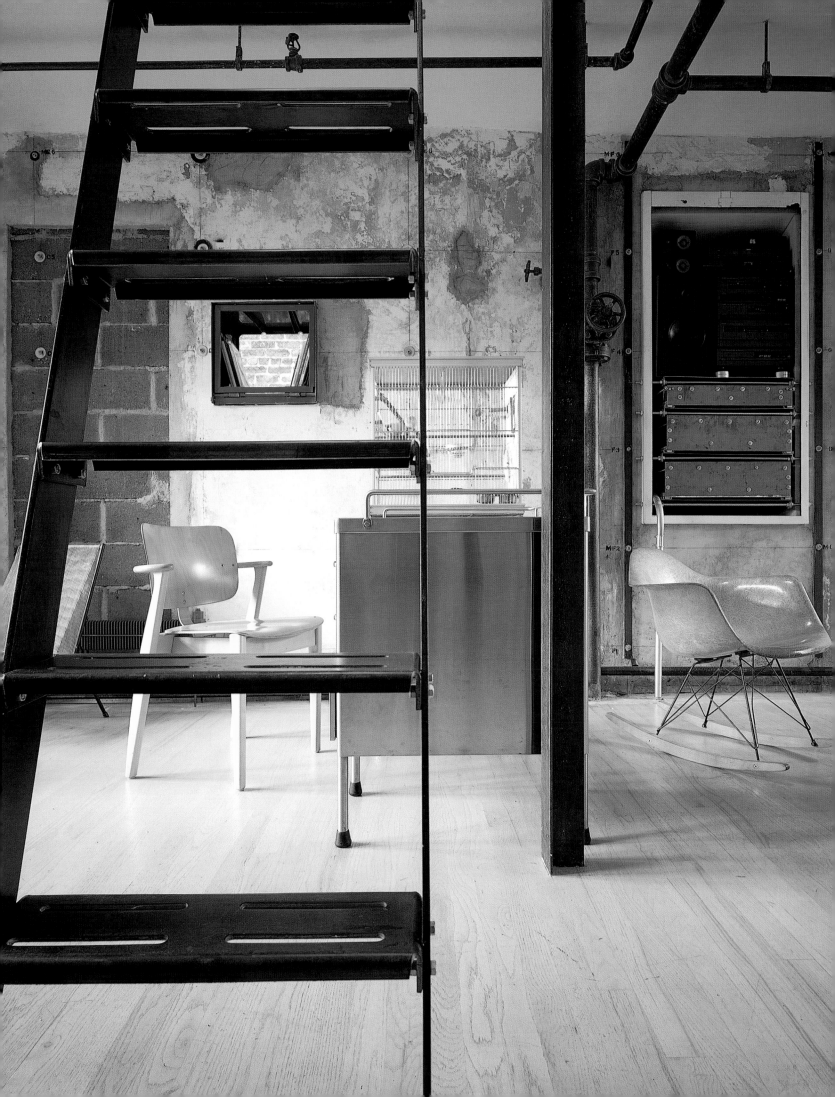

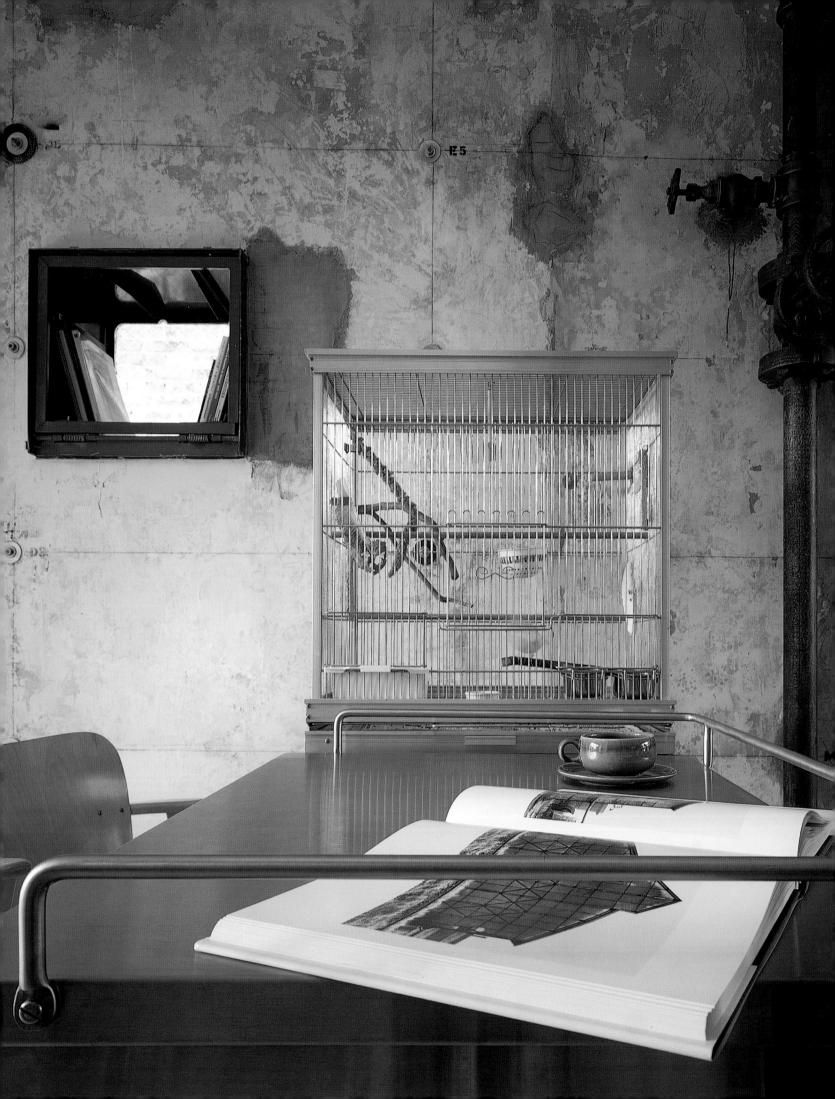

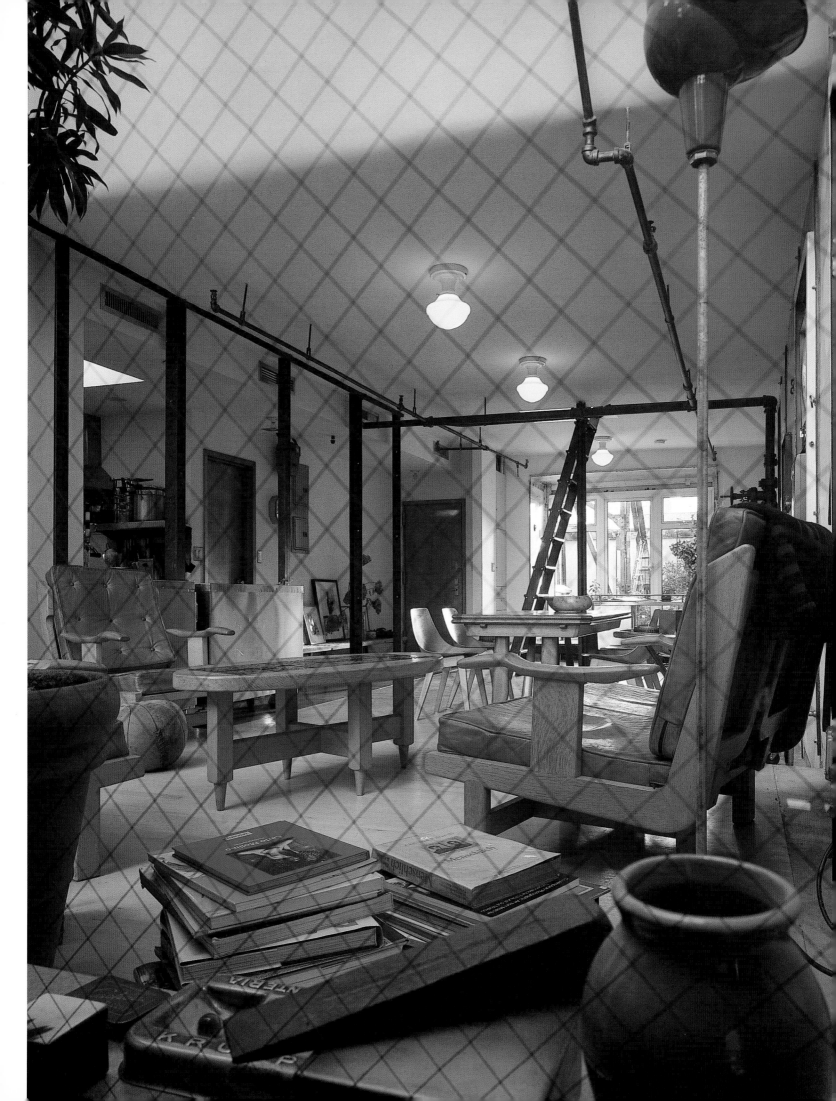

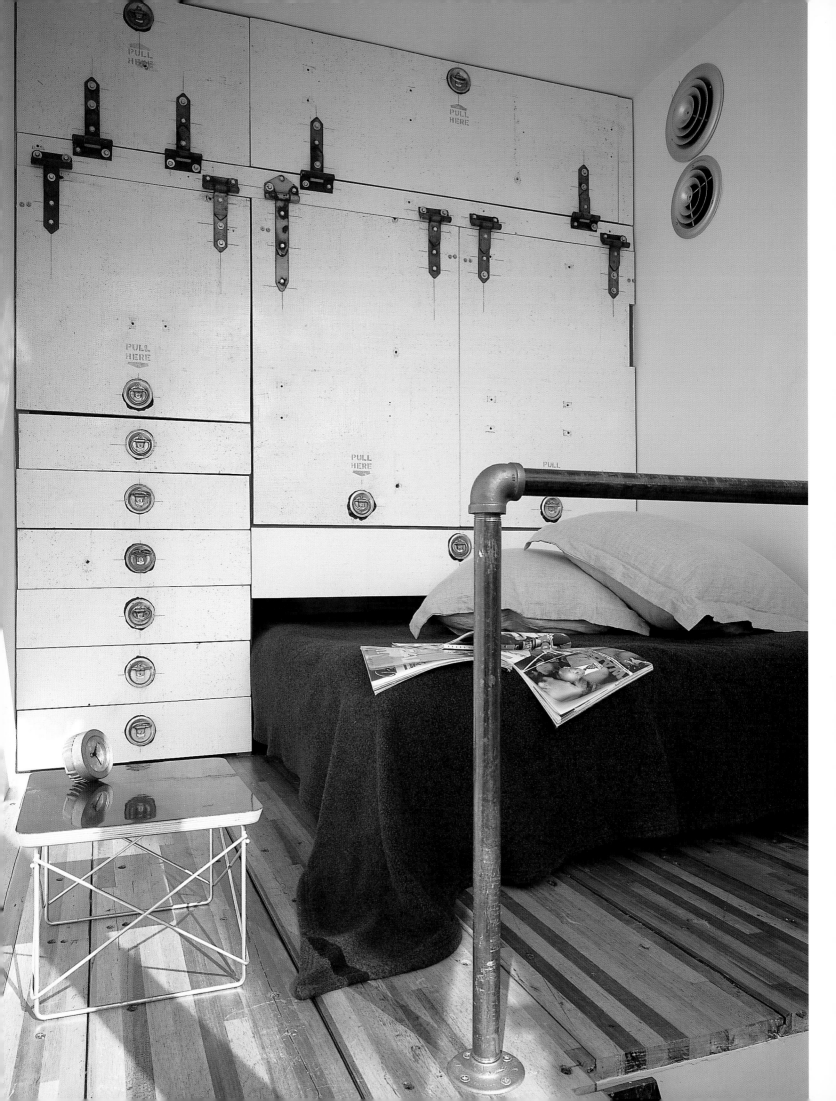

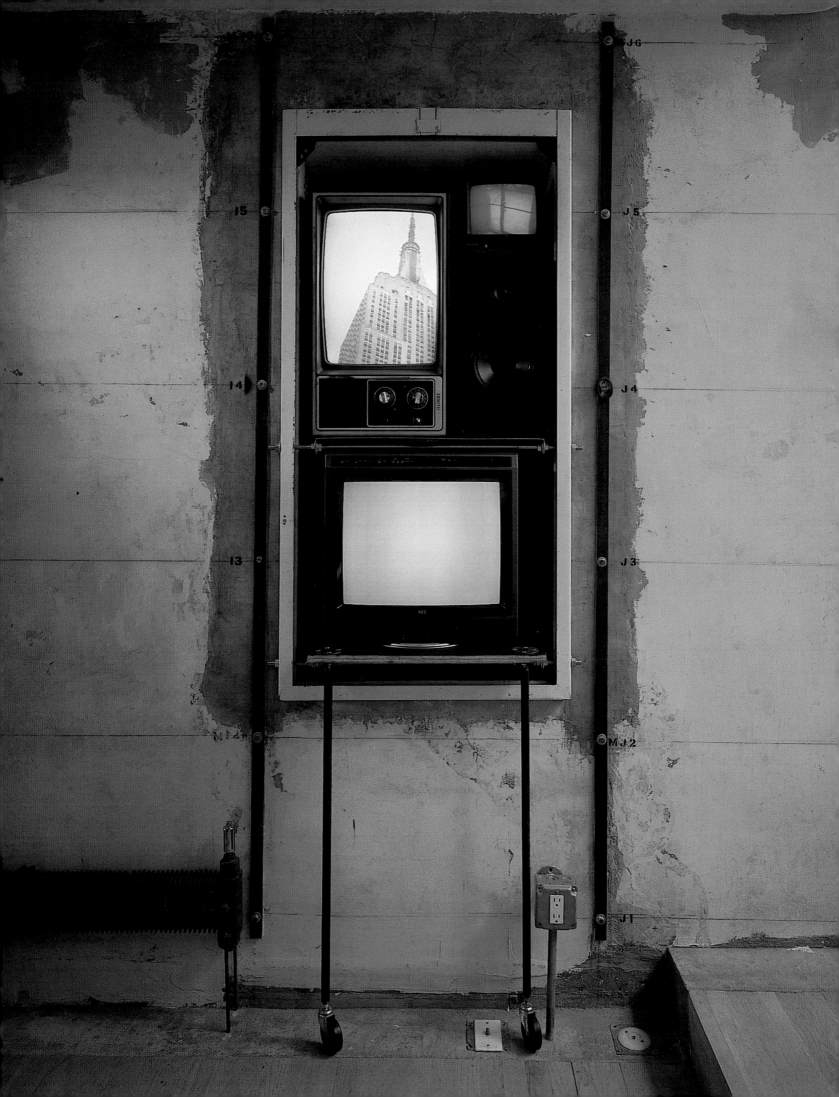

Zambetti Loft, Lower Fifth Avenue, 1997

Pasanella + Klein
Stolzman + Berg

For the initial phase of a duplex loft renovation, Pasanella + Klein Stolzman + Berg was commissioned to redesign the lower, 1,800-square-foot level to accommodate a comfortable seating area, small office, master bedroom, flexible home gym–cum–guest bedroom, and decidedly sybaritic master bath and dressing suite. Located on a high floor in a lower Fifth Avenue building, the loft offered an uncommonly generous influx of natural light, with windows along the southern and eastern walls. Open views to Madison Square Park extend the expansive quality of the space.

The PKSB design team—Henry Stolzman, Wayne Berg, and Jonathan Schecter—faced a typical client directive: to maintain the loft's essential openness while still allowing for flexible subdivision into discrete areas as necessary. The mahogany plane that constitutes the headboard in the master bedroom is the primary fixed point in the new design scheme; around it, panels and planes rotate or slide with ease to provide numerous options for spatial reconfiguration. The mobile partitions are finely detailed but low-key constructions of translucent glass framed in painted aluminum.

Materials selected for furnishings and finishes have a degree of refinement very much non-industrial in flavor. The panel that conceals the guest Murphy bed, for example, is finished in hand-applied white gold leaf. Marble crowns the Florence Knoll–style credenza that runs along the length of the loft's southern wall; the long unit is interrupted in two places to receive the sliding partitions that fully enclose the master bedroom. In the large master bath, back-painted glass panels define the recessed niche for the Jacuzzi, itself illuminated from below with fiber-optic lighting; opposite, a platinum-leafed wall anchors a solid teak counter and clear glass sink.

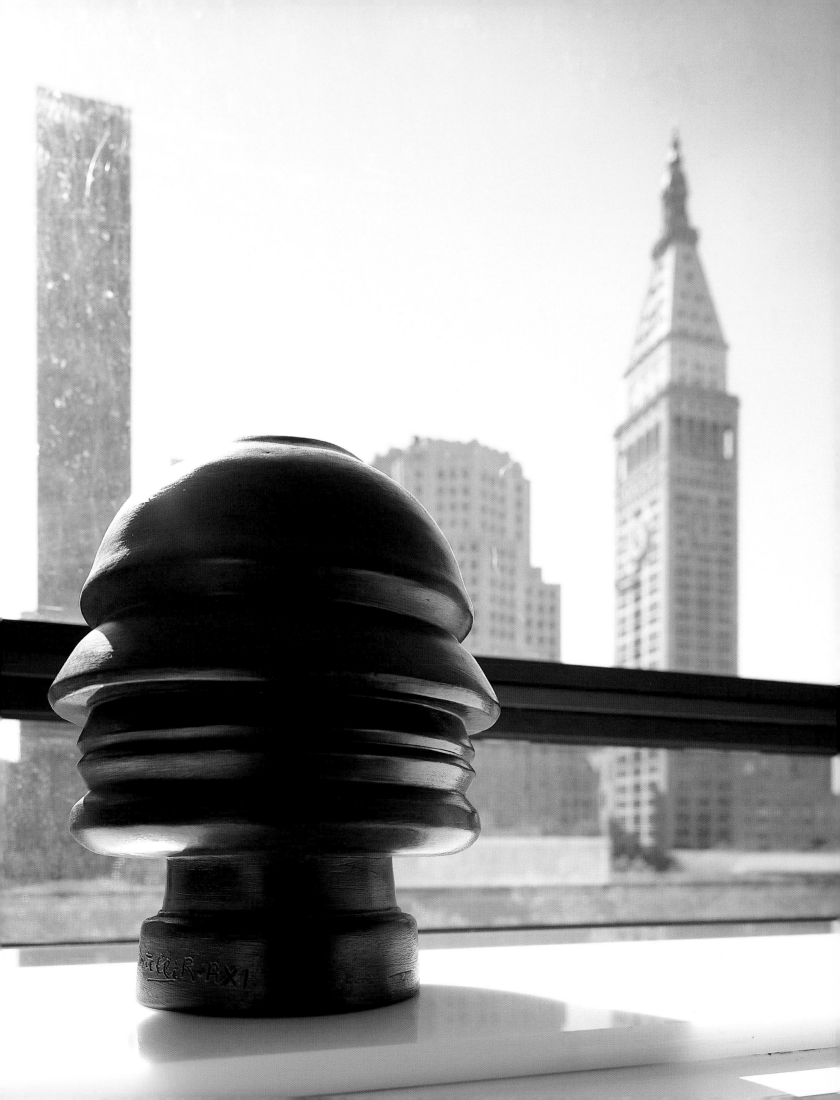

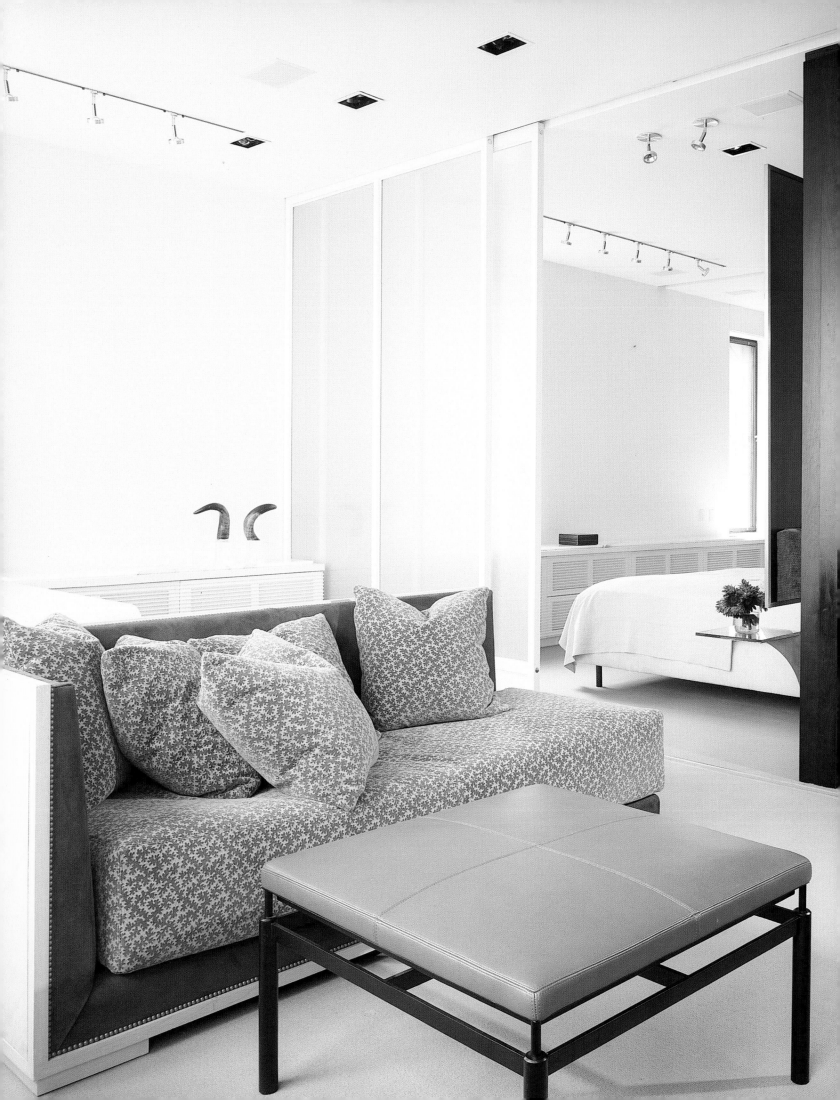

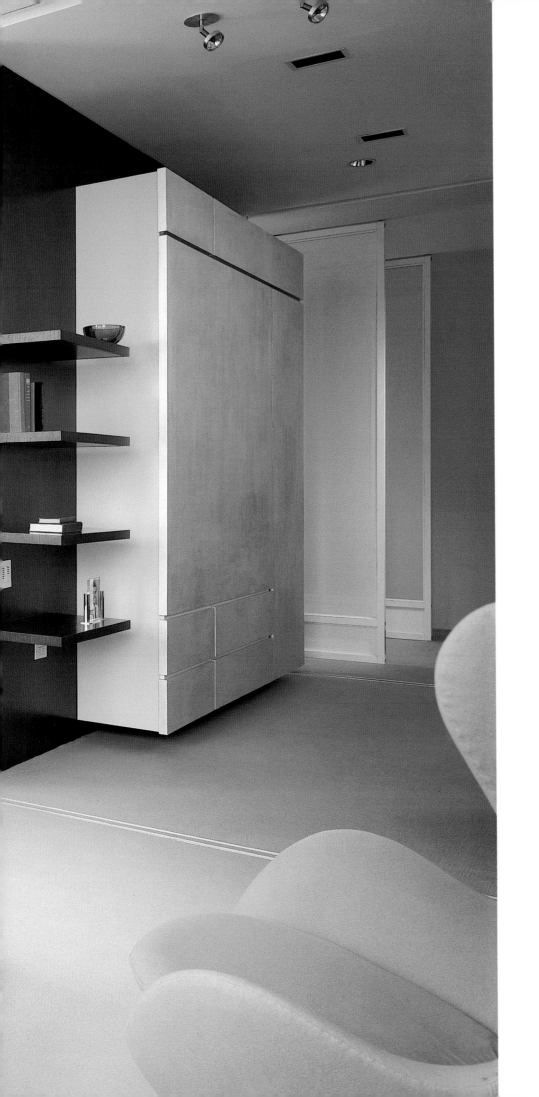

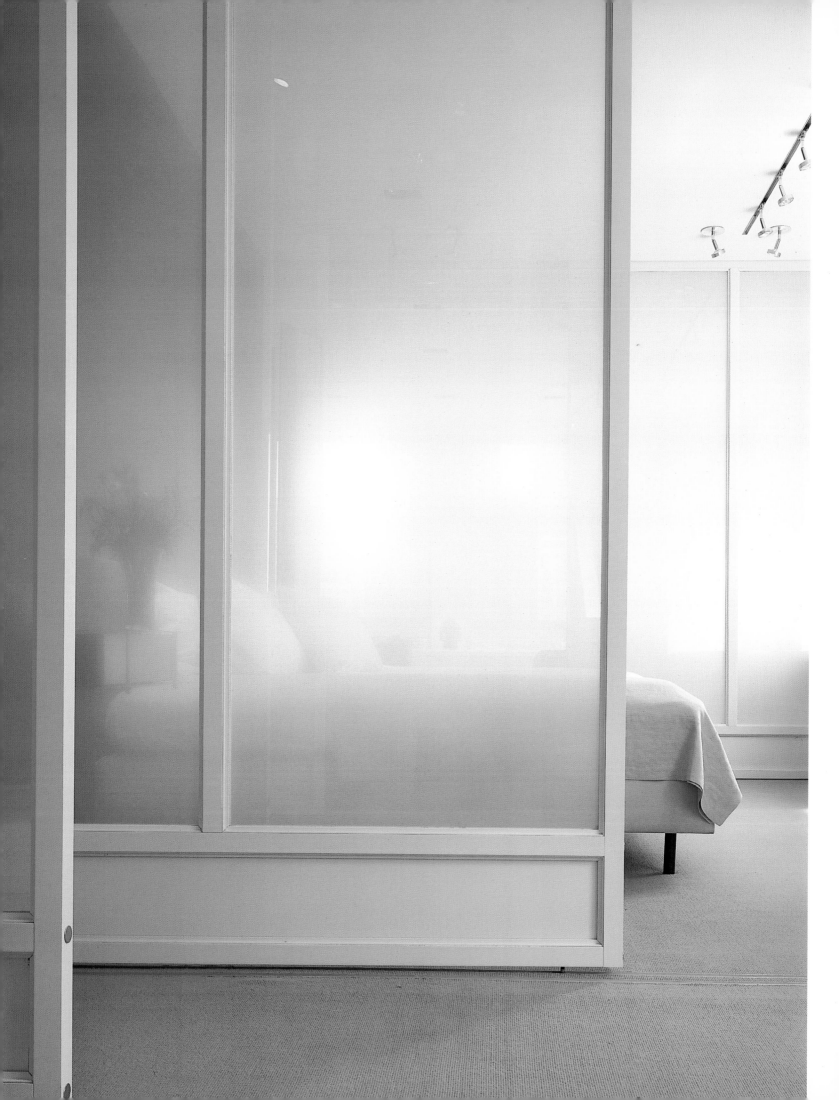

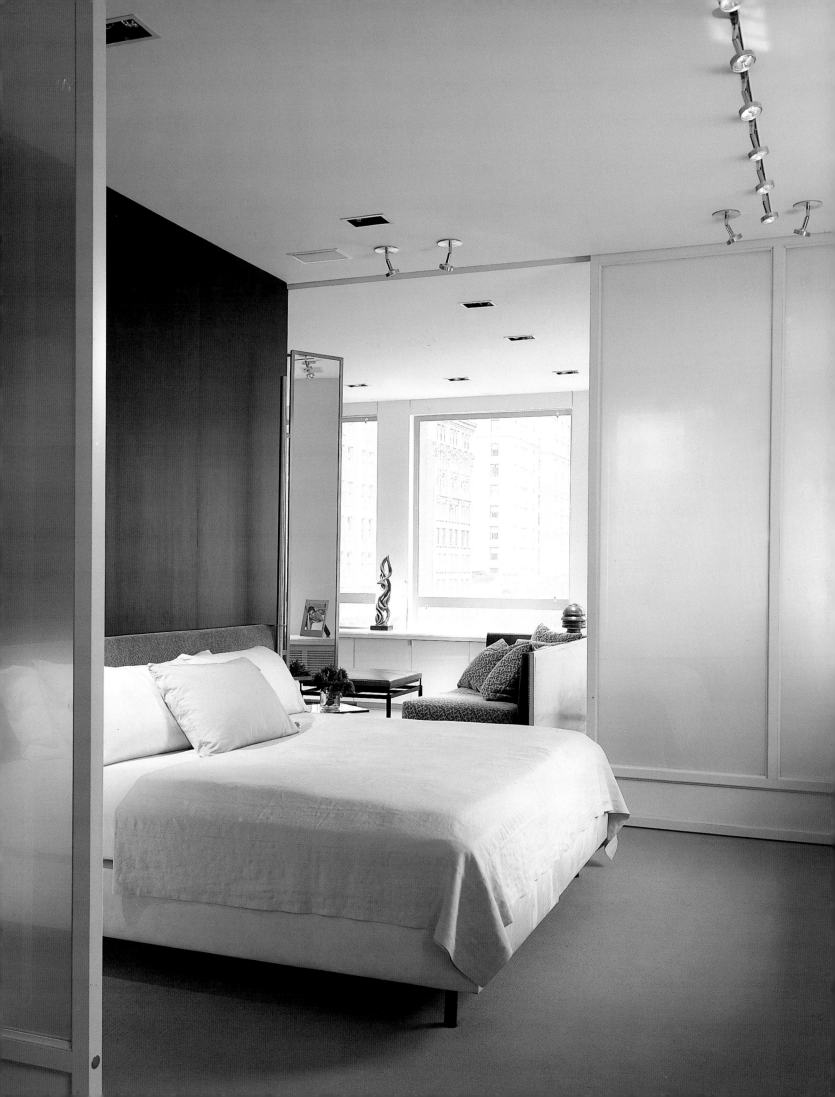

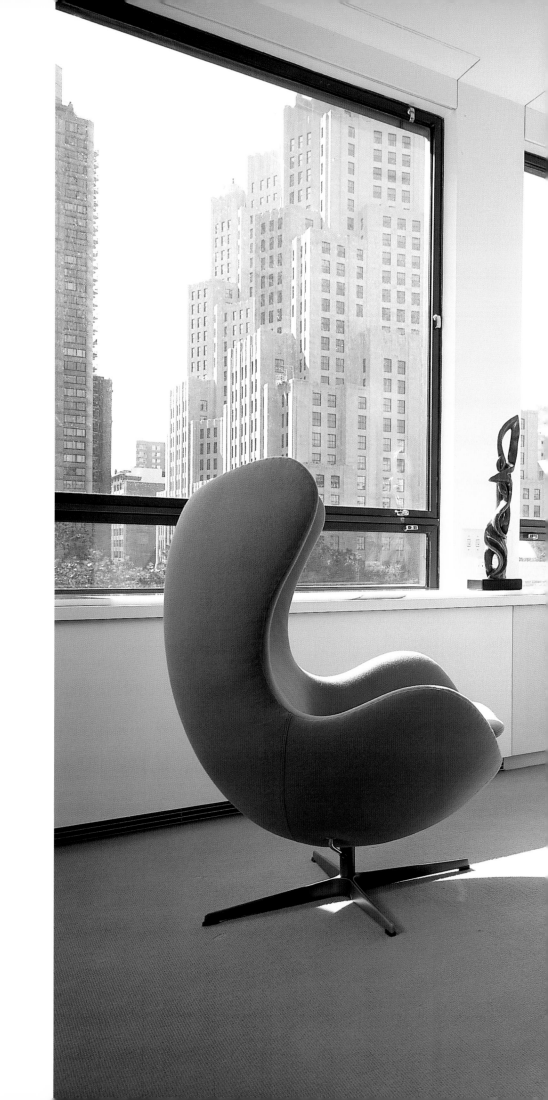

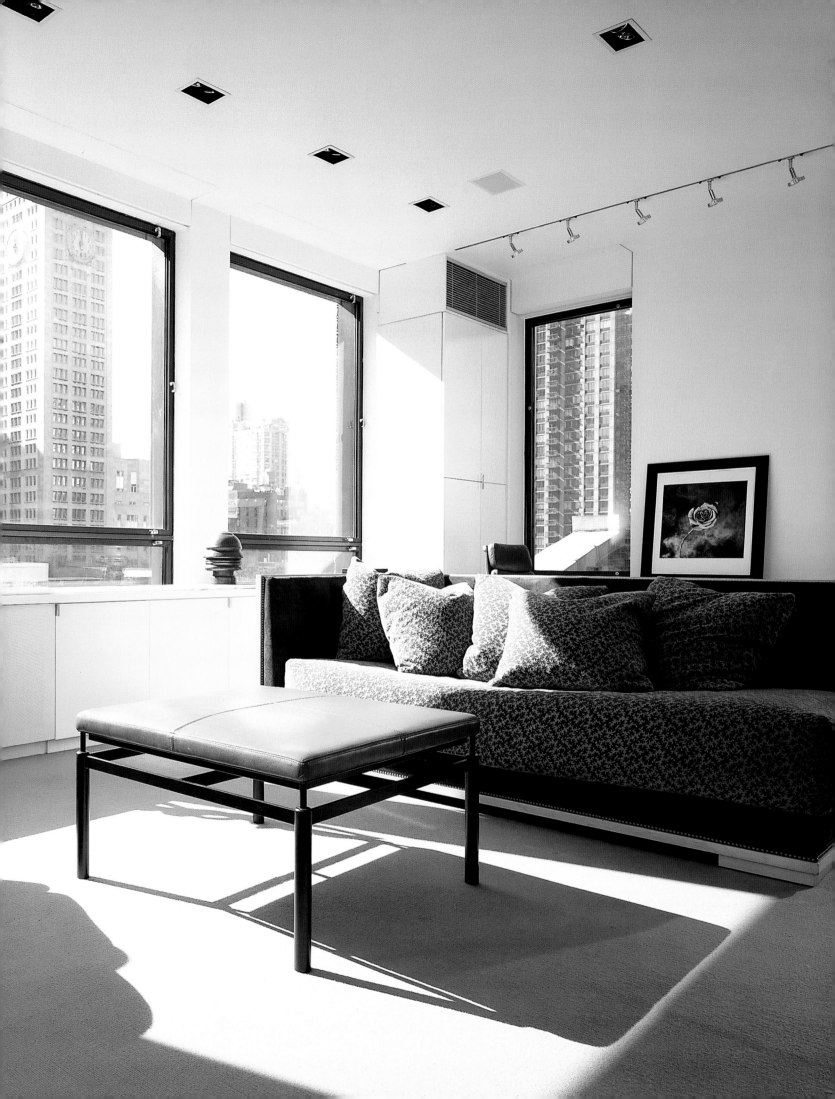

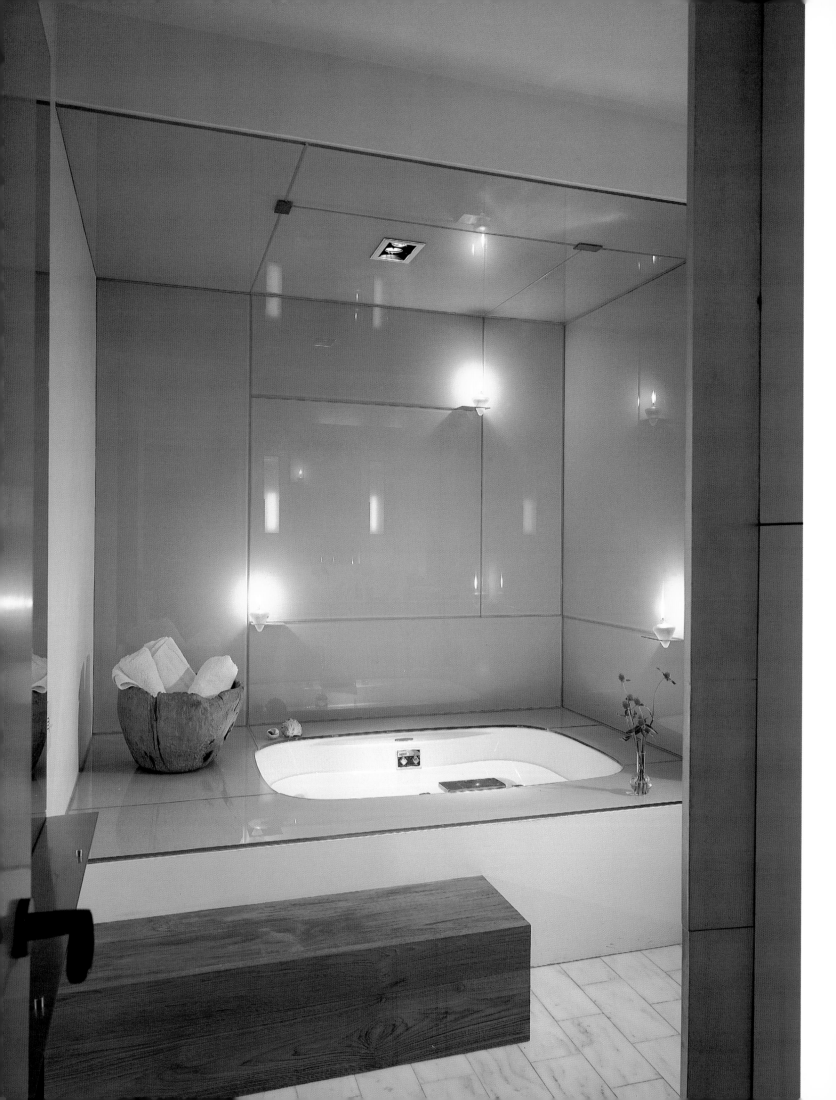

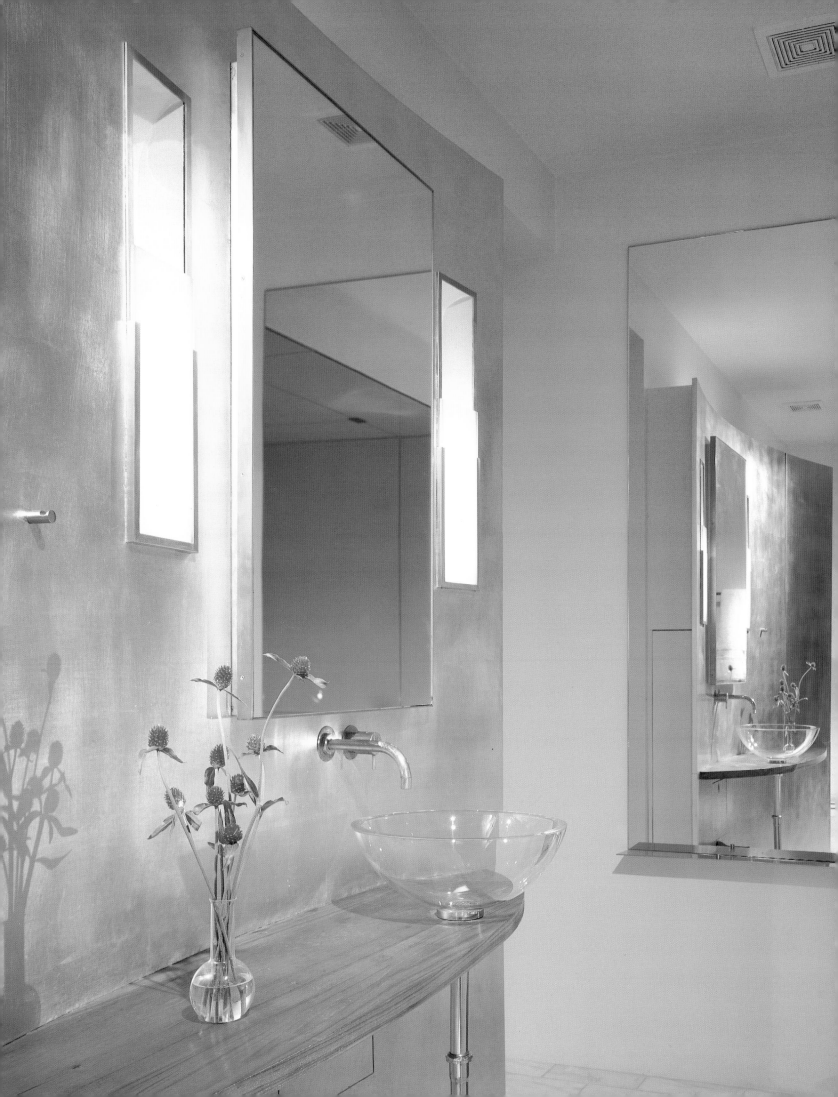

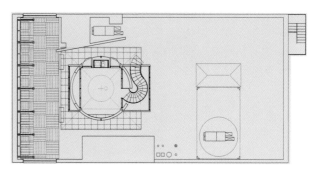

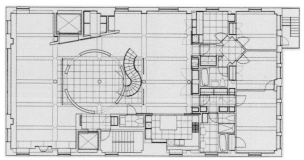

Mindel Loft, Chelsea, 1997

Shelton, Mindel & Associates

The spectacular loft of architect Lee Mindel—designed with partner Peter Shelton and associate architect Reed Morrison—represents a monumental exercise in willpower. It is an act of determination and defiance: determination to create a total environment in which every square inch of space, every issue of scale and proportion, every programmatic requirement is obsessively analyzed and resolved; defiance of any existing spatial irregularity or structural complexity that might challenge an enterprise of such ambition.

The 3,800-square-foot space comprises the top floor of a twelve-story former hat factory in an area of Chelsea where most buildings rise only nine floors. Determined to take full advantage of sweeping views on all four sides, Mindel and company planned the loft—and the newly added cubic penthouse aerie—as a multilayered composition of complex geometries that seamlessly integrates architecture, interior design, and the alluring cityscape unfolding in all directions.

The architects divided the loft into four east-west bays whose borders are defined by a variety of architectural gestures—some discreet or simply implied, others deliberately emphatic, all emphasizing spatial connections as they facilitate the flow of natural light from multiple angles. The southernmost bay houses the formal living room, an expansive space with multiple seating groups offering views of lower Manhattan and both the Hudson and East Rivers. Metal-framed glass walls define the borders of the second bay, which houses the loft's focal entry rotunda/gallery. Inhabiting the third bay are casual lounge space, the main dining area, and an L-shaped service sector containing kitchen, bathroom, and storage facilities. Two layers of sliding floor-to-ceiling panels control access to the service areas. Mindel's private realm—three bedrooms, two baths, and a study—occupies the fourth, northern bay.

The rotunda is the fulcrum of the architects' elaborate plan. Bathed in glorious natural light, the entry zone teases visitors with multiple possibilities for circulation: passageways and peekaboo punctures interrupt the rotunda's circular walls, allowing visual and/or physical access to the spaces beyond. The glass walls that contain the rotunda penetrate the loft's ceiling plane, where they are transformed into vaulted skylights flanking the new rooftop penthouse.

To one side of the rotunda, a sculptural curving stair of stainless steel and concrete—a massive, unapologetically dramatic, double-helix construction—leads to the sitting room aerie and its adjacent outdoor deck and garden. A seductive anomaly among the rough wooden water tanks that dominate the urban roofscape, Mindel's finely wrought glass-and-steel penthouse appears to float above the building, its hauteur emphasized with a cantilevered steel crown (an abstraction of the one atop the Statue of Liberty, according to Mindel).

While many architects frequently (and sometimes disingenuously) announce the discretion of their work, Shelton, Mindel, and Morrison have created a loft that is unabashedly grand, a dazzling celebration of the architects' passions. And dazzle it does.

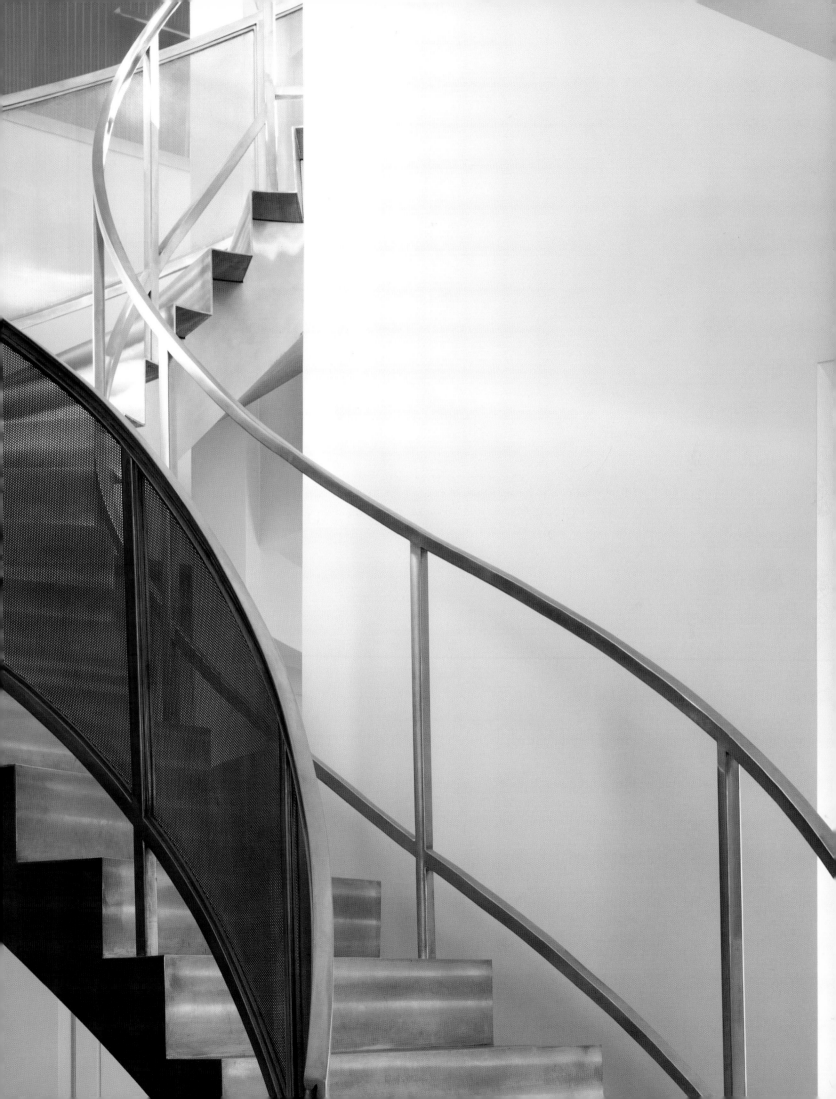

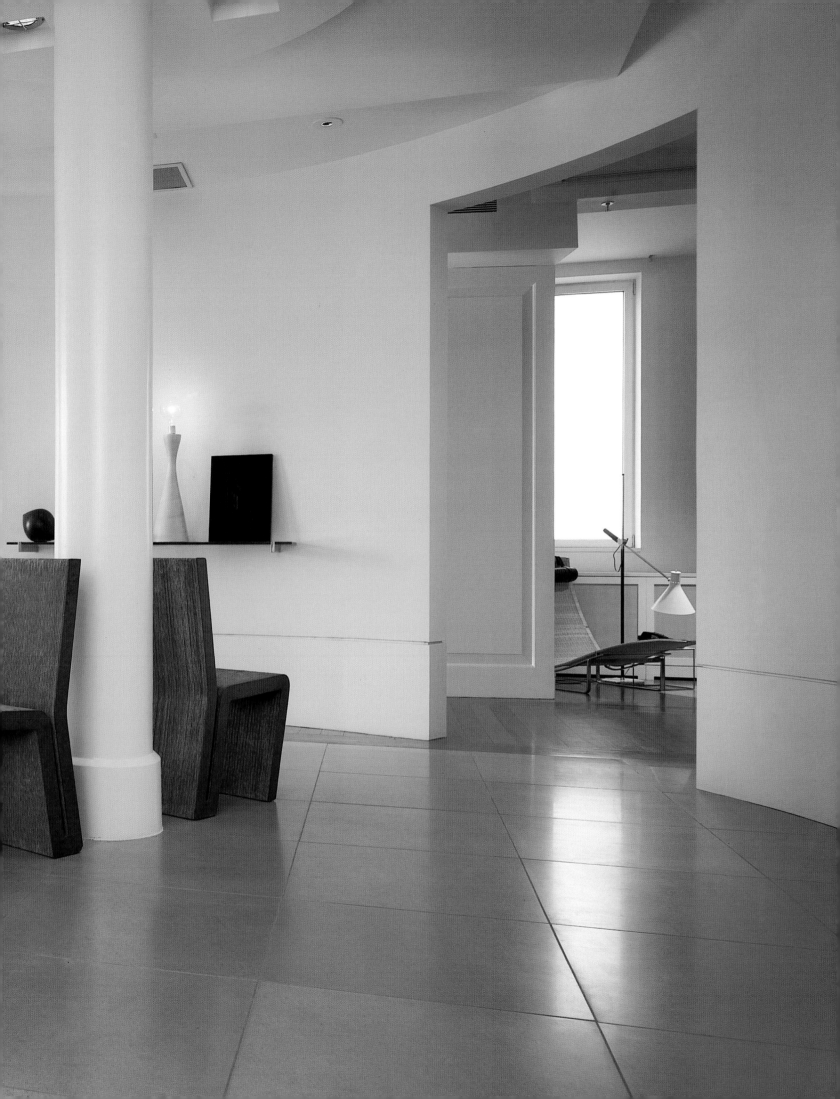

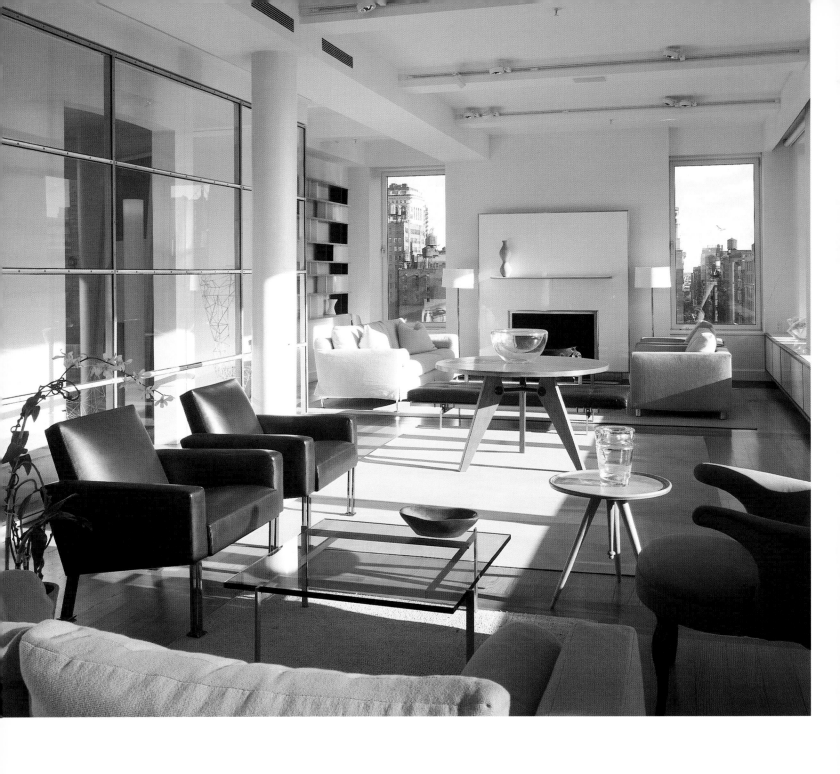

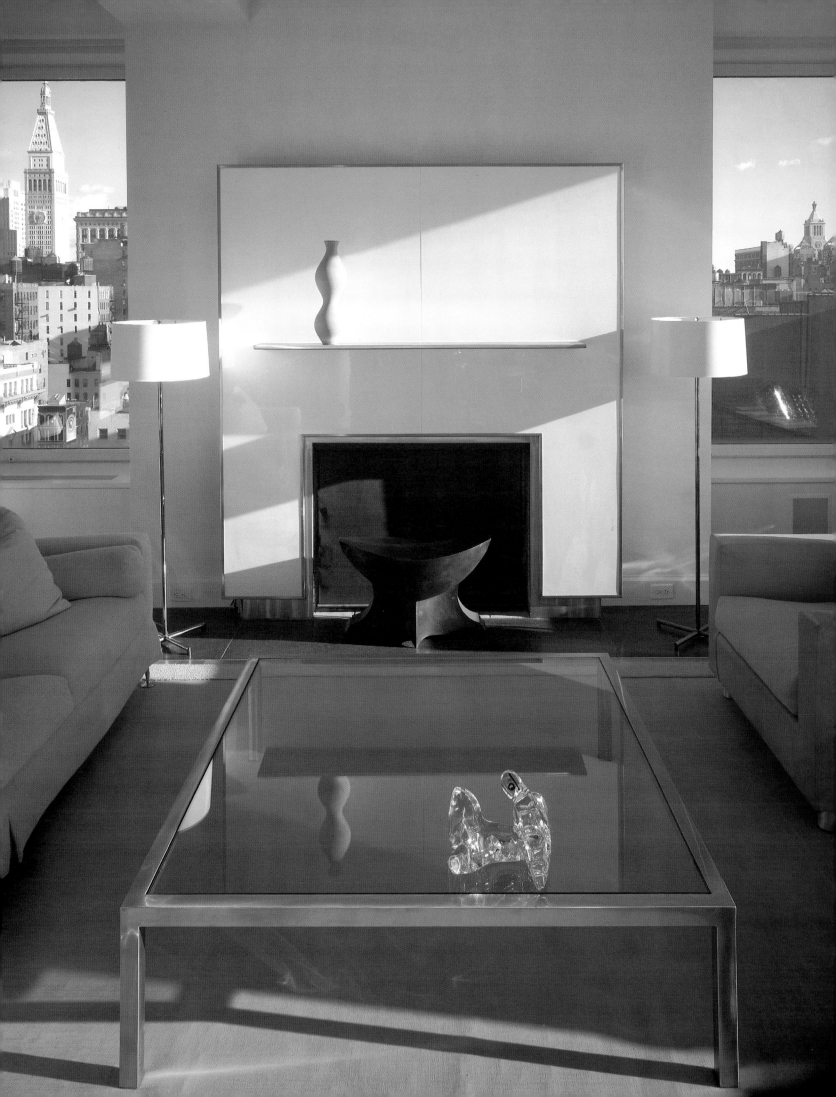

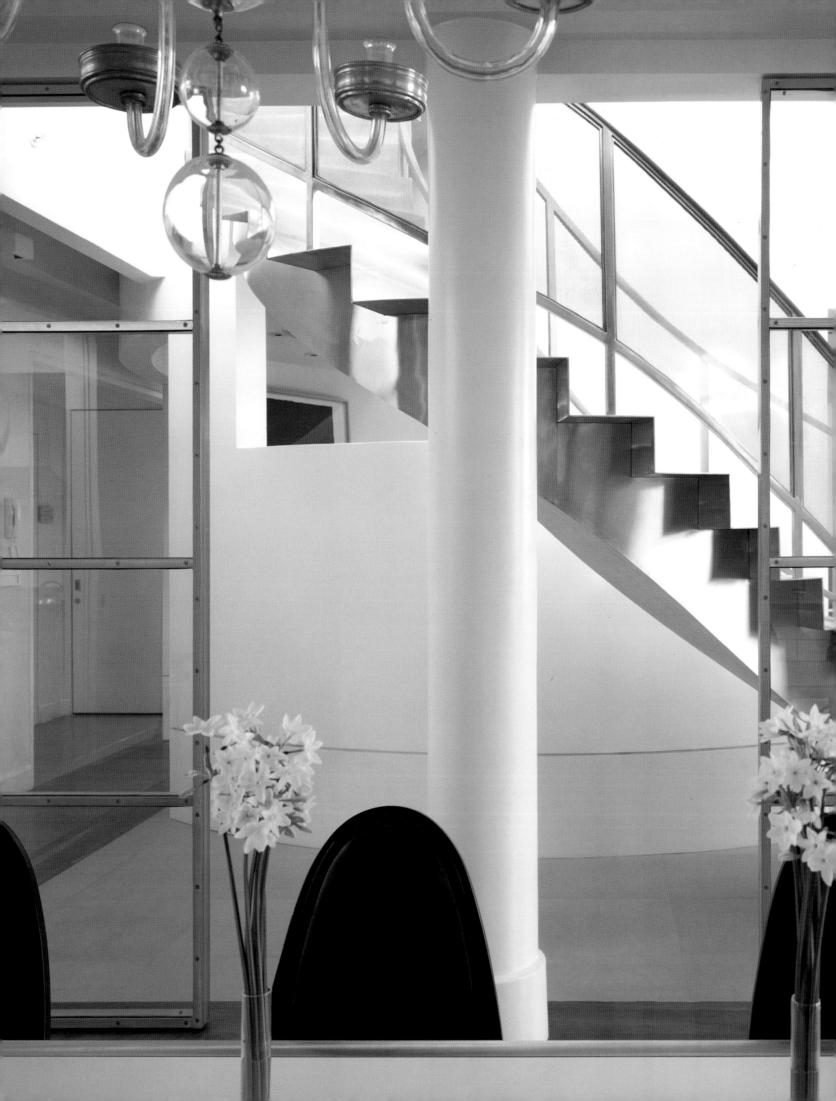

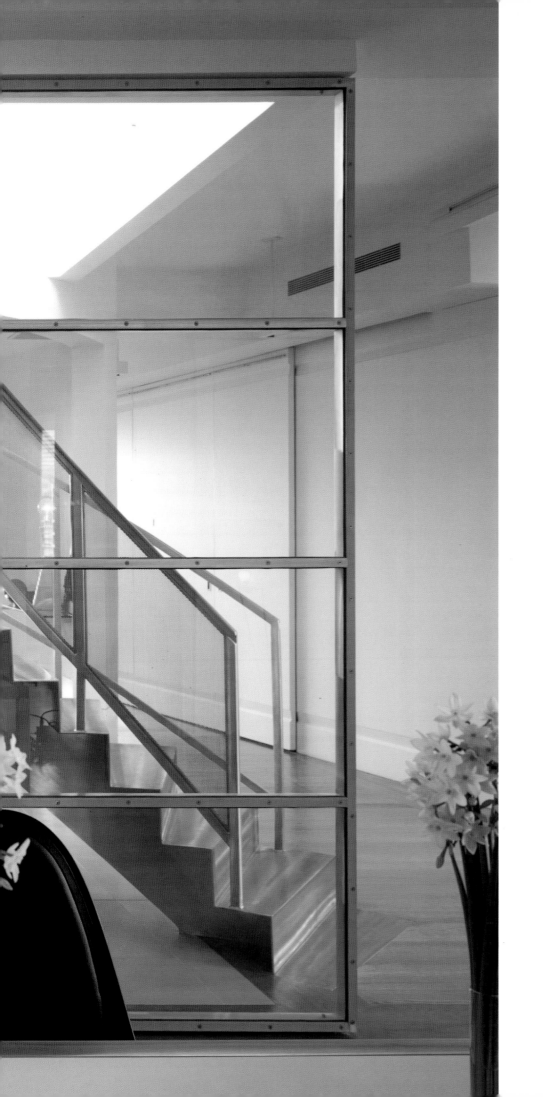

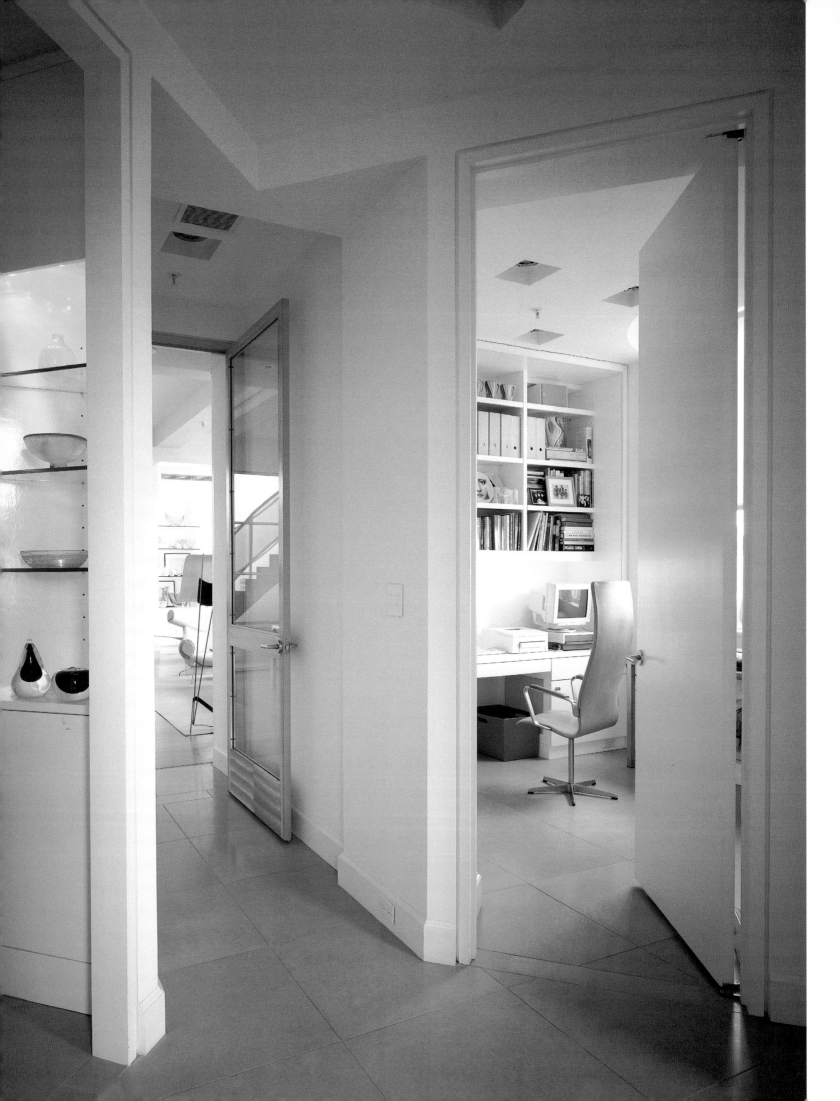

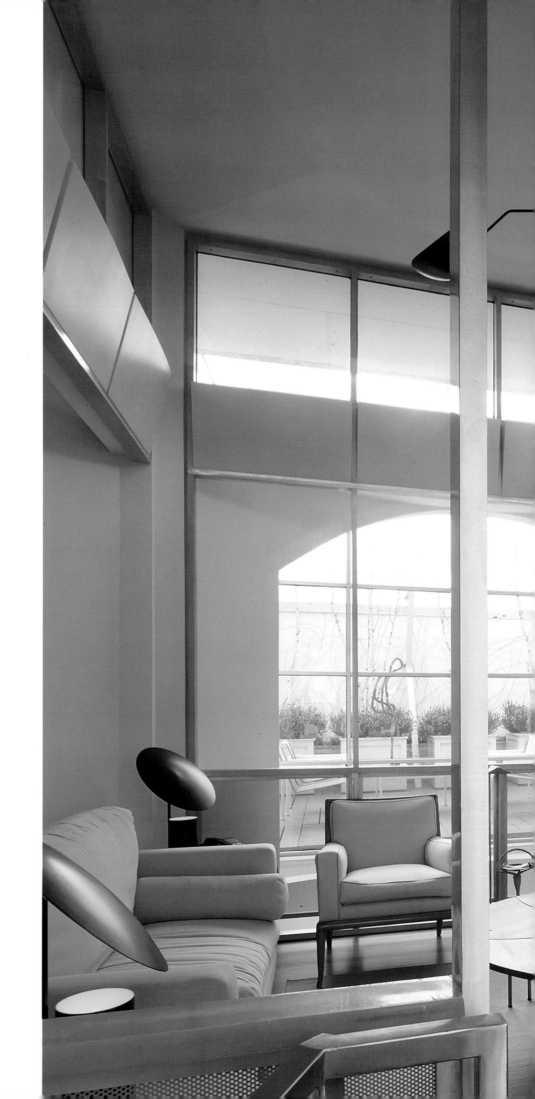

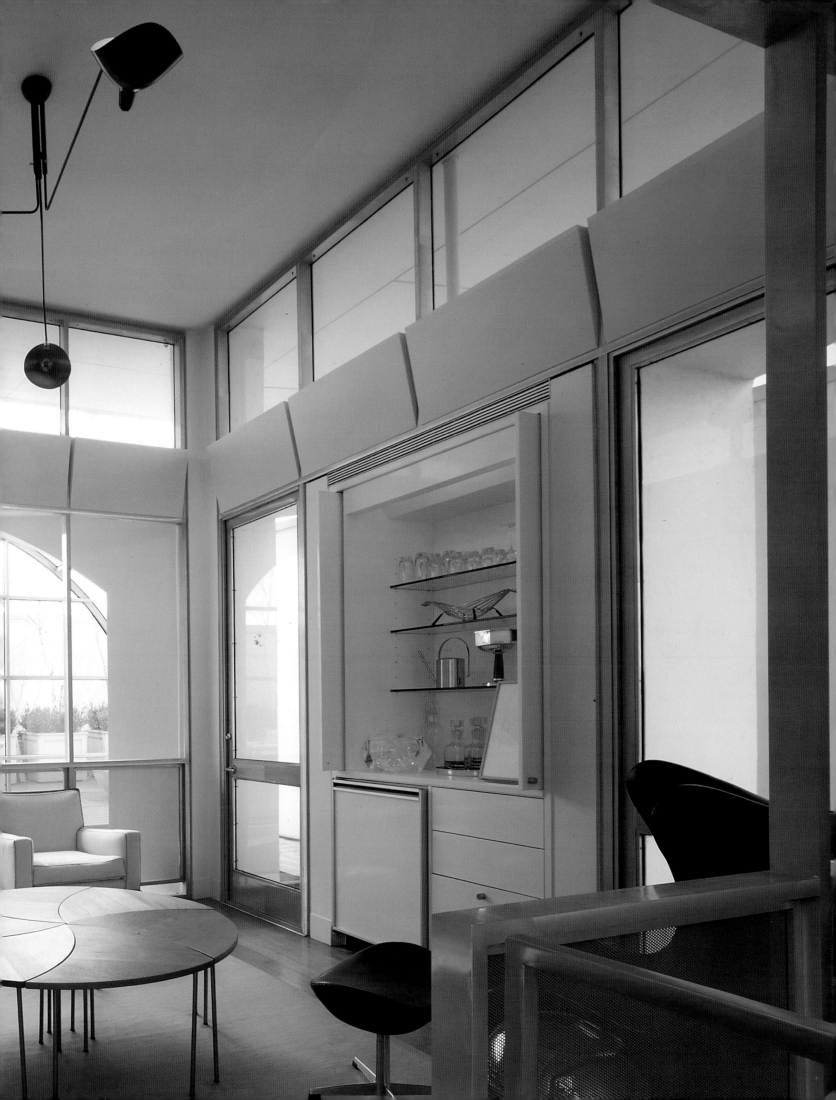

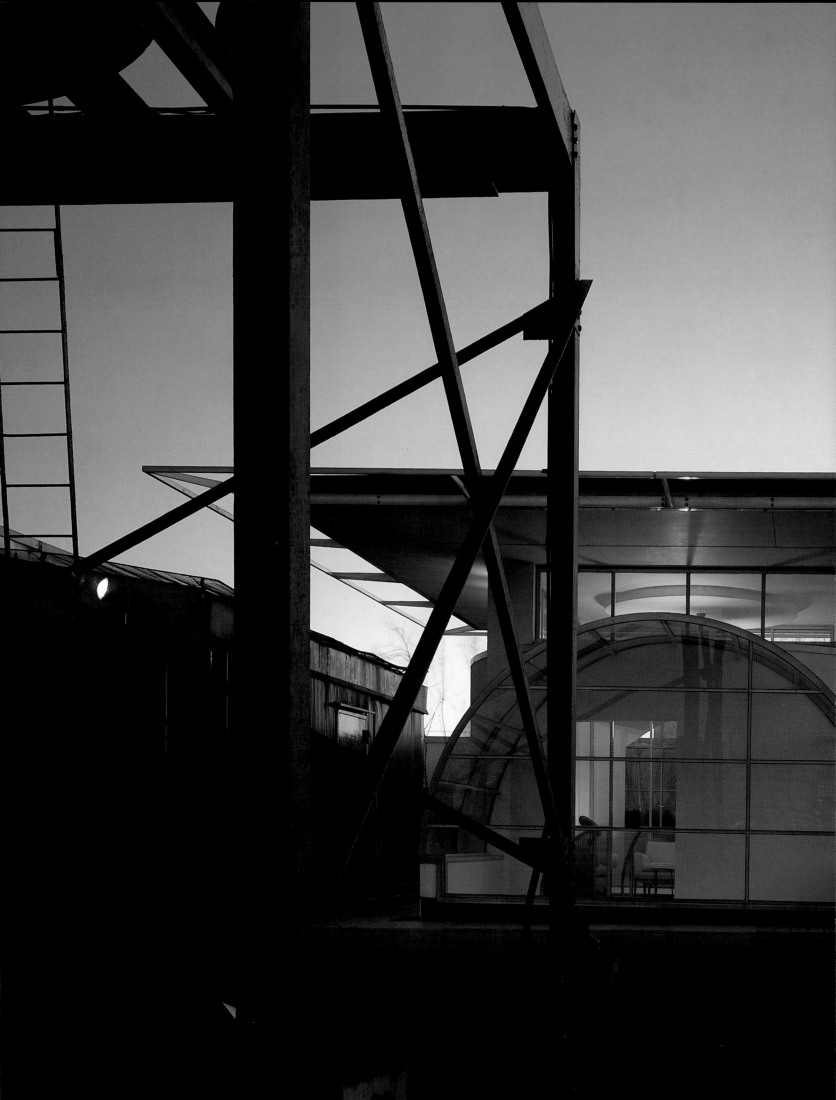

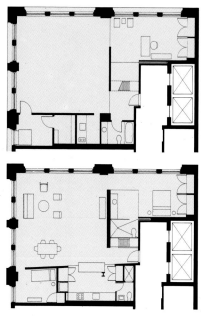

Lower Manhattan Loft, 1997

Belmont Freeman
Architects

In developing a work/live loft in a renovated commercial building on lower Broadway, architect Belmont Freeman confronted the standard challenge attendant to such multi-use projects: adequate differentiation of living and working zones. He was blessed, however, with an uncommon advantage: the client, an artist and founder of a not-for-profit organization providing arts education to underprivileged children, owned two consecutive 1,500-square-foot floors, each perfectly sized to fulfill the domestic and professional aspects of the program. Freeman's task thus became one of balancing desires for segregation and connection between the two floors. Working with associates Alane Truitt and Sangho Park, Freeman developed an elegant yet straightforward environment that nods to the late-1990s vogue for minimalist design without evincing the obsessive reductionism and excessive refinement characteristic of similar efforts.

Freeman's restraint is evident in the few architectural gestures that satisfy the program. On the lower working level, sliding partitions of gypsum board and translucent glass provide the requisite flexibility for spatial rearrangement. Here, as above, partitions were held away from the perimeter to maintain open sight lines to views of City Hall and the Brooklyn Bridge. The concrete floor that grounds the studio level gives way to warmer maple flooring on the living level above, where concrete was reserved for kitchen and bath areas. Partitions and open passageways on the upper floor were kept to a height of seven feet, providing an intimacy of scale close to the height of the standing body. Lighting further emphasizes the distinction between the floors, with standard track fixtures and pendant lamps serving the work level and more indirect lighting and concealed fixtures for domestic areas.

Although the abundant space offered ample opportunity to introduce a more conventional stair connecting the two floors, Freeman opted for a steel ship's ladder pitched at a steep seventy-five-degree angle. In the words of the client: "I didn't want to carve a path of desire between my studio and home. I wanted the passage to be a deliberate and transitional act."

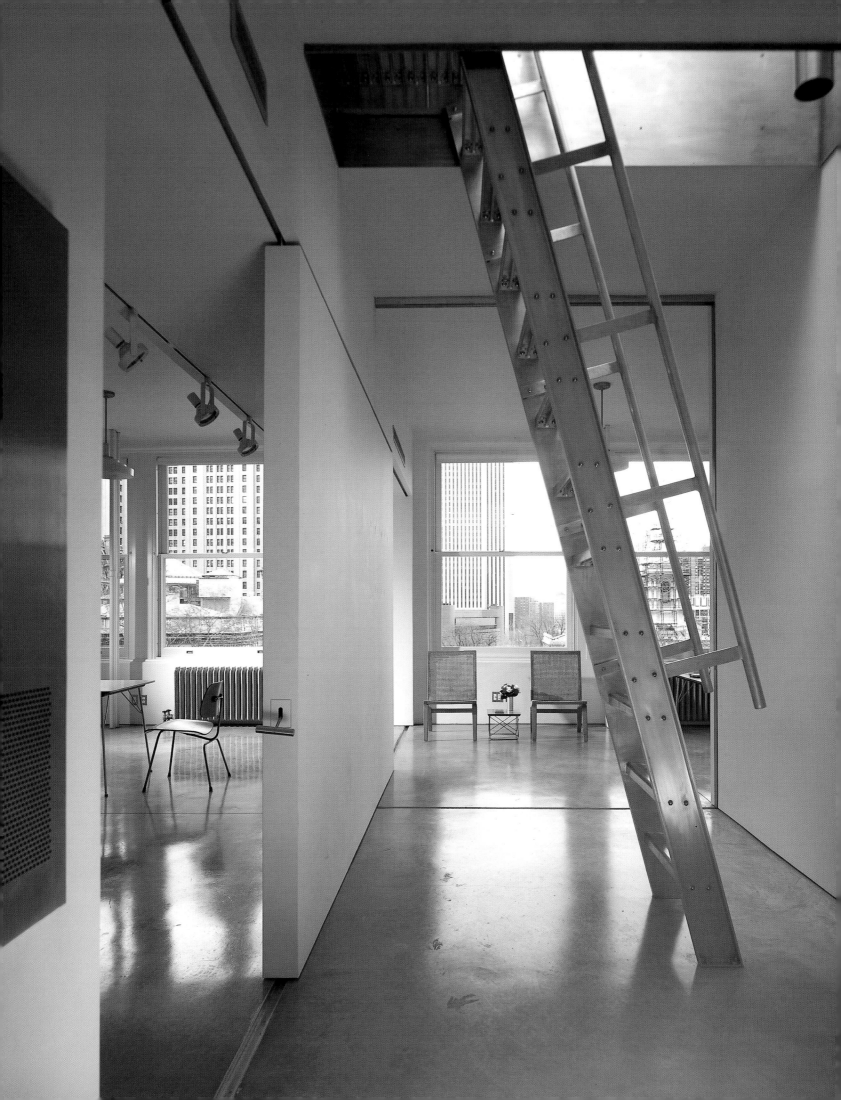

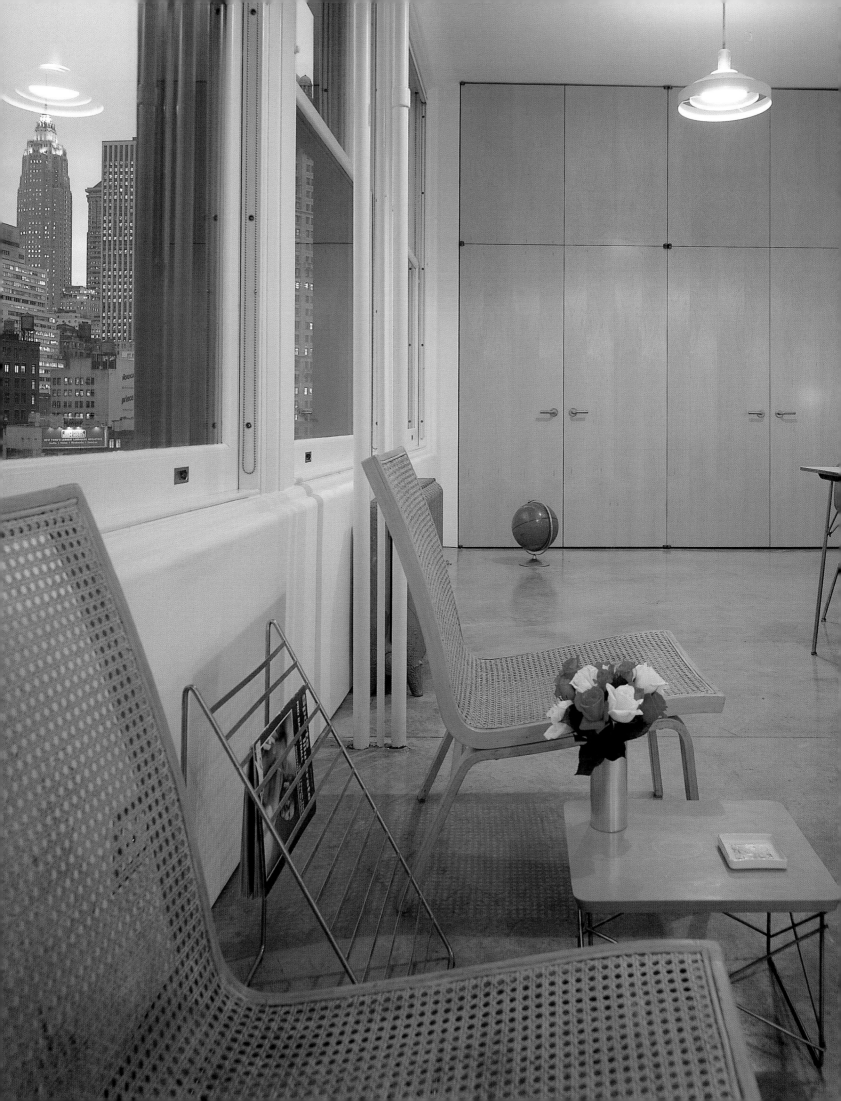

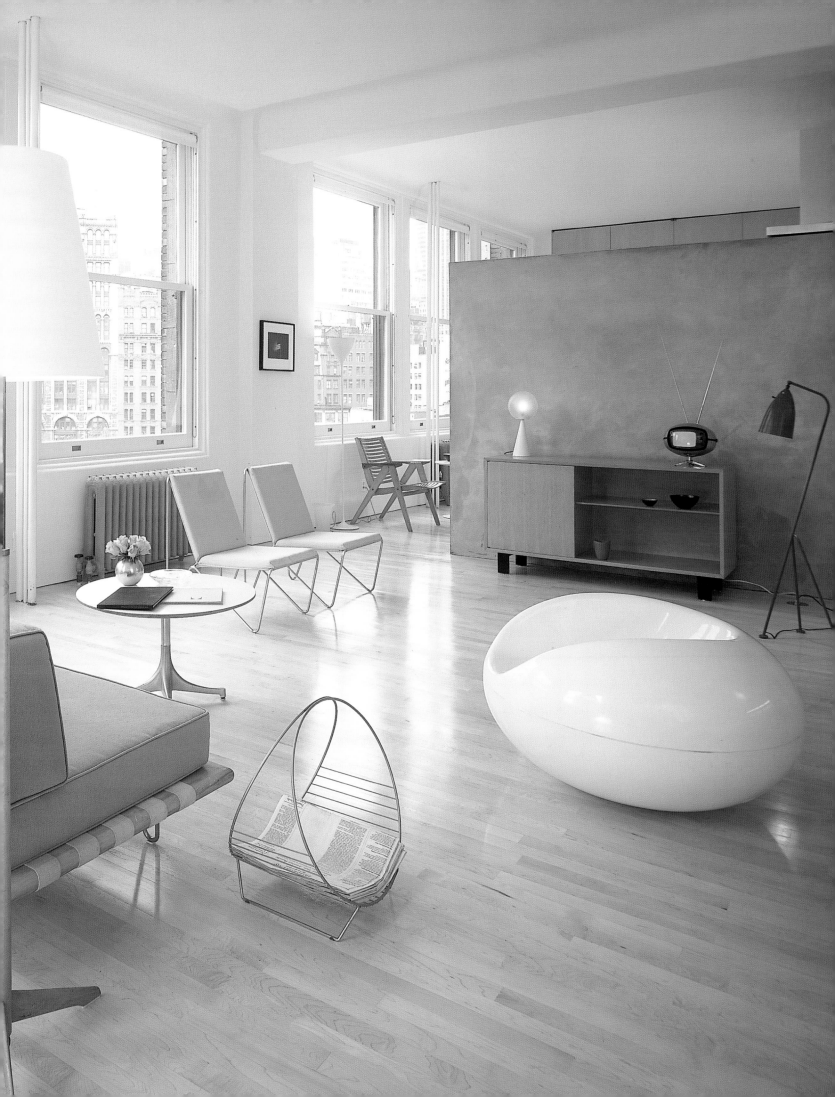

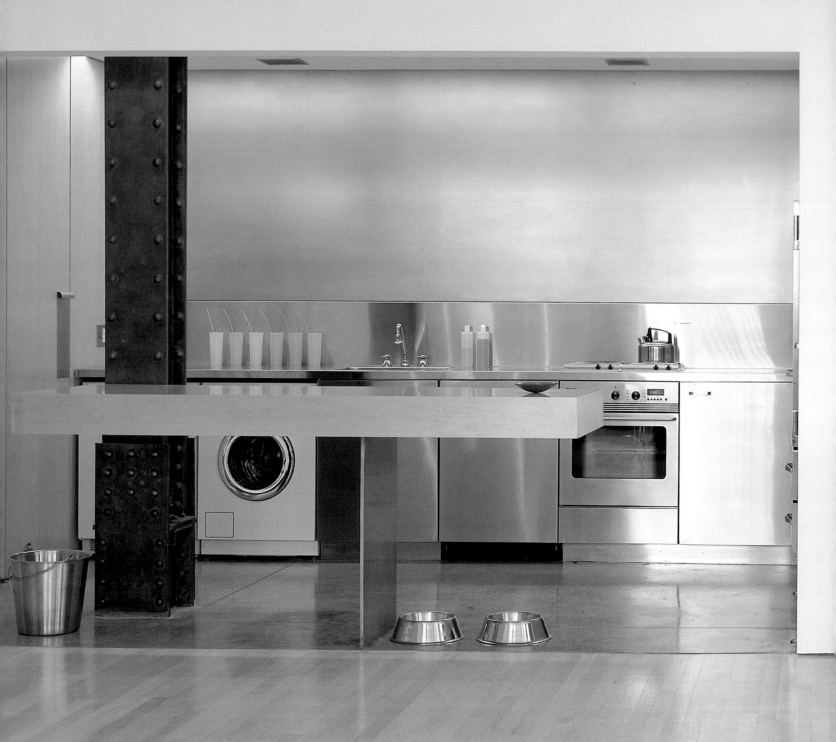

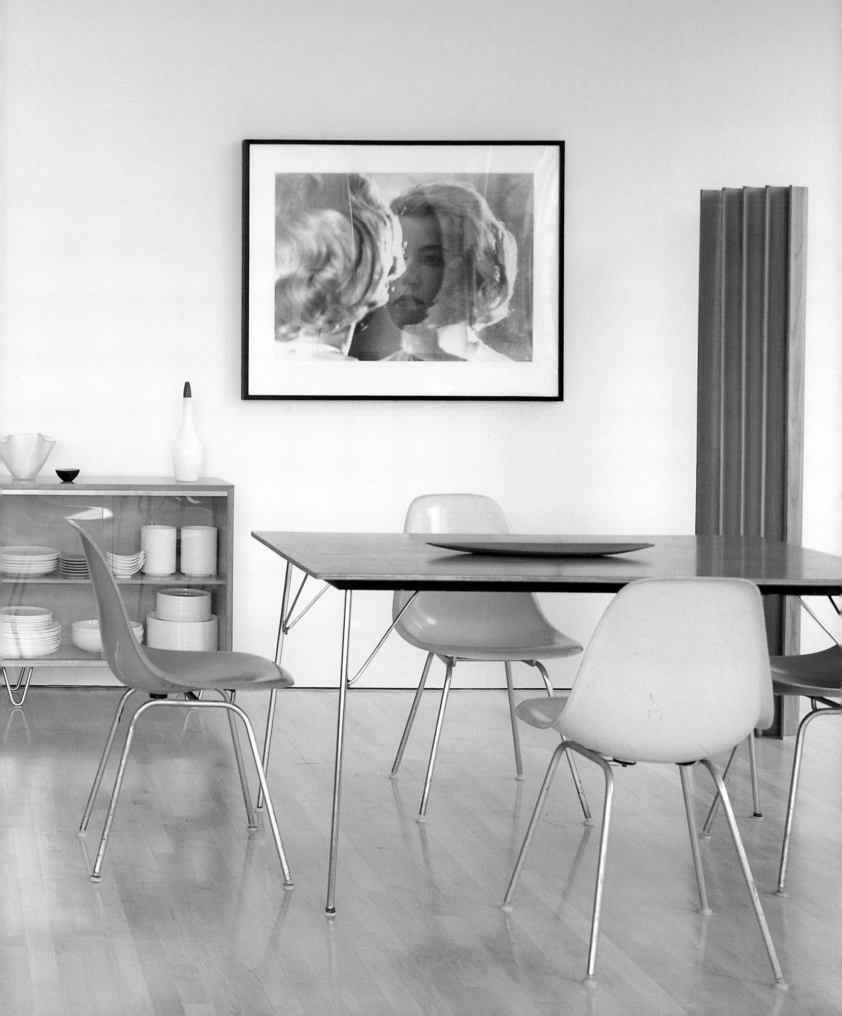

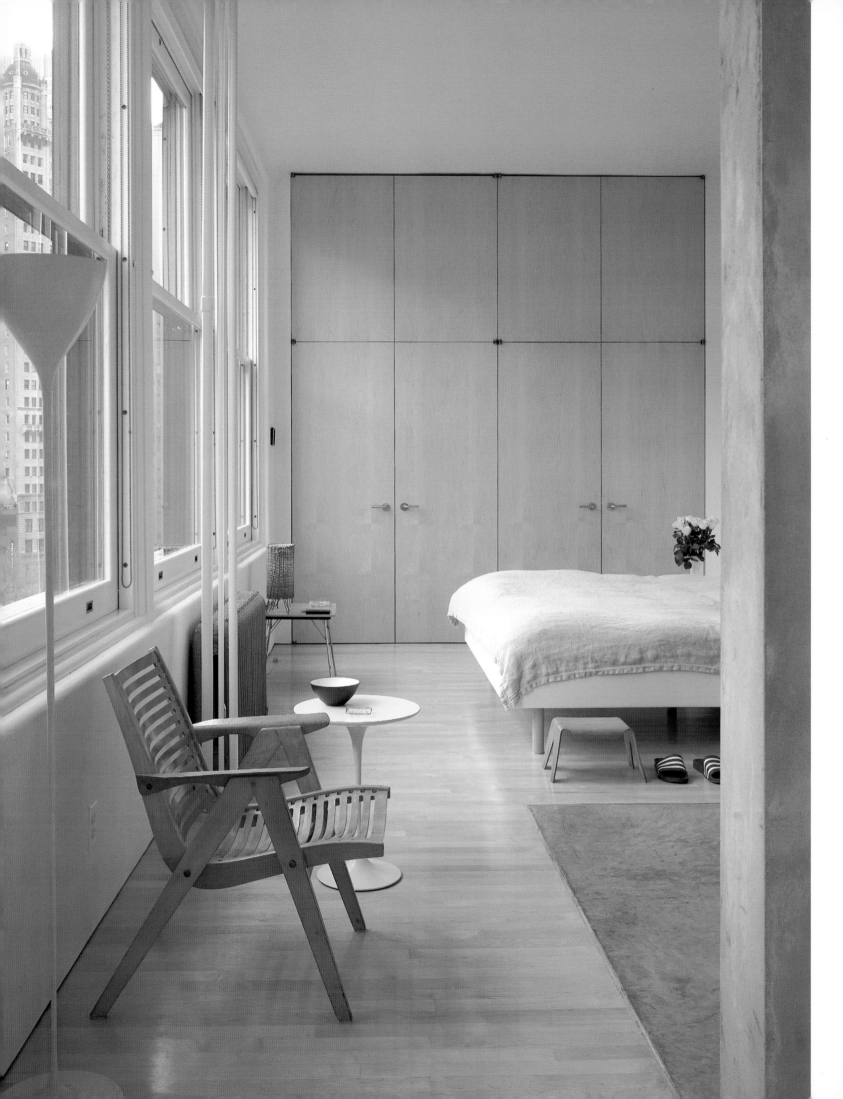

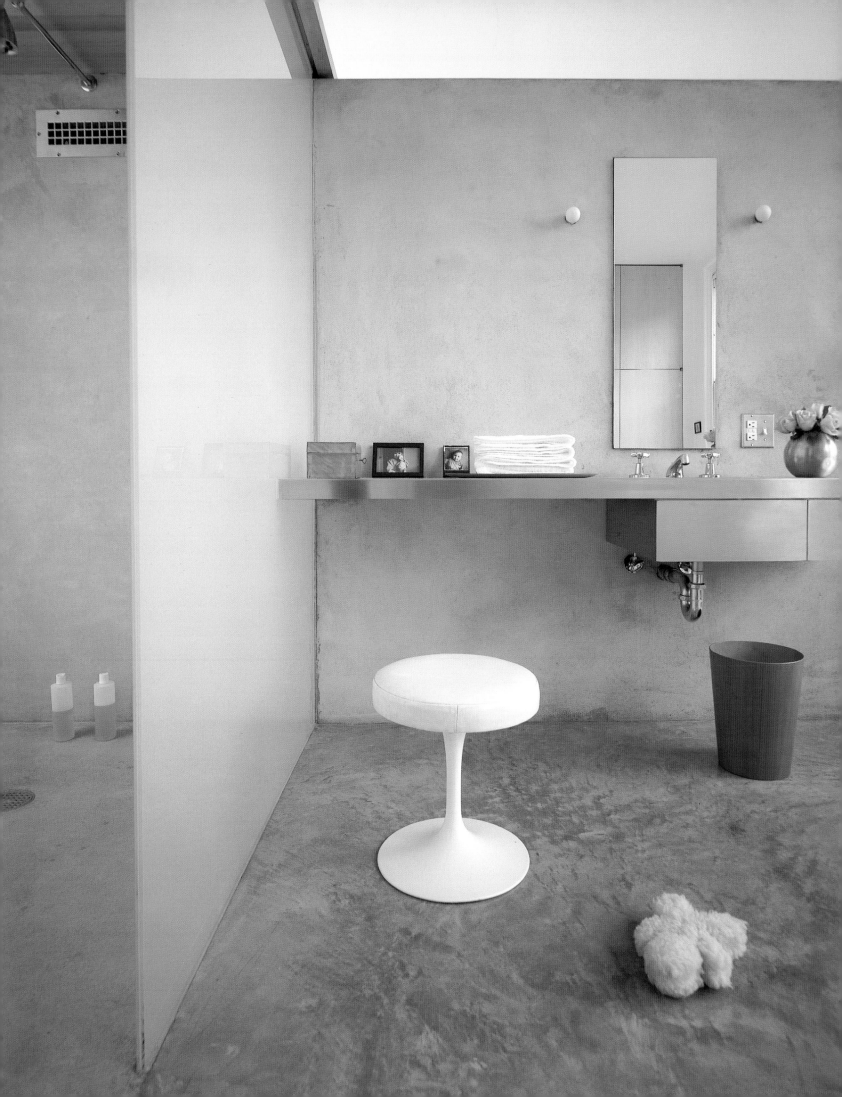

Flatiron Loft, 1995

American Design Company

An unusually close collaboration between client and architect resulted in the clever design of this 3,200-square-foot loft on lower Fifth Avenue. Corinne Calesso and William Hellow of American Design Company were asked to apply order and definition to a hodgepodge of undifferentiated rooms that had accumulated in the space over many years. Complicating this effort was a New York loft law that prohibited genuine structural modifications. Another challenge involved the divergent requirements of the two clients, both of whom are involved in aesthetic pursuits, but on two completely different scales. One is a photographer and fabricator of large-scale set props and sculptures in metal; the other is a designer of small, refined objects and accessories. Neither had a definitive vision of what the loft should be beyond a loose directive to make the space playful and comfortable. The first phase of the project thus involved a series of explorations to determine basic aesthetic directions and spatial hierarchies.

Once those initial expectations were mapped, the team embarked on a design/build process in which Calesso and Hellow generated plans and drawings for demountable architectural elements that the clients constructed themselves. Using materials and components ordered from industrial supply sources, the photographer and his assistants crafted many of the design interventions that shape the reconceived loft. Chief among them is the curved "wall" of interlocking panels of Masonite and acrylic that separates the central dining and social zone from the library, office, and workshop. Another client-built element is the master bedroom's dropped ceiling of $\frac{1}{8}$-inch-thick plywood strips woven through suspended aircraft cables. In tandem with new seven-foot-high doors that replaced the existing ten-foot-high bifold dividers, the bedroom ceiling establishes a more intimate, domestic scale for the private enclave.

Because of the limited budget, economy of means was not limited to the client-as-contractor arrangement. Calesso and Hellow utilized inexpensive wardrobe cabinets, bookshelves, and other storage units to form walls that define space without bypassing the restrictive loft law. The diverse color palette and arrangements of furniture provided additional spatial definition, modulating the sequential experience of the loft without compromising fluidity.

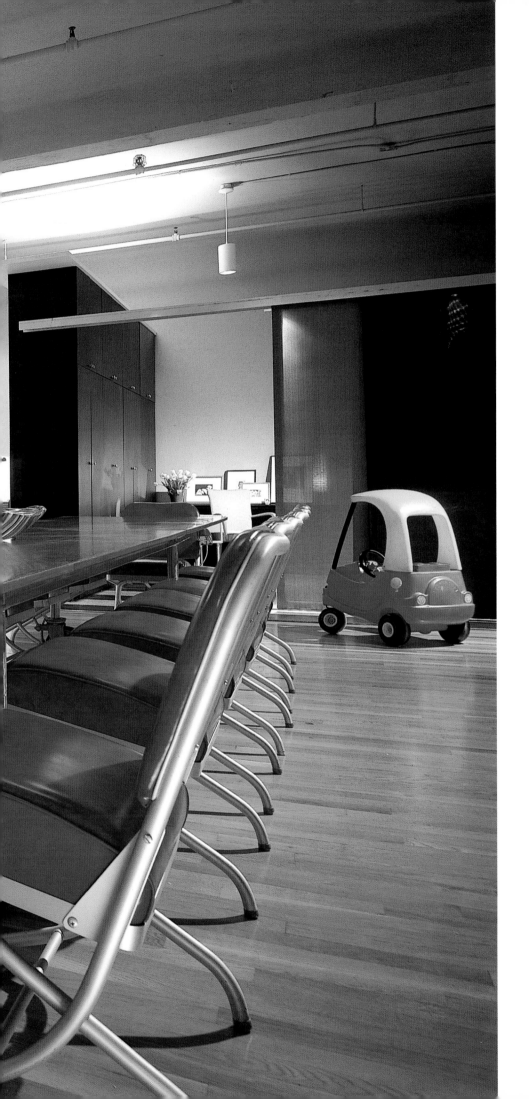

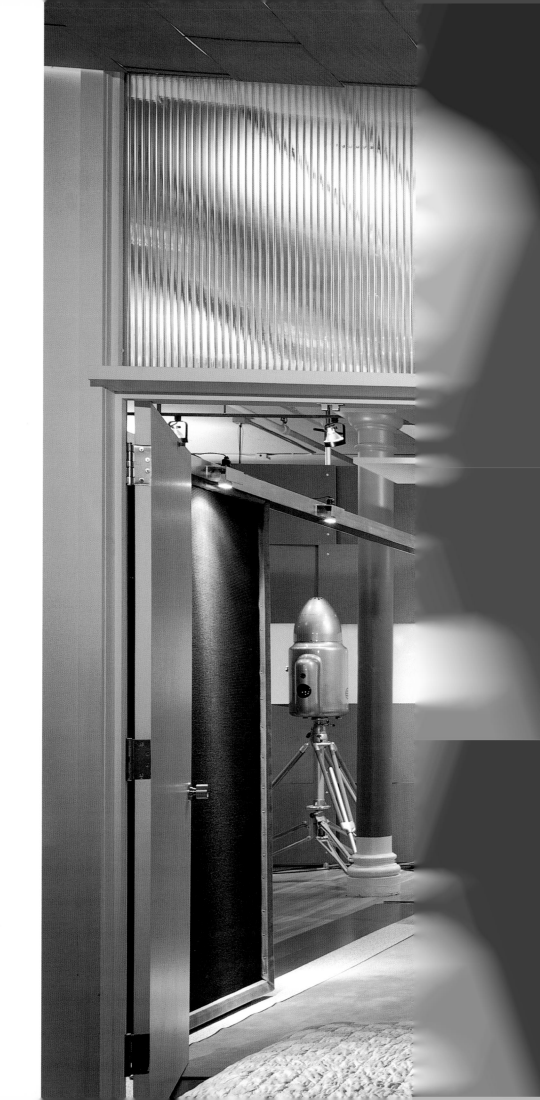

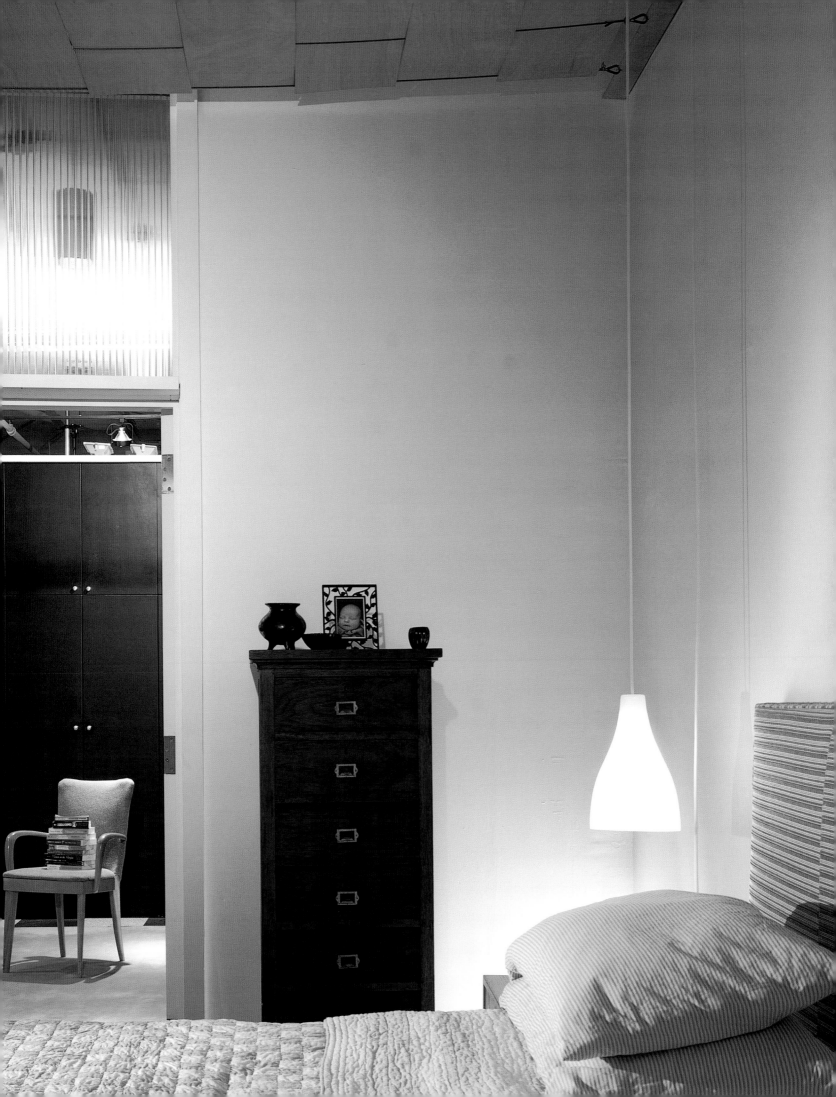

Resolution: 4 Architecture

As found, this 1,700-square-foot space, located on a low floor in a Tribeca building originally used for light industry, presented the typical rewards and limitations of loft living: long and narrow, it offered a generous sweep of space but minimal natural light and few original architectural details of genuine aesthetic or historical interest. The design team from Resolution: 4 Architecture—Joseph Tanney, Robert Luntz, John DaCruz, and Clay Collier—responded to the loft's rectangular plan with a scheme of great economy and clarity. With the entry positioned at one end near the building facade, the requisite living room, dining area, kitchen, and bedroom progress without aid of fixed walls along the length of the loft. At the rear of the space, the architects had the luxury of installing two new windows, considerably abetting the infiltration of natural light.

Subtle spatial manipulations and custom design elements lend definition and intimacy to the various zones without restricting physical or visual access across the floor. The orientation of the living room is turned toward the media wall, designed as an asymmetrical composition of open shelving units for display and storage. The arrangement of furnishings and carpet defines the boundaries of this area on the floor plane. Above, the living zone is further articulated by a collaged ceiling treatment of layered Homasote panels that else-where form a level overhead plane. A large round dining table and an Italian glass pendant light anchor the dining area, which is bordered by a wall composition of varisized Durock concrete panels. The kitchen and bedroom are more formally separated by a vertical divider that, on one side, houses the stove and cooktop and, on the other, becomes the headboard in the master bedroom. Sliding acrylic panels extend from both sides of the dividing unit, effectively enclosing the bedroom suite when desired without blocking the transmission of light.

While many loft designers employ low-cost, off-the-shelf building materials, the Resolution: 4 team explored imaginative possibilities for both functional efficiency and artistic expression. Beyond the Homasote ceiling collage, the Durock wall composition, and the ubiquitous use of Baltic plywood, the architects experimented with various types of commercial acrylics to define and obscure boundaries between spaces. In the process, they created an ever changing theater of shadow and light.

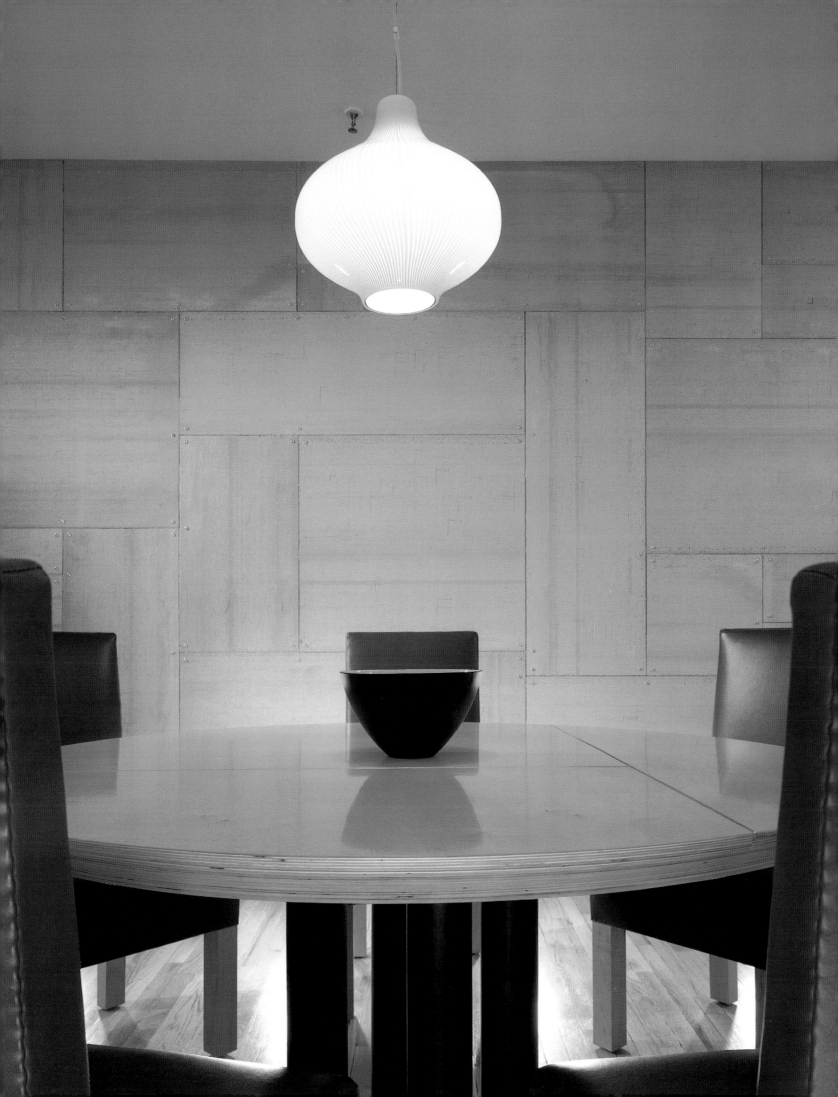

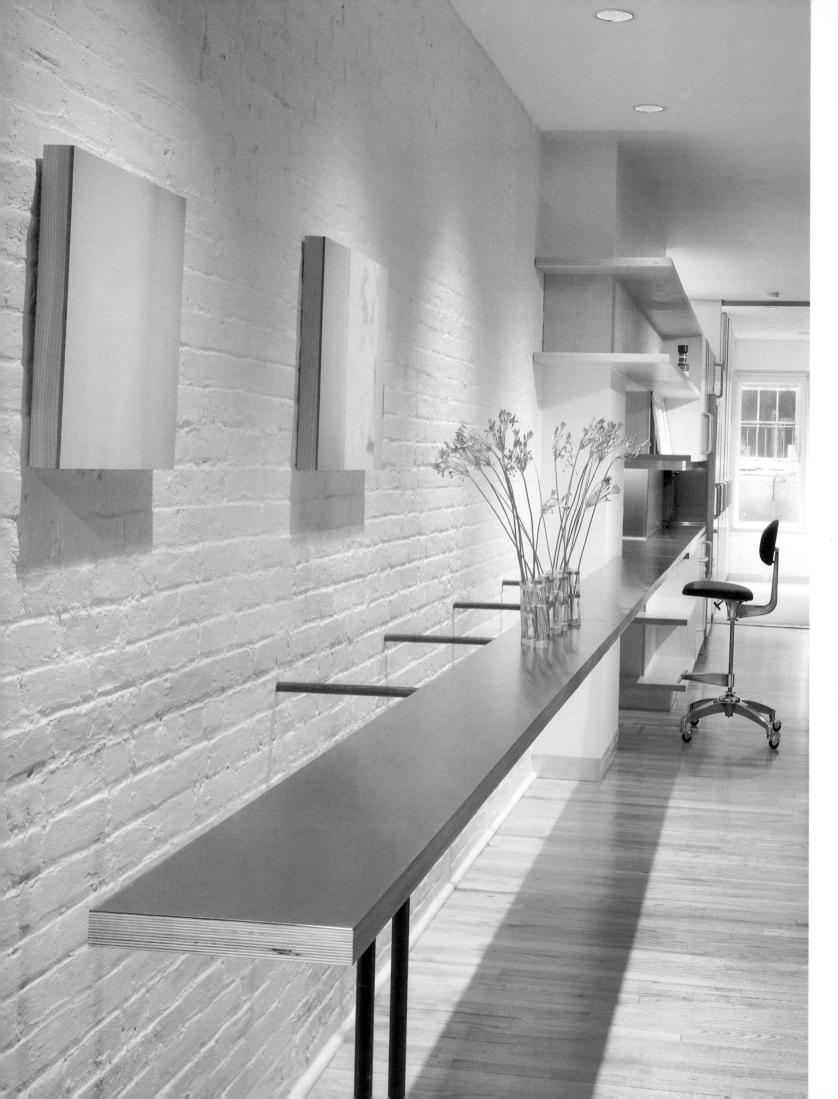

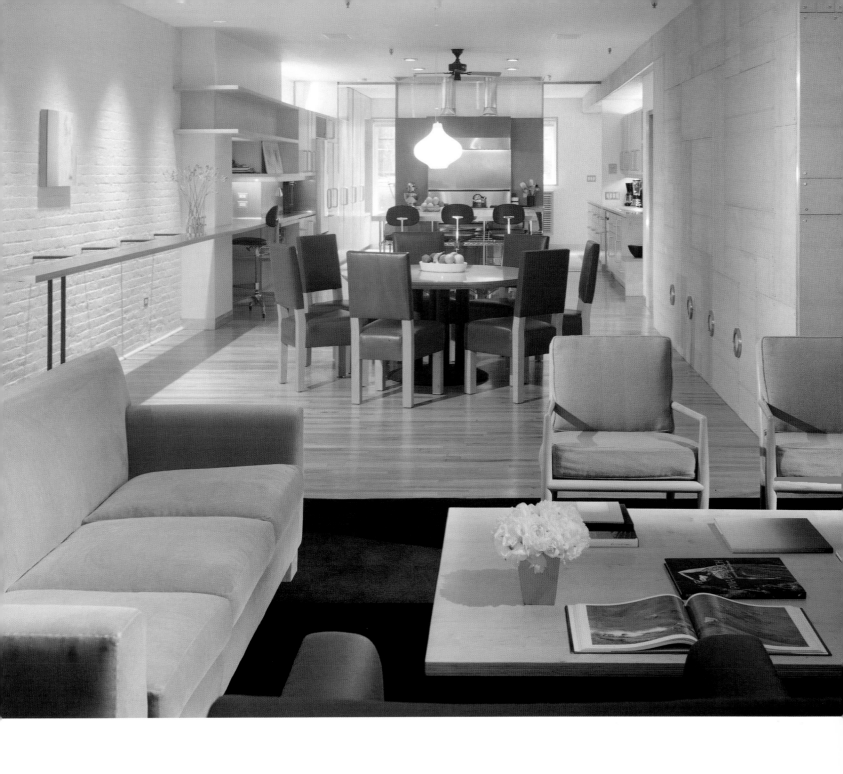

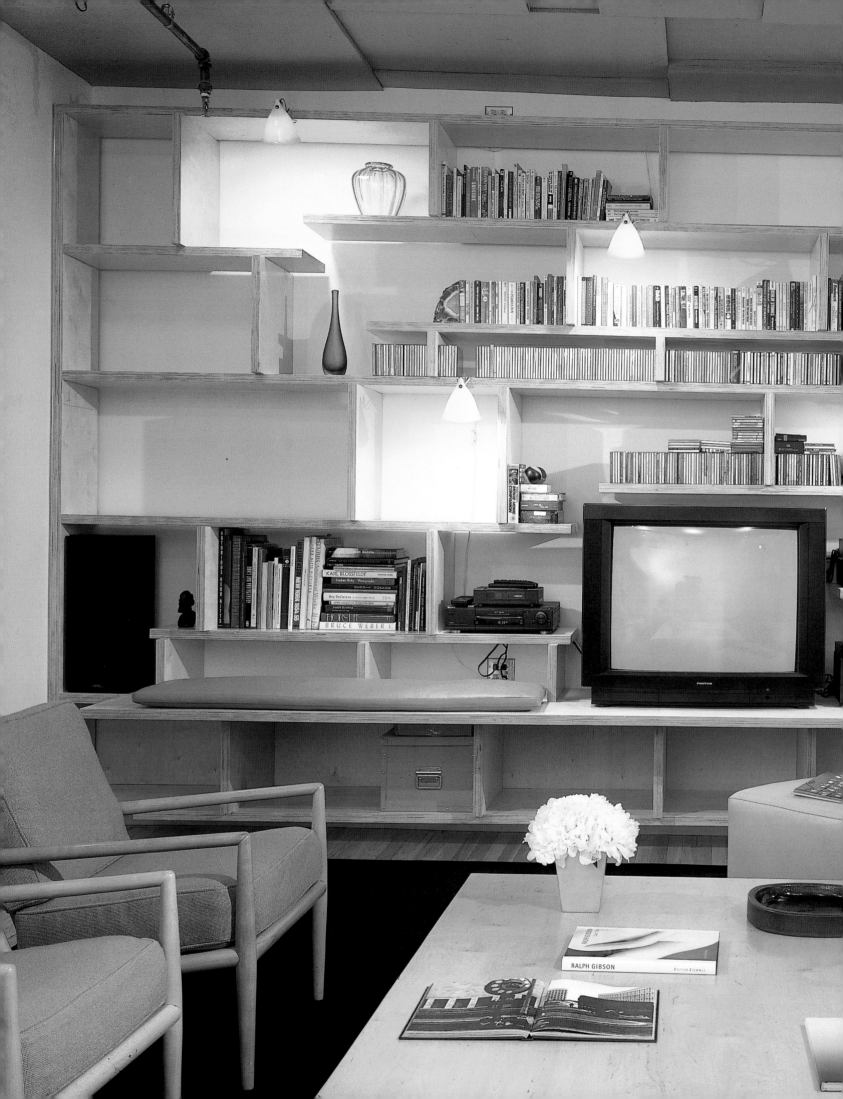

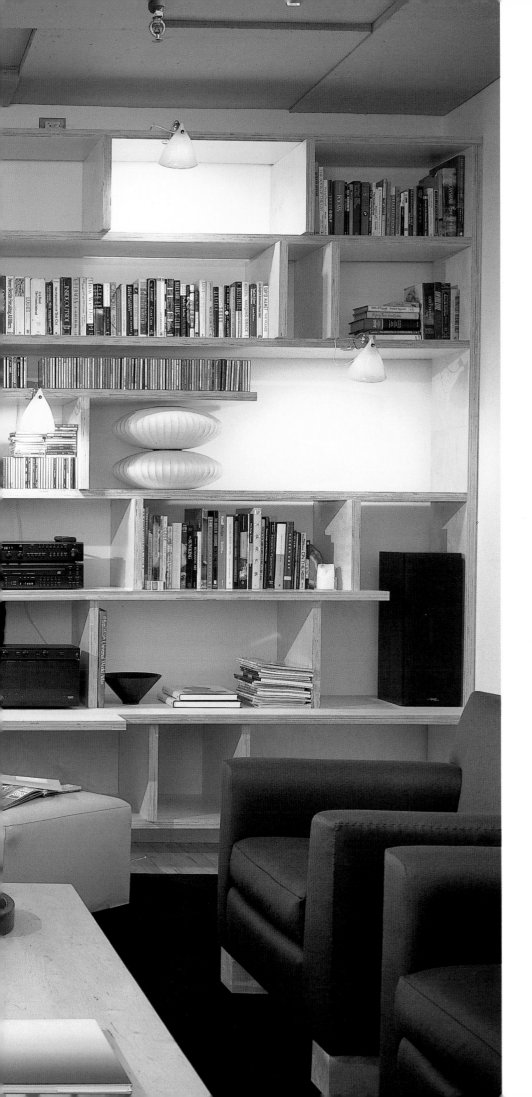

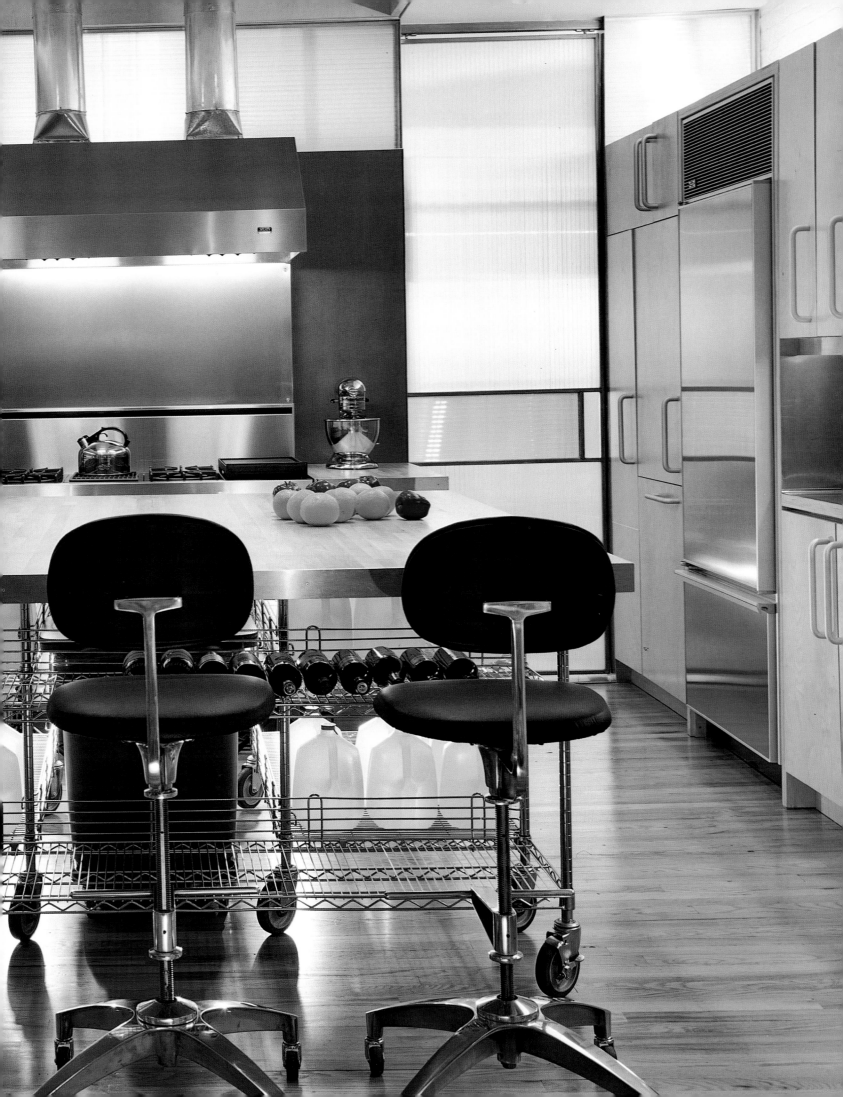

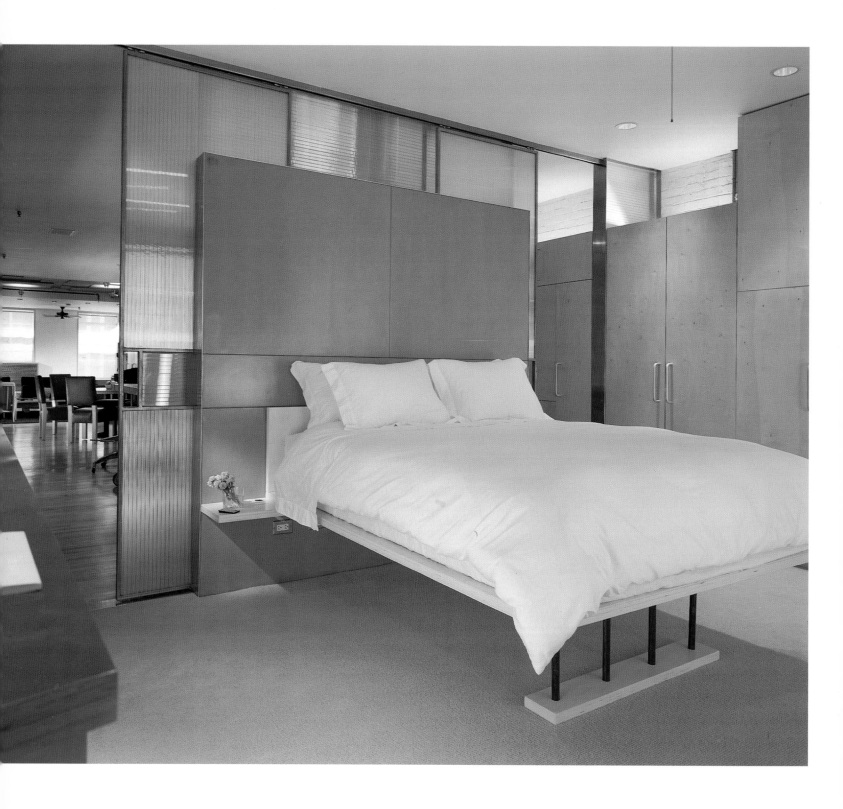

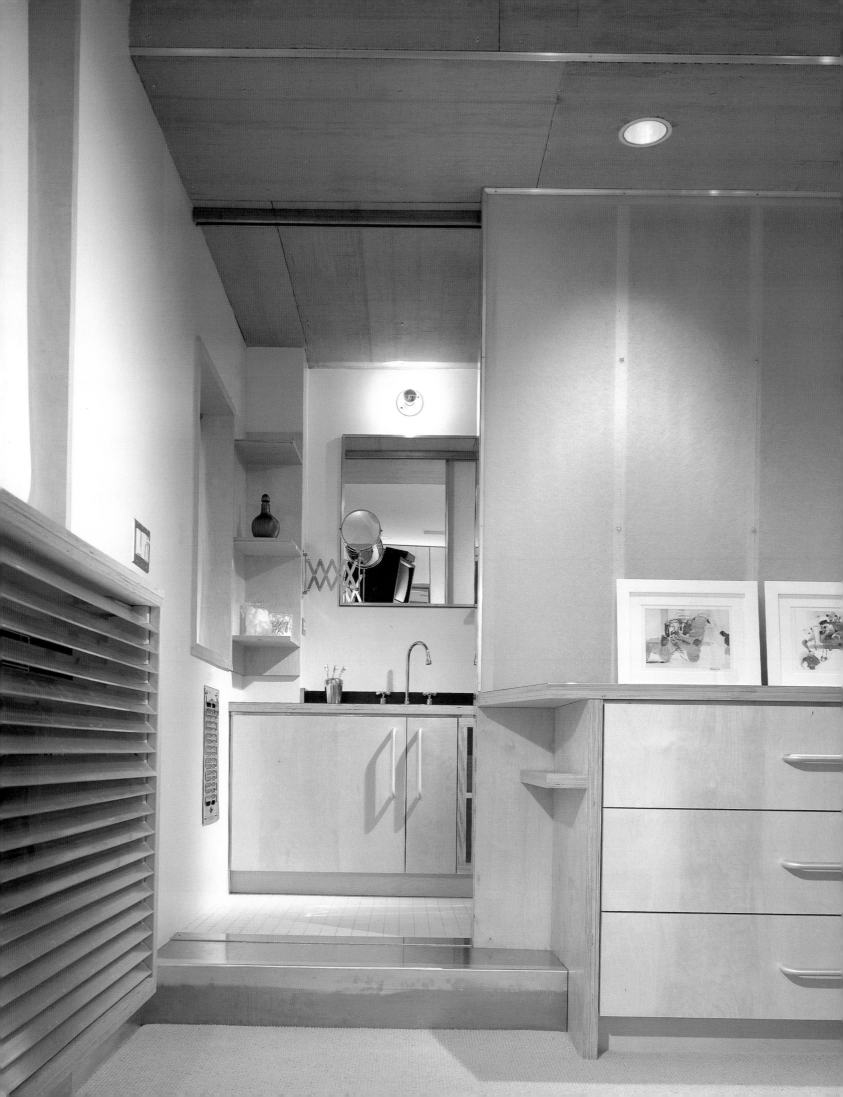

Flatiron Loft, 1997

Architecture Research Office

In creating a loft for two young collectors of contemporary art and eclectic twentieth-century furniture, the design team from Architecture Research Office enjoyed the luxury of copious space and natural light. The 6,200-square-foot loft—encompassing two floors and a double-height corner volume containing a mezzanine library—came with a fine pedigree: Julian Schnabel and Anselm Keifer, both artists who work on a large scale, had at different times utilized the expansive space as a painting studio.

The sheer size of the loft, however, posed as many challenges as possibilities. By necessity, ARO dedicated a large portion of the limited budget to upgrading antiquated mechanical systems in the century-old loft. Economy of means and selective intervention thus became the guiding principles of the project. ARO retained the existing kitchen and bathroom cores. The firm also preserved the original wood-strip flooring, its rough scars and metal patches providing a foil to the refinement and precision of the new construction.

On the upper floor, a central spine of structural columns creates a natural division between open and enclosed areas. The western half of the floor is subdivided into a series of rooms with distinct functions: sleeping, bathing, studying, exercising, and playing. Separating these rooms from the main living area is a system of sliding fabric screens and solid panels that establishes a variable edge with multiple options for controlling view, sound, and movement.

Other program areas are distinguished from the continuous space of the loft by the use of distinctive, highly tactile materials. The dining area is anchored by a floor of leather tiles laid in a complex "isohedral monohedral" pattern that creates an intriguing decorative effect. Further defining the intimate dining zone is a large panel made of beeswax layered on an acrylic base. The panel's luminosity, not unlike that of alabaster, shifts in intensity in response to changes in artificial and natural light over the course of the day. The mezzanine library—essentially an expansive landing in the connecting stair—achieves an independent identity by virtue of its cork floor and its meticulously crafted, blackened-steel bookshelves and balustrades. The lower floor, utilized mainly as a gallery for rotating works of art, was left relatively untouched. The architects' primary gesture there is a series of pivoting doors of translucent water-white glass that separates the gallery space from the guest bedroom and bath.

Marshalling the luxurious influx of natural light from tall windows at both ends of the structure, ARO's layered composition unifies the cavernous loft's diverse spaces, subtly marrying existing and renovated elements. The plan provides seemingly endless possibilities for spatial reconfiguration. Of most importance, perhaps, it creates a gracious, comfortable environment deferential to the aesthetic demands of the myriad artworks and sculptural furniture that inhabit the loft along with the family.

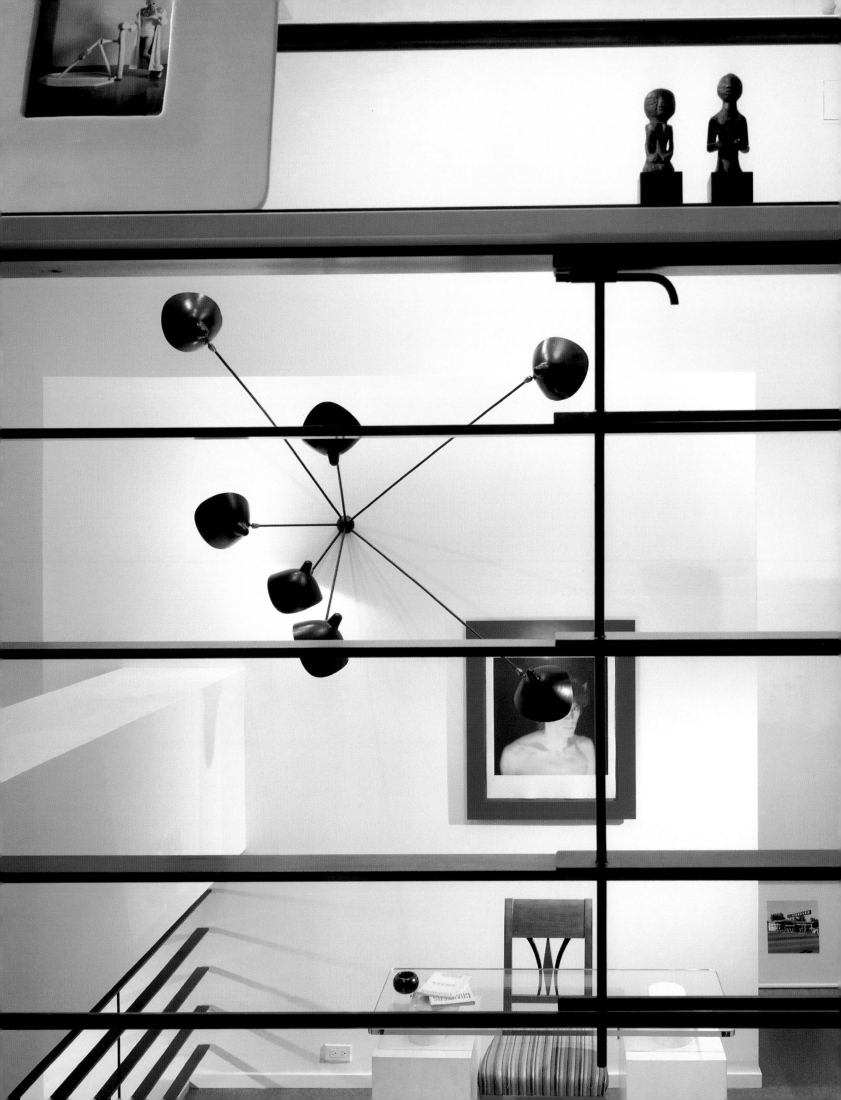

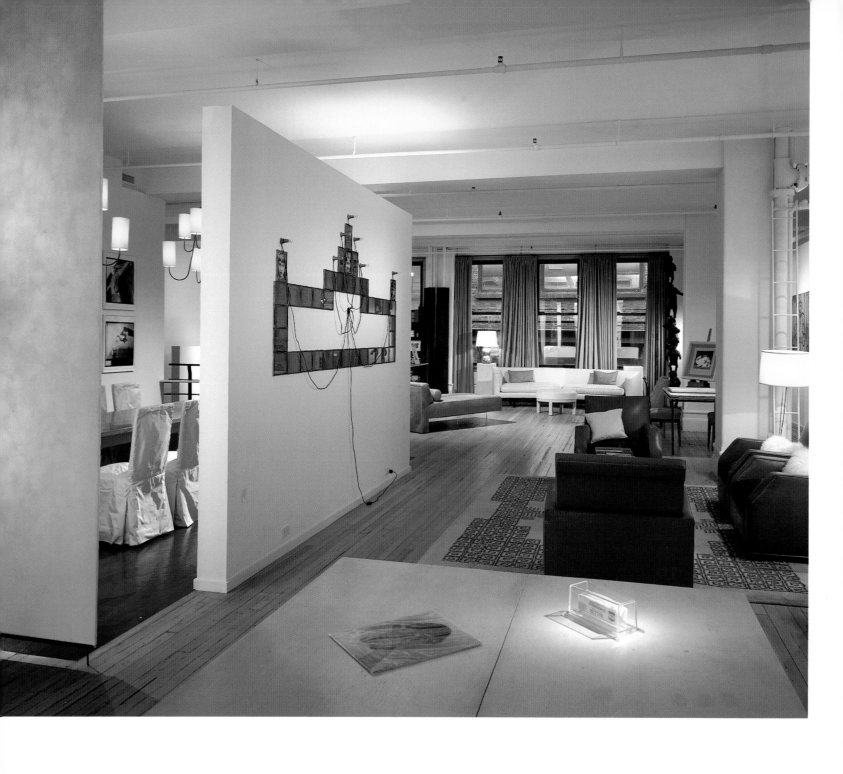

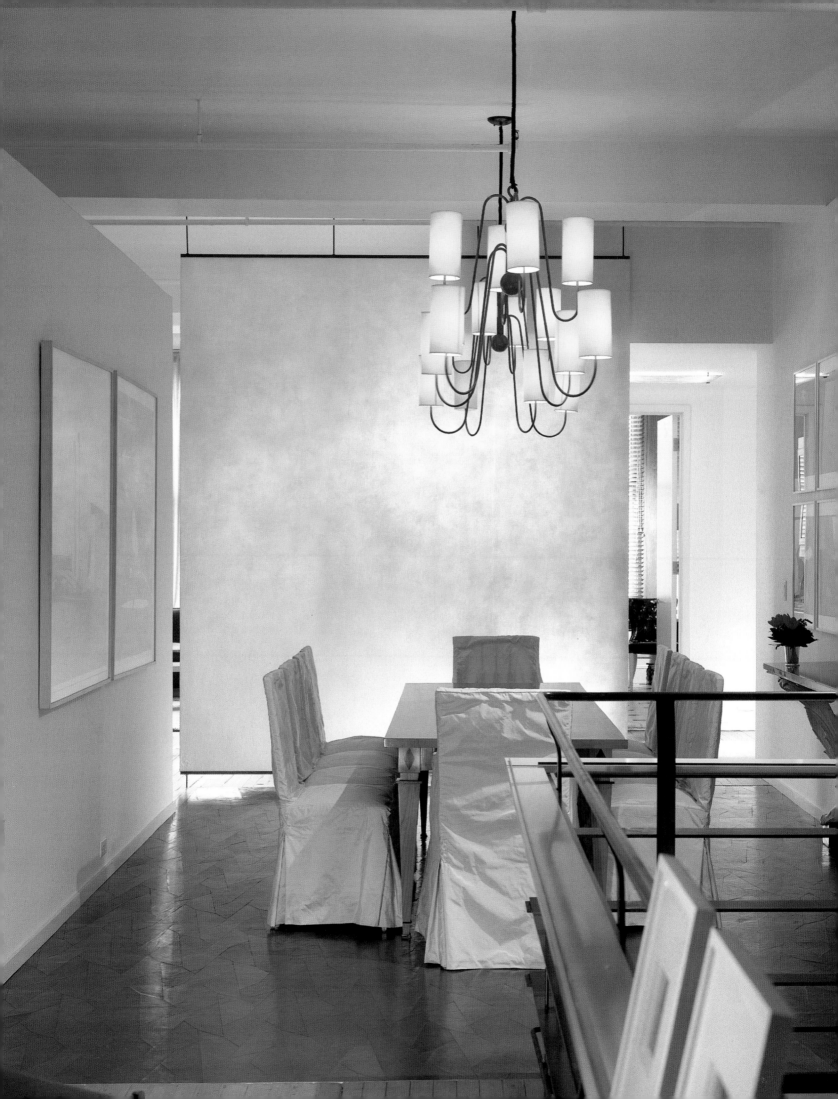

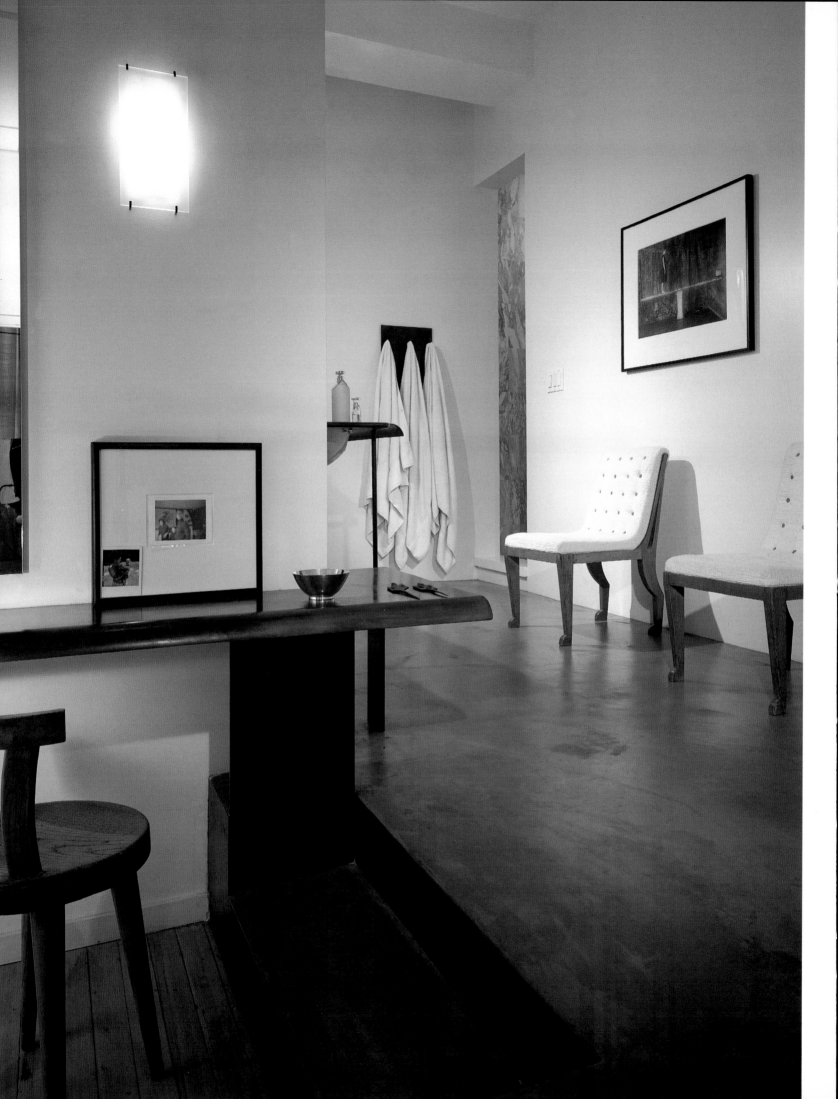

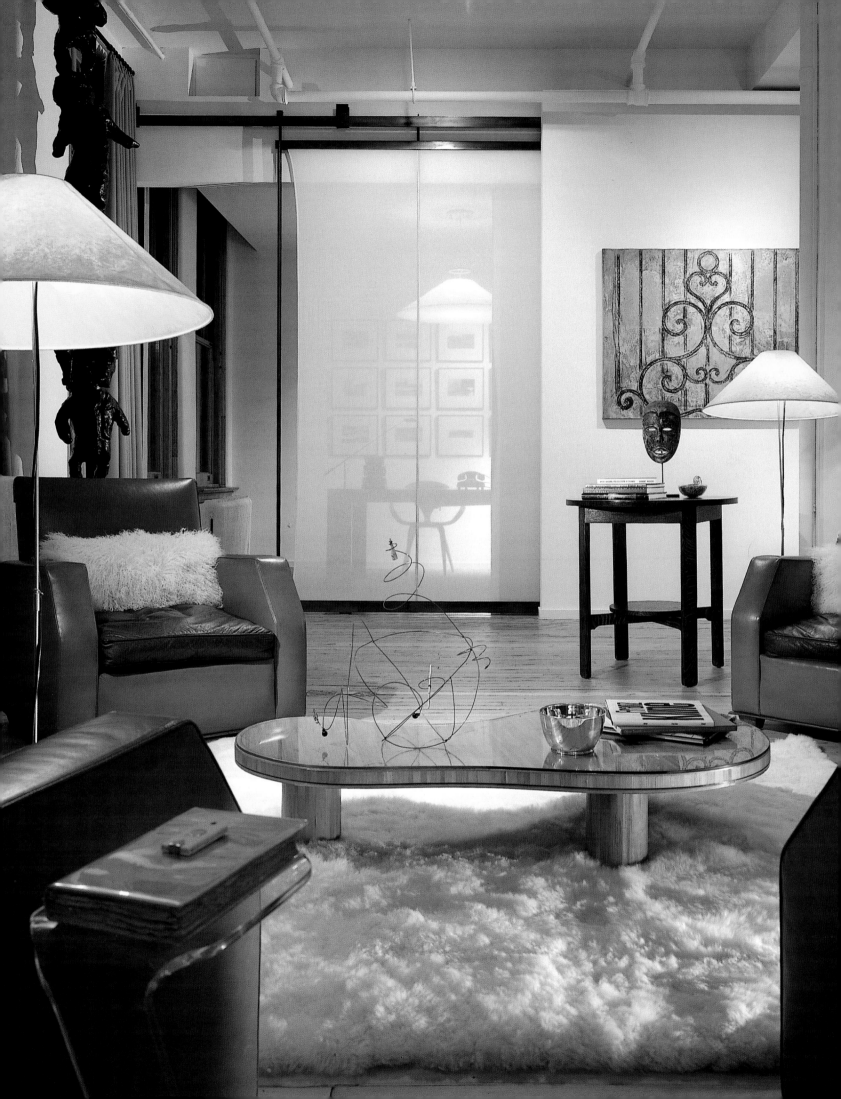

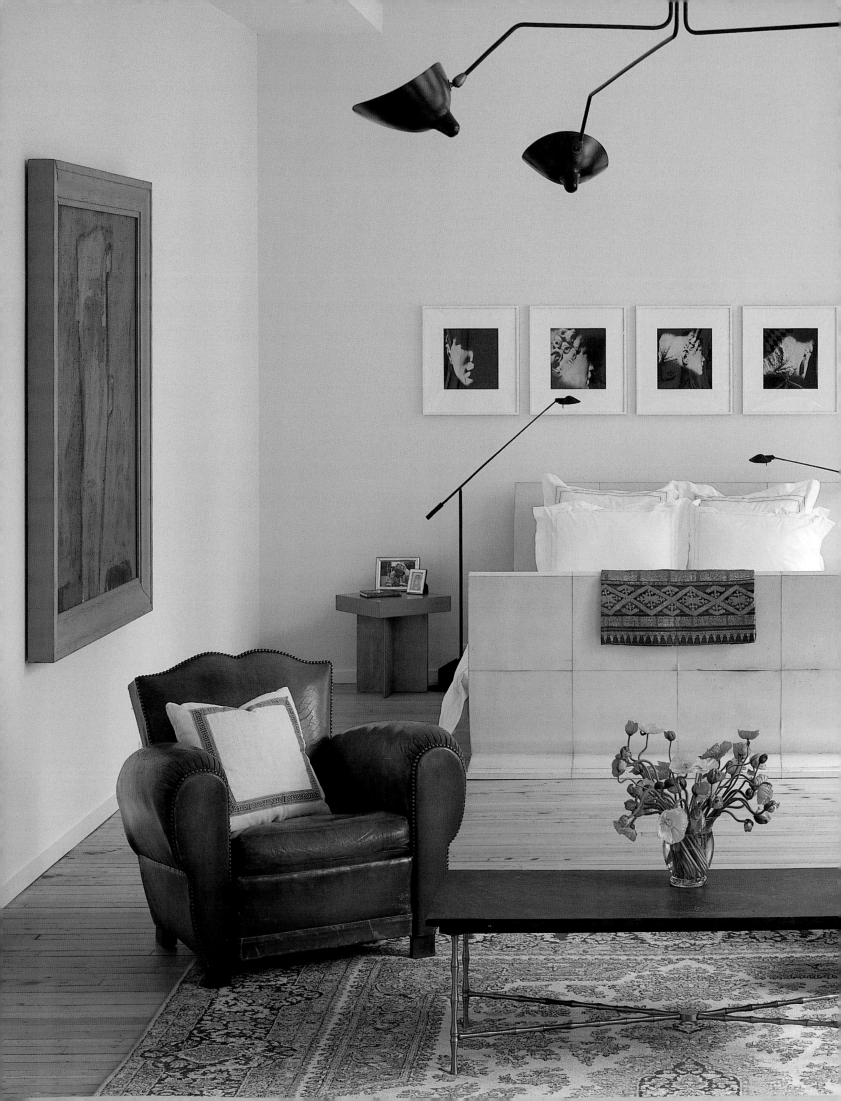

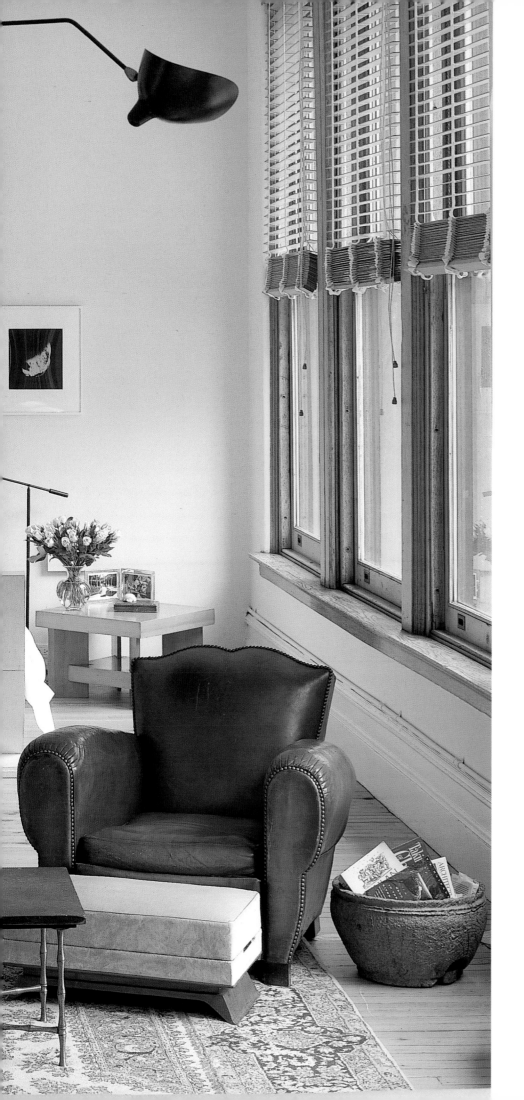

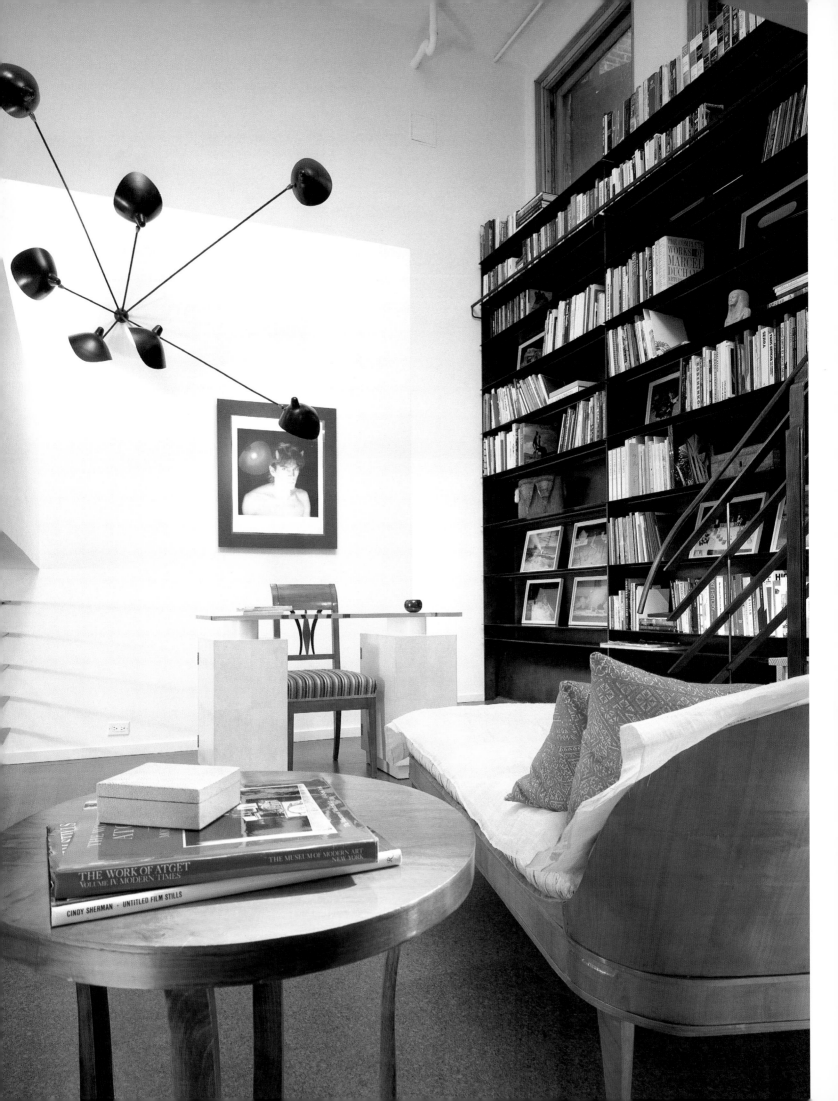

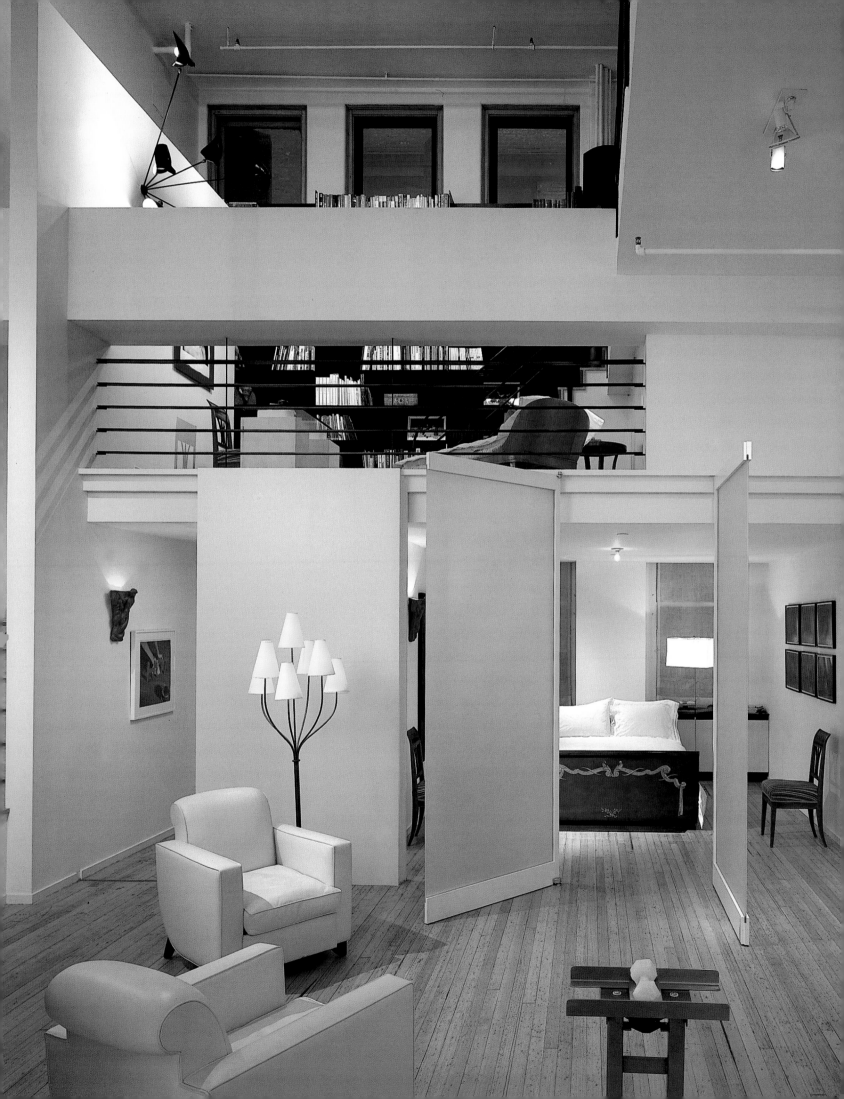

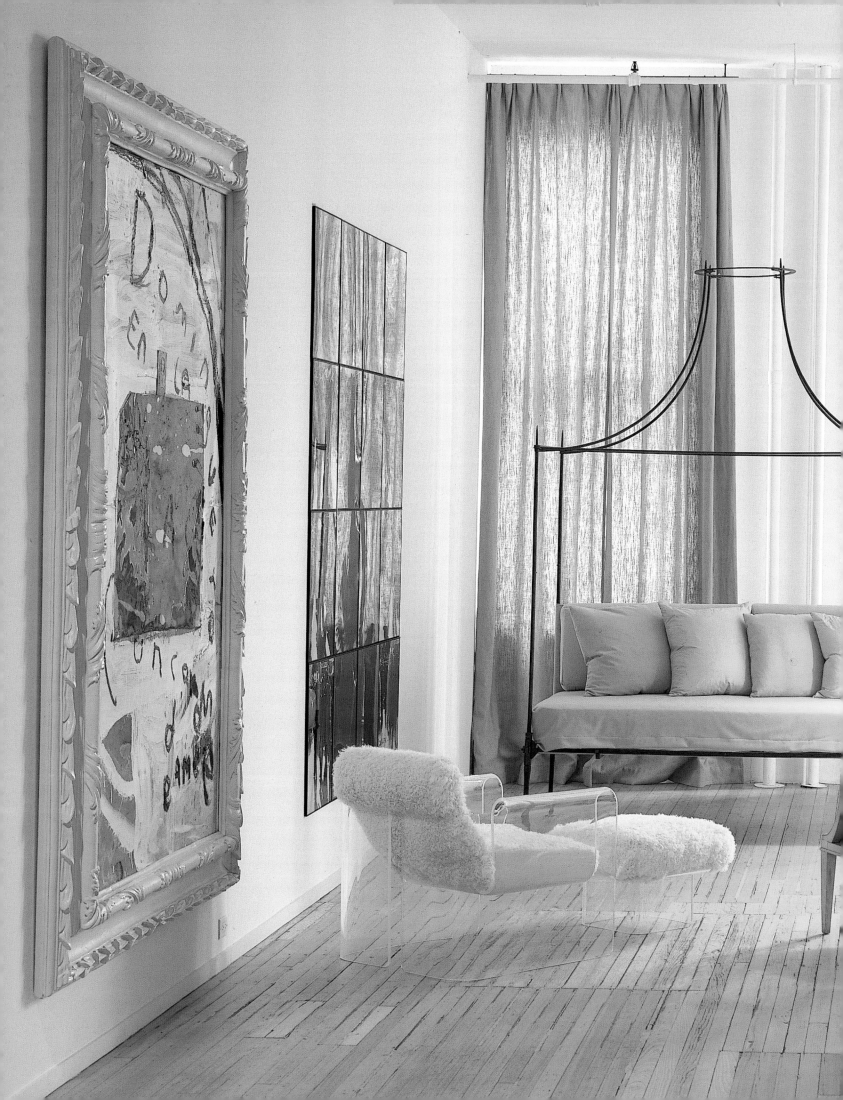

Holley Loft, Greenwich Village, 1995

Hanrahan & Meyers, Architects

The 3,800-square-foot loft designed by Thomas Hanrahan and Victoria Meyers for lawyer Steven Holley has acquired a kind of iconic status since its 1995 construction. Widely covered by the international architecture press, the loft's design responds to the program with exceptional eloquence and clarity. The architects' tightly controlled composition—manifesting a deceptive effortlessness actually achieved through intense analysis of the site and project type—resolves the universal loft dilemma of privacy versus openness with such authority that it suggests approaches and applications in widely varied settings. Think of it as a "case study" loft.

Located on the second floor of a former mercantile building near Union Square, the loft presented a set of conditions antithetical to any desire for a clear sense of expansive space. The former tenant had installed no less than fifteen fully enclosed rooms and numerous platforms, effectively negating the value of the loft's thirteen-foot ceilings and large windows. Total demolition remedied the situation.

Although economic constraints were imposed, Holley offered Hanrahan and Meyers maximum freedom in design, fully supporting the architects' vision of spatial complexity achieved through layered planes and unpretentious forms. New casings of plaster, for example, diminish the visual impact of the central spine of structural columns, entombing their efflorescent Corinthian capitals. A series of fixed and mobile planes defines the mutable boundaries of function areas and modulates the loft's spatial rhythms. A curved cabinet wall enclosing the kitchen relieves the pronounced linearity of the design.

Modest materials were deployed with great subtlety to organize and connect public and private arenas. In certain applications, the materials reinforce intentional spatial ambiguities. Ubiquitous maple plywood panels and cabinetry arise naturally from flooring of the same material. In contrast to the warmth of the wood, cold-rolled steel forms the monolithic elevator enclosure. Other strategically placed planes are composed of steel frames supporting various kinds of glass: transparent, translucent, and opaque. The spare furnishings scheme developed by interior design consultant Tse-Yun Chu echoes the economy and restraint of Hanrahan and Meyers' work.

The net effect of these meticulously orchestrated gestures is one of attenuated elegance without ostentation: a provocative spatial symphony composed without recourse to unnecessary architectural bravado.

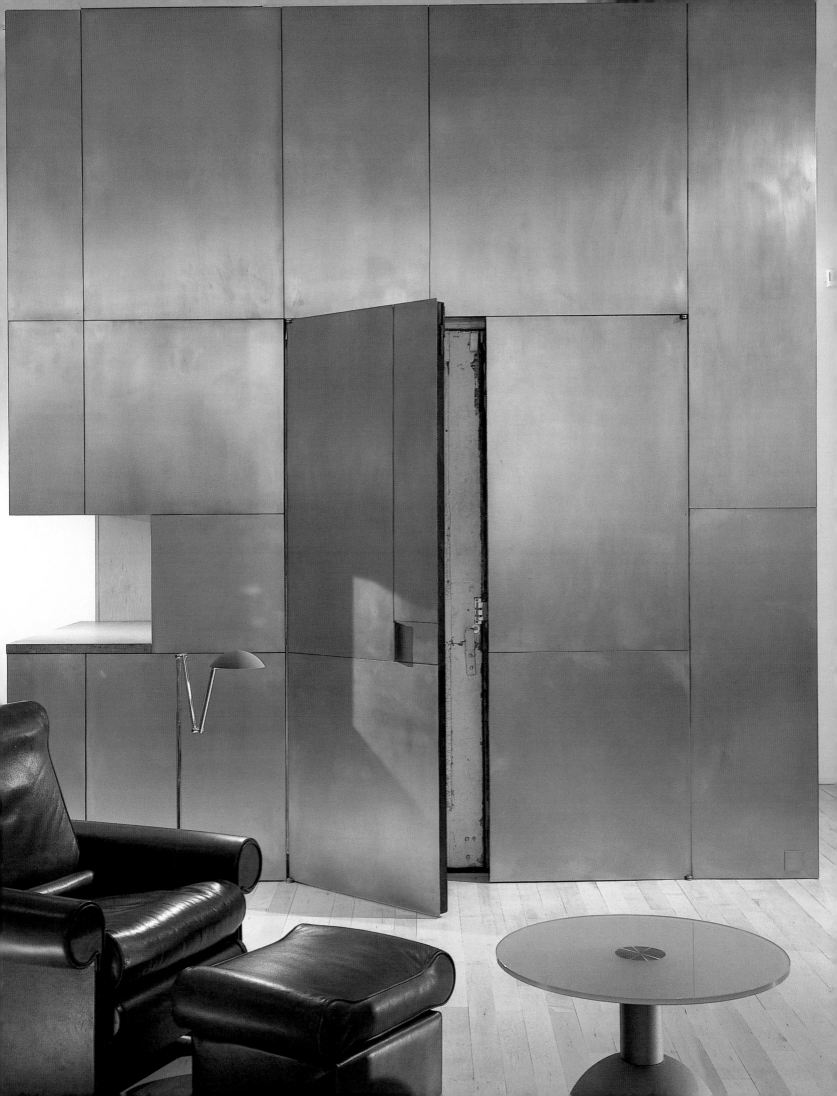

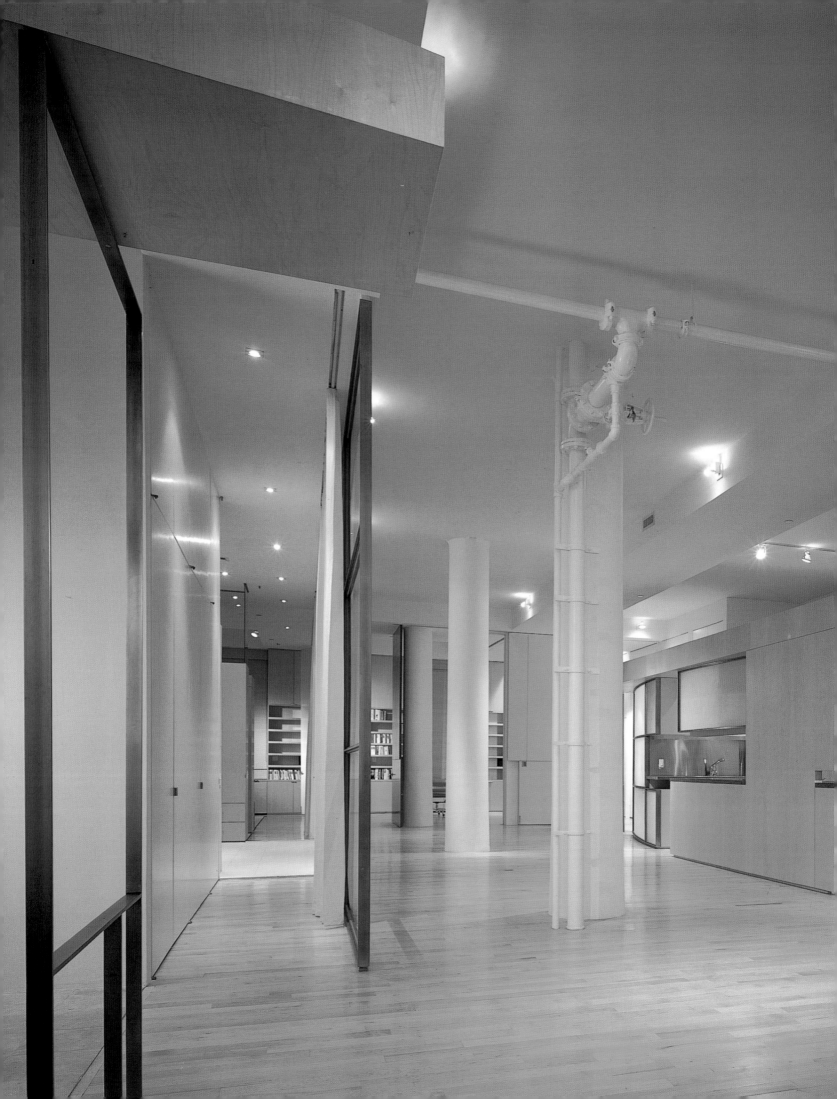

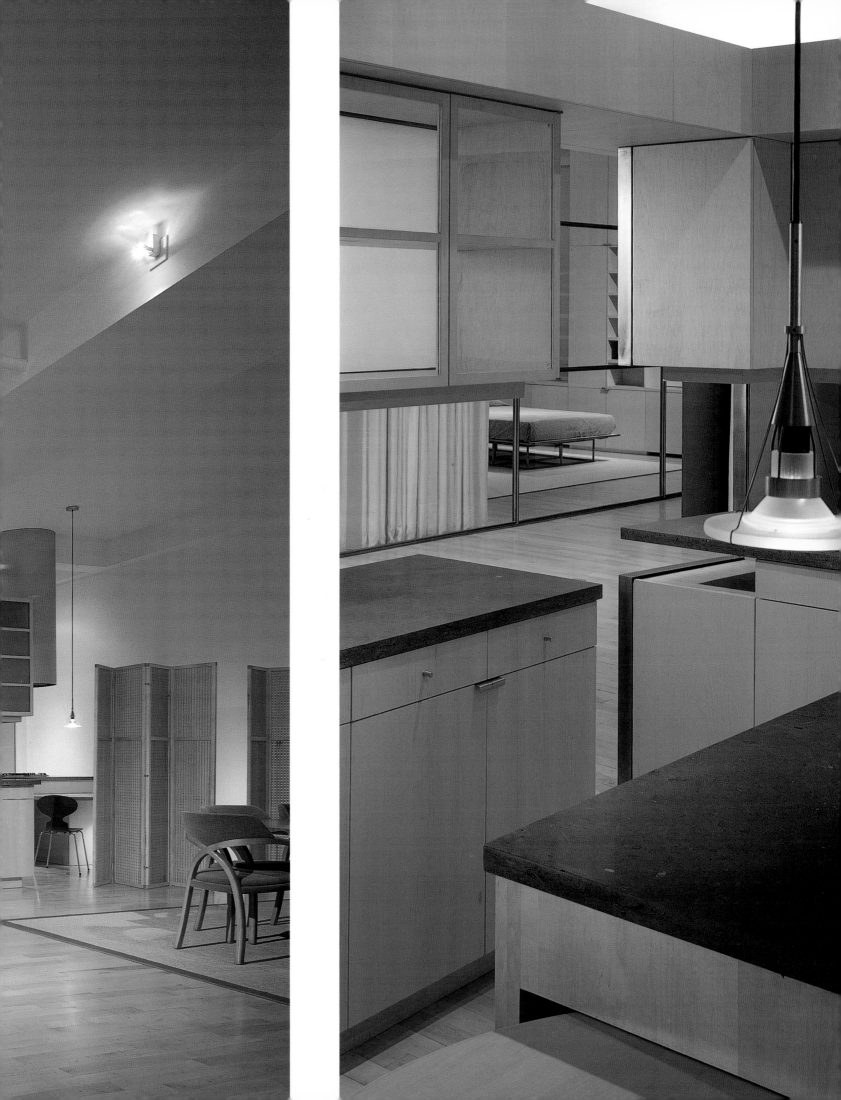

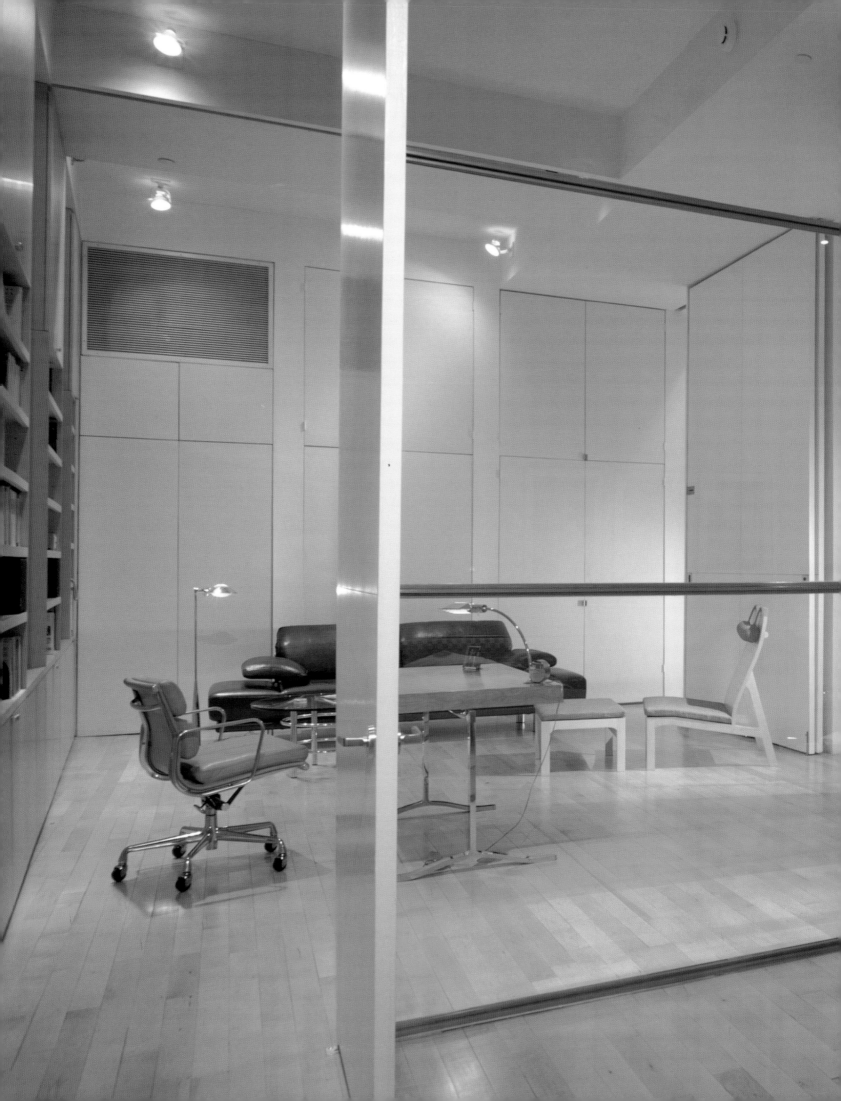

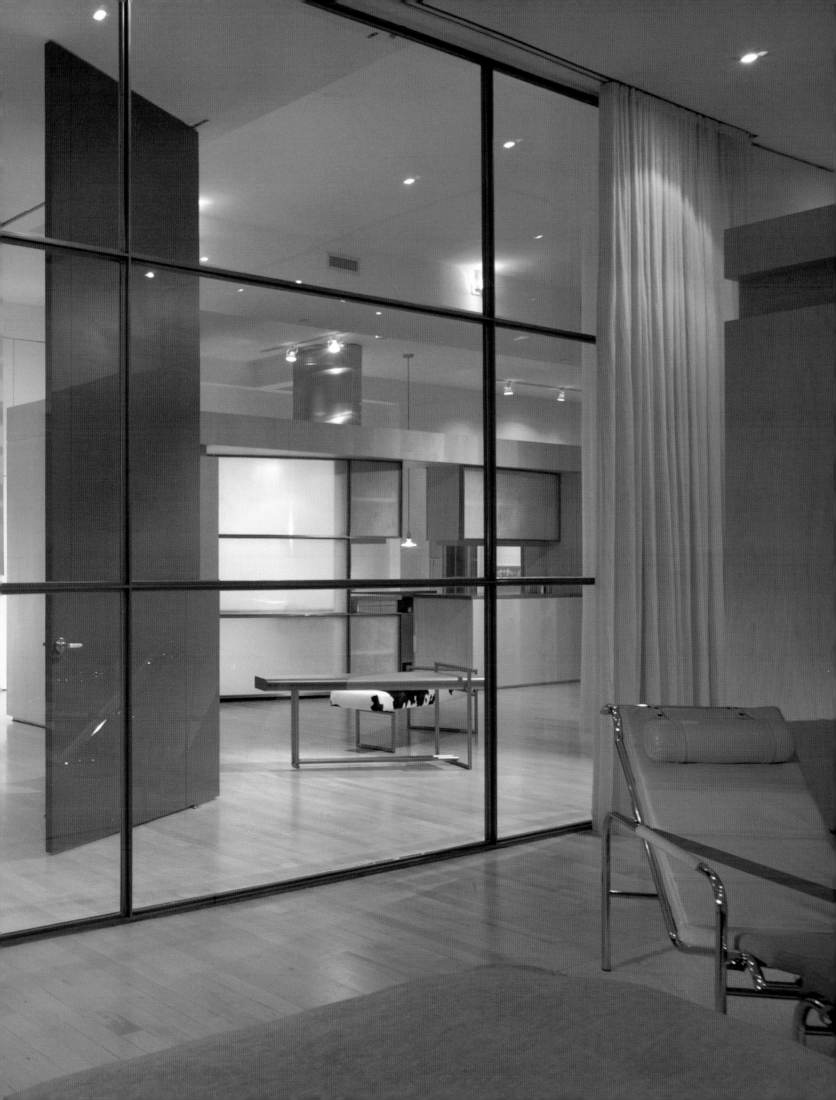

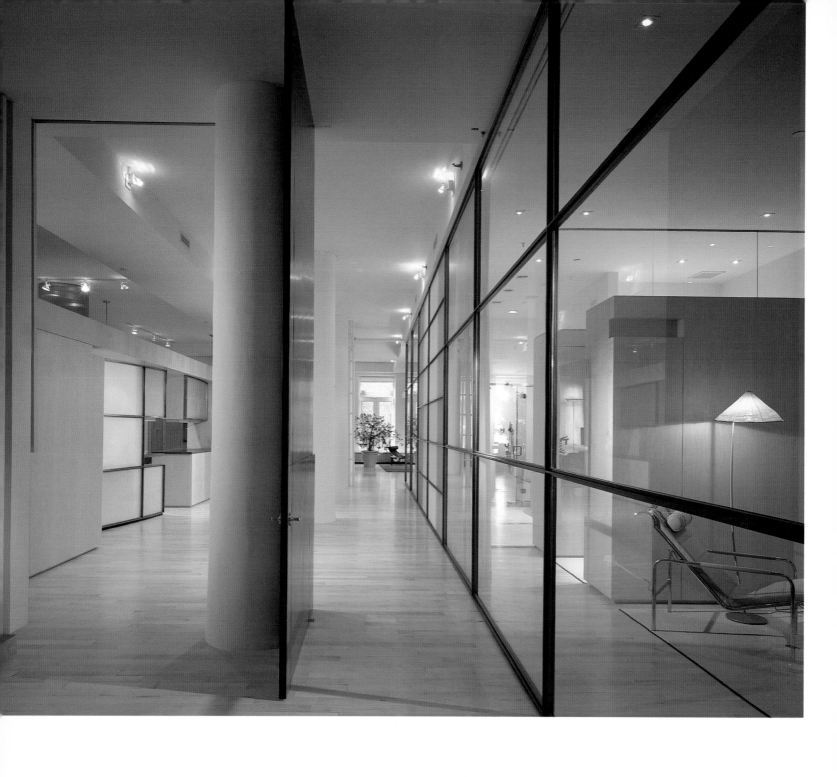

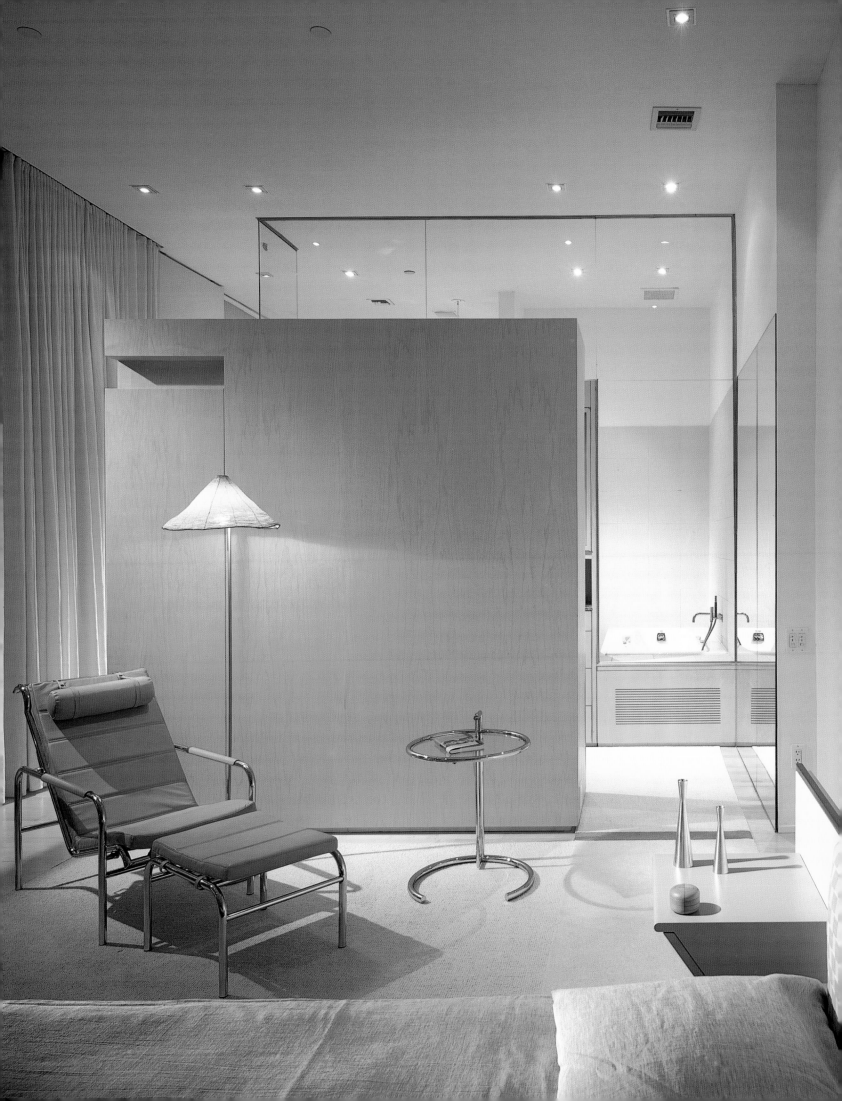

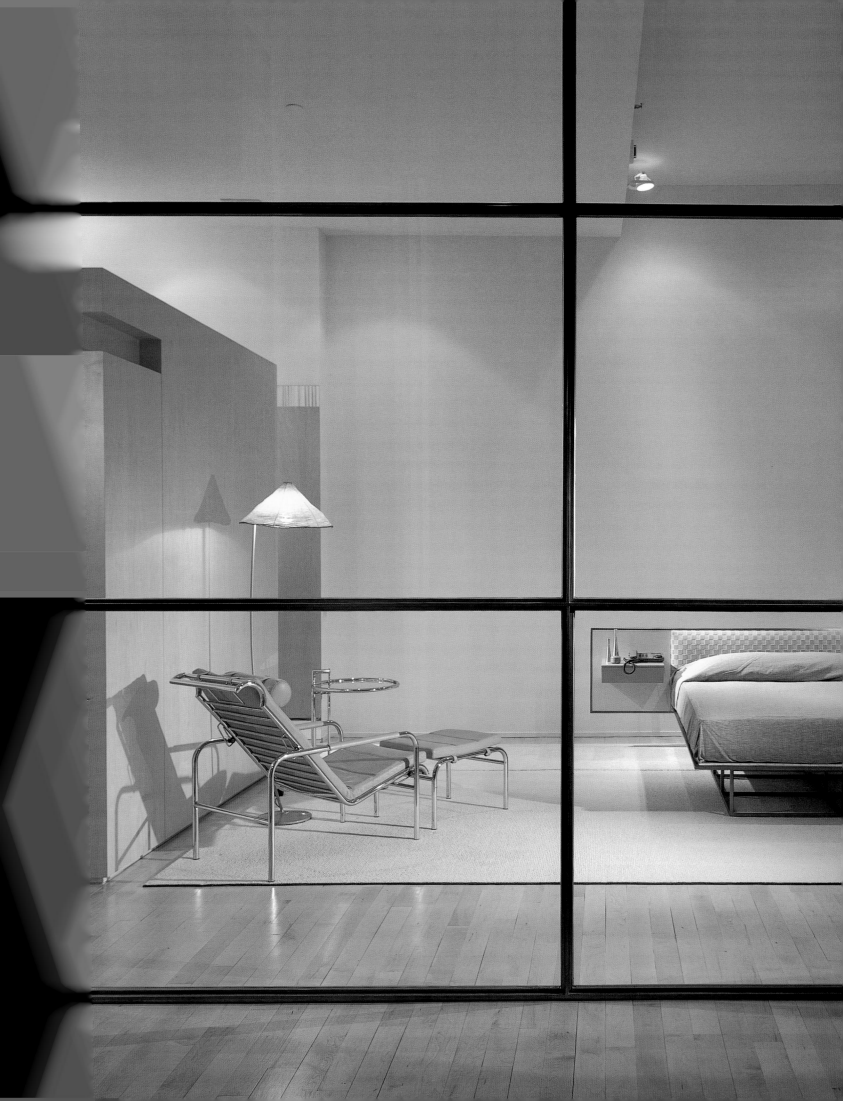

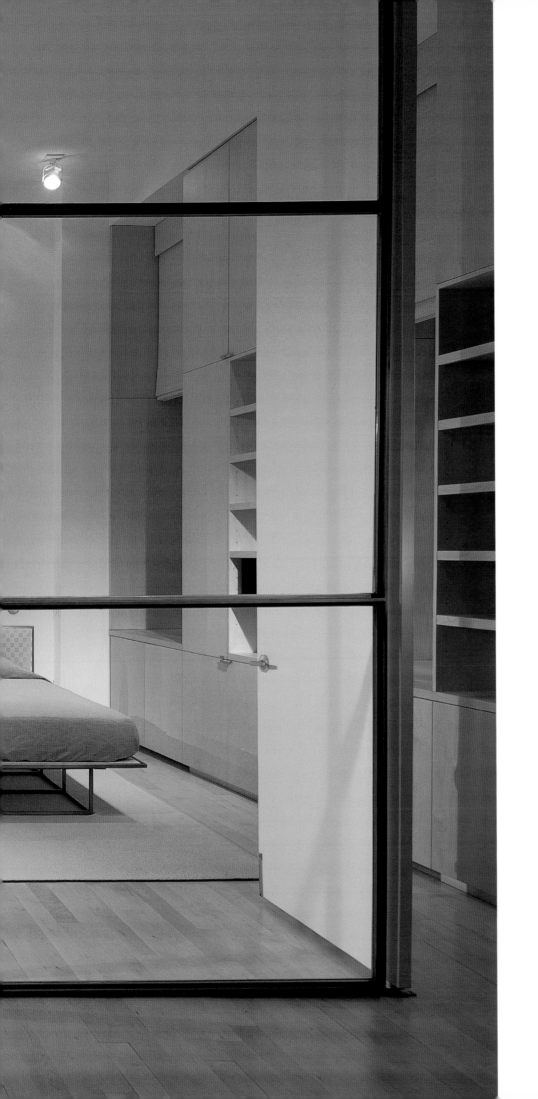

George Ranalli, Architect

George Ranalli describes this 2,100-square-foot loft housed within a hundred-year-old former sewing factory as a "very compelling space of raw brick, hermetic and silent." Indeed, his scheme for the loft responds not only to the specific programmatic requirements of his clients—artists Robert Kirschbaum and Jacque Metheny—but also to the palpable materiality of the existing shell, a highly textured envelope crowned with a vaulted ceiling of exposed brick.

The plan clearly articulates zones, with an open central arena for cooking, dining, entertaining, and lounging flanked by studio/exhibition space at one end of the loft and more private bedroom areas at the other. Ranalli introduced a level change in the bedroom zone to conceal plumbing requirements and establish a more intimately scaled room for the couple's young child. In most areas of the loft, ceilings reach eleven feet two inches to the underside of the steel beams, with an additional six inches gained in the shallow vaults.

Deferring to the strong architectural shell, Ranalli and project architect John Butterworth conceived the loft as a tightly knit composition of volumes and planes that sits within the space. The architect's studied imbrication of materials and forms emphasizes important spatial relationships, underscoring the alternately porous and solid layers that together establish the loft's rhythm. Humble materials such as drywall and plywood are ennobled in Ranalli's intricate design. He celebrates joints and connections—between materials and volumes, between new and old—with inviting details both functional and decorative. Plywood sheets that protect the corners of drywall construction, for example, are cut into stepped patterns that subtly echo the loft's geometries and the irregular silhouette of the urban skyline. In the master bathroom, Surell solid surfacing material is treated in the same fashion, applied to address functional requirements and to maintain the design vocabulary established in the more public spaces. Voids and linear incisions in the plywood and Surell elements add yet another layer of complexity and interest to the composition.

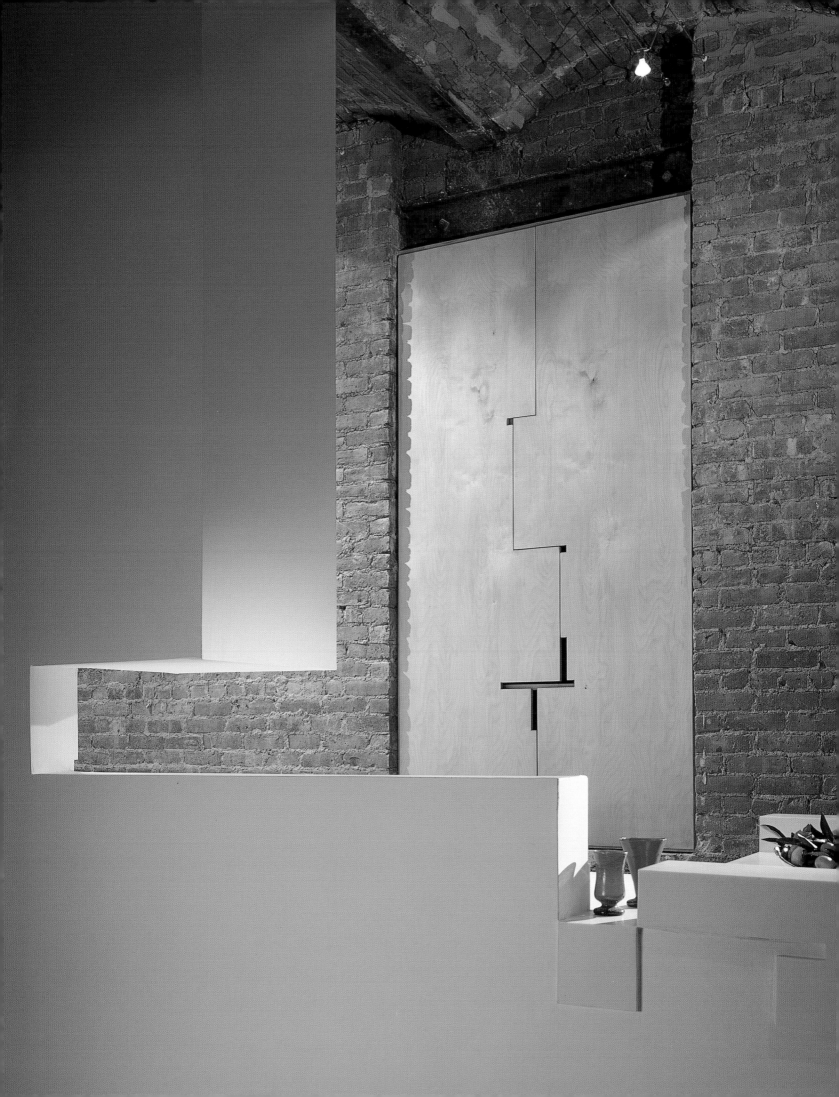

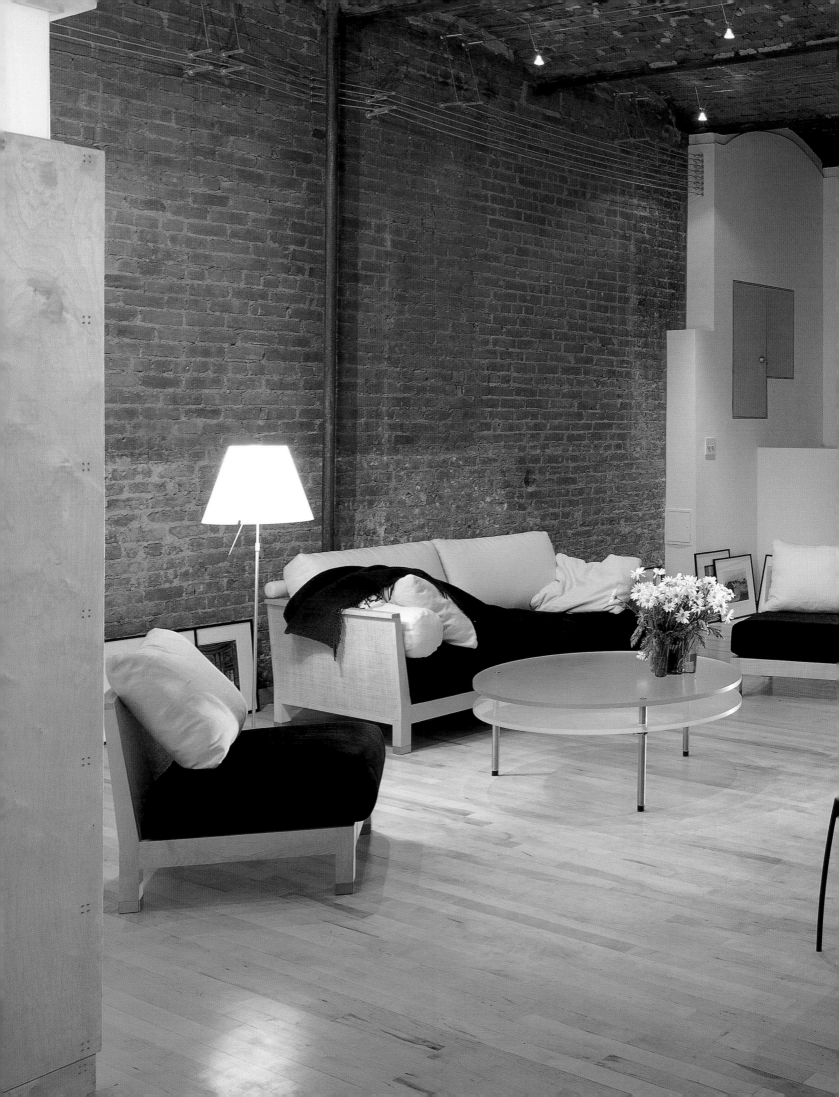

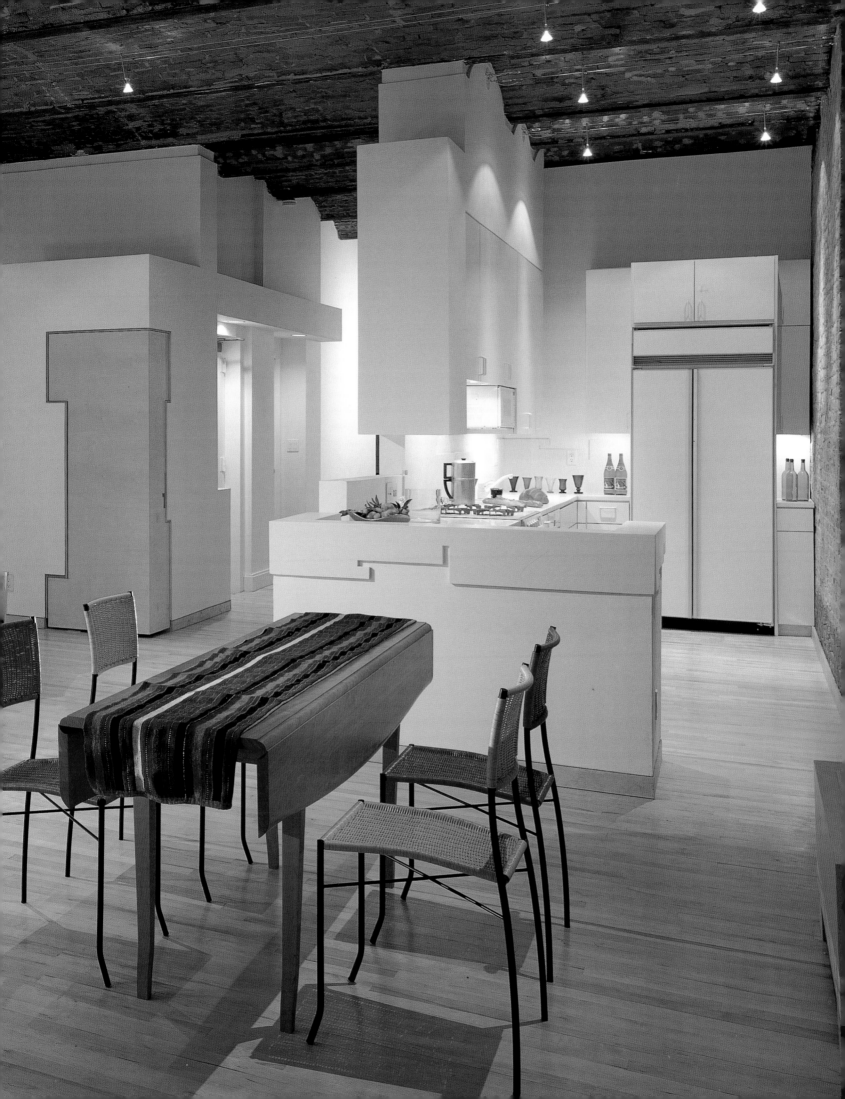

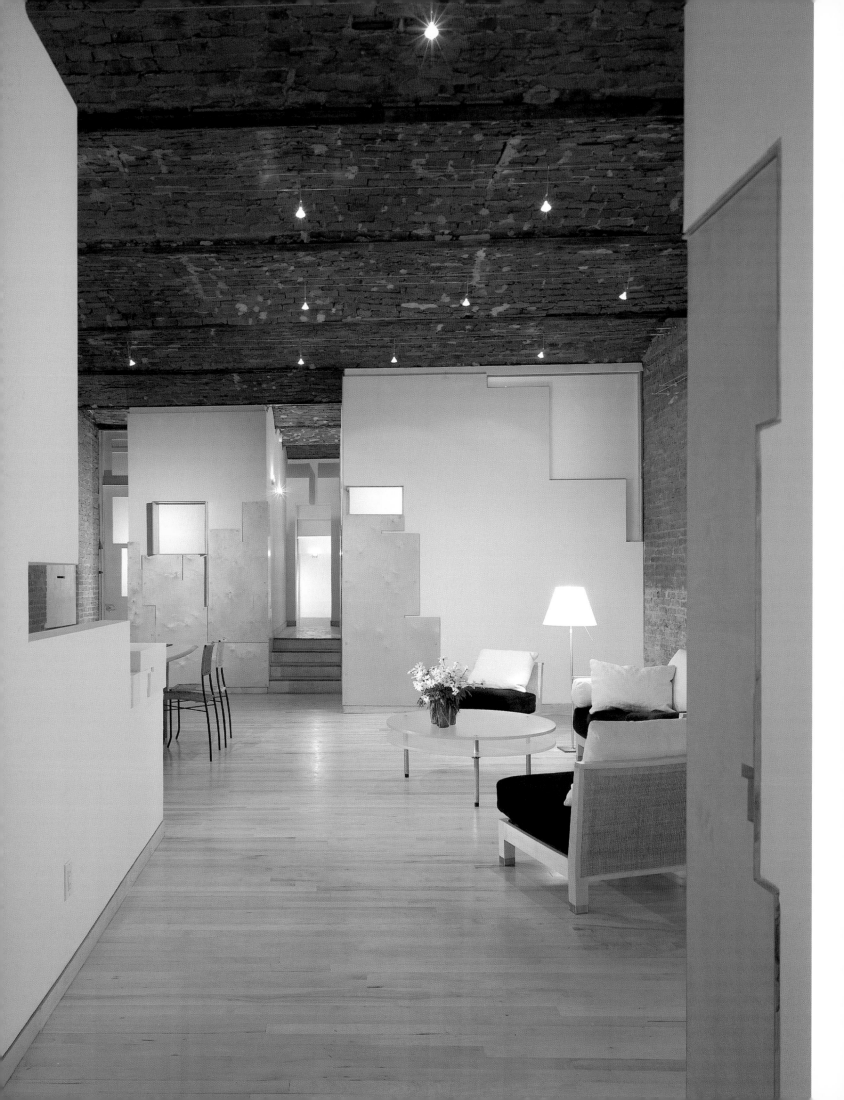

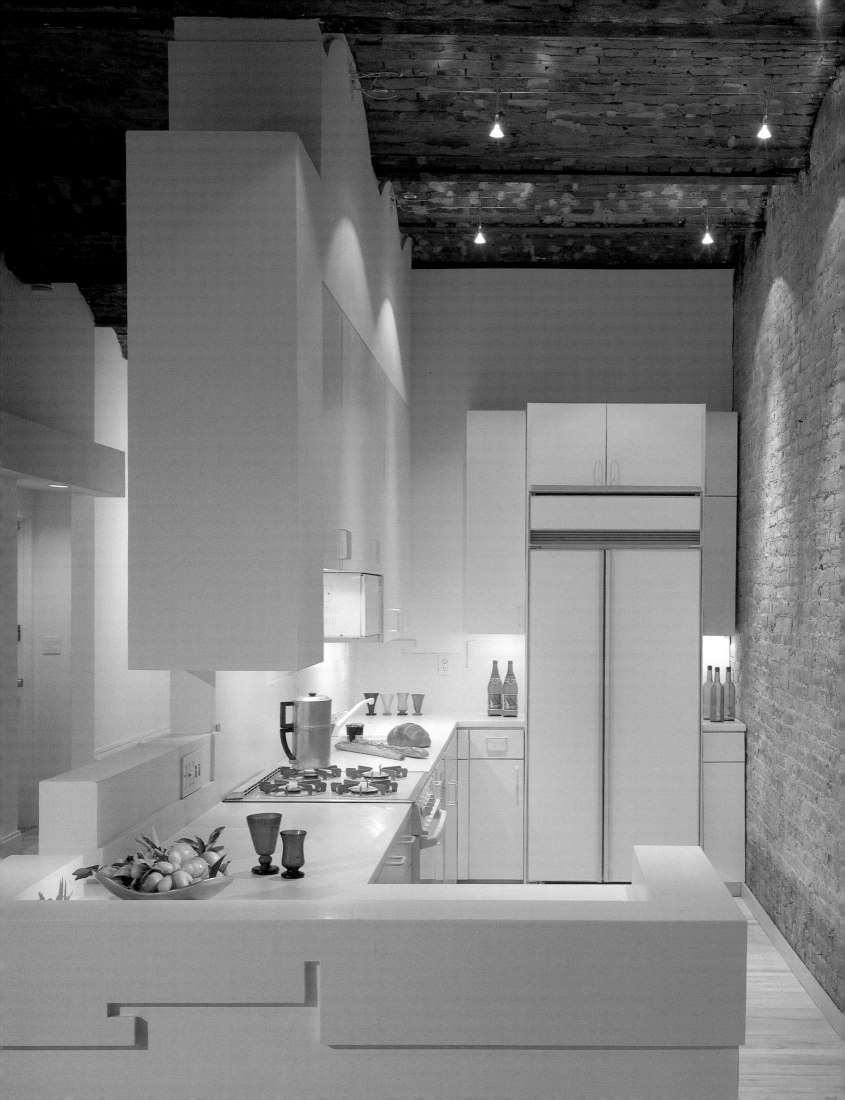

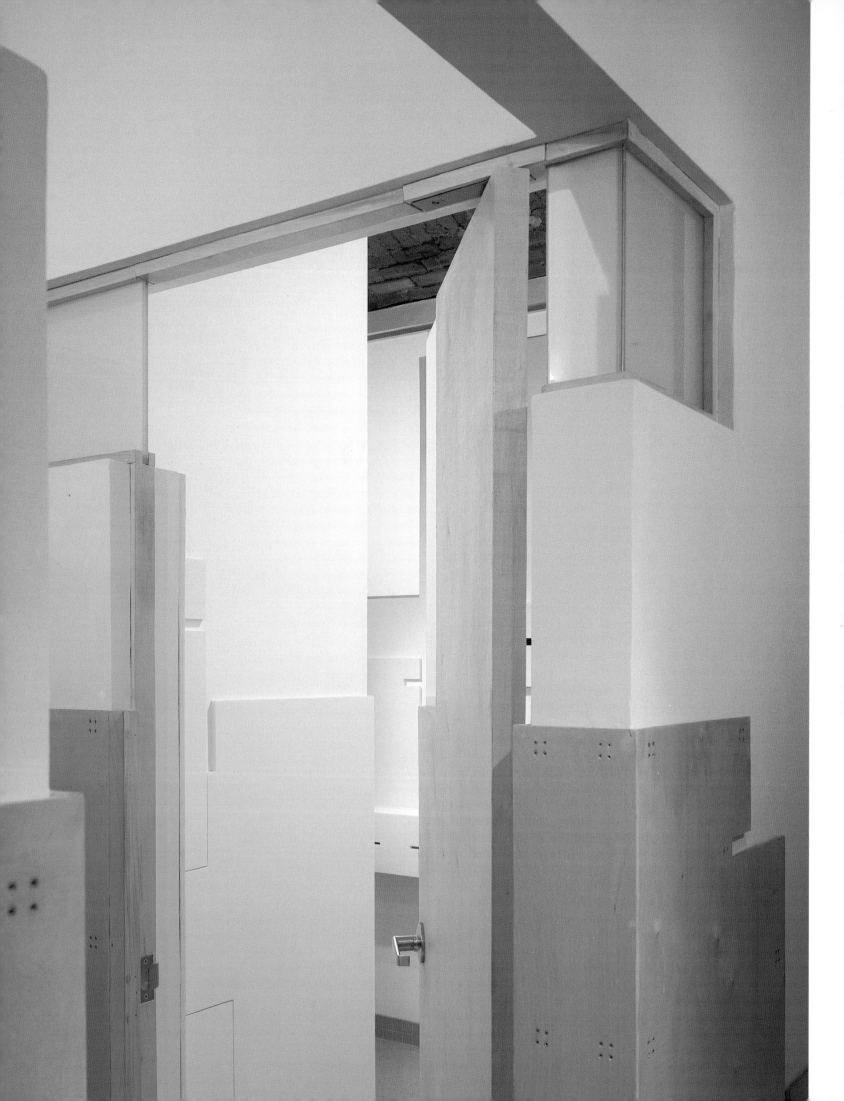

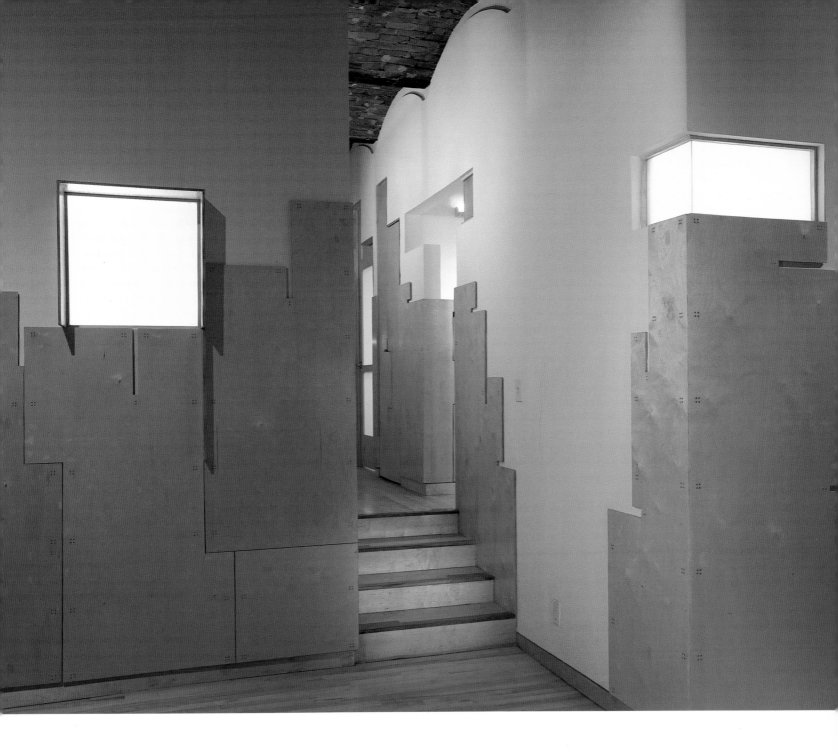

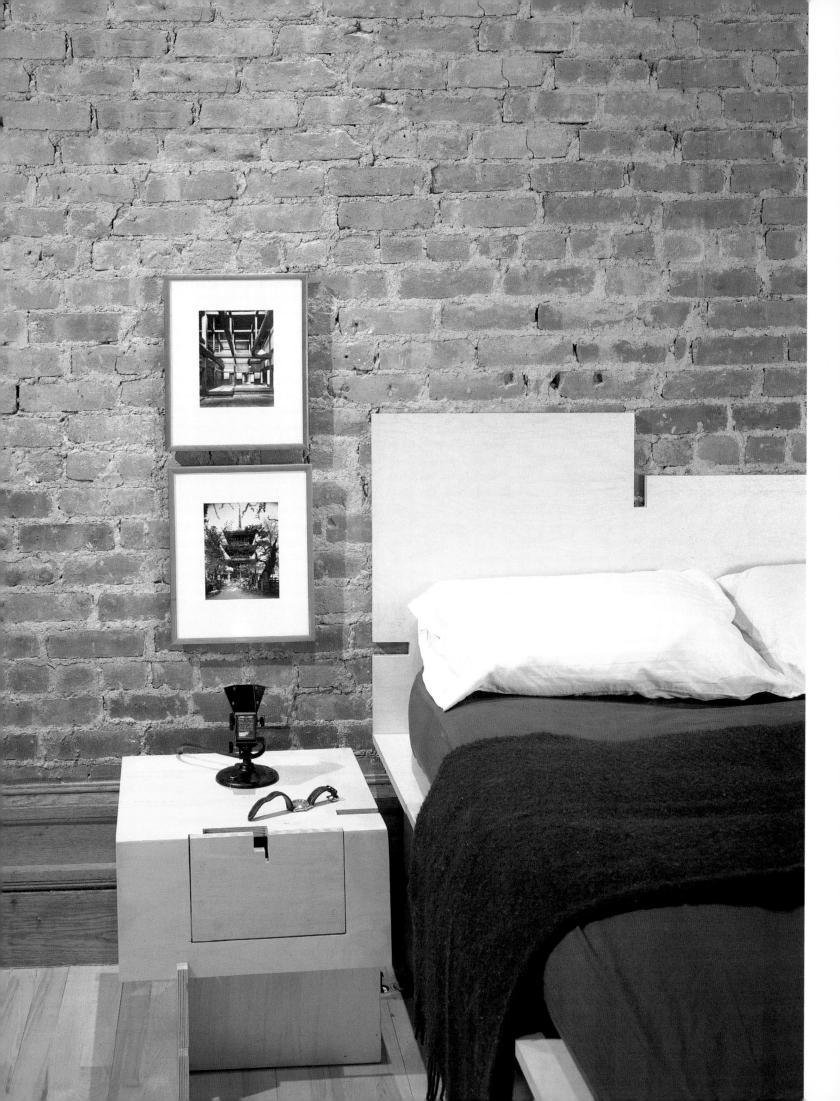

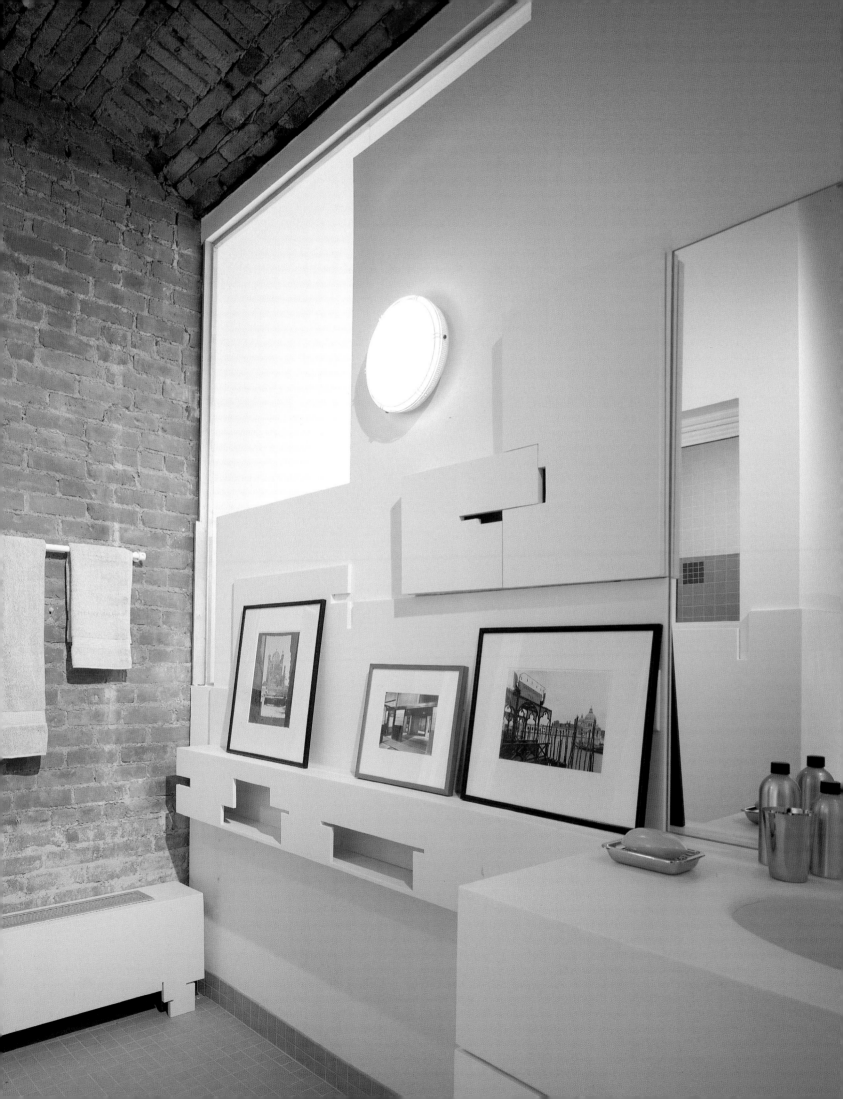

Zoran Loft, Greenwich Village, 1994

Zoran

The downtown loft of fashion designer Zoran perfectly echoes the couturier's attitude toward his clothing: all extraneous details are banished; ideas are distilled to their purest form. Zoran's highly personal brand of minimalism celebrates design as a process of subtraction in which refinement follows from obsessive reduction. In Zoran's approach (and, indeed, in his appearance), the quest for essentials takes on a marked spiritual aspect.

Trained as an architect in Europe, Zoran reinvented his 3,000-square-foot loft as a pristine environment of dazzling white emptiness. The typical characteristics of the existing space—exposed brick walls, wood beams, and a wood floor—held no appeal for the designer, who envisioned something decidedly "more clinical," in his words. With the help of consulting architects Peter Moore and Peter Pennoyer, Zoran rid the loft of all inherited partitions, opting instead to suggest spatial definition with two sets of shallow stairs: one leads up to the primary living platform; the other descends to the sleeping area, an ascetic parcel furnished only with a futon. In the main arena, two lone panels of translucent acrylic marginally enclose a freestanding shower. There is no kitchen.

The materials and methods of Zoran's madness are quite simple. Newly plastered walls are covered in glossy white paint. White epoxy floors amplify the luminous shell, creating reflections upon reflections. Large windows along the loft's perimeter open the space to the kinetic play of lights in the chaotic urban landscape that unfolds beyond the walls of Zoran's white paradise. In the end, the aggressive, studied minimalism of this enterprise manifests a certain kind of nontraditional extravagance: call it decadent monasticism.

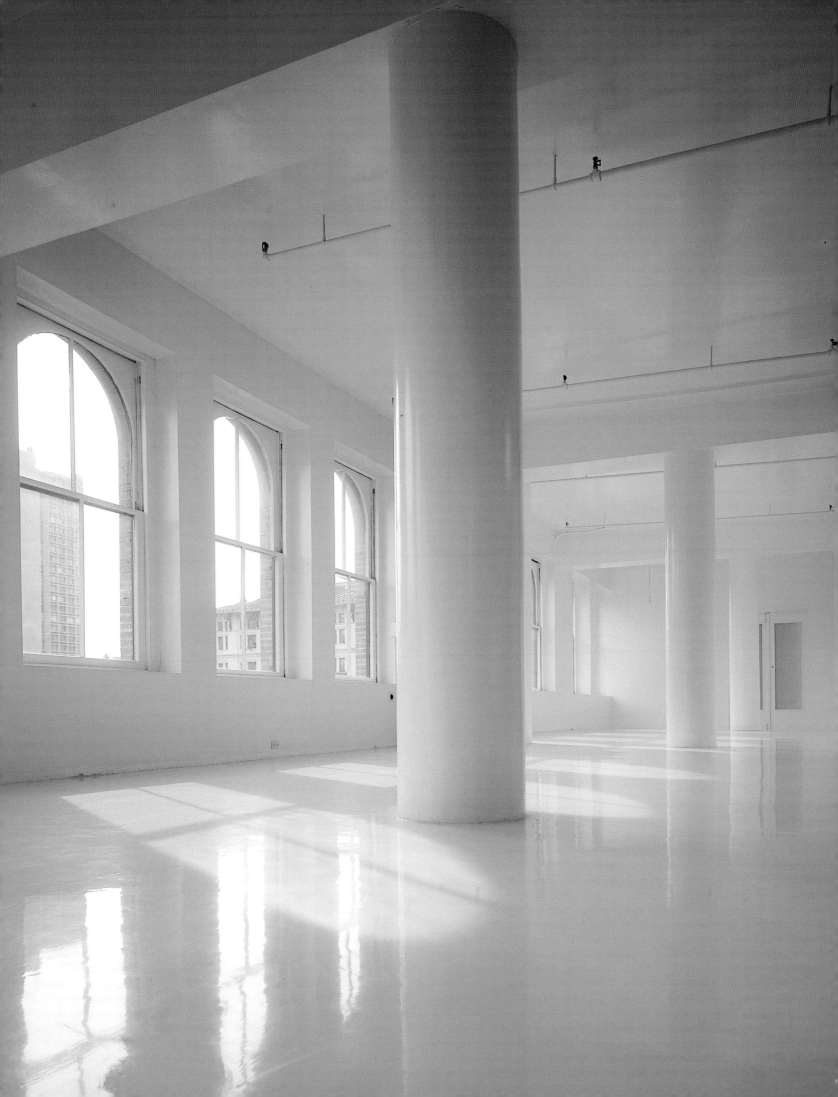

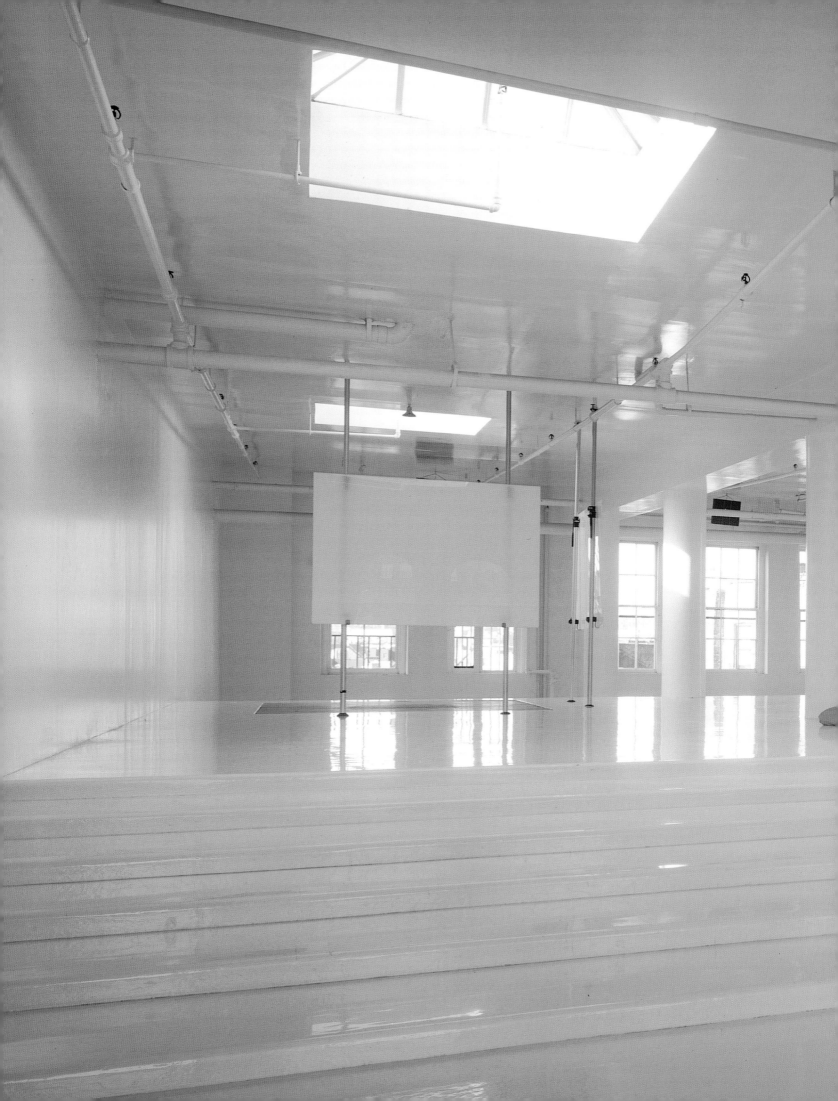

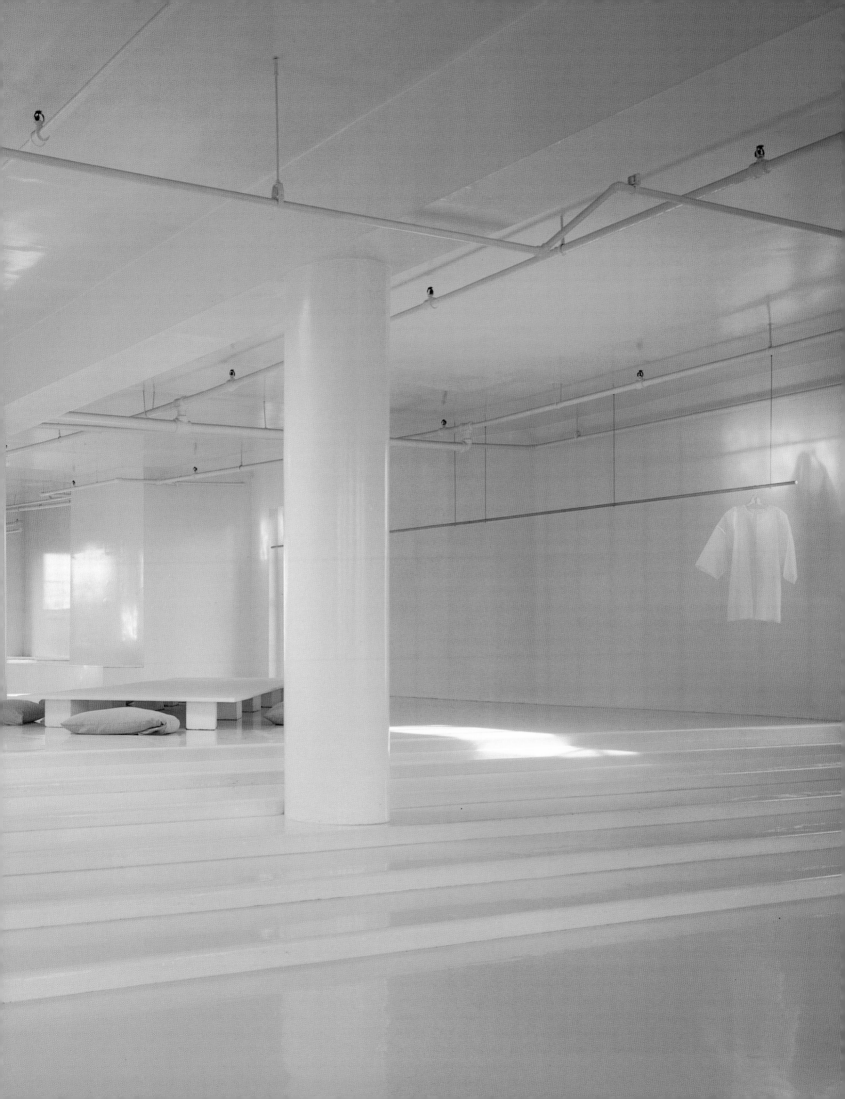

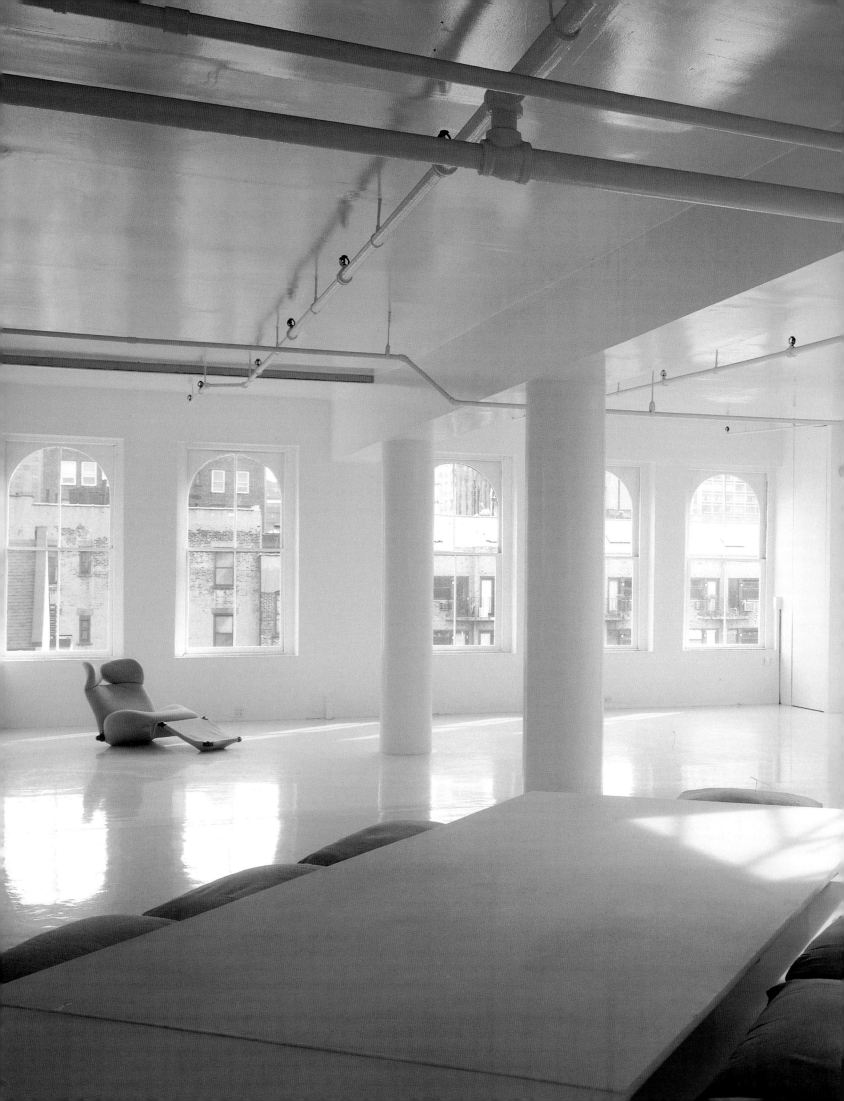

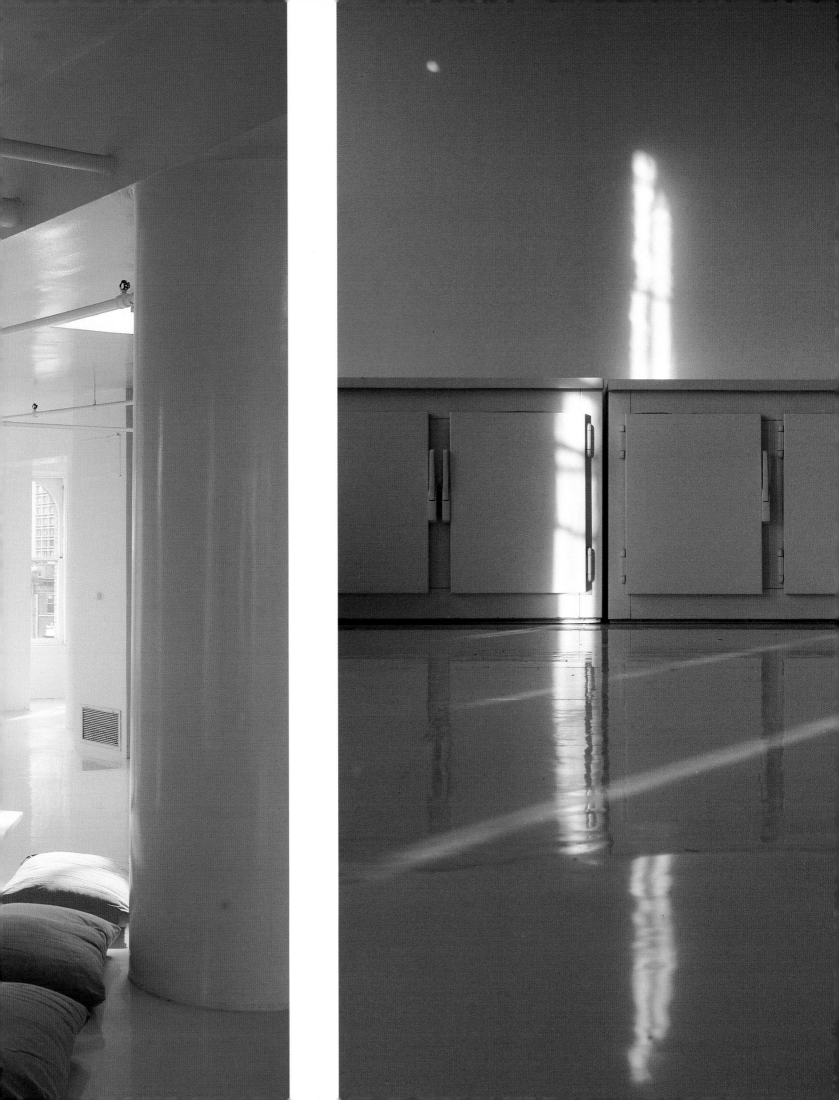

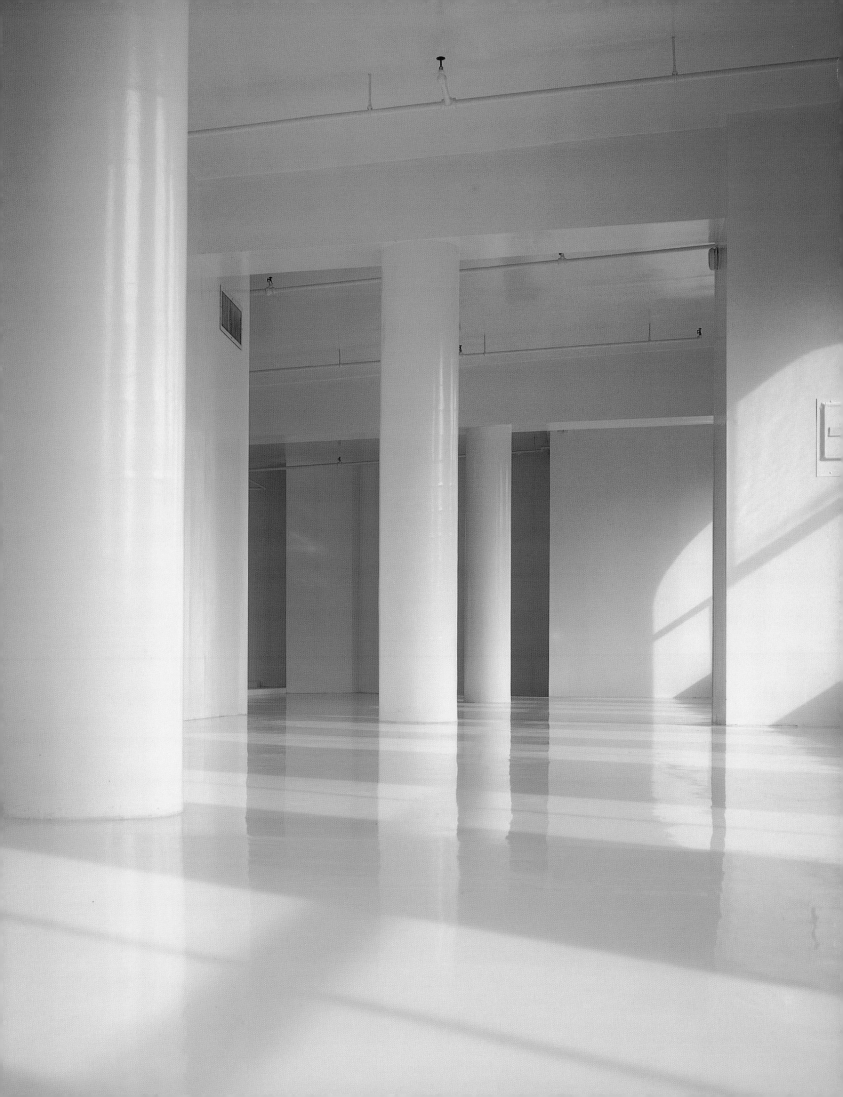

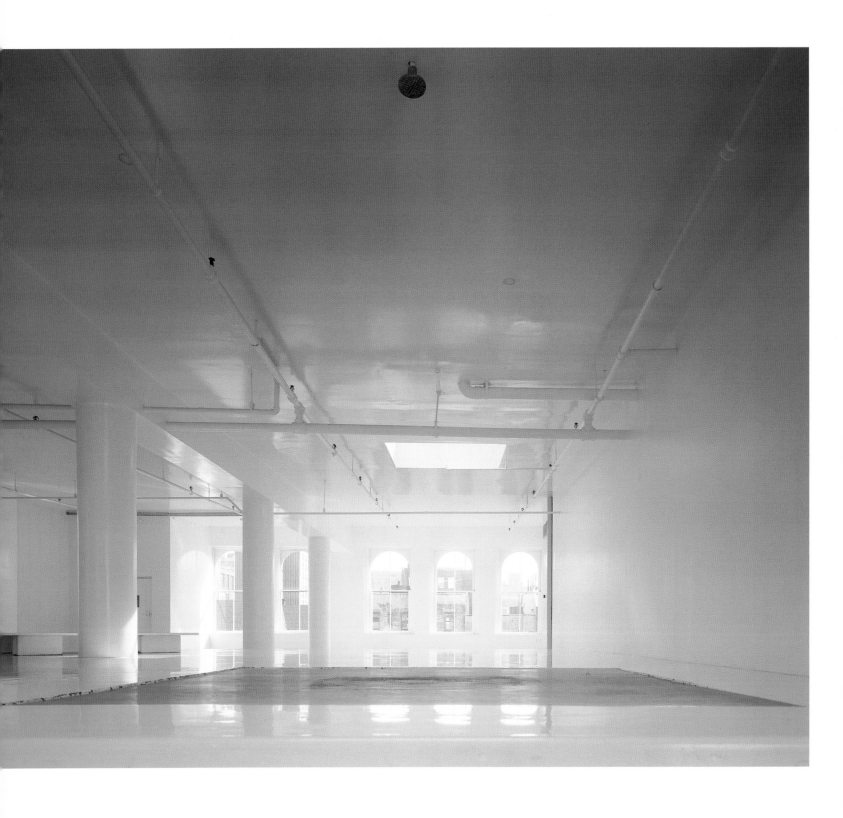

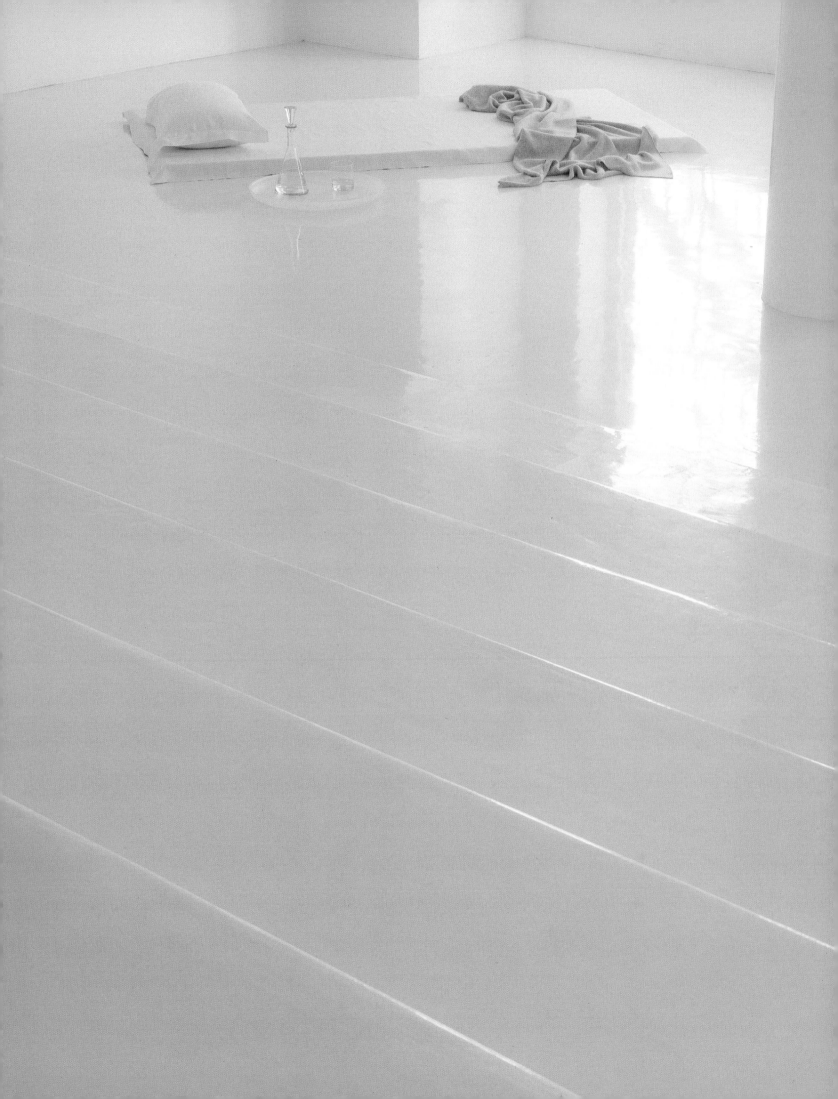

Dan Miller Loft, Soho, 1992

Studio Sofield

A "developer special" is how William Sofield describes the original speculative renovation of graphic designer Dan Miller's live/work loft. The 2,000-square-foot space had been divided into a maze of fully enclosed rooms, most with no access to natural light, all unsympathetic to the base building design and the industrial flavor still prevalent in this stretch of Soho. Beyond developing a scheme more responsive to the loft's urban context, Sofield's challenge involved the total reconfiguration of the plan to integrate working and living functions without unnecessarily blurring distinctions between public and private spaces. Specifically, the office was meant to feel like an office, not a makeshift work space inserted uncomfortably into a domestic setting.

After tearing out the existing warren of rooms, Sofield implemented a plan using mobile panels, screens, cabinetry, and various framing devices to distinguish zones without rudely compromising the flow of space. Three pairs of doors and openings that separate the living room and office from the more private areas beyond duplicate in scale the windows arrayed along the facing wall. Panels of translucent glass framed in teak close off the kitchen and bedroom as needed while still allowing the passage of light and views from space to space. Mesh screens constructed of stainless steel and copper, purchased locally from industrial supply shops, are used extensively to conceal radiators, appliances, and storage.

Exposed brick walls display painterly traces of earlier fire stairs and mechanical systems long since removed. Sofield also retained two original Corinthian columns, uncommonly elegant examples of the decorative aspects of Soho's cast-iron architecture. Miller's collection of vintage midcentury office furniture and his attraction to the crisp, functional aesthetics of industrial design formed the basis of the furnishing scheme and custom detailing.

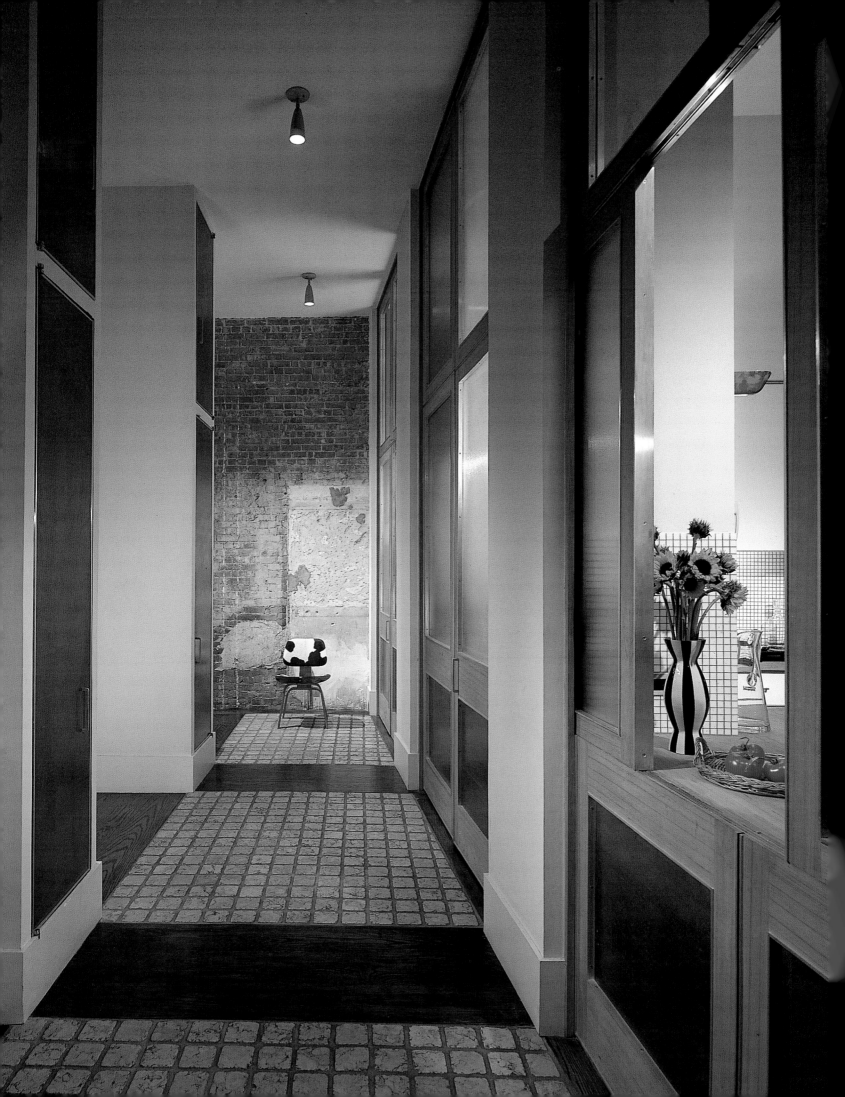

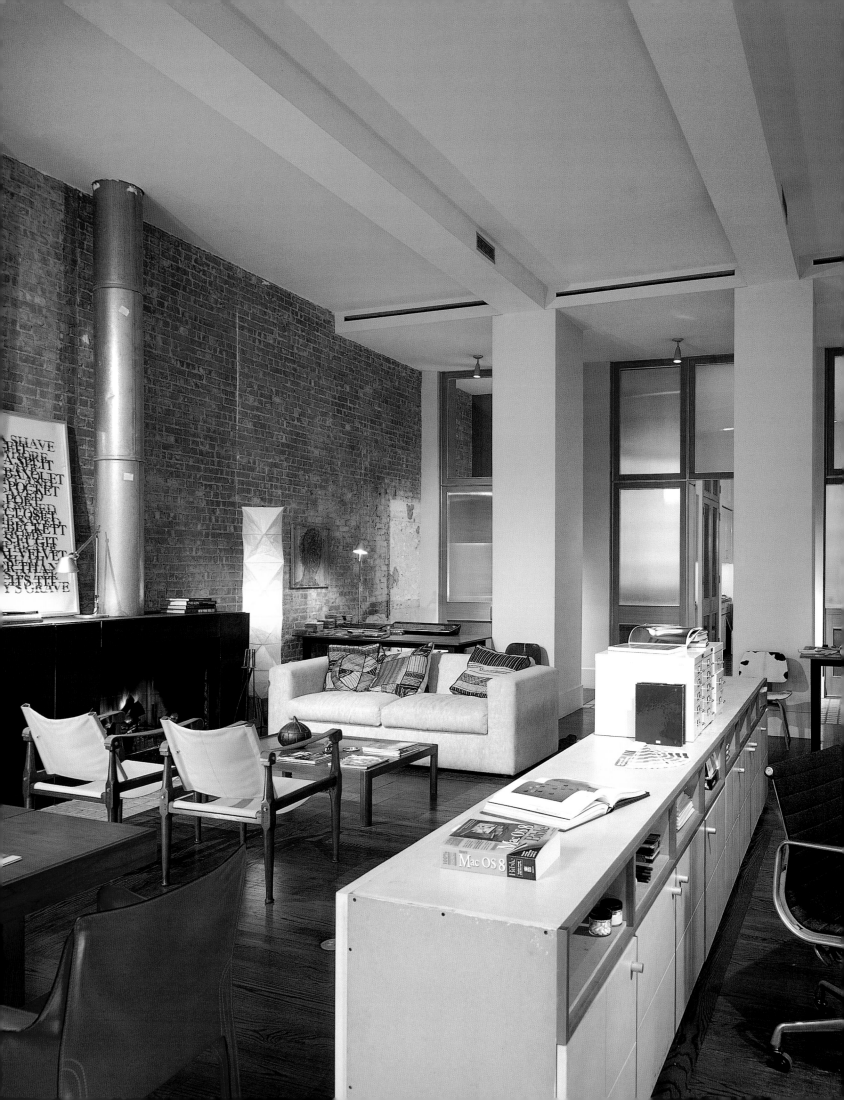

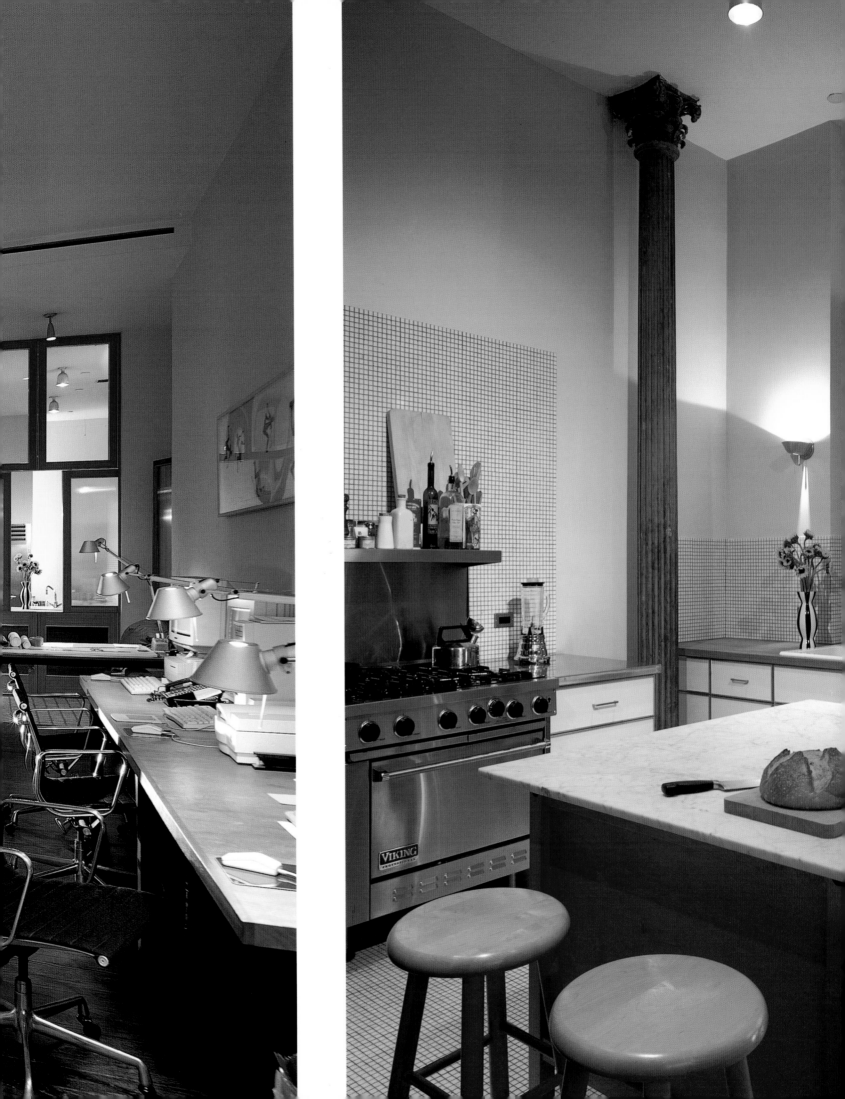

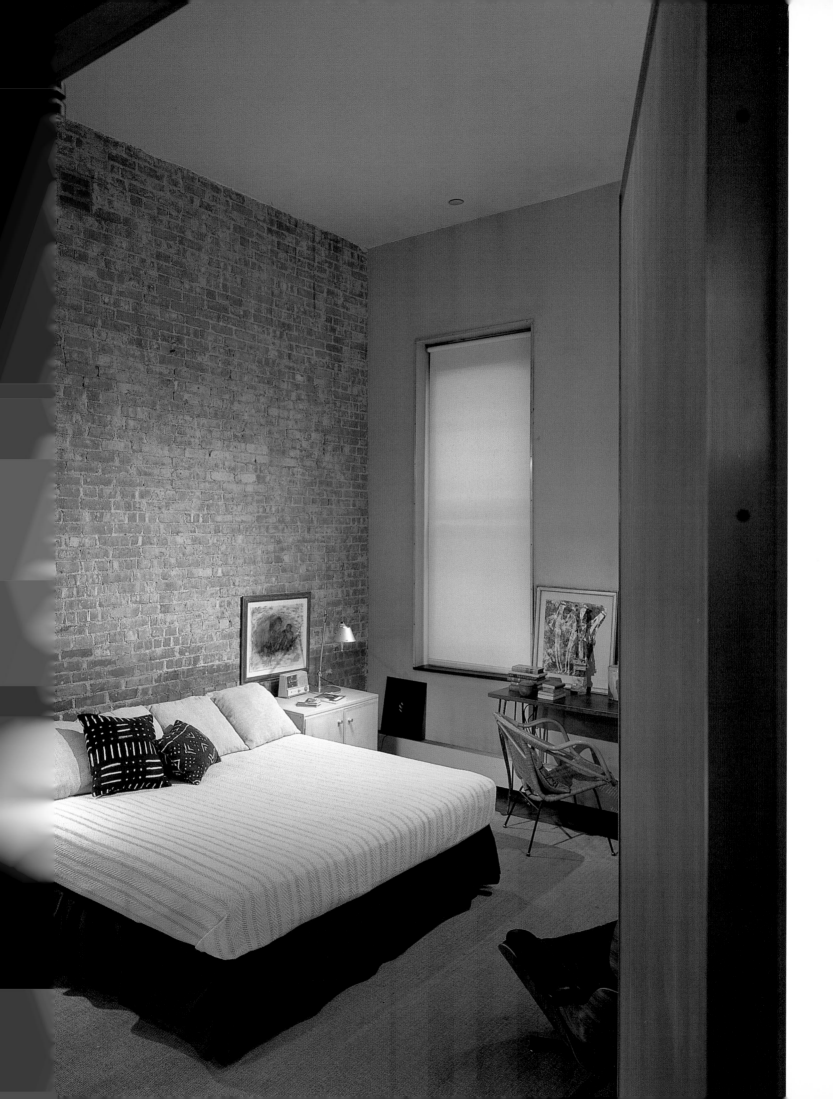

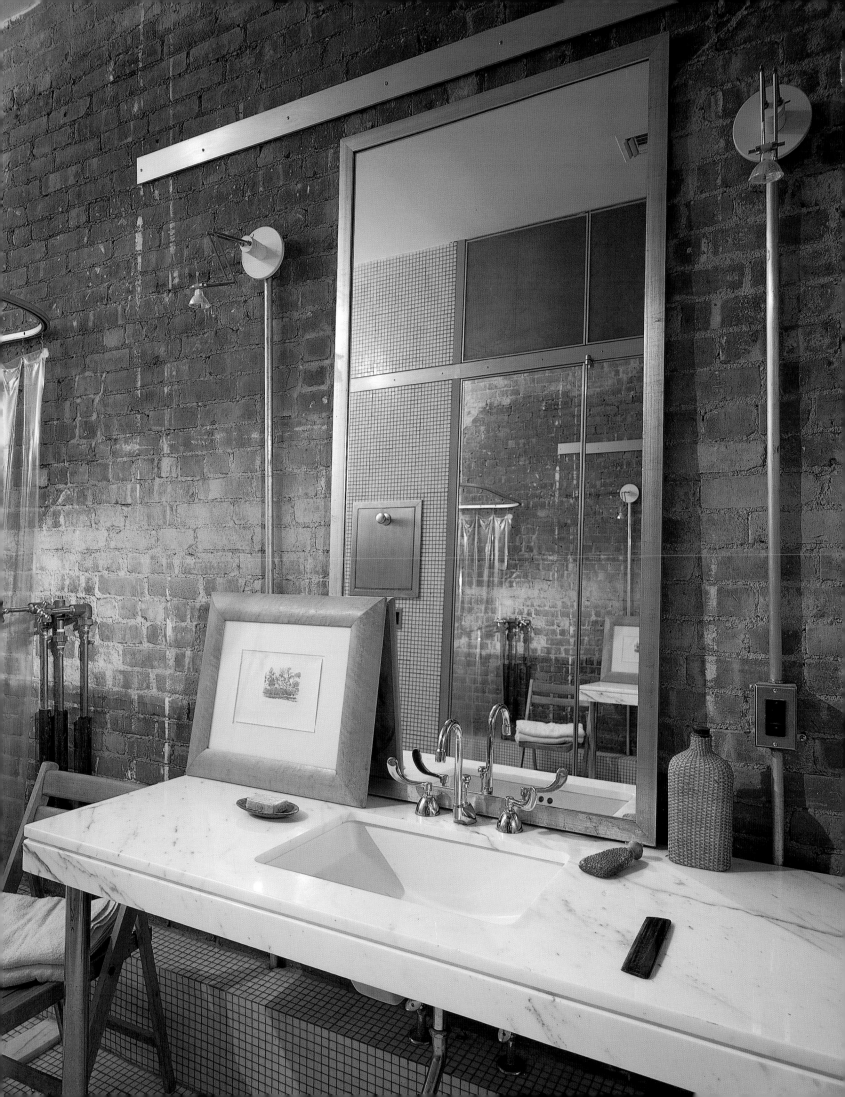

Chelsea Loft, 1995

Scott Marble
Karen Fairbanks
Architects

While the programmatic requirements for this 4,500-square-foot loft for a family of four were fairly typical—allowing for multiple possibilities in spatial configuration to suit shifting needs for privacy and openness—the design solution developed by Scott Marble and Karen Fairbanks is uncommonly efficient, beautiful, and, in its treatment of light and shadow, poetic. The architects had designed two earlier lofts for the same clients, each of which responded directly to the changing needs of the growing family. The spatial strategies and specific design elements implemented here thus represent an evolution of earlier ideas and schemes, adapted and refined to embrace the unique qualities of the new site.

The architects' plan revolves around a central spine of sliding screen walls that runs parallel to the existing row of structural columns, bisecting the public portion of the loft. Aligned side by side, the panels can separate the more formal living room from the casual lounge space adjacent to the kitchen. Marble and Fairbanks extended the strategy to the study at the end of the public zone: a screen wall perpendicular to the column line allows the study to be integrated with or detached from the living room as necessary. Each area unfolds into the next, or slides into it, or abuts it, or disappears altogether. There

are, however, indications that mark important transitions, divisions, and connections. The cork floor in the study, for example, creeps into the bedroom and then gives way to the maple flooring used elsewhere. Pivoting doors regulate the link between these two spaces. The kitchen and breakfast area are discreetly connected by a low circular soffit that establishes a more intimate scale.

The artistry in the loft's design is perhaps most apparent in the construction of the mobile elements. Each of the sliding screens, made of medium-density fiberboard and translucent glass, is uniquely configured in visual composition and physical weight distribution. The resulting asymmetry is multiplied as the screens are shifted along their individual tracks in infinitely varied arrangements. The bedroom's pivoting doors are three-dimensional parallelograms constructed of fiberboard, translucent glass, and aluminum. Circular cutouts in the aluminum allow for the passage of light and produce a striking visual effect not dissimilar from the subtle beauty of high minimalist art.

Indeed, the handling of the natural light that floods the loft from numerous large windows along the south wall is perhaps the architects' most intriguing achievement. The beautifully crafted screens and doors, with their variable translucencies, choreograph dancing patterns of light and shadow in a constantly changing theater of immateriality.

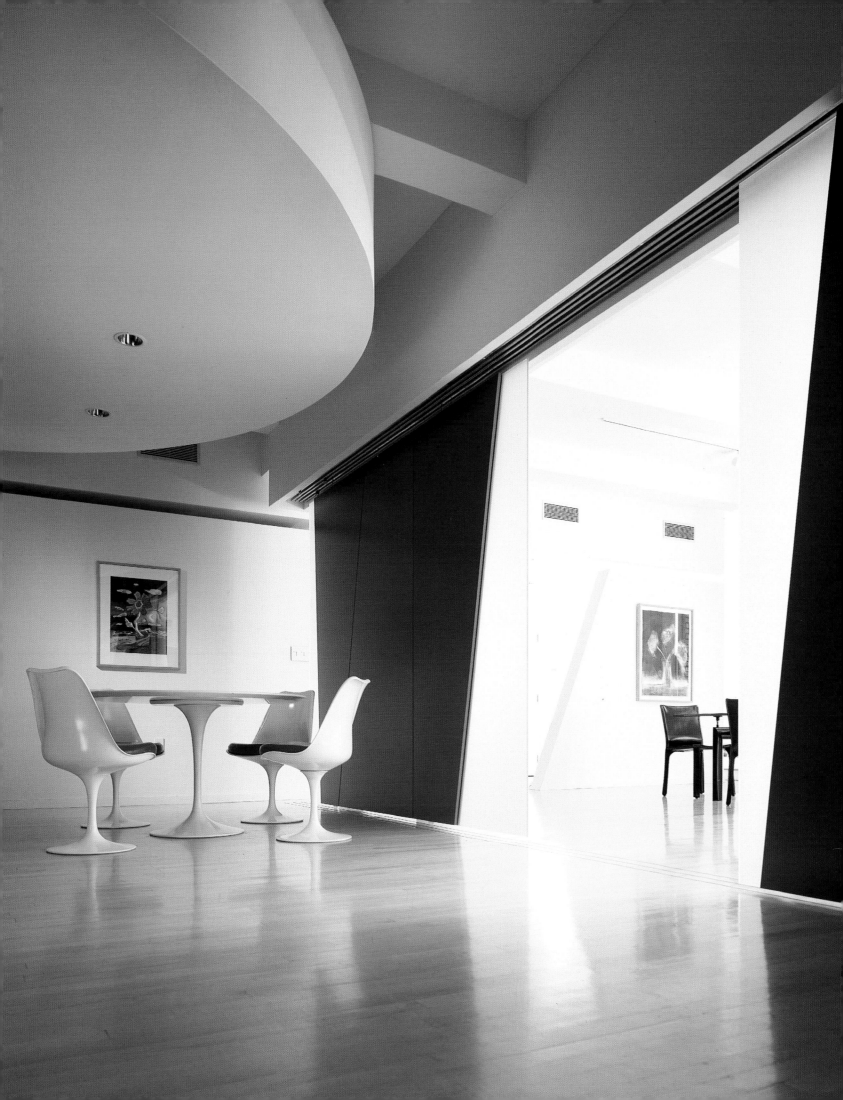

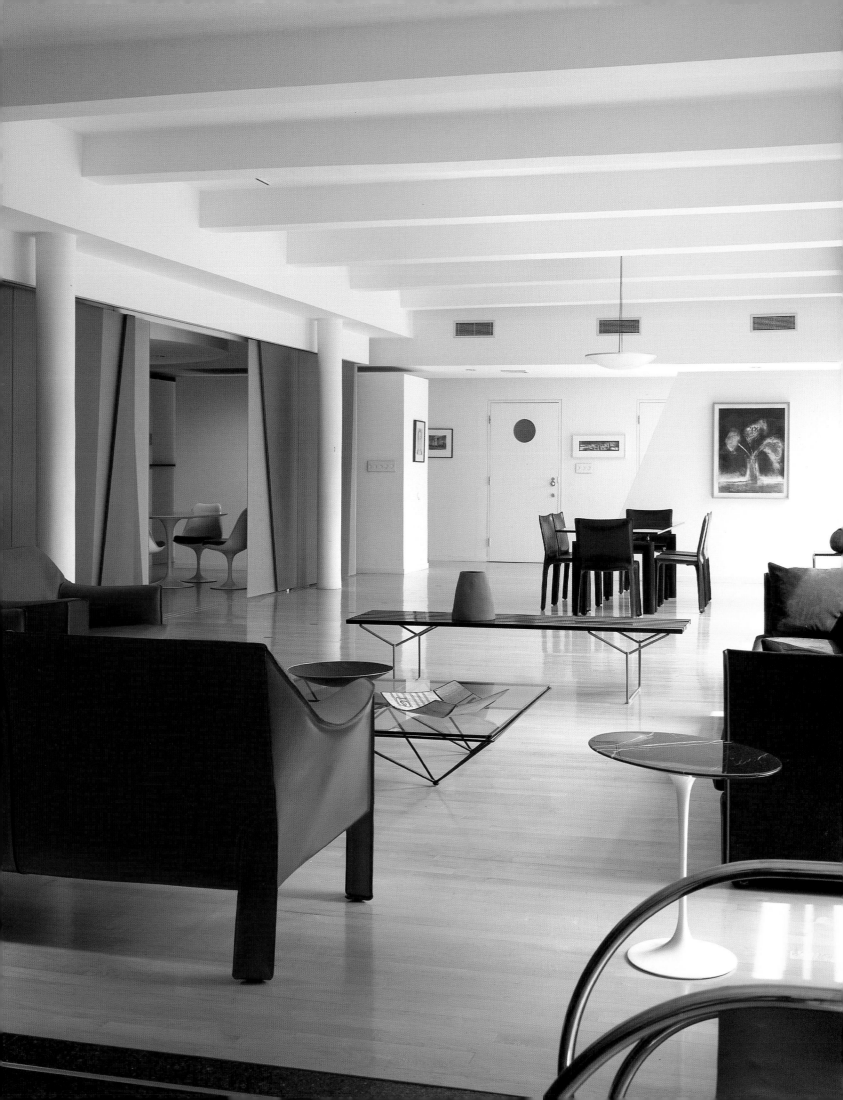

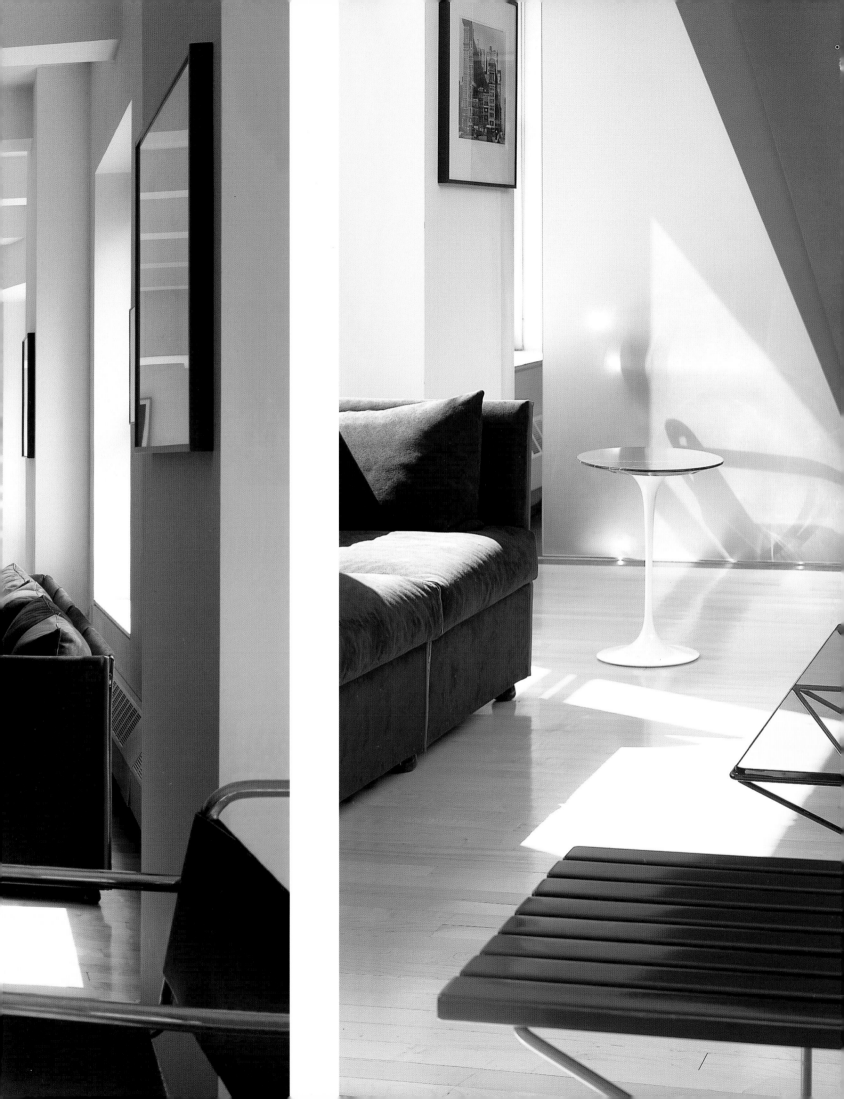

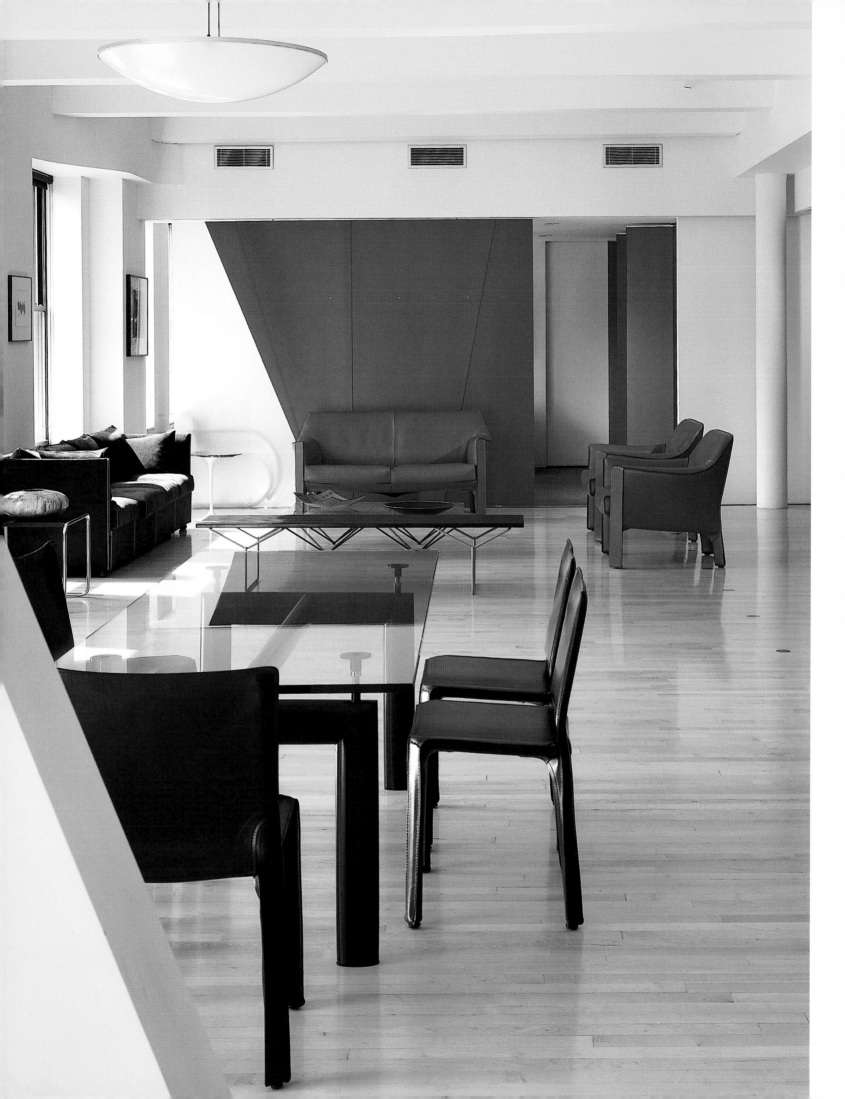

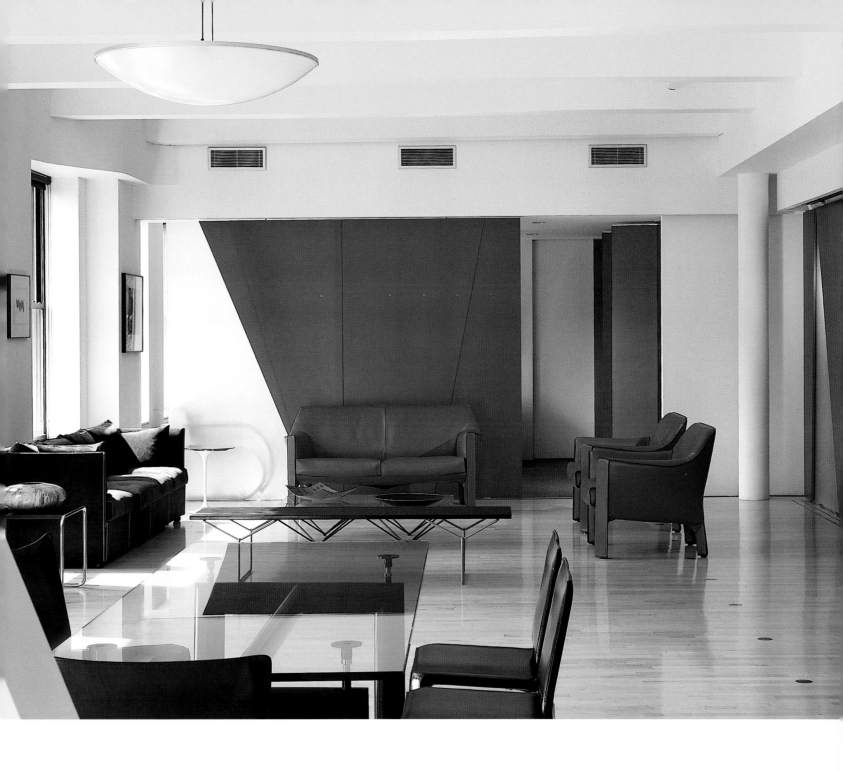

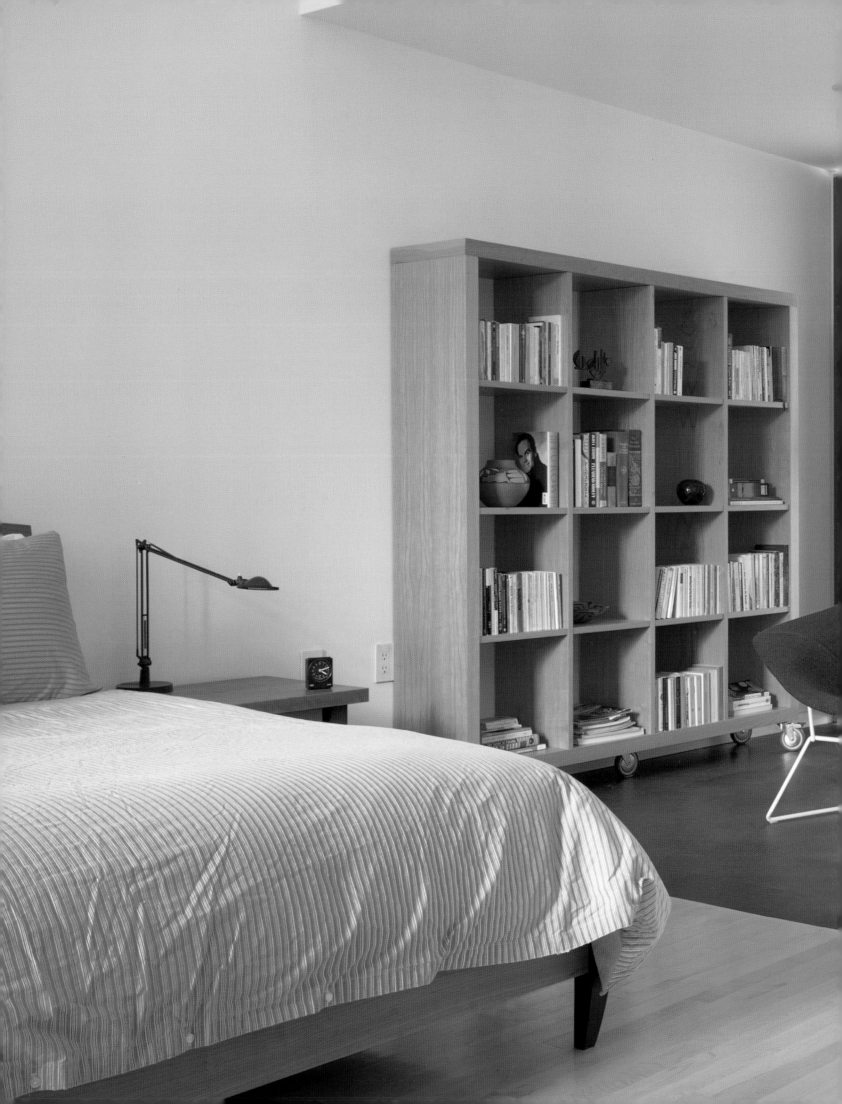

Flatiron Loft, 1997

Martin Raffone

Abundant space, the strongest attraction of loft living, was not a factor in this lower Manhattan loft. Martin Raffone had a mere 900 square feet in which to create an efficient live/work environment with enough flexibility to shift gracefully between those two aspects of the program. Located within a converted warehouse building in the Flatiron district, the loft, as found, retained all the design elements from the original renovation in the 1970s. This, however, was not the fabulous, freaky-chic 1970s style so popular with designers and stylists in the 1990s. The charmless space was covered in textured plaster and beige laminate, grim and utterly forgettable.

The program required a professional office for two, with a meeting area for clients and sufficient work space to accommodate three computer stations and the high-tech tools of a computer-imaging business. This same space also needed to function as a comfortable, domestic living environment. Raffone devised a clever, compact scheme that utilizes custom multifunctional furniture, lighting, and storage elements as the primary means for transforming the loft both in function and atmosphere.

A canted wall of zebrawood, the loft's primary volumetric gesture, conceals ample storage for both work and living functions: printers and clothes, fax machines and books. The expansive work surface that extends parallel to the storage wall takes on various duties: desk, computer station, credenza, buffet. The sleep loft, perched above the kitchen, opens to the living area, which by necessity does double duty as a client meeting space. Ironically, once Raffone purged the loft of its original 1970s design, he detailed the new environment and its custom-designed furniture with materials that themselves gained popularity during that era: Lucite, plastic laminate, stainless steel. Textured and frosted glass, fiberglass mesh, glass mosaic tile, lava stone, bamboo flooring (in the sleep loft), linen, wool bouclé, and silk complete the diverse materials palette.

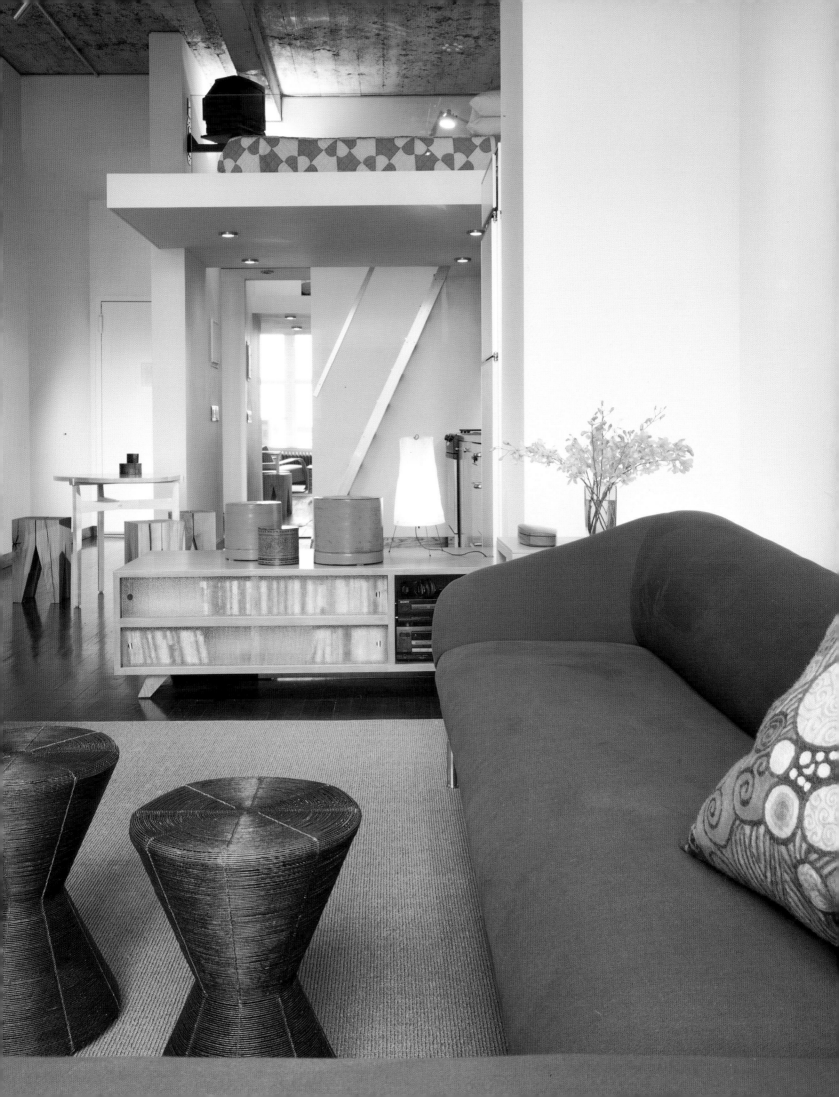

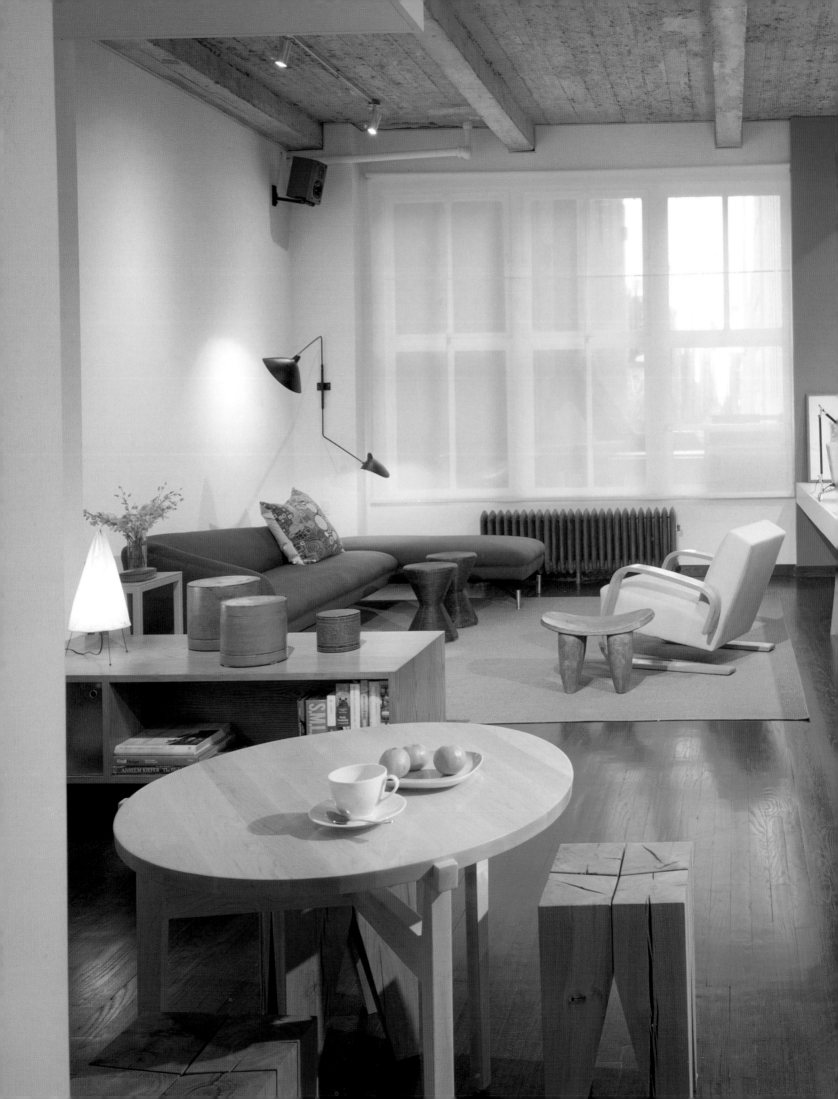

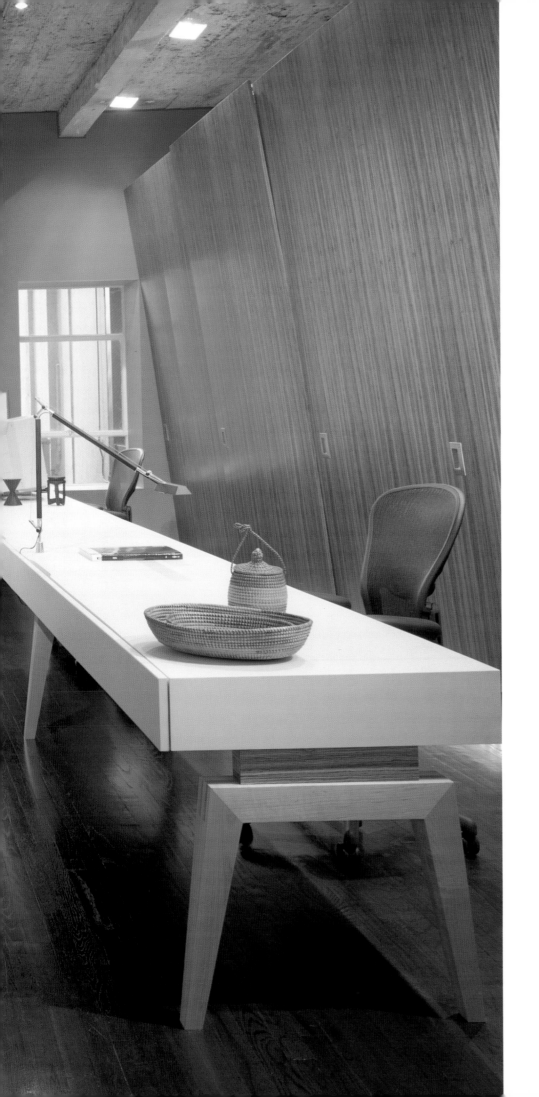

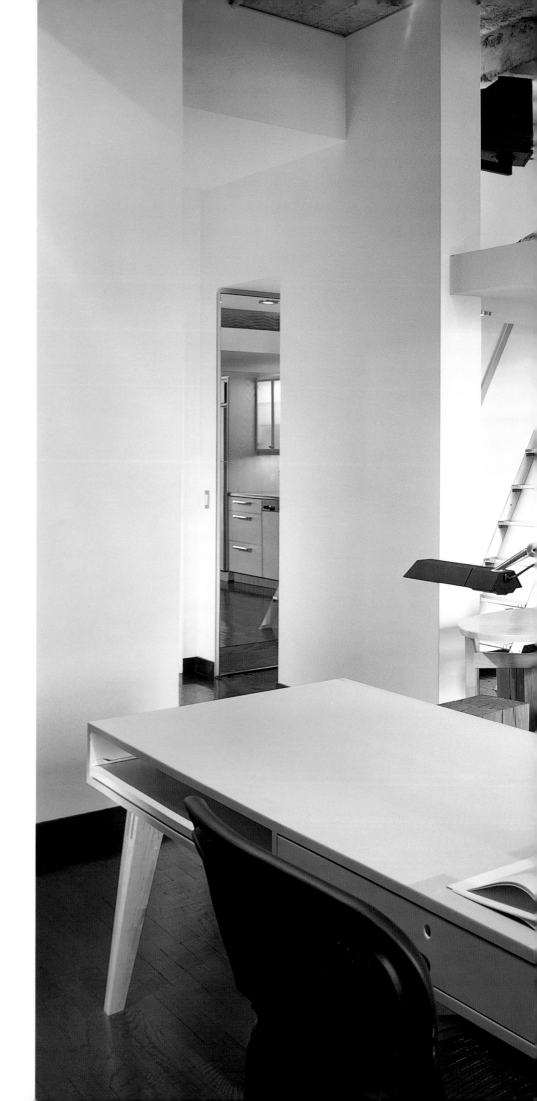

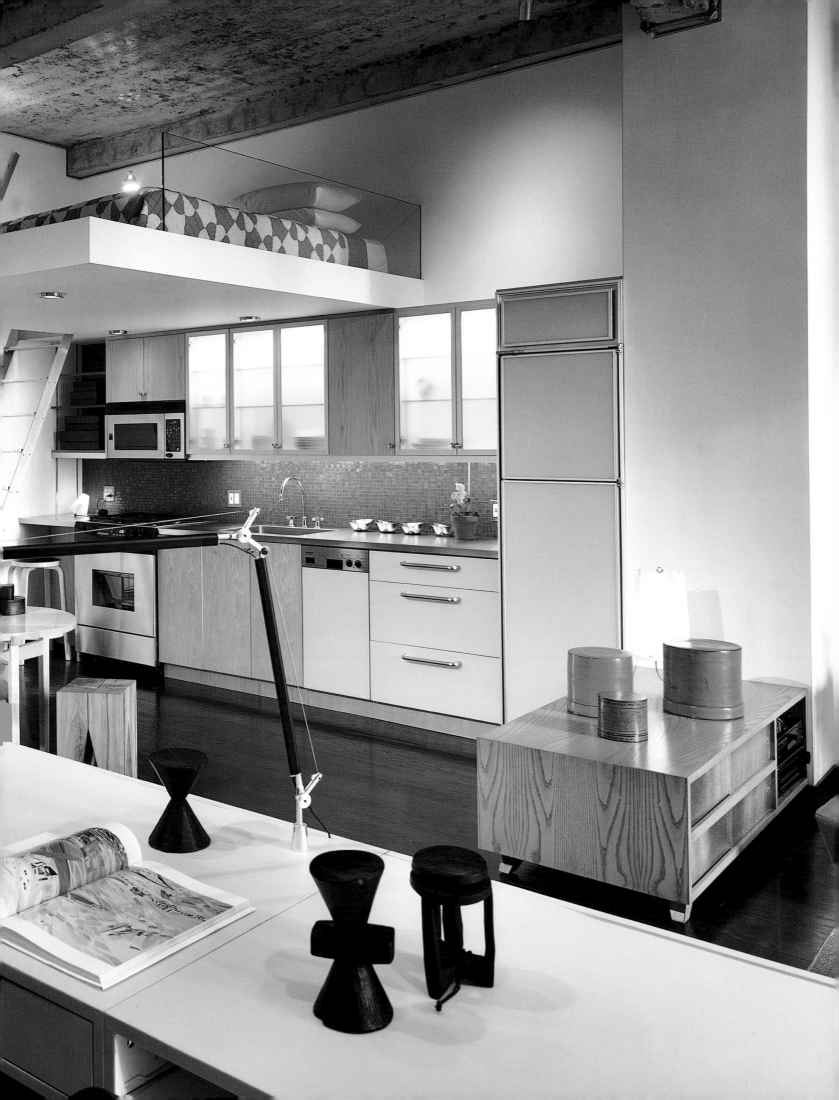

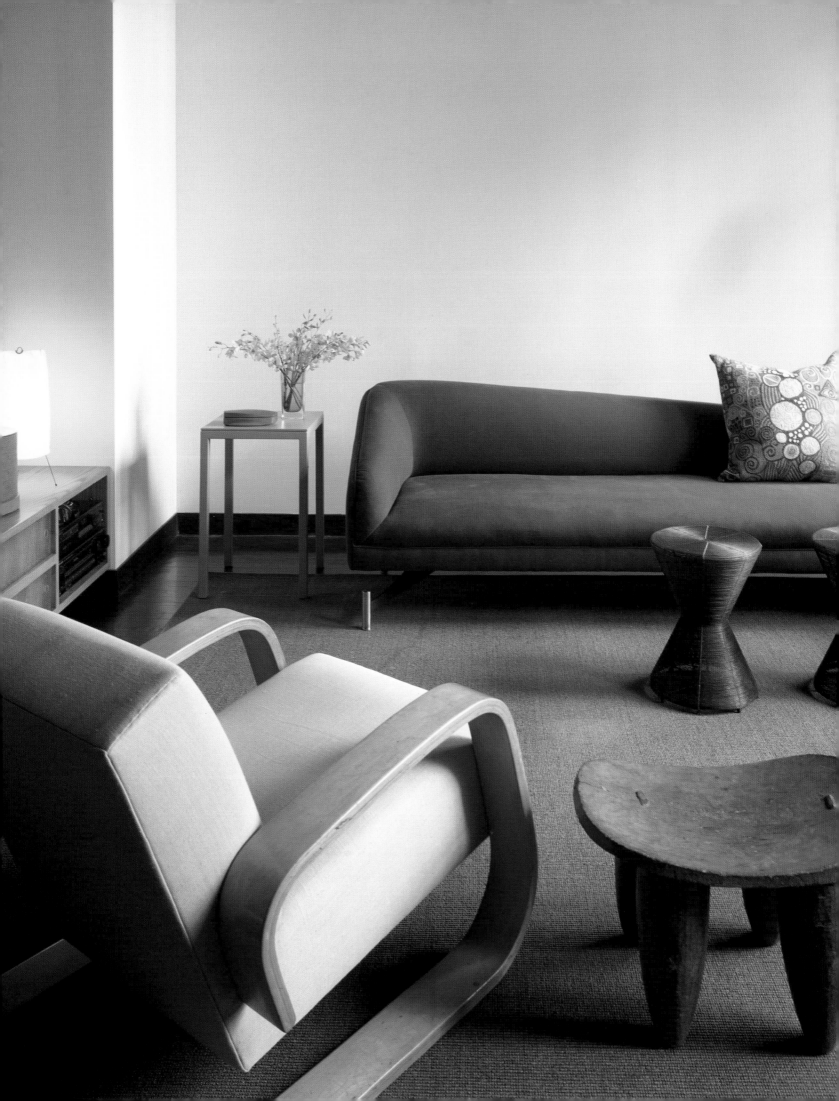

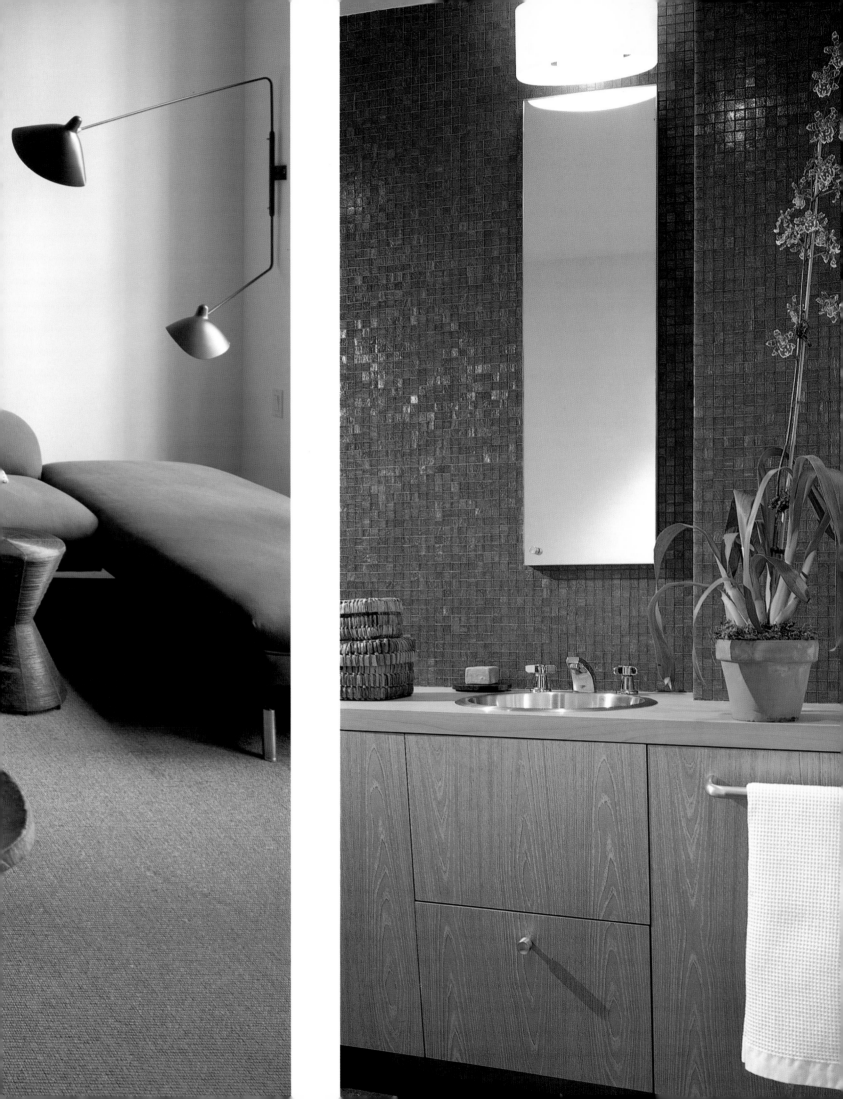

Water Street Loft, Lower Manhattan, 1996

Phillip Tefft, Architect

The story of this renovation is something of an anachronism. It recalls a bygone era of loft colonization when artists were zealous urban pioneers, manipulating New York's tenant laws to stake claims on large expanses of space in derelict commercial properties. In 1981 a small group of artists moved into a rundown building on Water Street, leasing live-in studios from an absentee landlord who provided far less than the required maintenance and infrastructure support. By necessity, the tenants organized to maintain their rights in the face of eviction notices and numerous attempts by developers to assume control of the building. After protracted and complex legal battles, the group obtained official co-op corporation status from the state of New York in the early 1990s and subsequently, in 1994, purchased the building.

The artist client of architect Phillip Tefft earned rights to the building's top floor loft, a generous 3,750-square-foot space with an existing mezzanine level centrally located beneath a skylight. After ridding the loft of numerous partitions erected over many years, the architect and artist developed a design strategy predicated on the preservation and revitalization of original structural elements and building materials. Needs for living and studio space were addressed with minimal device in a scheme emphasizing openness and exposure.

The 1,250-square-foot mezzanine, bathed in natural light, was the obvious location for the painting studio. Directly beneath, Tefft developed an intimate zone for study, reading, and writing. Sleeping and bathing areas were placed to the east of the mezzanine, where they embrace the influx of morning light as well as views to the Brooklyn Bridge and East River. West of the mezzanine, living and dining areas take advantage of afternoon light and views to City Hall.

The client required accommodation for the display and storage of large paintings, which was provided by the construction of an elongated "light box" that defines the formal entry gallery and study area. Illuminated internally, this thirty-foot-long assemblage incorporates sliding screens of translucent acrylic framed in steel. The mobile screens, as unpretentious and effective as the overall design, also offer options for spatial manipulation. Assisting Tefft on the project were Scott Devere and James Cathcart.

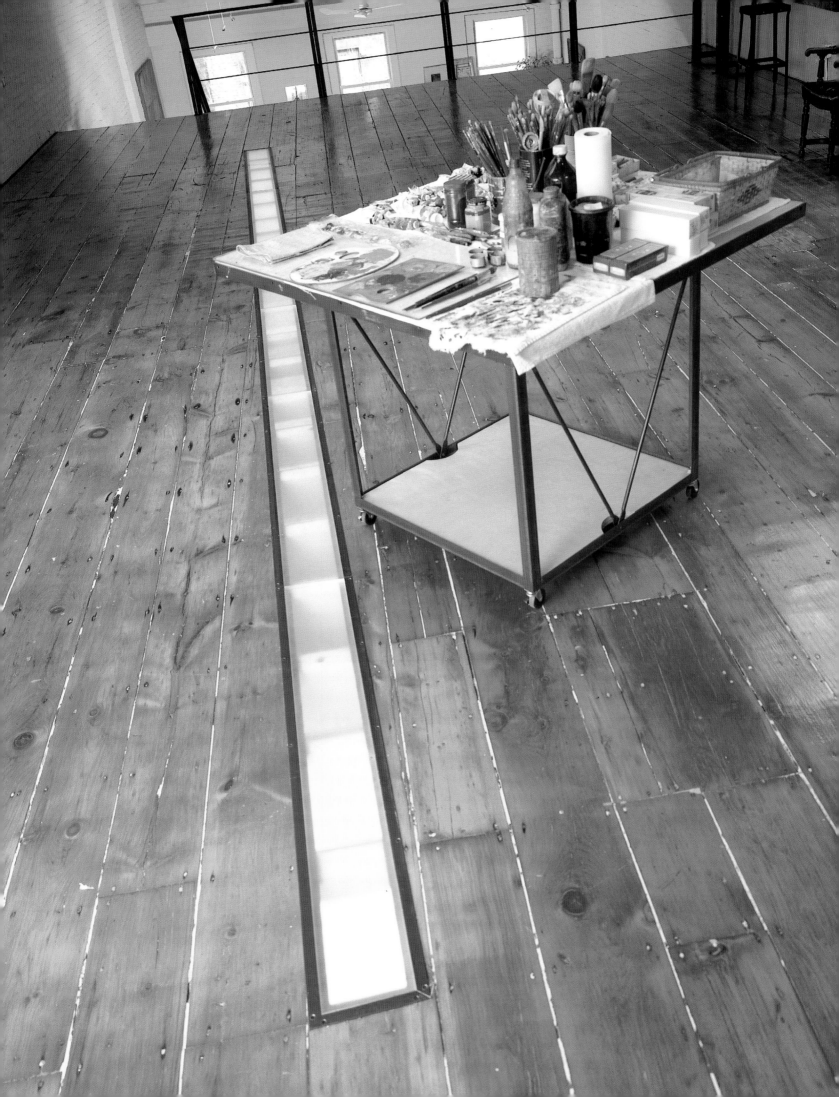

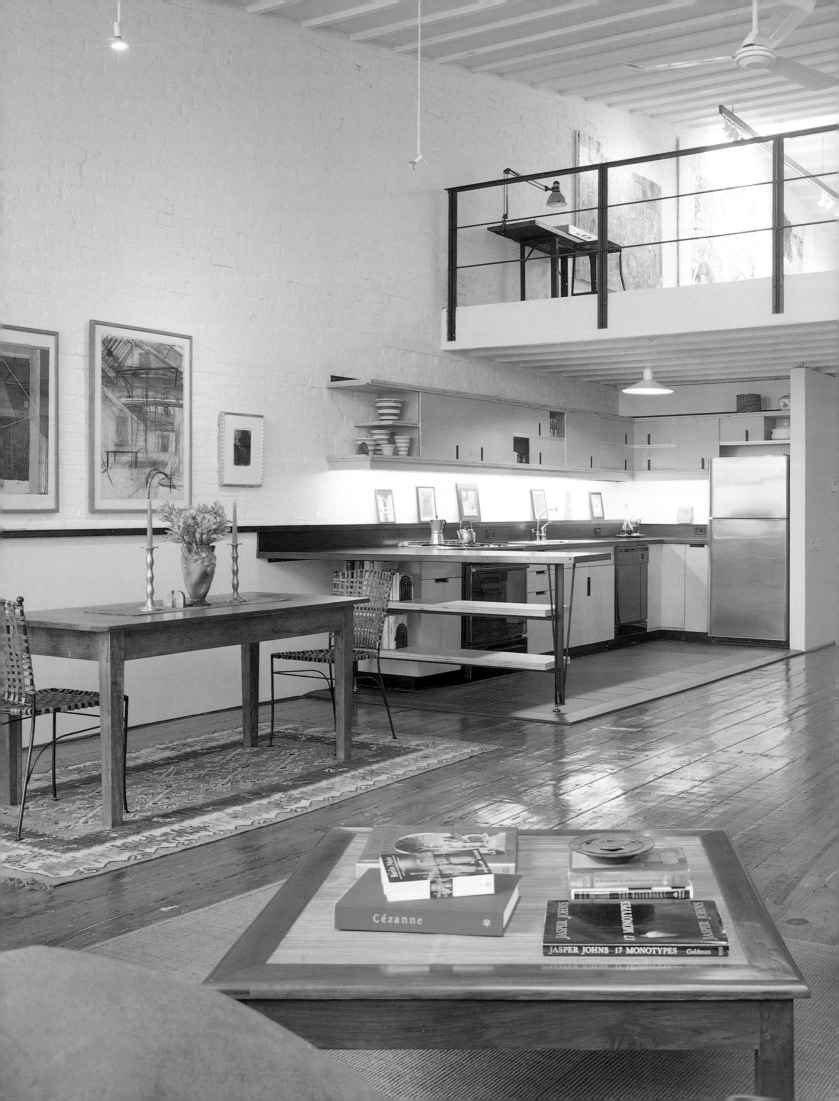

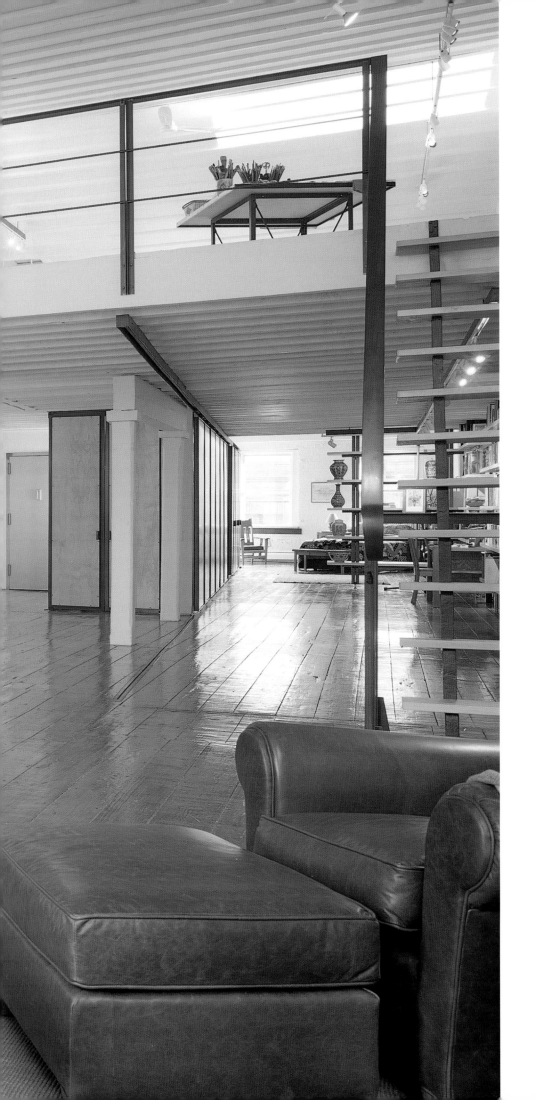

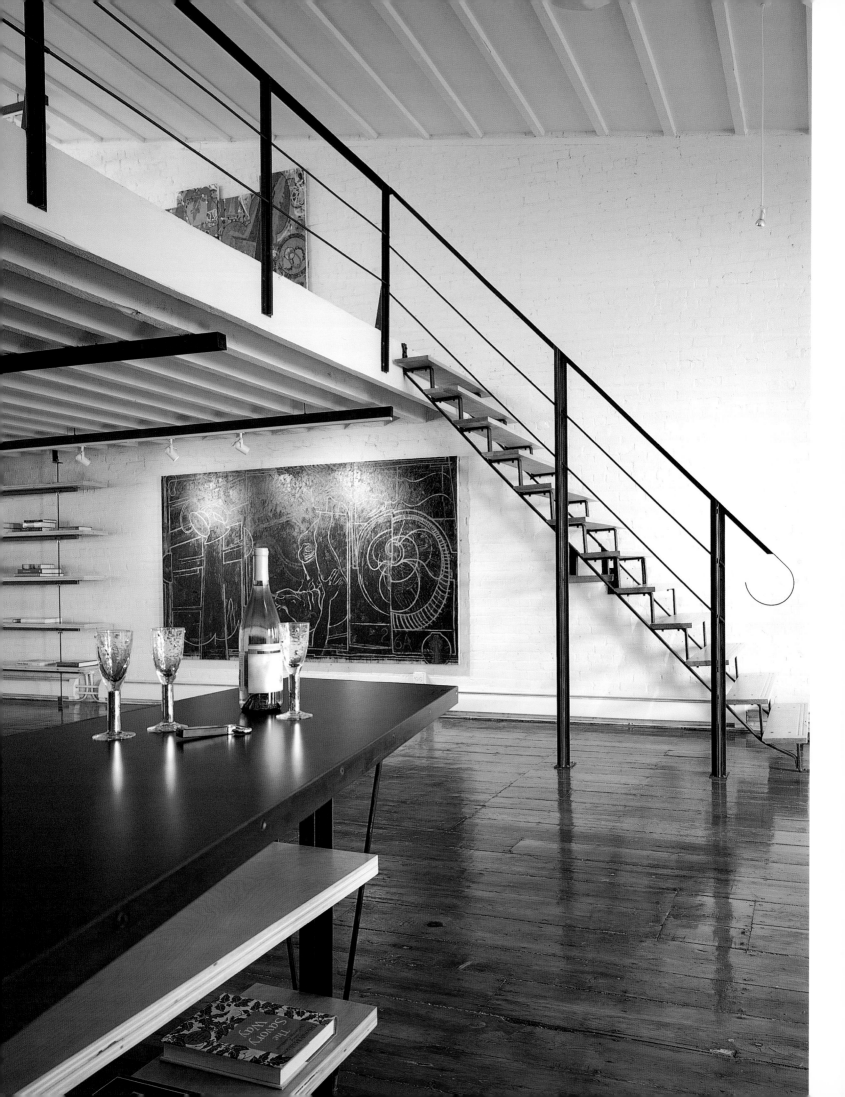

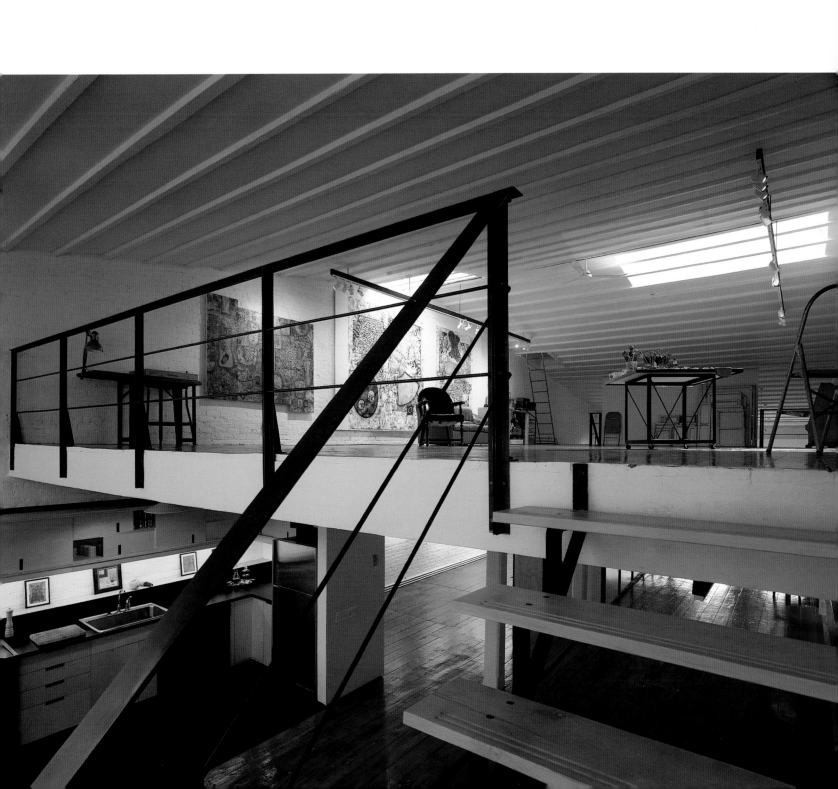

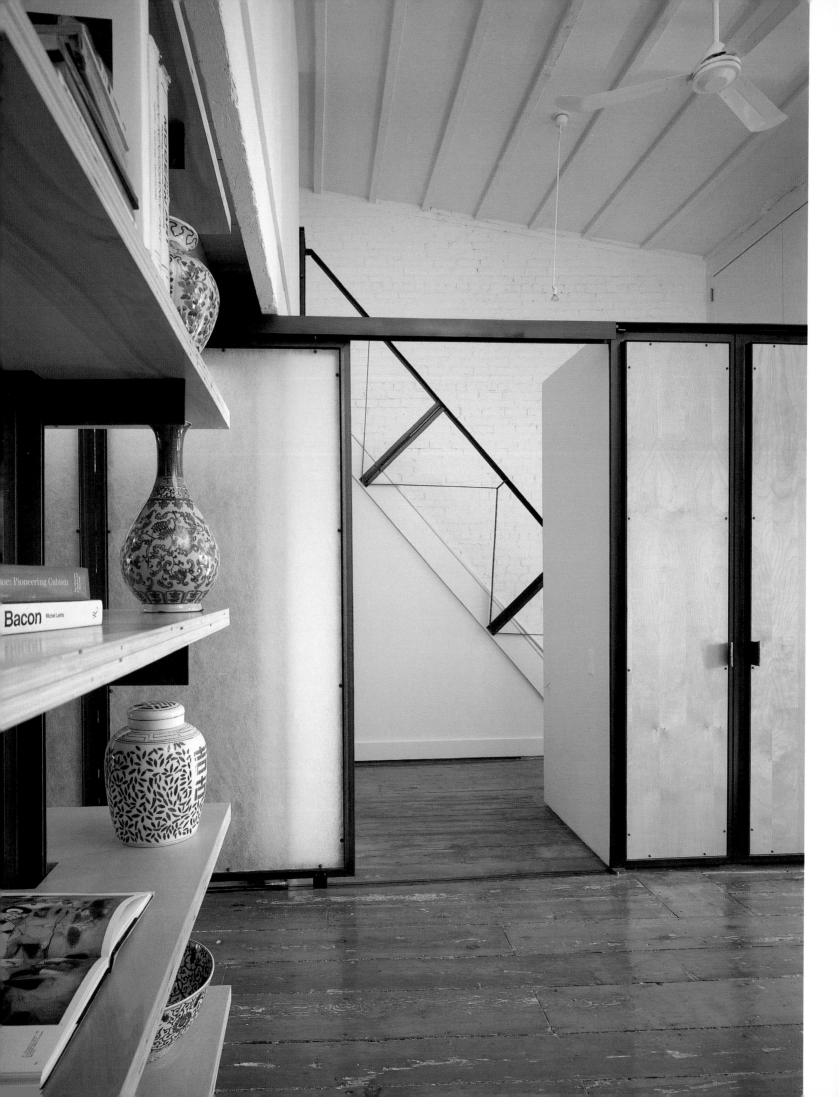

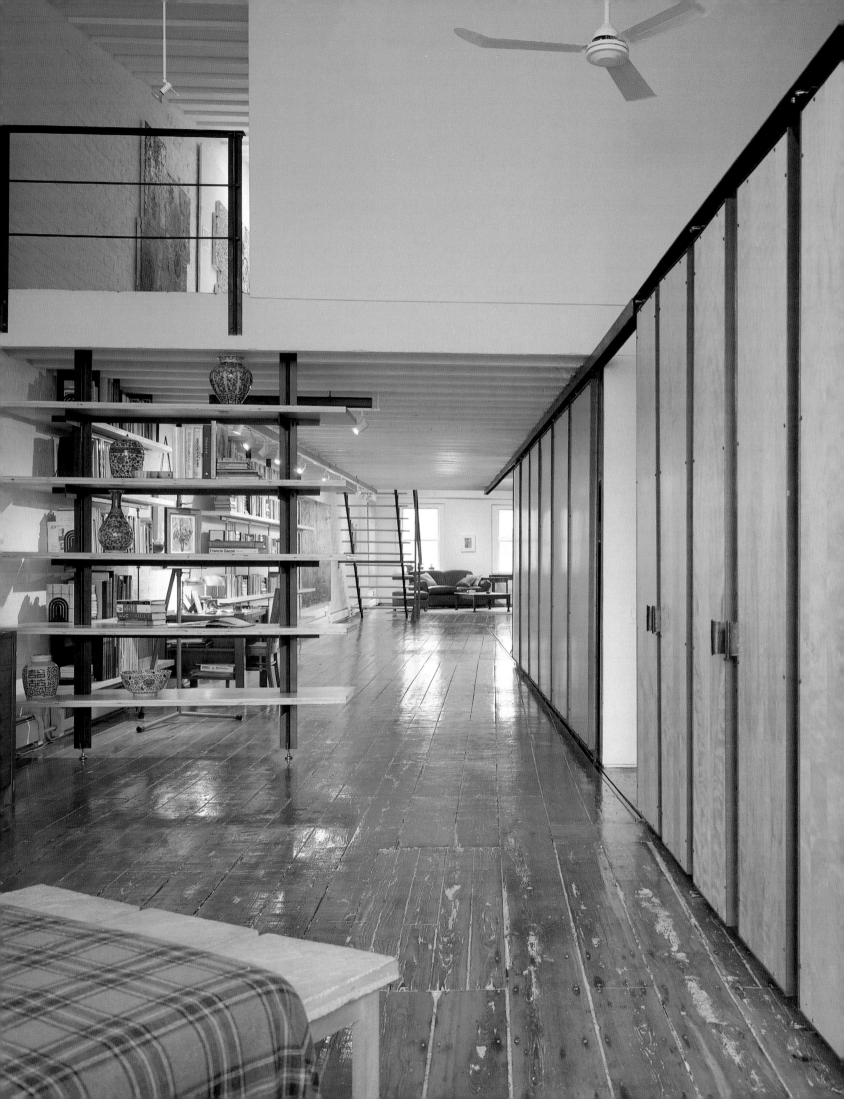

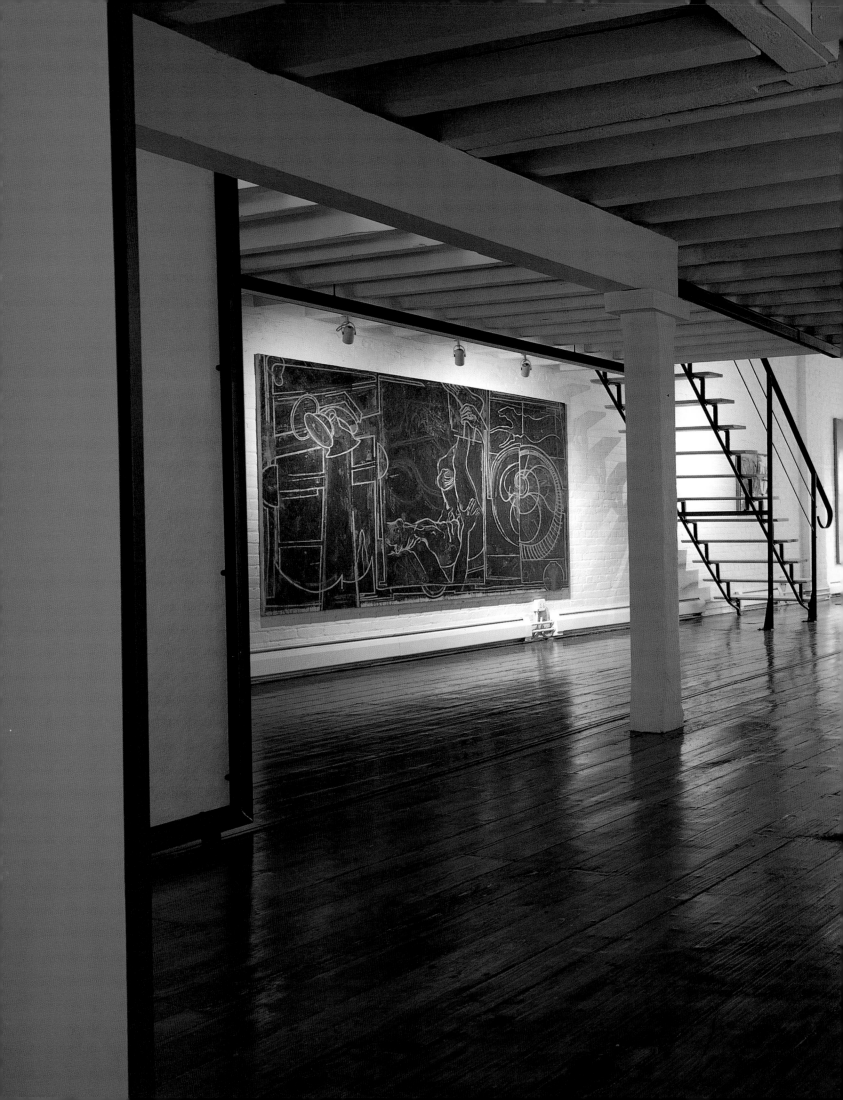

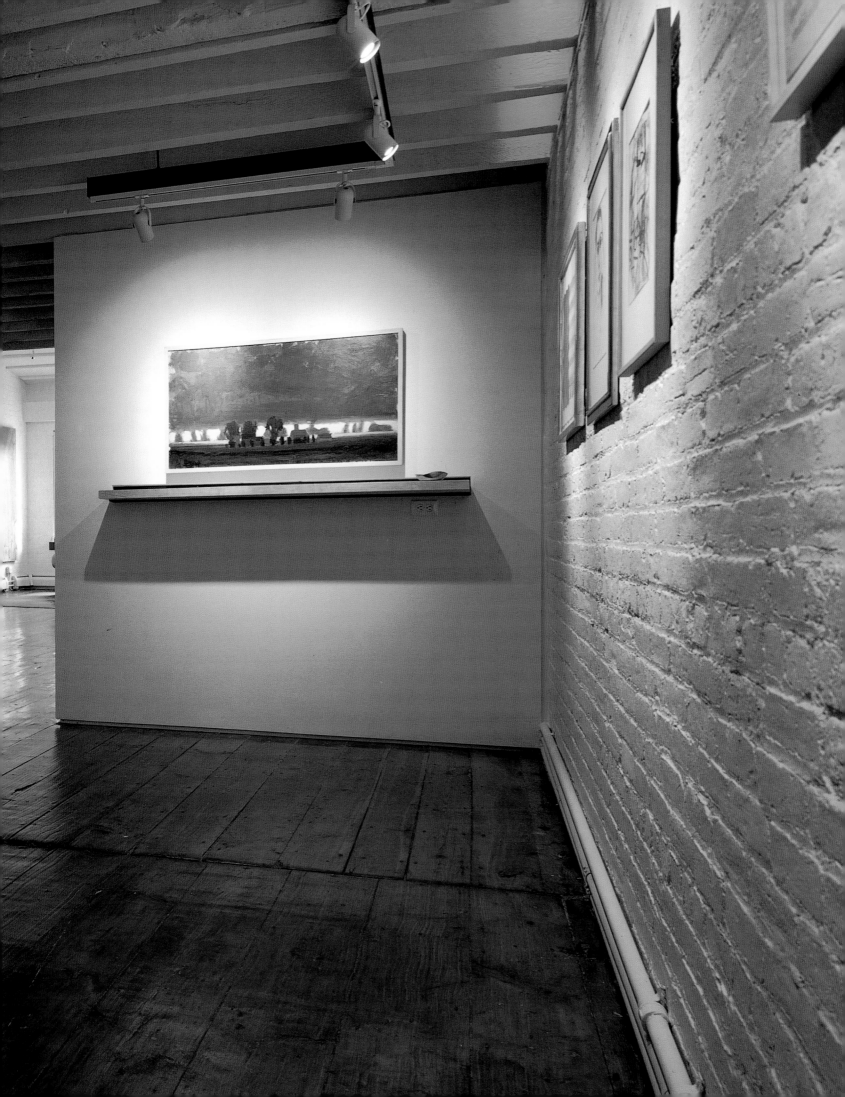

Spencer / Booker Loft, Noho, 1997

Smith and Thompson Architects

Eschewing bold architectural moves and dramatic gestures, architects G. Phillip Smith and Douglas Thompson developed a design notable for its restraint and economy. Their clients, two Australian executives, entertain frequently and thus required a large flexible space for parties. Ample storage space throughout the loft was the other major stipulation of the program.

The 1,600-square-foot loft is located in a converted industrial building situated in the loosely defined neighborhood north of Houston Street. After clearing the space of walls and partitions, Smith and Thompson implemented a logical plan that locates the open kitchen and entertaining area in the center of the loft. Private enclosed areas for two bedrooms were placed at opposite corners. The lone structural column, on axis with the entry, subtly demarcates the transition from the entry foyer to the main social arena beyond.

Taking a cue from their clients' love of sailing, the architects devised a storage solution drawing on the economies of nautical design. Ubiquitous maple cabinetry and paneling—in the form of overhead compartments, storage walls, and window seats doubling as horizontal closets—unify the interior by providing a calm, neutral backdrop conceived for utilitarian efficiency. In the master bedroom, a multifaceted assemblage of maple panels can be manipulated to allow varying degrees of privacy and light infiltration. Clear glass transoms further aid the spread of natural light from windows along the northern and eastern walls.

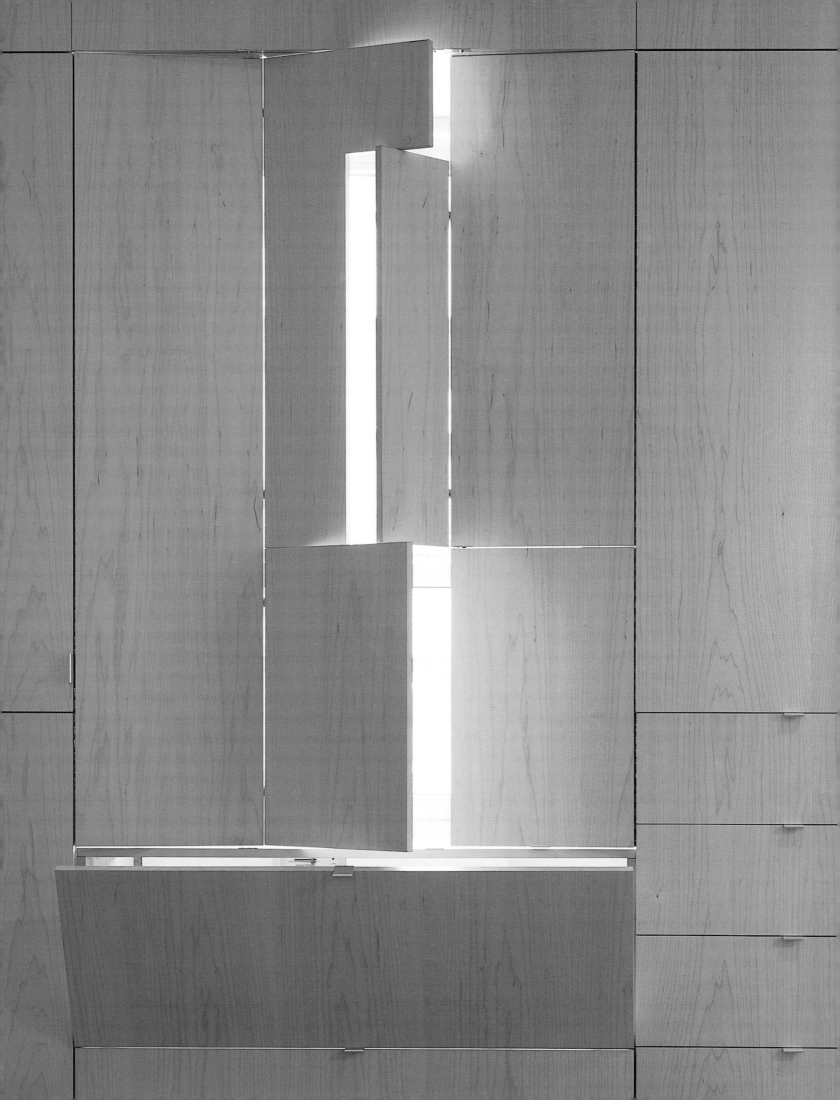

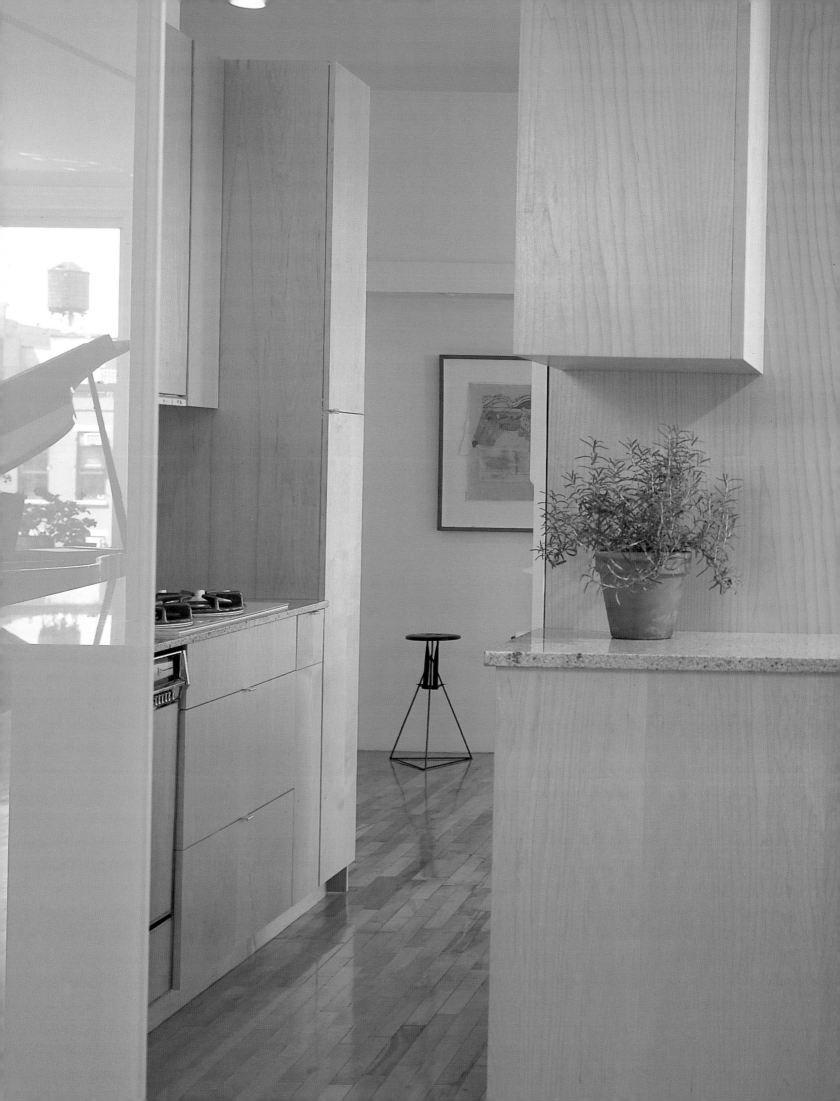

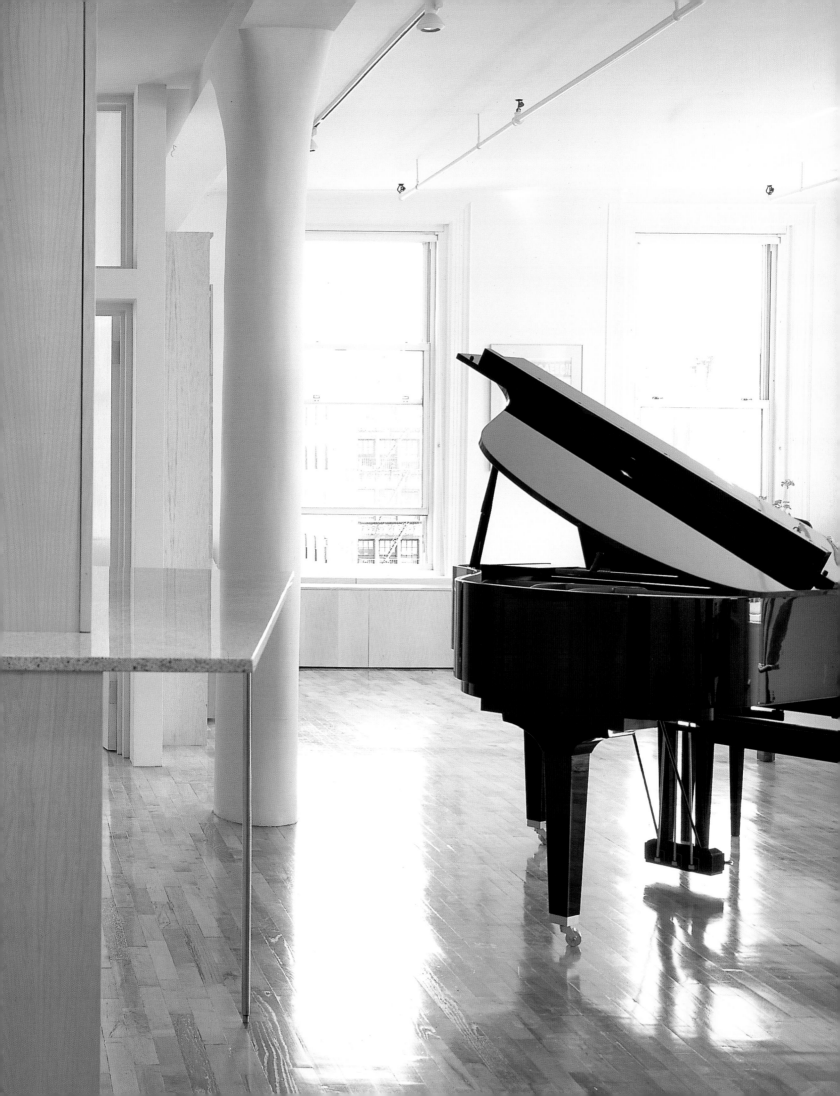

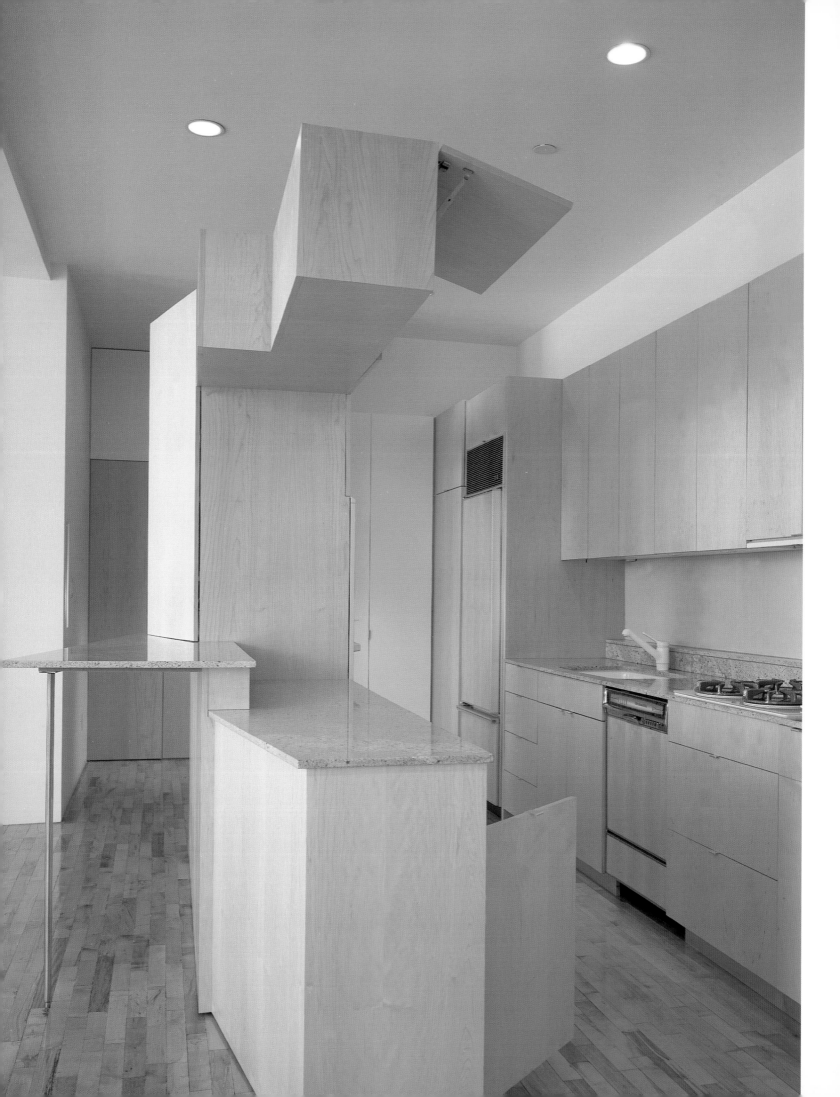

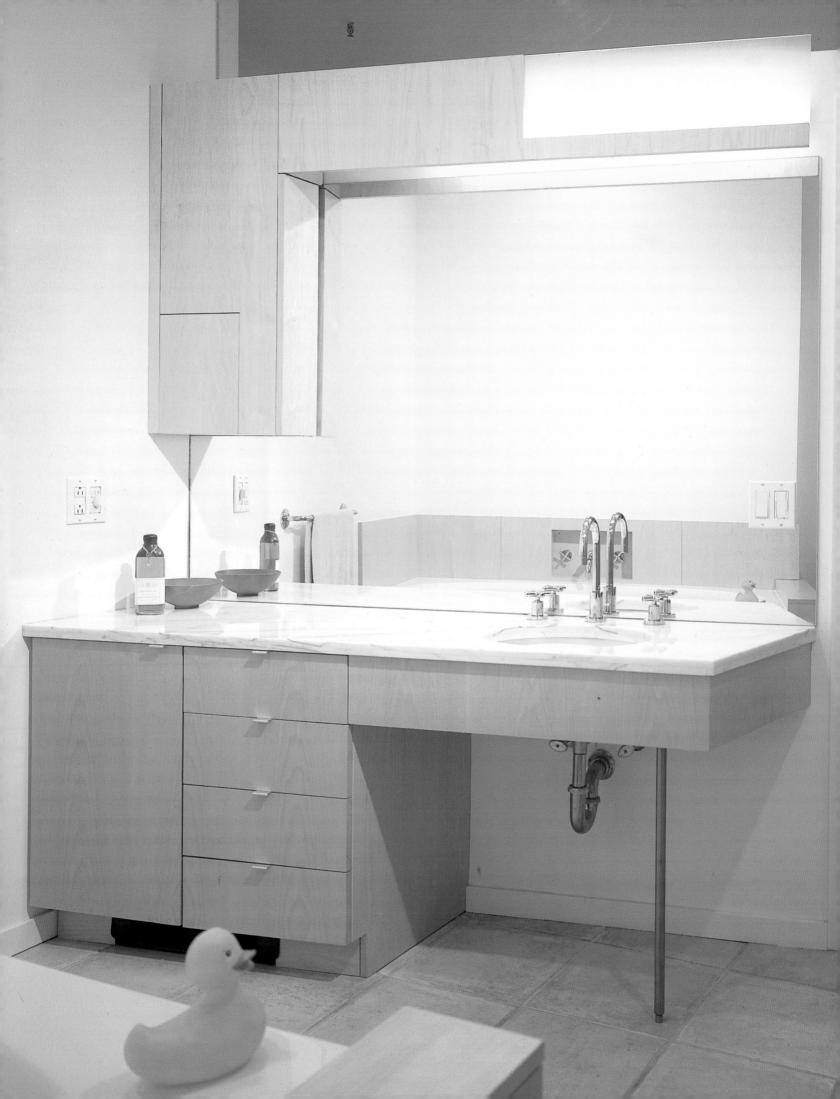

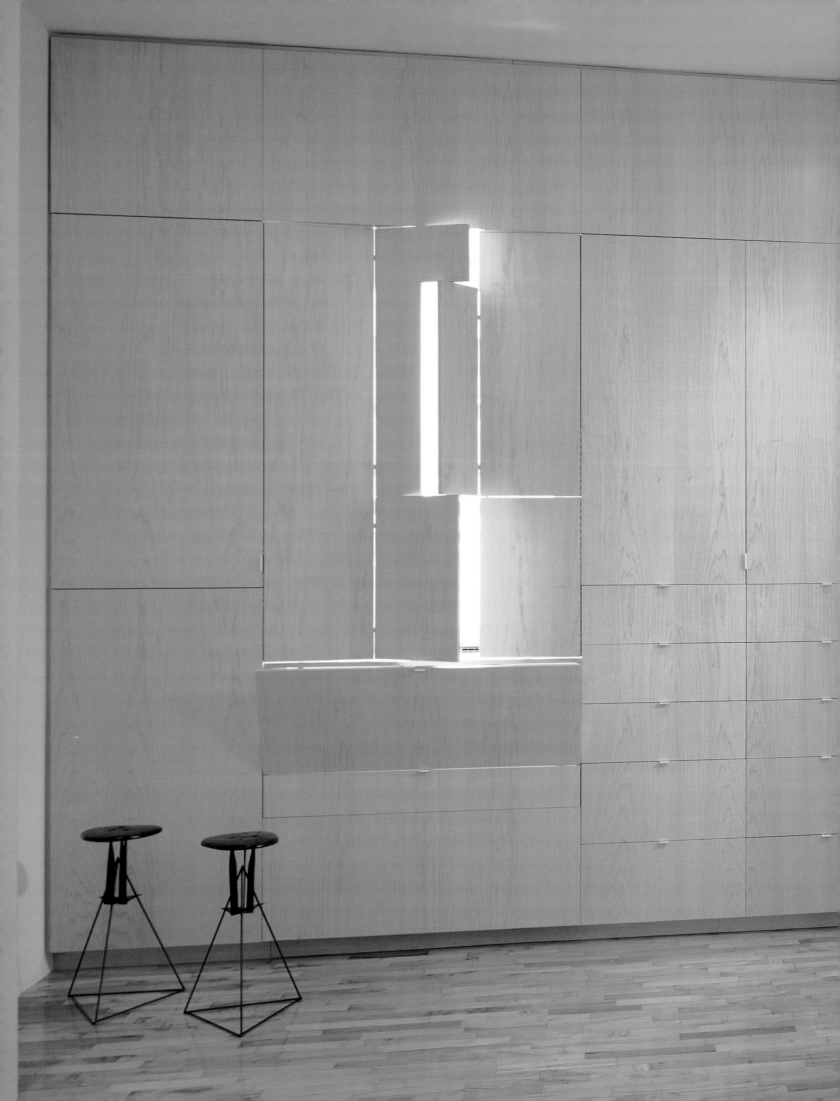

Bleckner Loft, Tribeca, 1990

1100 Architect

Though designed in 1990—a generation in loft design can be as little as five years—the Bleckner loft developed by David Piscuskas and Juergen Riehm of 1100 Architect remains remarkably fresh, having weathered the whirls and eddies of changing tastes and styles. The issues explored by the architects—the definition of public versus private, the possibilities of radical spatial reinvention—prefigure many of the basic architectural forms, materials, and strategies employed in the most contemporary of loft renovations.

1100 Architect was responsible for the renovation of the entire six-story loft building owned by artist Ross Bleckner. In contrast to clients and designers who aggressively maintain (and occasionally fetishize) vestigial architectural traces of past uses and lives, Bleckner requested that his architects erase the residue of previous tenants. The

architects' work on the first and second floors encompassed routine rehabilitation and structural reinforcement. Much of the building's fourth floor was stripped away to create a capacious double-height painting studio on the third level.

Refinement of detailing and spatial transformation intensify in the domestic spaces on the fifth floor and, most dramatically, on the uppermost level. There, the architects removed the existing roof and a central row of columns, freeing the space for the implementation of a plan organized around a focal outdoor garden/terrace that separates public and private zones. Two new roof designs reinforce the distinctive character and proportions of the bedroom and living areas. Natural light collected in the garden well is distributed to adjacent rooms and passages through doors of clear and translucent glass. The paving stones of the outdoor court are interspersed with glass blocks that funnel daylight into the kitchen and dining areas on the fifth floor. The final layer of design intervention—furniture, window treatments, surface finishes—reinforces the unexpected domesticity and graciousness of the reconceived space.

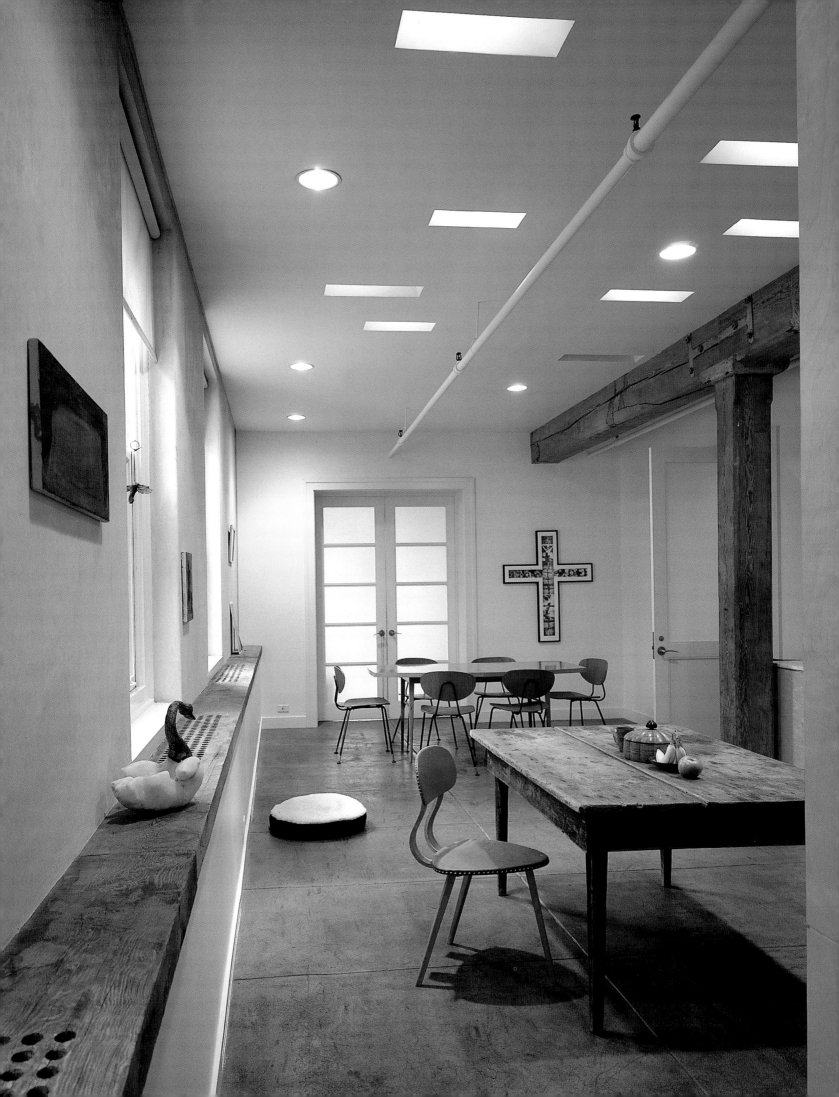

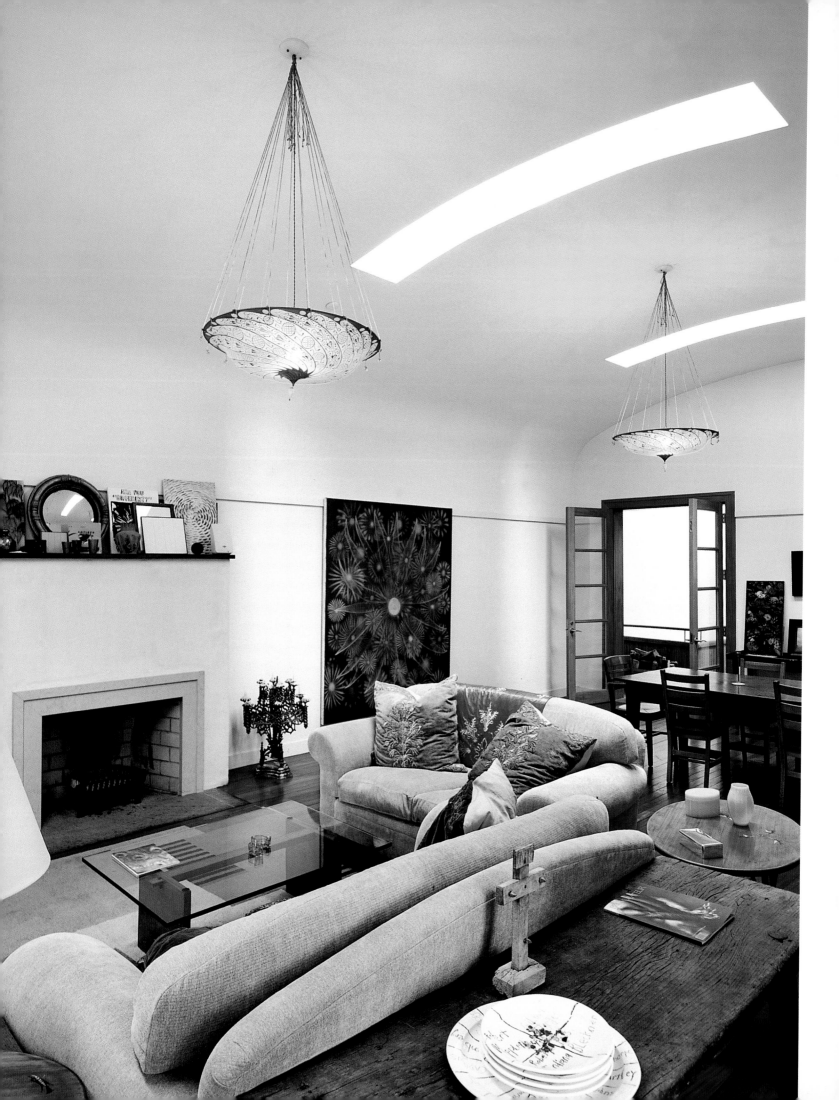

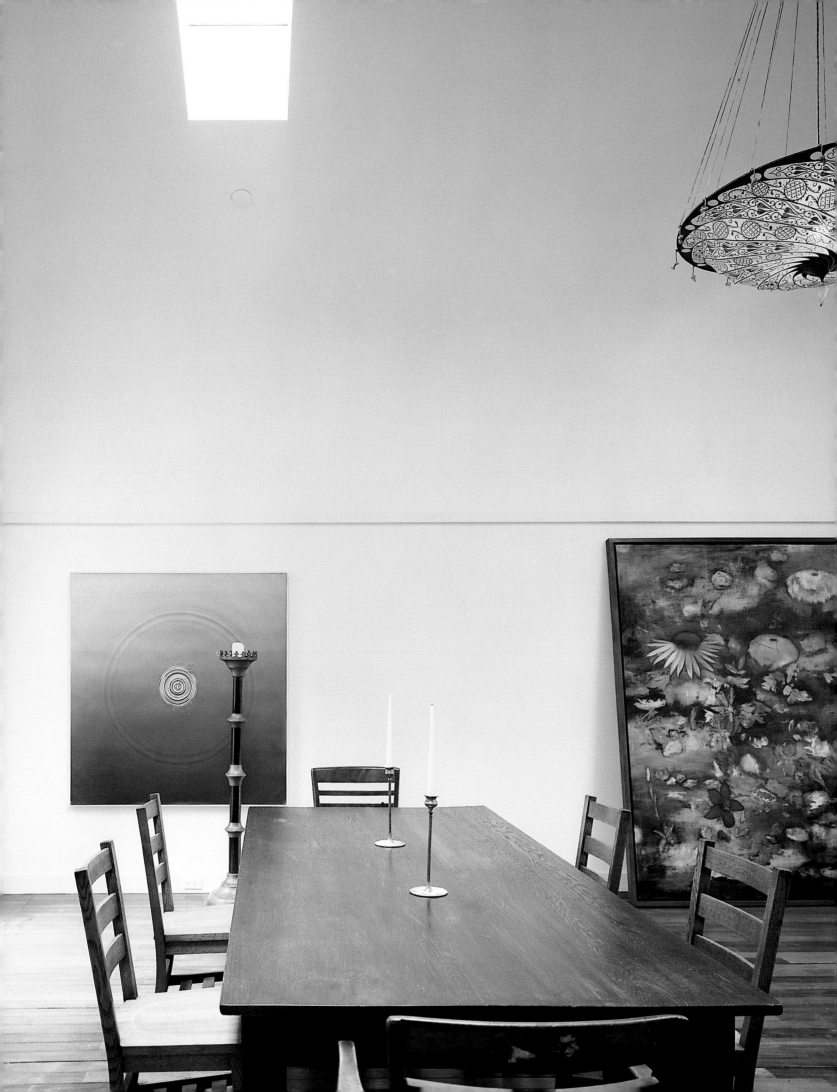

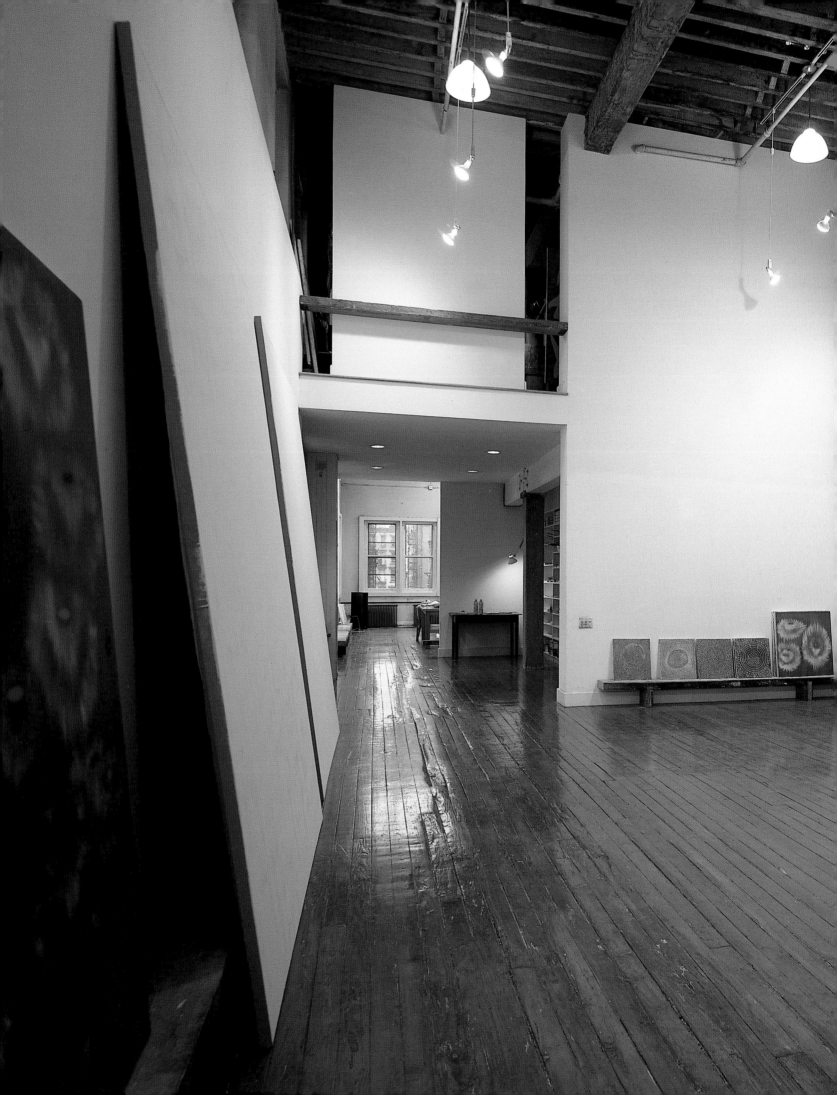

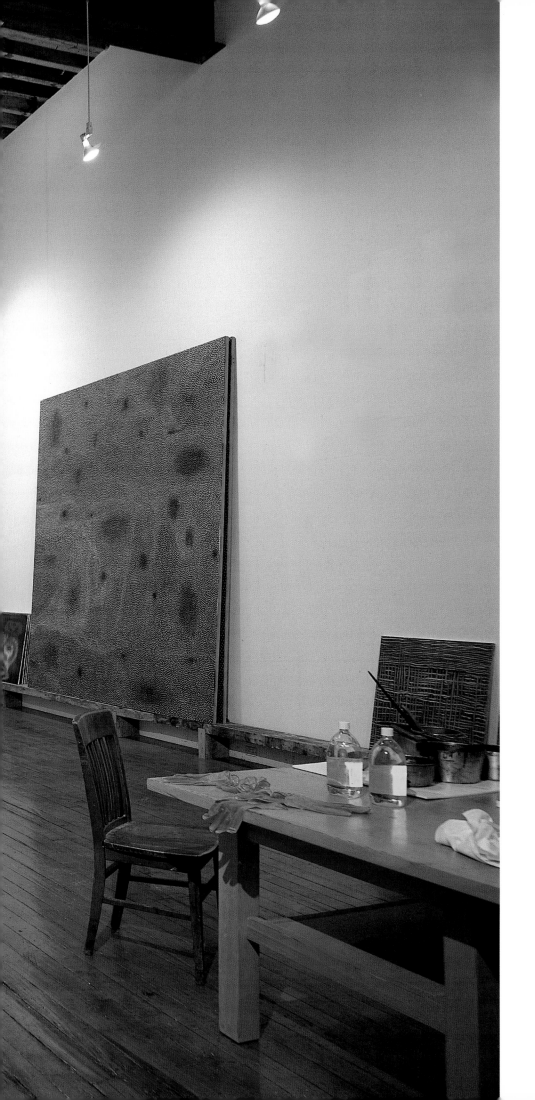

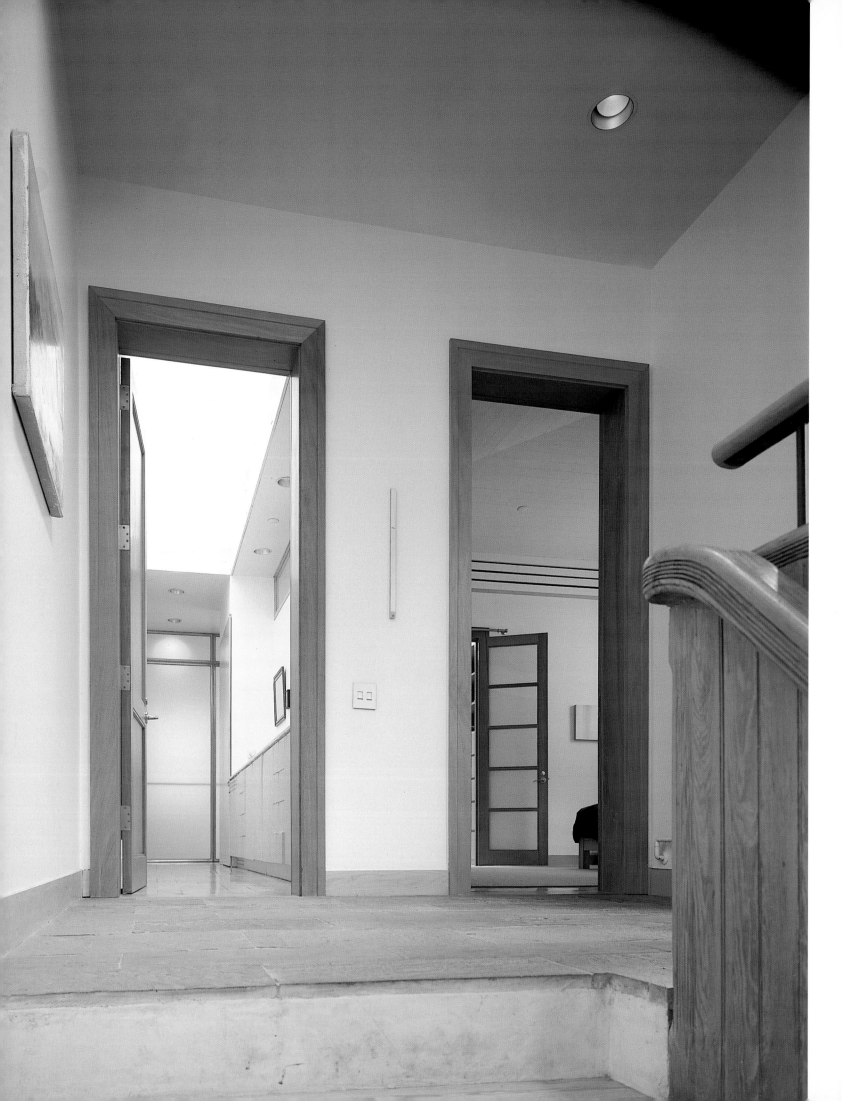

Weisz and Warchol Studio

This is a loft with a colorful history. In the 1920s, it housed the office and printing press of a Communist political organization; news photos from the period document police raids of the premises. More recently, the 2,500-square-foot space was owned by Mikhail Baryshnikov, who used it as an office for his dance company, and often as a crash pad for itinerant dancers. Baryshnikov's design legacy was not a pretty one: an elaborate maze of peach Sheetrock walls, installed in the late 1970s, defined small areas throughout, effectively negating any perception of open space.

Architects Claire Weisz and Ursula Warchol were commissioned to implement a potentially difficult program predicated on the restoration of spatial fluidity and openness. The clients, a married couple with grown children, were leaving a centuries-old Connecticut farmhouse to move into the city. In addition to typical living areas, they required two additional rooms designed with enough flexibility to serve either as bedrooms for visiting children and guests or as work/lounge space easily accessible (and visually connected) to the main living area.

Weisz and Warchol developed a clear, logical plan that reflects the unpretentious quality of the client couple as well as the limited budget. Space is organized and subtly layered to move from public to semipublic to private with boundaries either clearly expressed or merely suggested. At one end of the loft, a large communal area accommodates living, dining, and kitchen functions. The master bedroom and bath occupy the other terminus. In between, an existing single bedroom was divided into two smaller spaces that double as public sitting rooms or private quarters. To accent the dual role of the intermediary rooms, the architects installed two entrances to each space: wide French doors open to the public spaces along the primary north-south axis; more intimate single-width entrances open onto the long, narrow hallway leading to the master bedroom. That thirty-foot-long corridor is defined by a sculptural, twisted soffit with integrated uplighting.

The soffit notwithstanding, Weisz and Warchol eschewed bold architectural gestures. A subtle yet precise color palette shifts between warm and cool tones, emphasizing the rhythmic progression of spaces along the length of the loft. Doors and transoms of translucent sandblasted glass reinforce spatial connections as they facilitate the spread of natural light.

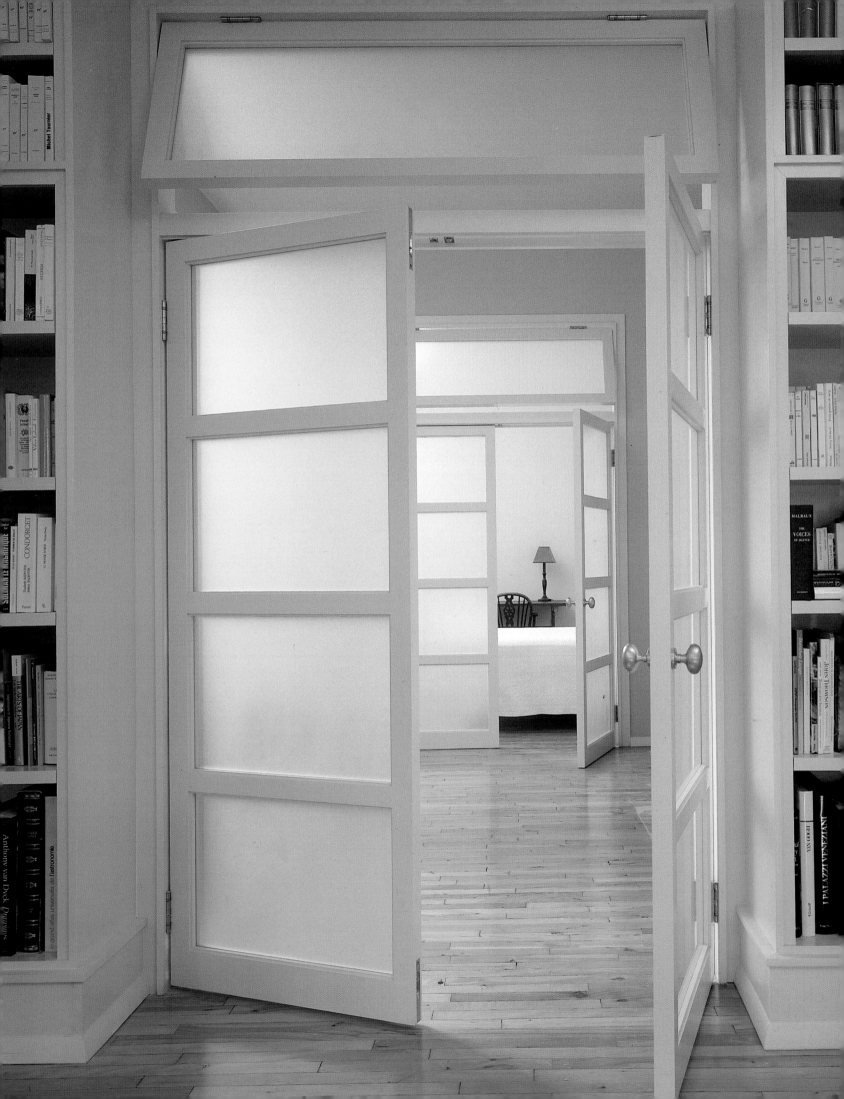

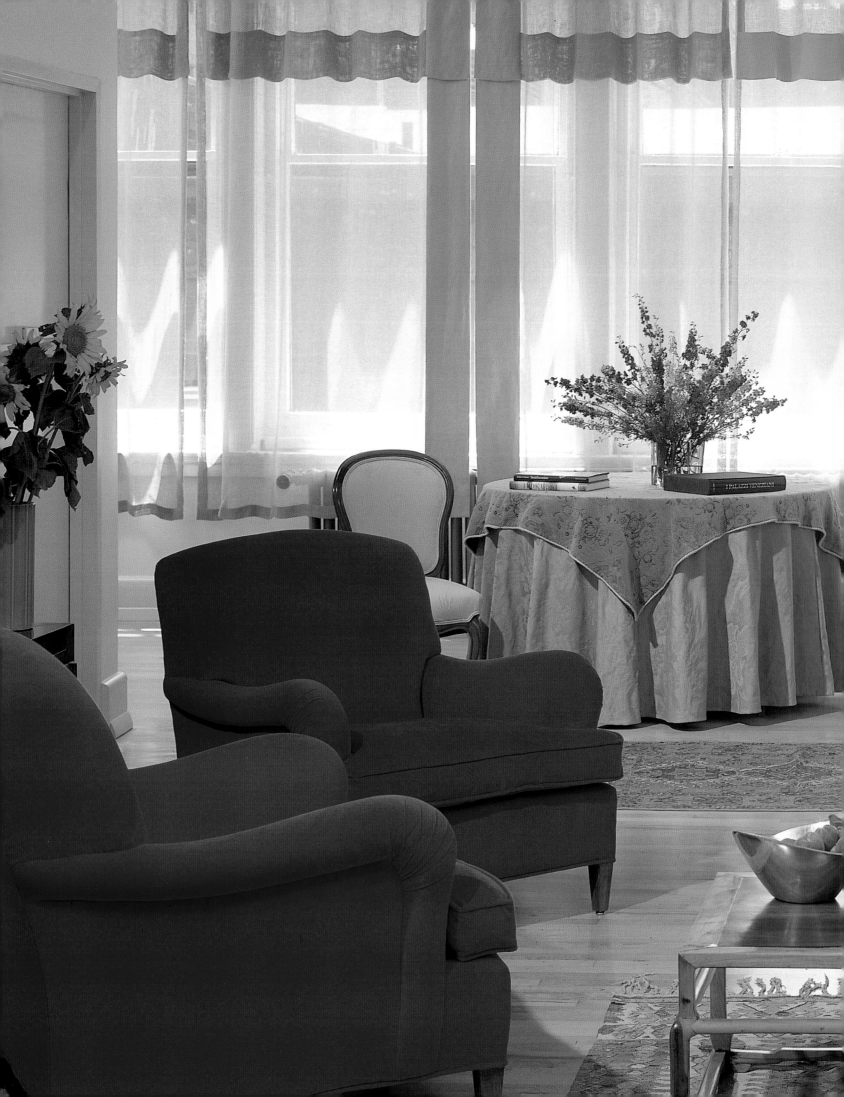

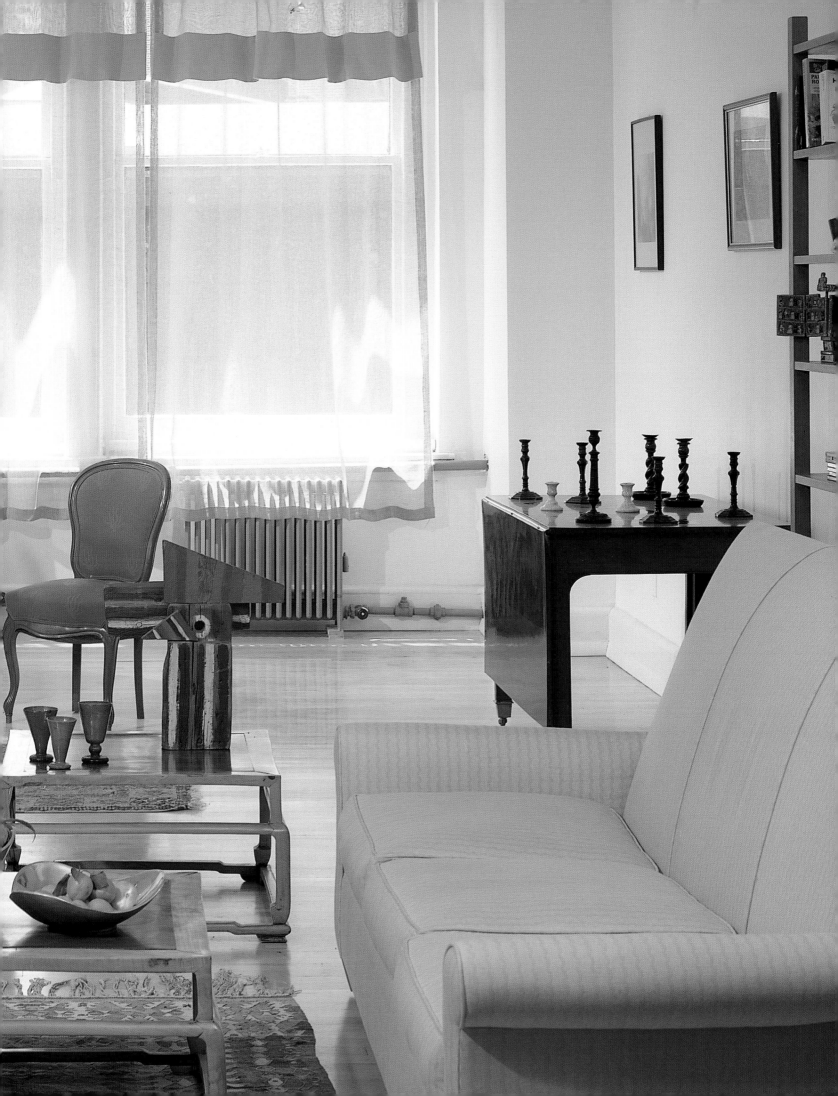

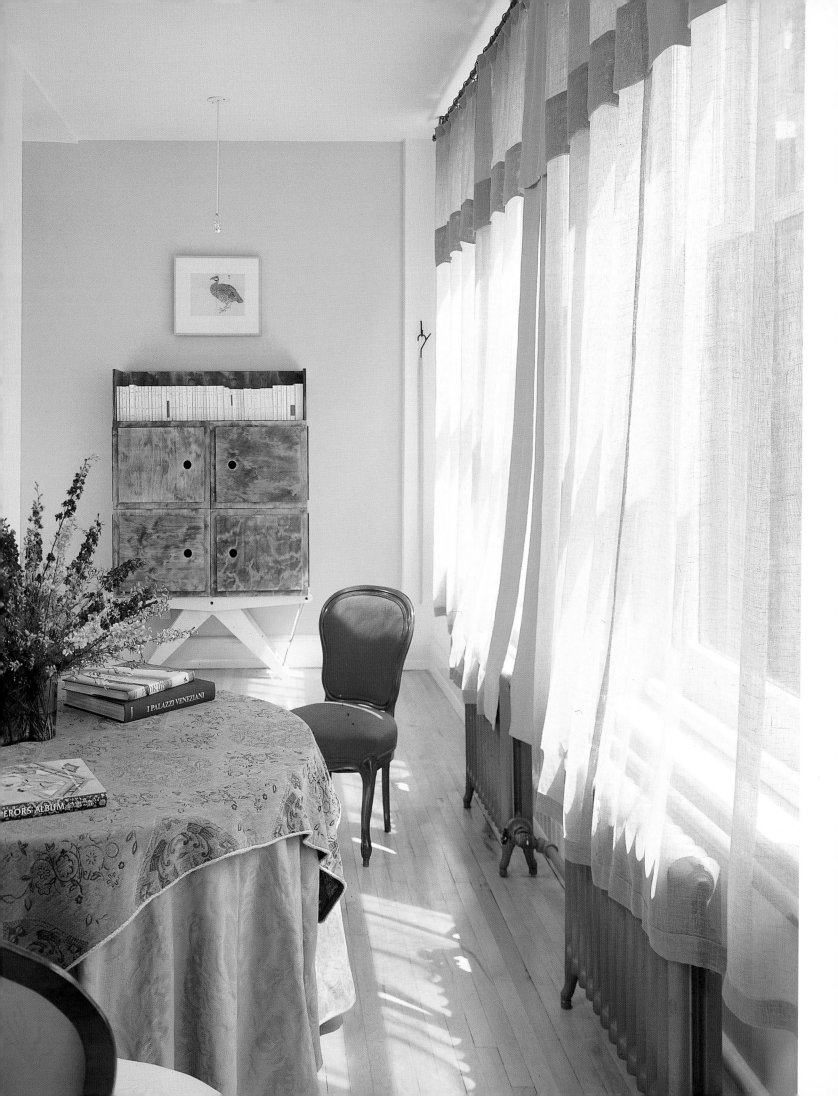

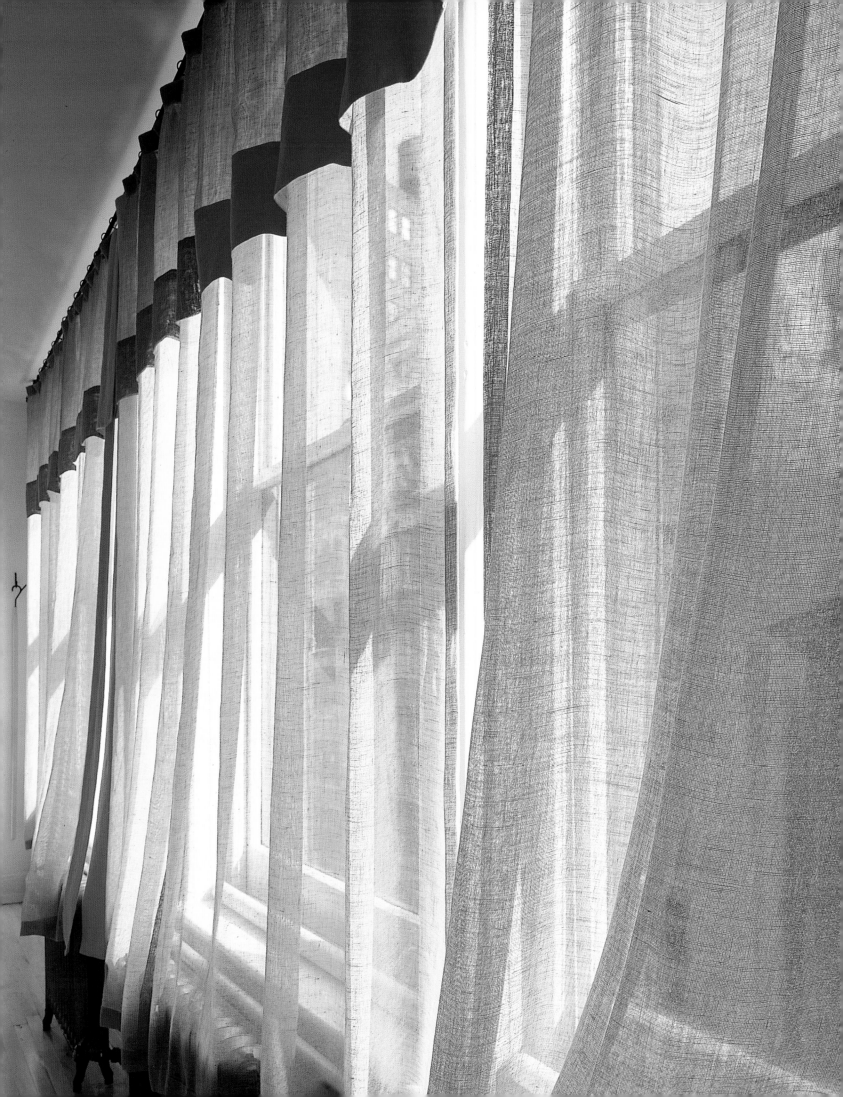

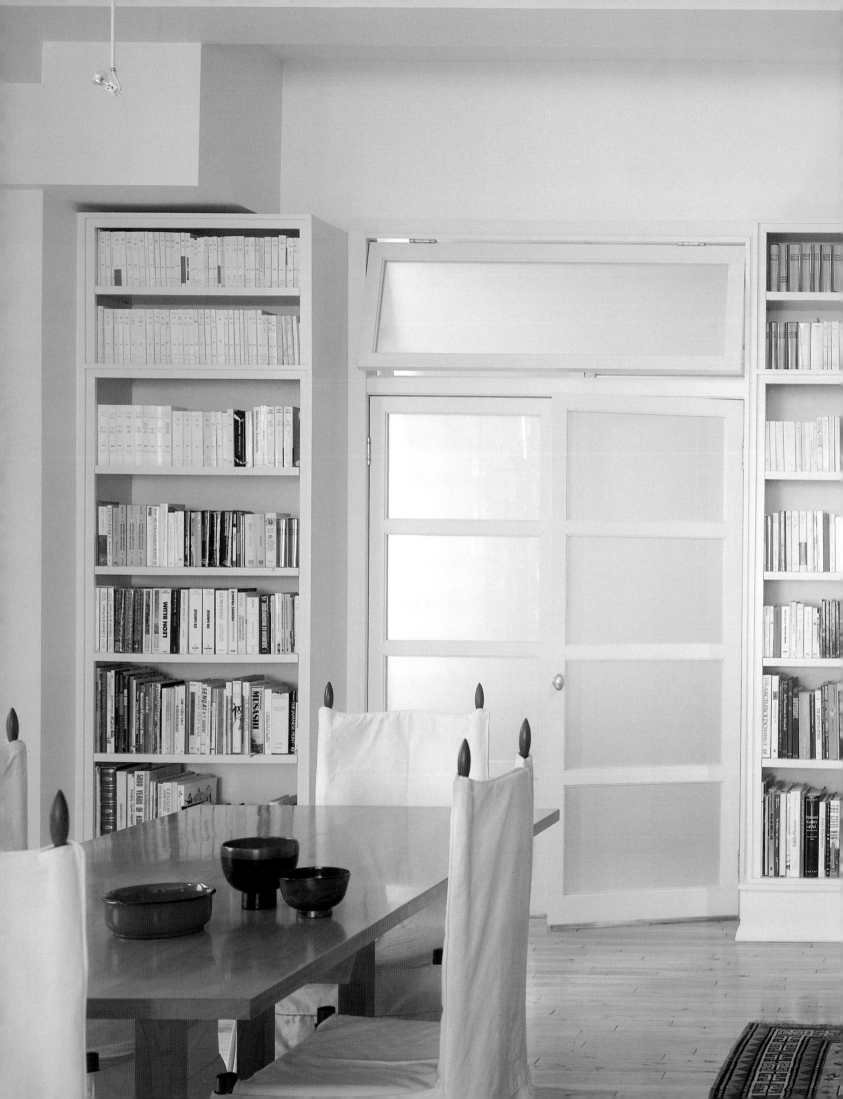

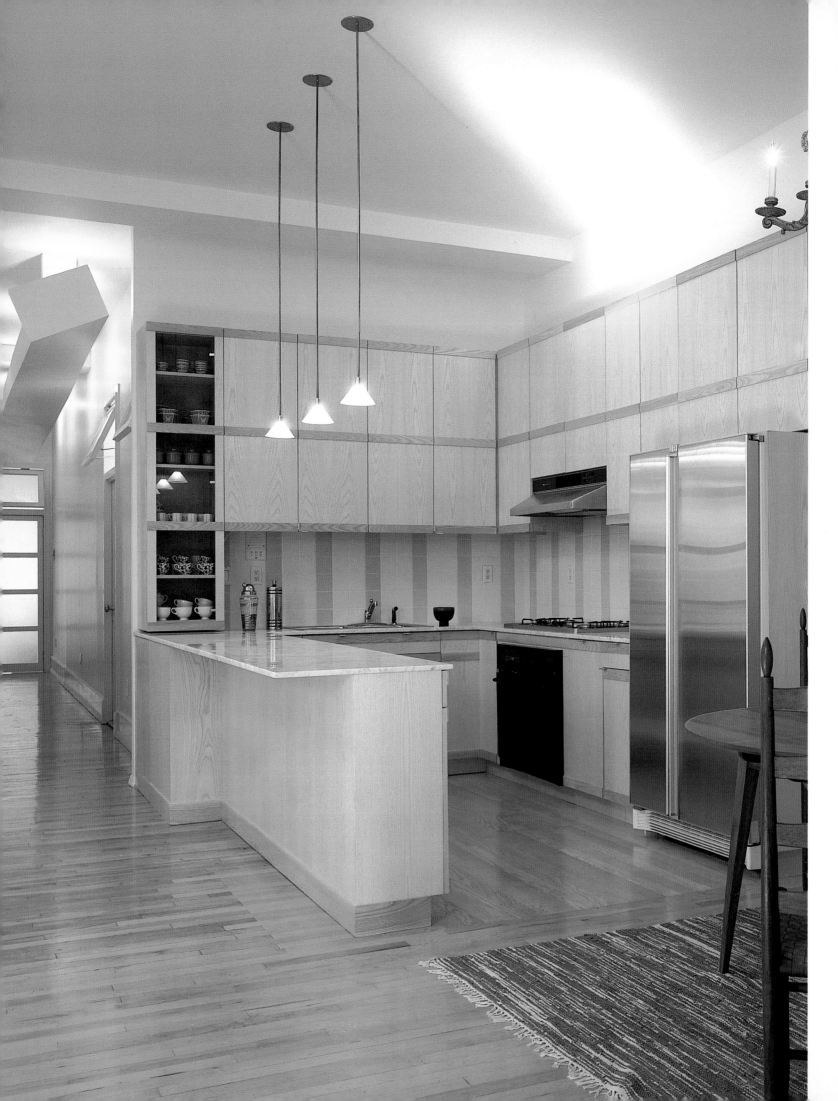

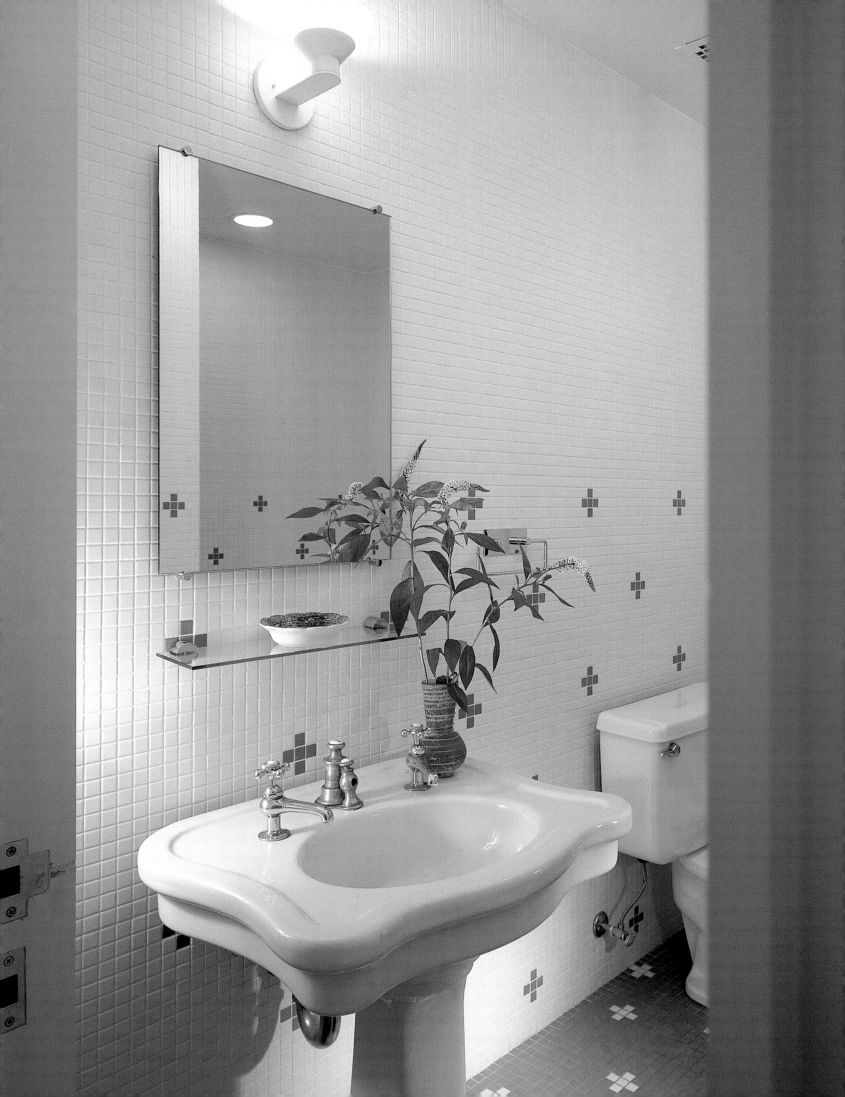

Stamberg Aferiat Loft, Flatiron District, 1976–93

Stamberg Aferiat Architecture

The story of the loft shared by architects Peter Stamberg and Paul Aferiat is one of slow evolution, not radical reinvention. The two have occupied the 2,500-square-foot loft since 1976, when both were young designers struggling to establish themselves professionally after college. At the time, the fashionable Flatiron district was not any kind of distinguishable area at all, merely a bleak nether region between Fourteenth and Twenty-third Streets unclaimed by either nearby Chelsea or Greenwich Village. The area's low rents afforded Stamberg and Aferiat the opportunity to acquire a large space for little money, but the obstacles to.comfortable habitation of that space were many and varied.

Originally designed in the early 1920s for the manufacture of clothing, the building had been used as a book warehouse for nearly forty years when Stamberg and Aferiat moved in. The loft had no running water and only direct current. With a tiny budget, the architects brought up water and power, and erected a raw, skeletal arrangement of metal studs and drywall. In addition to revealing a series of twenty expansive windows blacked out by years of accumulated dirt, the initial renovation effort unearthed a scrap of newspaper from 1925 with a headline decrying the blasphemy of Charles Darwin during the Scopes trial.

Spectacular city views to the north and east dictated the plan for the walls and partitions that define the various spaces. Realizing that the views were most impressive from vantage points close to the windows, Stamberg and Aferiat purposely blocked long sight lines from the loft's entry, saving the majestic cityscape until visitors moved further into the space. The walls—both partial and full height—that define the bedroom, bathroom, kitchen, office, and guest room were held away from the perimeter to preserve those panoramic vistas. Over the course of several years, the architects refined and finished the drywall construction and laid a new floor. Finally, in 1993, they followed the suggestion of their friend David Hockney and painted the walls in a polychrome fantasia of colors derived from the palette of Matisse. The determined use of strong color to enhance and articulate interior space has since become a signature of the architects' work.

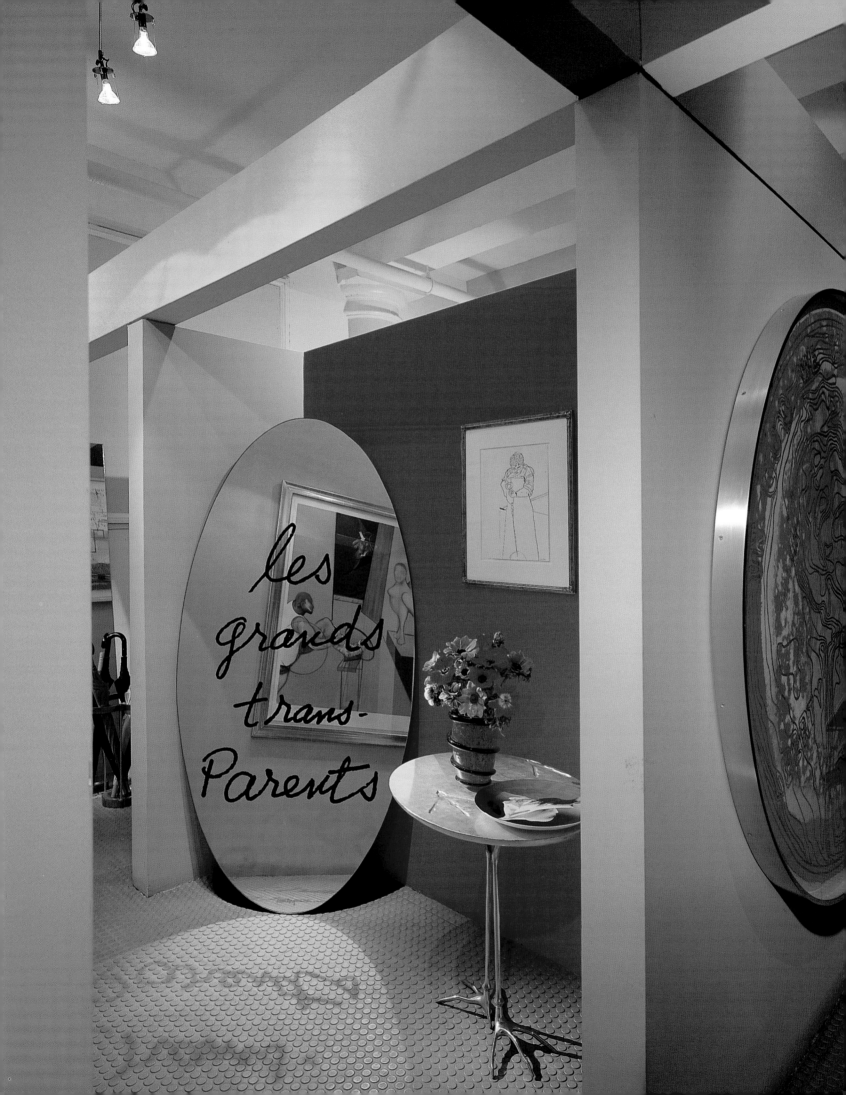

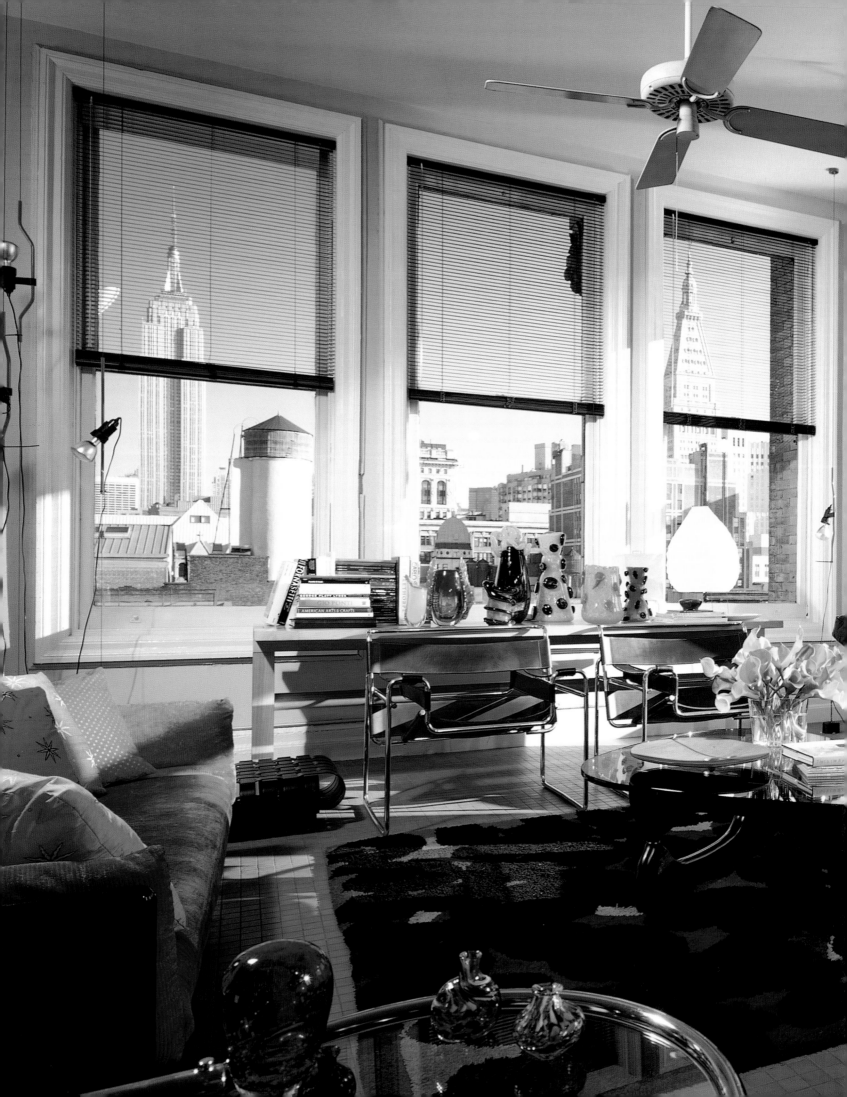

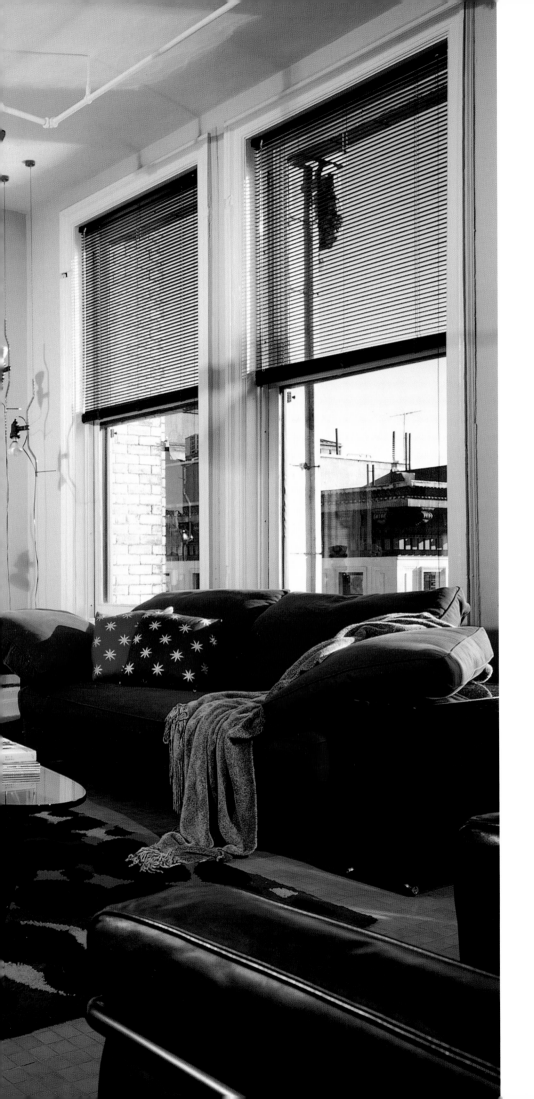

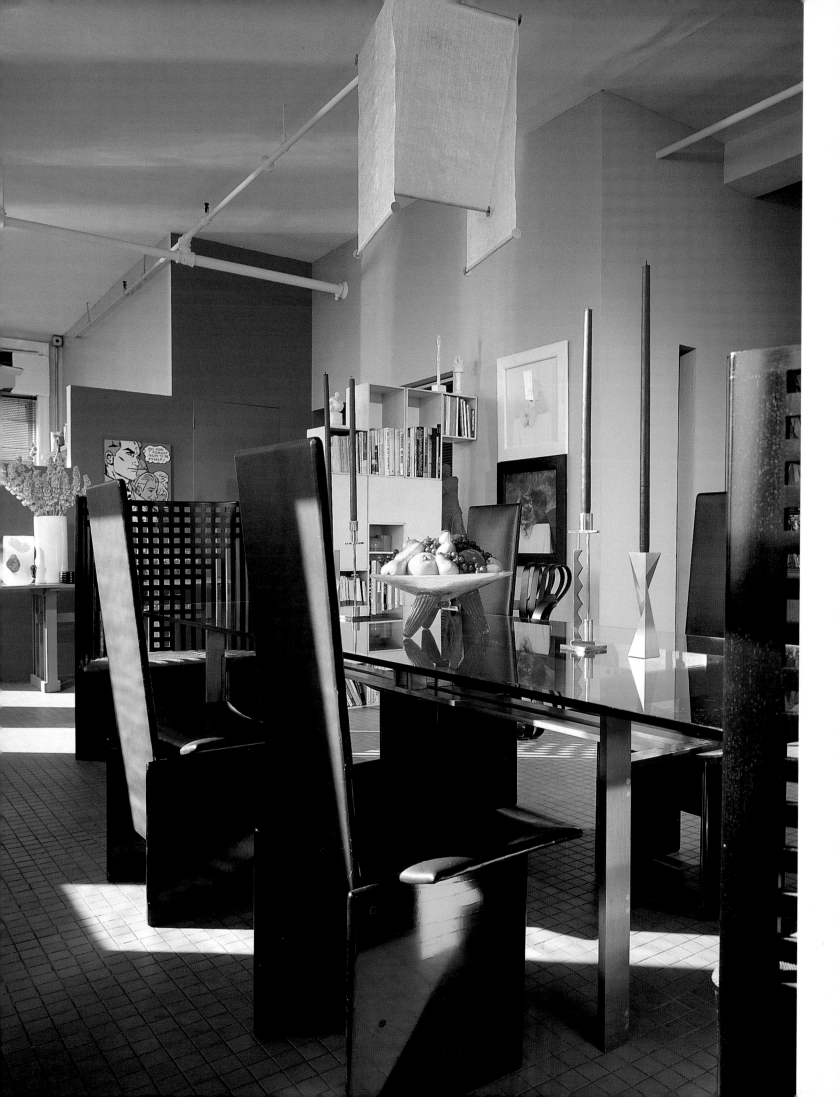

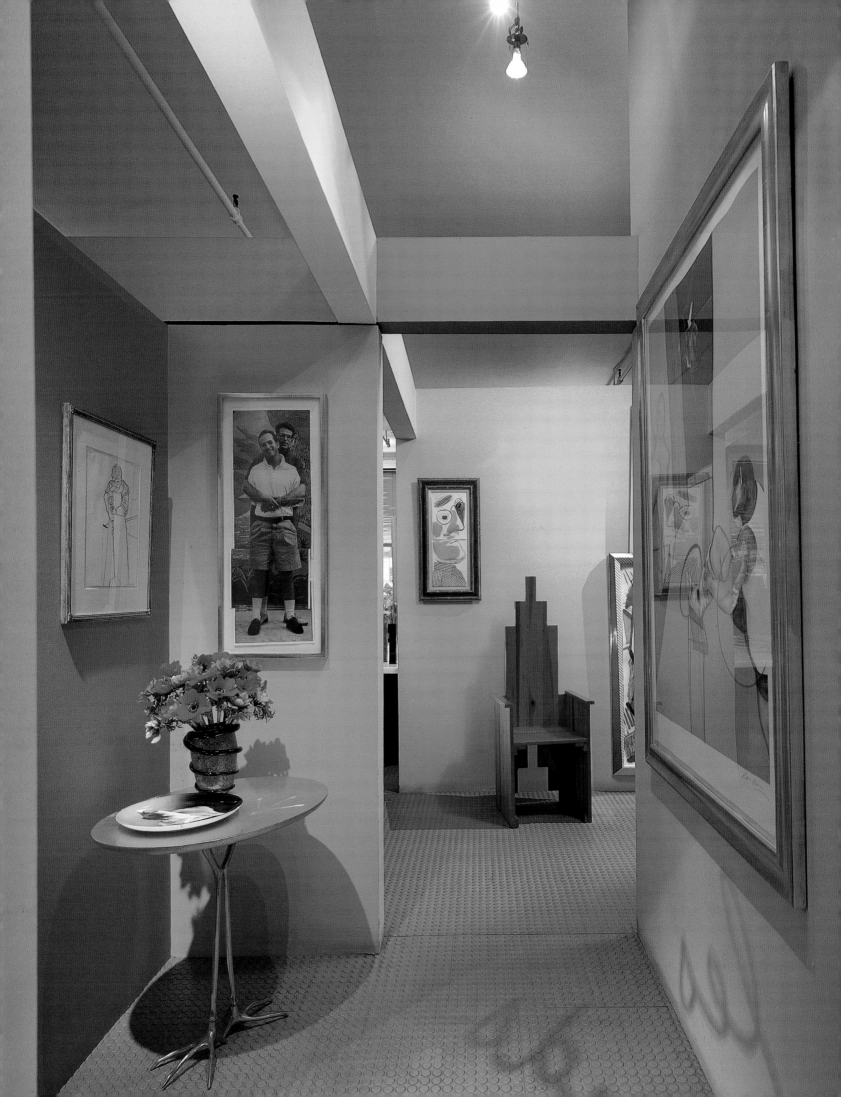

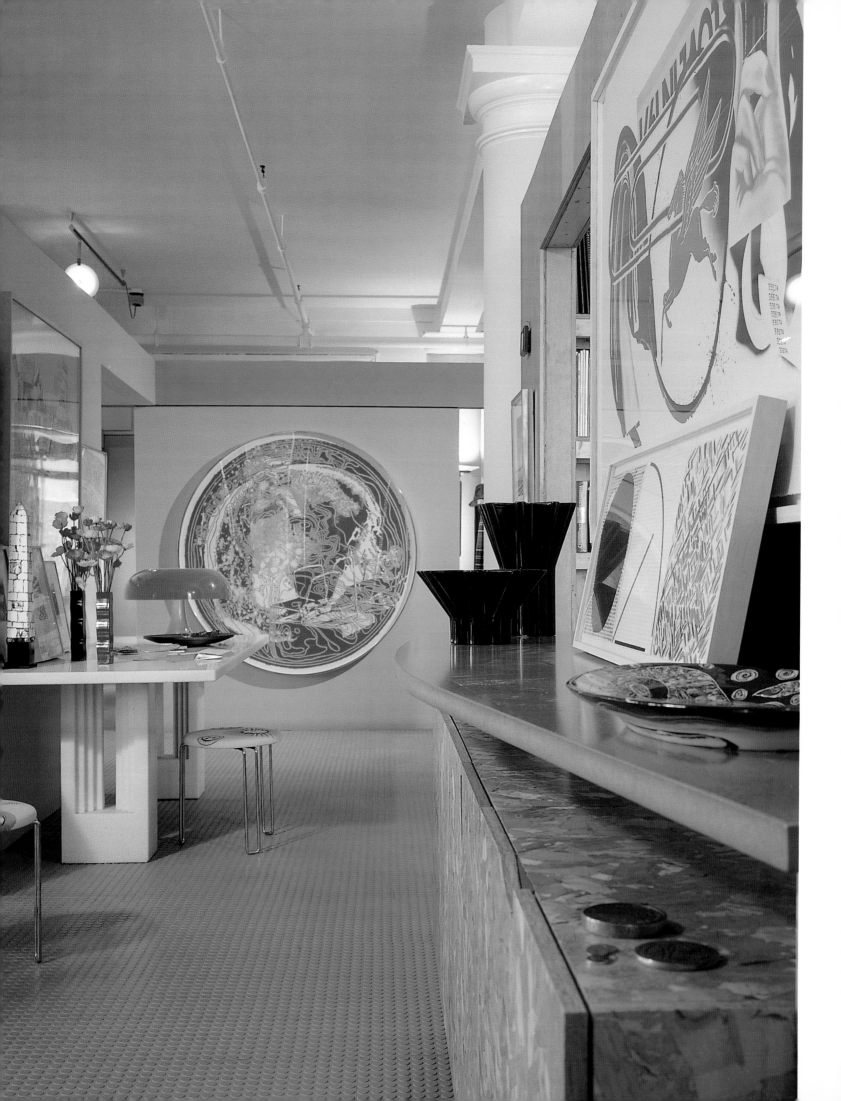

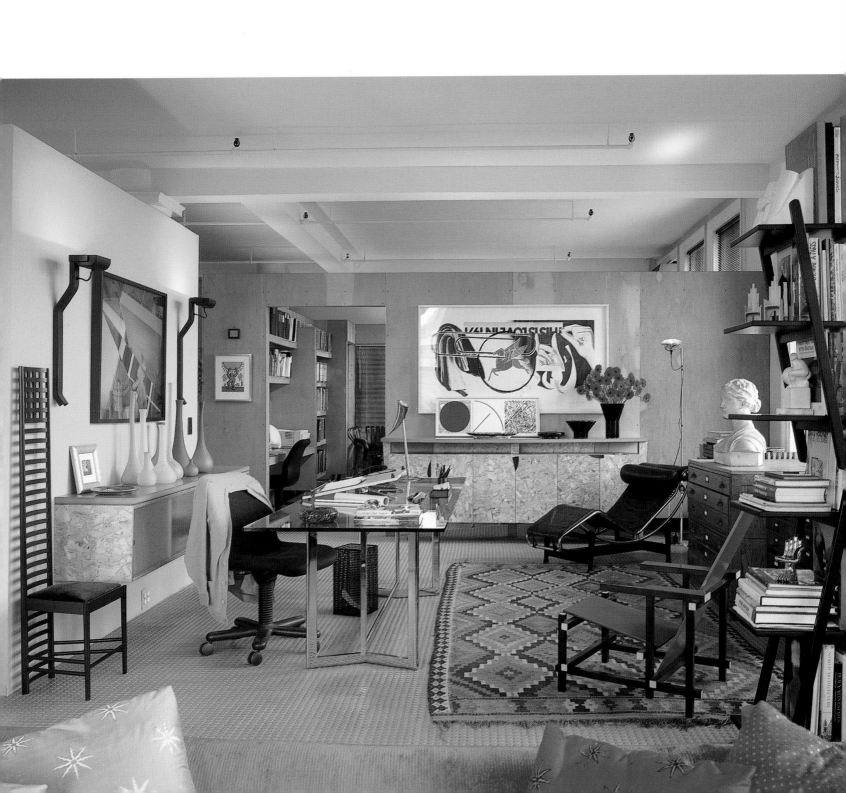

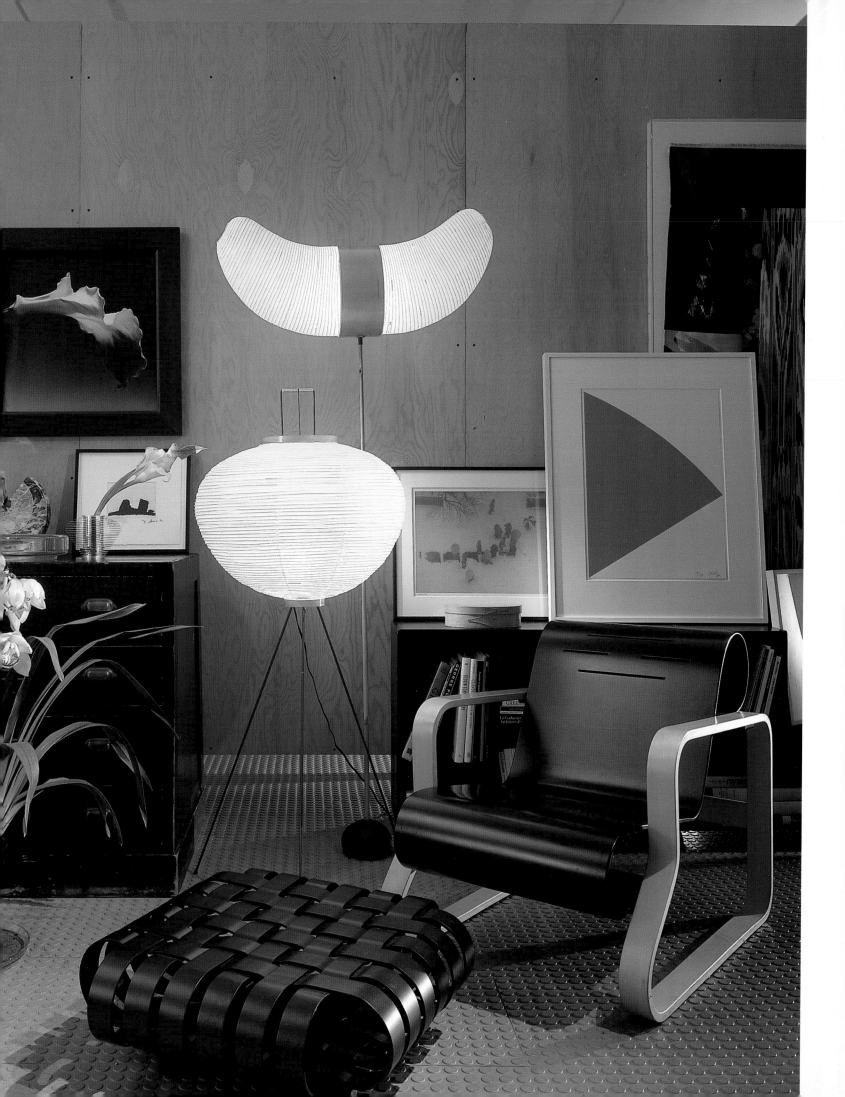

Loft was designed by David Israel and Michael Rock of 2x4, New York City.
The sans-serif font is Interstate Thin, designed by Tobais Frere-Jones based on the typography
of the United States interstate highway sign system. The slab-serif font is Caecilia,
designed by Peter Matthais Noordzij.